Early American Modernist Painting 1910-1935

Early American Modernist Painting 1910-1935

Abraham A. Davidson

DA CAPO PRESS • New York

First Da Capo Press edition 1994

This Da Capo Press paperback edition of *Early American Modernist Painting*
is an unabridged republication of the edition originally published in
New York in 1981. It is reprinted by arrangement with the author.

Published by Da Capo Press, Inc.
A Subsidiary of Plenum Publishing Corporation
233 Spring Street, New York, N.Y. 10013

Manufactured in the United States of America

Library of Congress Cataloging in Publication Data

Davidson, Abraham A.
 Early American modernist painting 1910–1935 / Abraham A. Davidson.
— 1st Da Capo Press ed.
 p. cm.
 "Icon editions."
 Includes bibliographical references.
 ISBN 0-306-80595-2
 1. Modernism (Art)— United States. 2. Painting, American. 3. Painting,
Modern— 20th century— United States. I. Title.
ND212.5.M63D38 1994 94-14968
759.13'09'041— dc20 CIP

Contents

A section of color photographs follows page 182.

Preface

I began my study of the history of early American modernist painting in the late summer of 1961. At that time, as a graduate student in Columbia University's art history department, I was casting about for a dissertation topic; and when I was using the library of the Fogg Museum, the late Professor Benjamin Rowland helped me inestimably (as he had helped so many others) by suggesting that this field represented a lacuna in studies in the broader history of American painting, a lacuna, by the way, which has been growing smaller and smaller. In my dissertation, which I entitled (I would not use the same title today) "Some Early American Cubists, Futurists, and Surrealists: Their Paintings, Their Writings, Their Critics," I focused on certain aspects of the Stieglitz painters, Arthur G. Dove, Marsden Hartley, John Marin, Alfred Maurer, and Max Weber, and on Charles Demuth. Since its completion in 1965, I have kept up my interest in the field, and written some articles and reviews. Although I was born in 1935, the last year of this book's time span, the first third of this century has had a special appeal to me, perhaps because my grandfather and grandmother, and my mother settled in this country from Russia in 1923.

Through the years certain painters, relatives of the painters, dealers, collectors, and scholars have shared with me their knowledge and information. To all of them I am indebted. They include, among others, Myron Barnstone, Thomas Beckman, Milton W. Brown, John Castagno, Anne O'Neill Donohoe, William Dove, Mrs. Malcom Eisenberg, Emily Farnham, Donald Gallup, William I. Homer, Anne d'Harnoncourt, Douglas Hyland, Leon Kelly, John Marin, Jr., Elizabeth McCausland, Garnett McCoy, Georgia O'Keeffe, I. David Orr, Henry M. Reed, Dr. Ira Schamberg, Robert Schoelkopf, Beth Urdang, Burt Wasserman, Mrs. Max Weber, E. H. Weyhe, Ben Wolf, and Tessim Zorach.

I am also indebted to Temple University, which provided me with a research grant in 1979 that helped to defray costs of travel.

I wish to thank Cass Canfield, Jr., for his close interest. Some of his suggestions were incorporated into the text. My gratitude to Carol E. W. Edwards for her careful editorial work, and to Pamela J. Jelley for her help in a variety of ways.

<div align="right">A.A.D.</div>

Philadelphia
May 1980

Early American Modernist Painting 1910-1935

Introduction

This book attempts a survey of the field of early American modernist painting from 1910 to 1935, the period before American avant-garde painting assumed its position of international leadership. The American modernists of 1910 to 1935, inheriting those attitudes of modesty toward their accomplishments shared by the American painters preceding them when they too confronted their work in comparison with European painting, made no proud claims, issued no manifestos (except for the Synchromists Stanton Macdonald-Wright and Morgan Russell). Rarely did they acknowledge that they had made a dramatic break with American painting of the late nineteenth century. They did not refer to their paintings as Fauvist, Expressionist, Cubist, Futurist, Abstract, Dadaist, or Surrealist.

Like the European Fauvists and Expressionists, they replaced local colors of objects with colors revealing states of feeling, inner reactions to the subject. Like the European Cubists, they fragmented objects, or took them apart, placing their flattened parts next to one another. Like the Futurists, they arranged objects or parts of objects in a kaleidoscopic manner, or overlapped forms or parts of forms to convey in a nonrepresentational way the sense of motion or speed. No less than Kandinsky or Mondrian, they presented shapes and colors that bore no resemblance to anything in the world the eye recognized. Like the Dadaists and Surrealists, they evolved a conceptual sort of art. Like the Surrealists, some early American modernists (Demuth, Dove, and others) illogically juxtaposed objects in groupings that could not have occurred in real life. If these painters did not exhibit the revolutionary fervor of the Europeans, it should not blind us to the significance of their accomplishments.

The beginnings of early American modernist painting may be set generally at about 1910. That was the year of Arthur G. Dove's first nonobjective paintings, of Max Weber's nudes based on Picasso's Iberian figures, and of Morgan Russell's

first still lifes done in the manner of Cézanne's. It was the year before Marsden Hartley's first landscapes in an Analytical Cubist style; two years after Patrick Henry Bruce's luminous still lifes and landscapes based on the paintings of Matisse, with whom he had studied in 1908; and three years after Alfred H. Maurer's first broadly brushed, brightly colored landscapes. Obviously no single year can be stated as the firm beginning of modernism for all four dozen or so painters. Of these, the dozen or so younger Precisionists begin with their modernism around 1920. So it should be stressed simply that much of early American modernist painting begins around 1910.

Modernism is but one of several directions that can be found in American painting at various points from 1910 to 1935. Prevailing at the beginning of that period were artists and styles that had found their directions at the end of the previous century. Winslow Homer (1836–1910) in the last decade of his life painted not the struggles of man against the sea, but the waves pounding triumphantly against an uninhabited shore (*West Point, Prout's Neck*, 1900, Sterling and Francine Clark Art Institute, Williamstown, Mass.), in which man, when he does appear, is a passive onlooker. Thomas Eakins (1844–1916) in his last years painted remarkable portraits of older women, reflective, resigned, but dauntless (*Mrs. Gilbert Parker*, 1910, Museum of Fine Arts, Boston). Albert Pinkham Ryder (1847–1917) began his *Racetrack* (Cleveland Museum of Art) some time in the early 1890s and continued work on it until 1910, making this the only one of his dreamscapes based on a contemporary event—a waiter who committed suicide over his losses at horse betting. James Abbott McNeill Whistler died in 1903, as his influence was rising in America. Mary Cassatt, who had studied with Degas, lived until 1926; Henry Ossawa Tanner, who had studied with Eakins, until 1937; Ralph Albert Blakelock, confined to a New York sanitarium for the insane the last twenty years of his life, until 1919; and Louis Michel Eilshemius until 1941.

The first decade of the twentieth century was also a time for the formation and coalition of groups of painters. In 1898, John E. Twachtman, Childe Hassam, J. Alden Weir, and others joined to form an Impressionist group called "The Ten." Their silvery landscapes (Childe Hassam, *Southwest Wind*, 1905, Worcester Art Museum) were similar to—but not as mystically inclined as—the late muted work of George Inness. More notorious was "The Eight" or "Ashcan School," who under the leadership of Robert Henri exhibited together in 1908 at the Macbeth Gallery in New York City. Four of the members (Luks, Glackens, Sloan, and Shinn) had been Philadelphia newspapermen. They brought to their painting their experiences as reporters. With The Eight, for the first time in the history of American painting, the city and the life within the city became the focus of interest. But the styles of the various members, and the aspects of the city that attracted each, varied greatly. Maurice Prendergast, working in a Pointillist idiom somewhat similar to that of Signac, preferred to show festive groups

promenading in parks or by the seashore. Glackens, whose compositions were often based on those of Renoir, showed members of New York's upper middle class sitting in restaurants or enjoying life in their homes in the suburbs. But Luks and Henri, who worked in a style of Dark Impressionism, and John Sloan, whose *Haymarket* (1907, Brooklyn Museum) and *Wake of the Ferry* (1907, Phillips Collection, Washington, D.C.) must be counted as among the most evocative canvases of the group, depicted the dwellers of the city's slums and near slums. These they showed not as downcast by their poverty, but as vigorous, vital creatures, enjoying life to the fullest. The burst of exuberance coming with The Eight had its complement in the unabashed freedom of color in many paintings by the modernists.

George Bellows (1882–1925), a follower of the Ashcan School, peopled his cityscapes and countryscapes with especially energetic and forceful types reminiscent of the legacy of Jack London. In the 1920s and 1930s, however, there appeared visions of the city less optimistic than those of the Ashcan School. For Edward Hopper (1882–1967), the city was a lonely place, where the inhabitants never really touched when coming into physical contact with one another. Some of his pictures without the presence of people, of buildings by themselves, dryly rendered and looming against a bare backdrop (*Early Sunday Morning*, 1930, Whitney), remind us technically of buildings by the Precisionists, who did not, like Hopper, envision the city as a place of oppressive silence but of lucid machine forms interrelated aesthetically and functionally. A pole apart from Hopper was Reginald Marsh (1898–1954), whose sometimes leering sometimes lurching figures and pressing crowds partook of an earthy, almost animal vitality that made the city a place of frightening intensity (*The Bowl*, 1933, Brooklyn Museum).

Beginning in the late 1920s—the closing period of the time span of this book—and continuing through the 1930s were two movements in painting, Regionalism and Social Realism, that were the opposite sides of the same coin. Like Precisionism, they both put their emphasis on the American scene, but unlike Precisionism were naturalistic and antimodernistic, and propagandist in their orientation. The Regionalists went for their subject matter to the heartland of America, to the authentic American nonethnic types found in the farms of the Midwest and South, and to the prairies and cattle country of the West. Except for a few pictures, somewhat sarcastic in tone, by Grant Wood (1892–1942), the canvases of the Regionalists were celebrations of the fortitude, enterprise, resilience, and colorfulness of America. Thomas Hart Benton (1889–1975), who had been a color painter in the second decade under the tutelage of the Synchromist Stanton Macdonald-Wright, came to condemn the effeteness of the Eastern cities, and painted in the 1930s bronco busters, country fiddlers, and card-playing, hard-drinking cowboys (*Mural No. 2, Arts of the West*, 1932, Art Museum of the New Britain Institute, New Britain, Conn.).

While the Regionalists applauded America, the Social Realists, dwelling on the suffering brought on by the Depression, condemned its injustices and inequalities. The Eastern cities were usually their focus. Daumier and Goya were their artistic forebears, though they often used a bold magazine-like format suggested both by current illustration and by certain Mexican muralists like Diego Rivera to get their ideas across forcefully and quickly. The Social Realists were mainly Socialist, even Communist, if not in their ideologies at least in their sympathies; and it was not surprising that there were a good number of Jews (Ben Shahn, William Gropper, Jack Levine, Philip Evergood) and Blacks (Jacob Lawrence) in their number. Evergood (1901–1973) revealed the brutality used by billy-club-wielding police in breaking up a strike (*American Tragedy,* 1937, Private collection). Gropper (1897–1977) pictured senators as fat, insensitive windbags (*The Senate,* 1935, Museum of Modern Art). Ben Shahn (1898–1969) in 1931–32 did a series of twenty-three paintings showing the trial, imprisonment, and execution of the Italian anarchists Nicola Sacco and Bartolomeo Vanzetti, who had been prosecuted—as he and the liberals of the time felt—on flimsy evidence and then found guilty because of their political beliefs.

For the early modernists, the end of World War I was a watershed. Most of the boldest ventures occurred before 1920 or so: the Stieglitz Group, with the German Symbolist series of Hartley, the kaleidoscopically arranged buildings of Weber and Walkowitz (but those of Marin came in the 1920s, as did many of the nonobjective biomorphic paintings of O'Keeffe); the conceptual art of the Arensberg Circle (except for the collages of Dove and Stella and the Poster Portraits of Demuth); and the fully developed paintings of the Synchromists, of the followers of Delaunay, such as Bruce and Frost, and of other color painters. After 1920 came the brunt of Precisionism or (in Milton Brown's term) Cubist Realism, where the approach was less European and the object was preserved fairly intact rather than fragmented in the fashion of European Analytical Cubism, as, say, the buildings had been in Weber's *New York at Night* of 1916 (University of Texas Art Museum, Austin). Belonging in the Precisionist group were George Ault, Preston Dickinson, Charles Sheeler, Charles Demuth, and Niles Spencer, among others.

This situation in painting was a reflection of wider considerations. In the second decade America was more intimately involved with Europe than it was to be in the third—an isolationist period marked from the first by the refusal to join the League of Nations. Before World War I, President Wilson had lowered tariffs, regulated big business, and refused to cut down immigration quotas from Europe; America was seen as full of promise for the foreign oppressed, as vividly pictured in Mary Antin's *The Promised Land* of 1912. It was in this interval before World War I that many of the American modernists made their contacts with modern painting in Europe. These included the Stieglitz painters Oscar Bluemner (1912), Dove (1908–09), Hartley (1912), Marin (1905), Maurer

(1897), Walkowitz (1906), and Weber (1905); the Arensberg painter John Covert (1908); the Synchromists Macdonald-Wright (1907), Morgan Russell (1909), Andrew Dasburg (1907), and Thomas Hart Benton (1908); the Delaunayists Patrick Henry Bruce (1903), Arthur Burdett Frost, Jr. (1906), and James Henry Daugherty (1914); the color painter Arnold Friedman (1908); the Precisionists Charles Demuth (1904, 1907), Preston Dickinson (1910 or 1911), Morton L. Schamberg (1902, 1903, 1905–06, 1908), Charles Sheeler (1905, 1908), and Joseph Stella (1909); the Philadelphia painters Arthur B. Carles (1907) and H. Lyman Saÿen (1906); and the independents Manierre Dawson (1910), Marguerite Zorach (1908), and William Zorach (1910).

But if Precisionism, a realism pared down, was an authentic American approach, this is not to say that American modernist painting of the second decade when more directly affected by European modernism lacked its own stamp. There was not what could be called an American style in the painting of that second decade to which all the four dozen or so American painters working then subscribed. But there were attitudes differing from those in Europe, and causing a number of distinct directions.

A salient factor about the development of early modernism in America is that it appeared when it did with such arresting suddenness. There was no Post-Impressionism, no Seurats, Cézannes, Van Goghs, Gauguins, or Ensors to pave the way. In Europe there were theoretical concepts of proportionality that continued from Seurat through Gris and Cubist painters of the so-called golden section,[1] all of whom used the ratio where a small measure was to a large as the large was to the sum of the two. As a result much of French Cubism shows a geometrical substructure even when the "golden section" is not used. In Picasso's and Braque's Analytical Cubist paintings of 1910 through 1912, the elements are commonly shaped into a triangular format, with smaller triangles containing 30-, 60-, and 90-degree angles used within that format. In American paintings that can be called Cubist there is a more haphazard compositional pattern, with the geometrical substructure seldom in evidence. This can and should be stated positively: there is in American paintings adopting the Cubist idiom an energy, a directness, an exuberance. At the same time there is a subtlety about much European Cubist painting that the Americans either missed or seldom tried to emulate. In Picasso's *Ma Jolie* of 1911–12 (Museum of Modern Art), the spectator feels that he or she can catch momentary glimpses of something recognizable within the total integration of diaphanous zones. With the American modernists, whole bits of something clearly recognizable became suddenly intruded.[2]

When the American artists of the Arensberg Circle responded to the works of Duchamp and Picabia, an iconoclasm emerged on the part of Covert, Davis, Stella, and others that was ironic and sometimes playful, rather than disturbingly nihilistic. But in retrospect this is the way it should have been, for America

then, compared to Europe, was younger in every sense of the word, less scarred, more innocently enthusiastic. What was disturbing in European Dadaism simply was not grasped. Hartley, for example, wrote that "a Dada-ist is one who finds no one thing more important than any other thing, and so I turn from my place in the scheme from expressionist to dada-ist with the easy grace that becomes any self-respecting humorist."[3] America could be enthusiastic about the machine and its burgeoning industrialism, whereas Italy in the first part of the second decade already felt an urgency, almost an apocalyptic fervor. The notion of a headlong speed from one expressed point to another in Italian Futurism, symbolic of the directed rush into the twentieth century, was replaced in America by a more general excitation (John Marin, *Lower Manhattan*, 1922, Museum of Modern Art). In Charles Demuth's cityscapes and factoryscapes (*My Egypt*, 1927, Whitney), the ray-lines resemble the Futurists' "lines of force" only morphologically. They assume none of the aggressiveness, functioning instead as beams of light, licking lightly upon heavy factory blocks or colonial facades.

Of course, there was tremendous resistance in America to modernism's spread and success. The charges could be violent and outrageous. Pictures made by patients in sanitariums for the insane were claimed to be just like the paintings and drawings of the Cubists [1]. After stating that the first Orphist (a branch of Cubism practiced by the Frenchman Robert Delaunay and others) picture was done by a donkey whose tail had been dipped in paint, Kenyon Cox, a chief debunker of modernism, asked: "If an artist is to choose his symbols to suit himself, and to make them mean anything he chooses, who is to say what he means or whether he means anything? If a man were to rise and recite with a solemn voice words like 'Akajan maradak tecor sosthendi,' would you know what he meant?"[4] Such outbursts were not sporadic, nor were they symptomatic only of the years immediately following the Armory Show. In 1924, eleven years after the Armory Show, there existed a Society devoted to the combatting of Cubism.[5]

There was another side to the ledger, the complement to the fierce debunking. On the pages of *Camera Work* and elsewhere, the new styles were defended passionately, sometimes with an irrational ecstasy. A quasi-moral superiority could be claimed for the adherents of the New Art. Mabel Dodge, who held a salon at 23 Fifth Avenue at which the social, political, and artistic issues of the day were bandied about, asserted that "many roads are being broken today, and along these roads consciousness is pursuing truth to eternity. This is an age of communication, and the human being who is not a 'communicant' is in the sad plight which the dogmatist defines as being a condition of spiritual non-receptivity . . . let every man whose private truth is too great for existing conditions pause before he turn away from Picasso's painting. . . ."[6]

Between these extremes lay a variety of more moderate responses. Some

of the early American modernist painters were taken notice of and reviewed in the press and in periodicals. Certain standards of acceptance emerged. Paintings that were nearly nonobjective could be favored if the colors were bright and cheerful, while Weber's archaically powerful nudes of around 1910, based on Picasso's Iberian figures, were universally criticized for their ugliness. For example, Arthur Hoeber of the New York *Globe* considered Weber to be the "high-water mark of eccentricity,"[7] but found Dove's work of the following year, 1912, more acceptable. Dove "seeks to present patterns," ventured Hoeber, "and offers a scheme of color with these that . . . is at least less objectionable than that of his confreres in these departments."[8] In 1909 J. Chamberlin of the *Evening Mail,* on the whole sympathetic to the Stieglitz painters, found Marin's color to be "pure, original, vivacious, and subtle," and predicted that Marin would become famous.[9] In 1912 he observed that Dove's early abstractions were "beautiful and strange, and the eye returns to them again and again as if with delight in finding something which it is not required to understand at all, but which is intrinsically agreeable."[10] Yet Chamberlin in 1911 found the ugliness of Weber's early Cubist paintings to be appalling.[11]

Pleasing designs, no matter how abstract, were usually favored. Objects pulled out of their normal contexts and combined in strange ways, as in Demuth's Poster Portraits of 1924 through 1929, confounded American critics. Demuth by 1925 had made a reputation for himself through his many shows at the Daniel Gallery—the next year Louis Kalonyme would call him "our only magician with watercolor"[12] —and to spurn him utterly would have been considered in poor taste. Hence a critic in the *Art News* of April 1926 found himself "unable to accept and unwilling utterly to reject" the Poster Portraits. He added prudently that "since change must be, we prefer to wait until that change has fulfilled itself."[13] D. Fulton, in commenting on the Stieglitz-sponsored Seven Americans Show, found that the Poster Portraits had "somewhat the same relation to the exhibition as the side show to the circus."[14]

All of this is not to say that the views of the early critics of American modernist painting were necessarily arcane and narrow. Few have surpassed Paul Rosenfeld in the pointed appropriateness of his observations. He felt especially the Americanness of the Stieglitz painters, their rootedness to their homeland, and, for all the novelty of their forms, their link to such artists of the nineteenth century as the great visionary Albert Pinkham Ryder.[15] His book of fourteen collected essays on those who had given him "the happy sense of a new spirit dawning in America" (Ryder, Van Wyck Brooks, Carl Sandburg, Hartley, William Carlos Williams, Margaret Naumberg, Kenneth Hayes Miller, Roger Sessions, Marin, Dove, Sherwood Anderson, O'Keeffe, Randolph Bourne, Stieglitz) was published in 1924 as *Port of New York*. In an essay for *Dial,* which had appeared three years earlier and from which he drew for the *Port of New York,* he denoted Hartley's paintings as being luxurious and frozen at the same time,

and observed that the mountain pieces of his first Maine period of the first decade were "powerful and memorable expressions of the starvation of the generation. The bare gloomy mountain sides, the shattered and dying evergreens, the rocks line piles of bones, the clouds that float high and insanely free and distant above the deserted valley, are woven into patterns almost Wagnerian in their grandiosity."[16] And of Demuth, who even at Provincetown dressed fastidiously, who visited New York dives and jazz spots as a dandy, and who idolized Proust, he wrote: "There is always the suspicion of an almost feminine refinement in his work. Masts of Gloucester schooners, red ventilators with gaping maws out of which the sound comes back, warehouses mirroring themselves in canals still as Vermeers, they are all pared of their nails, and made Sunday-afternoonish, lest Lancaster River be filled with swarthy devils."[17]

The effulgence of his prose notwithstanding, Rosenfeld saw early American modernist painting as the exceptional work of a small number of resolute experimenters isolated from the mainstream of American art, all associated with or at least close to Stieglitz's gallery 291, which Rosenfeld called "a house of God."[18] This narrow, rather exclusivist view of the field was dissipated with the publication in 1955 of Milton W. Brown's *American Painting from the Armory Show to the Depression*. Brown contrasted the realism of the Ashcan School and their followers, such as Bellows and Glenn O. Coleman, and that of the Fourteenth Street School with various strains of modernism, not all of which was centered about Stieglitz, such as the Synchromism of Macdonald-Wright and Russell and the Duchamp-inspired work of Man Ray and John Covert. During the 1960s, as research in American art history generally proliferated, the number of painters consigned especially to this field was uncovered at a dizzying pace. In the large exhibition held in 1975 in the Delaware Art Museum and entitled "Avant-Garde Painting and Sculpture in America 1910–1925," there were fifty-six artists, forty-six of them painters; and of these, twelve (Benrimo, Daniel, Dawson, Feitelson, Friedman, Frost, Jr., Kelly, Murphy, Saÿen, Van Everen, Wood, and Edith Williams) were not mentioned by Brown. In the Delaware show, from two to five works of each artist were shown. Organized by William I. Homer and his students at the University of Delaware, it was the broadest display to date of early American modernism.[19] It still missed some artists: absent were Newman, Horter, Breckenridge, and McCarter of the Philadelphia School; the New Mexican modernists Nash and Jonson; the Californian Rex Slinkard; and the Precisionists Ault, Spencer, and Lozowick. But it demonstrated that not all early American modernists were associated with Stieglitz, and that some were centered outside New York (the Philadelphian H. Lyman Saÿen), or even as far away as Chicago (Manierre Dawson) and Los Angeles (Lorser Feitelson). Here was a state of affairs that Paul Rosenfeld probably could not have imagined.

Through the 1960s and 1970s there were other large group shows of early American modernists. In 1961 Adelyn D. Breeskin of the National Collection of Fine Arts in Washington, D.C., organized a show of thirty-eight of these

painters and sculptors entitled "Roots of Abstract Art in America, 1910–1930."[20] From November 18, 1971, to January 9, 1972, the Museum of Art of the Carnegie Institute held its "Forerunners of American Abstraction" exhibition, which included about fifteen works of each of the following: Demuth, Dove, Marin, O'Keeffe, Sheeler, Stella, and the sculptors John B. Flannagan and John Storrs. Particularly instructive were those group shows in which the artists were chosen not randomly or to give a broad sampling of the advanced American art of the first three decades, but in accordance with a concept in which certain ones would be selected and others omitted. Omitted from the 1971 show "Cubism: Its Impact in the U.S.A., 1910–1930" were such standbys as Dove and O'Keeffe, who never grappled with Cubism. In 1975 the National Collection, and then the Pennsylvania Academy of the Fine Arts, staged "Pennsylvania Academy Moderns, 1910–1940," which included Breckenridge, Carles, Demuth, McCarter, Newman, Saÿen, Schamberg, and Sheeler.[21] In 1978 at the Whitney "Synchromism and American Color Abstraction: 1910–1925" was organized by Gail Levin. Included were not only the expected Synchromists and color painters but such unknowns as William Henry Kemble Yarrow and Henry Fitch Taylor, and such familiar Stieglitz painters as Hartley, Dove, and Maurer, who could now be examined from a new standpoint.

Since the publication of Brown's book in 1955, important studies covering aspects of the field have appeared. William C. Agee's *Synchromism and Related Color Principles in American Painting: 1910–1930*, a catalogue and essay done for an exhibition at the Knoedler Galleries in 1965, was the reliable foundation upon which Levin built the traveling show of American color painters, which originated at the Whitney. In his *Story of the Armory Show* (1963) Brown gave a full account of the history and unfolding of the great event in 1913, as well as a full catalogue of the pieces in the show, some of which moved a few American painters to become modernists. Dickran Tashjian, in his *Skyscraper Primitives: Dada and the American Avant-Garde, 1910–1925* (1975), dwelt on the interfoldings in meanings and intent among writers in the little magazines, such as Matthew Josephson; on the poetry of Williams, Crane, and Cummings; and on works produced by the artists of the Arensberg Circle. Martin L. Friedman has provided the best overviews of Precisionist painting (e.g., *The Precisionist View in American Art*, 1960). Although Homer's terminal year of 1917 (marking the closing of 291) was not a watershed in the stylistic development of any of the Stieglitz painters, his *Alfred Stieglitz and the American Avant-Garde* (1977) is as well-documented a chronicle of the events attendant upon and personalities surrounding 291 as one might hope to find. Almost the entire issue of *Arts Magazine* for May 1977 was devoted to essays treating the artists and issues of New York Dada.[22] And much of the issue of *Arts Magazine* for February 1980 was devoted to the symposium in honor of Milton W. Brown called "New Perspectives on American Art, 1890–1940," in which some papers concerned with early American modernism were presented.[23]

In planning the arrangement of this book, I considered using categories other than the present ones. For example, grouping paintings under such stylistic designations as Cubist Expressionism and Decorative Cubism—a category denoting flatter, brightly colored paintings that could be applied to much of the work of Stuart Davis, Gerald Murphy, Henry Fitch Taylor, the late work of Arthur B. Carles, and the *German* series of Marsden Hartley. Such a method presented two problems. First, the artists would have been left without firm moorings, and would have been made to shuttle in and out of chapters headed by the stylistic designations in too confusing a fashion. Second, it would have been inappropriate to use as chapter headings terms such as "Cubism," "Fauvism," or "Expressionism," which were conceived within and applied to the European experience. The present arrangement, with chapter headings on The Stieglitz Group, The Arensberg Circle, Color Painting, Precisionism, and The Independents, is the most obvious and direct one, and, this writer feels, the best in the long run, conforming as it does to the existent situation in America from 1910 to 1935.

But the reader should be aware that the Stieglitz Group and the Arensberg Circle, for example, encompassing different outlooks, did not always embrace all of an artist's expression. Thus Arthur G. Dove for his landscapes and waterscapes conforms to the outlook of the Stieglitz Group, and for his whimsical collages, such as the *Portrait of Ralph Dusenberry* (1924, Metropolitan) to that of the Arensberg Circle. Joseph Stella's collages, made usually out of bits of discarded wrappers, may be grouped under the Arensberg Circle; his *Coney Island* series under color painting; and his *New York Interpreted* "polyptich" (1920–22, Newark Museum) under Precisionism. Stuart Davis's collage *Itlksez* (1921, Lane Foundation, Leominster, Mass.) has that inspired nonsense favored by the Arensberg Circle, as does his combination in the *Eggbeater* series of the stylized eggbeater, rubber glove, and electric fan; while others of his paintings, although bright and gay in their impact, are more "straightforward." The chapter headings are meant to provide the reader with certain moorings, but not to obscure the variety of some artists' work nor to blind him to the possibility of other alternative headings.

NOTES

1. For a demonstration of the "golden section" in paintings of Seurat and Gris, see William A. Camfield, "Juan Gris and the Golden Section," *Art Bulletin,* 47 (March 1965), pp. 128–134.

2. For more on this difference between European classical Cubism and the Cubist adaptations of the early American modernists, see Abraham A. Davidson, "Cubism and the Early American Modernist," *Art*

Journal, 26 No. 2 (Winter 1966–67), pp. 122–129, 163. The case is overstated, especially since the American examples are chosen so as to prove the point; but on the whole the argument holds. This is not to suggest that the classical Cubists were necessarily the point of contact between the Americans and European Cubism. Seldom are the specific European Cubists seen by the Americans mentioned. The Cubist satellite Albert Gleizes was in New York in 1915 and 1916, knew Demuth, and had 22 pieces in the large group show (also shown were other cubist satellites Jean Crotti, Marcel Duchamp, and Jean Metzinger) in New York's Montross Galley in the spring of 1916. He was probably an important direct influence. Still it is noteworthy that the Americans did not generally produce paintings as hierarchial and geometrically contrived as those of the European classical Cubists, which they could have seen as well. In New York's Caroll Galleries in January 1915 the Cubist work of Duchamp, de la Fresnaye, Gleizes, Picasso, and Villon was shown, and they were shown again in March, as was the Cubist work of Metzinger. Picasso was not held up by the Americans above the others, as far as we can tell.

3. Marsden Hartley, *Adventures in the Arts,* New York, 1921, p. 248.

4. Kenyon Cox, "Artist and Public," *Scribner's Magazine,* 55 (April 1914), p. 517.

5. This group is mentioned in *Art News,* 23 (February 2, 1924), p. 2.

6. Mabel Dodge, "Speculations on Post-Impressionism in Prose," *Arts and Decoration,* 3 (1913), pp. 172, 174.

7. Arthur Hoeber in the New York *Globe* as quoted in *Camera Work,* 36 (October 1911), p. 31.

8. Arthur Hoeber in the New York *Globe* of February 28, 1912, as quoted in *Camera Work,* 38 (April 1912), pp. 44–45.

9. J. Edgar Chamberlin in the *Evening Mail* of April 3, 1909, as quoted in *Camera Work,* 27 (July 1909), p. 43.

10. J. Edgar Chamberlin in the *Evening Mail,* as quoted in *Camera Work,* 38 (April 1912), p. 44.

11. J. Edgar Chamberlin in the *Evening Mail,* as quoted in *Camera Work,* 36 (October 1911), p. 32.

12. Louis Kalonyme, "The Art Makers," *Arts and Decoration,* 25 (December 1926), p. 63.

13. Author not cited, "Charles Demuth: Intimate Gallery," *Art News,* 24 (April 10, 1926), p. 7.

14. D. Fulton, "Cabbages and Kings," *International Studio,* 81 (May 1925), 146.

15. Wanda M. Corn, "Apostles of the New American Art: Waldo Frank and Paul Rosenfeld," *Arts Magazine,* 54 No. 6 (February 1980), pp. 159–163.

16. Paul Rosenfeld, "American Painting," *Dial,* 71 (December 1921), p. 658.

17. *Ibid.,* p. 663.

18. Paul Rosenfeld, *Port of New York,* New York, 1924, p. 258.

19. The catalogue of the Delaware show is a compilation of entries, one from every artist. Each entry contained a photograph of the artist, one or two illustrated works, and an essay on the artist written by a student in the University of Delaware's Art History Department.

20. Four of the artists chosen by Ms. Breeskin ought not to have been included: the sculptor Alexander Archipendo, who made his reputation in Paris and Berlin before settling in New York in 1923; the painter Lyonel Feininger, who went to Germany with his parents in 1887 when he was sixteen and remained until 1936, and who did not even exhibit in America until 1931; the sculptor Paul Manship, who cannot really be considered a modernist; and the painter Mark Tobey, who did not hit upon a significant style until the 1930s. Patrick Henry Bruce spent all his working life in France, but as he submitted to the Armory Show (he requested that his four canvases be withdrawn when one by his friend, Robert Delaunay, was not hung) and associated closely with Arthur B. Frost, Jr., he ought to be included in this study, while Feininger

is not. Furthermore, Frost showed his series of *Compositions* in the Montross Gallery in 1917.

21. The catalogue contains statements by Joshua C. Taylor, director of the National Collection, and Richard J. Boyle, director of the Pennsylvania Academy, who observes that the vaunted traditionalism of the Pennsylvania Academy was not, as the exhibition reveals, as ingrained and all-encompassing as is usually supposed.

22. The articles in this issue are: "Marcel Duchamp in America: A Self Ready-Made" by Moira Roth; "Katherine Sophie Dreier and New York Dada" by Ruth L. Bohan; "Henry Adams and Marcel Duchamp: Liminal Views of the Dynamo and the Virgin" by Dickran Tashjian; "The European Invasion: American Art and the Arensberg Circle, 1914–1918" by Patrick L. Stewart: "An Interview with Man Ray: 'This Is Not for America' " by Man Ray and Arturo Shwarz; "Morton Schamberg: The Machine as Icon" by Earl A. Powell, III; "Gertrude Stein Among the Dadaists" by James R. Mellow; "Cryptography and the Arensberg Circle" by Francis Naumann; "I Shock Myself: Excerpts from the Autobiography of Beatrice Wood," Introduction and Notes by Francis Naumann; and "Primitivism and New York Dada" by Judith Zilczer.

23. The articles in this issue relevant to early American modernist painting are: "Alfred Stieglitz's 'Equivalents' " by Rosiland Krauss; "The New York Dada Movement: Better Late Than Never" by Francis Naumann; "Charles Sheeler: Industry, Fashion, and the Vanguard" by Susan Fillin Yeh; and "Apostles of the New American Art: Waldo Frank and Paul Rosenfeld" by Wanda M. Corn.

1
The Stieglitz Group

THE AIM OF 291

In the years preceding and following the Armory Show of 1913, the most progressive painting to be seen in America—both by American and European artists—was being shown at 291, a modest gallery named for its approximate location on Fifth Avenue, which opened on December 1, 1908, and consisted of only two rooms, one fifteen feet square, the other a hallway.[1] Curtains of dark green burlap were hung on the walls of the main room below a continuous shelf; the lighting was kept muted and quiet by a white screen suspended from the ceiling that acted as a filter.[2]

In January and April 1908, respectively, in the adjoining building, when the gallery was called the Photo-Secessionist and was devoted mainly to photography, shown for the first time anywhere in America were the drawings of Rodin and the etchings, drawings, watercolors, lithographs, and oil paintings of Matisse. In 1909 at 291 were seen the first American exhibitions of the caricatures of Marius De Zayas, the first one-man shows of Maurer, Marin, and Hartley, and the first showing of the lithographs of Toulouse-Lautrec. The second exhibitions of Matisse and Rodin, the first American exhibition of the Primitive Henri Rousseau, and the "Younger American Painters" show—which included works by Brinley, Carles, Dove, Fellowes, Hartley, Marin, Maurer, Steichen, and Weber— were the feature attractions in 1910. In 1911, Picasso was given his first one-man show in America, Cézanne's watercolors were shown, and Max Weber had his first comprehensive exhibition; the next year at 291, the first one-man exhibitions anywhere were staged of the paintings of Dove and Carles and of the sculpture of Matisse. Also taking place in 1912 were Hartley's second exhibition, the introduction to America of Manolo's sculpture and the caricatures of Alfred

1. Illustration in *Scribner's Magazine*, 63, 1918.

J. Frueh, and the first exhibition anywhere (to be taken seriously) of the art of children, aged two to eleven.[3] All this before the great Armory Show of 1913.

The proprietor of 291 responsible for these remarkable feats was the famous photographer Alfred Stieglitz (1864–1946). His father Edward had been a successful businessman; he was the only Jewish member of the New York Jockey Club, kept racehorses, and would serve thirty guests at his summer home at Lake George. In 1881, when he retired on an income of $400,000 invested at high rates, he took his family to Germany. Alfred, in 1882, entered the Technische Hochschule in Berlin to study mechanical engineering, a field he abandoned there in 1883 when he became fascinated with the scientific aspects of photography. From 1885 to 1887 he studied photography intensively, making photographs of works of art and the environment about him. At the same time, he visited art galleries and attended concerts, his favorite composers being Beethoven, Schumann, Mozart, and Wagner.[4]

By the time he returned to America in 1890, his reputation had reached England. As a champion of the sharp-focus, as opposed to the hazy, Impressionist approach in photography, he became the leading member of the New York Camera Club. In 1896 he established the journal *Camera Notes,* which ran feature articles about technical advances, as well as critical writings on photography and the relationships between photography and painting. In 1902 he founded the "Photo-Secession" group, which met at first in restaurants, then at the "Little Galleries" of the Photo-Secession at 291 Fifth Avenue, where the inaugural was held on November 25, 1905. Stieglitz founded the periodical *Camera Work* in 1903. The Little Galleries became 291 in 1908.

From 1913 until 291 closed in 1917, Stieglitz continued to champion worthwhile artists who were adventurous, and currents in art that until then had been ignored. In 1913–14, after the Armory Show, he featured the drawings,

pastels, and watercolors of Abraham Walkowitz; paintings by Hartley; sculptures by Brancusi; and a second exhibition of children's work, as well as African sculptures. Then, in 1915, came drawings and paintings by Picasso and Braque [2]; archaic Mexican pottery and carvings; three paintings by Picabia; paintings by Marion H. Beckett and Katherine N. Rhoades; oils and watercolors by John Marin; an exhibition of children's work, this for the third time; and drawings and paintings by Oscar Bluemner. In 1916 and part of 1917, the artists exhibited included Nadelman, Marin, Walkowitz, the photographer Paul Strand, Hartley, O'Keeffe, Charles Duncan, Rene Lafferty, the ten-year-old Georgia S. Engelhard, the Futurist Severini, and Macdonald-Wright.

Stieglitz opened the Intimate Gallery in Room 303 of the Anderson Galleries Building, 489 Park Avenue, in 1925. The scope was far more limited than that of 291, as he focused on a select group of American artists: "The Intimate Gallery is dedicated primarily to an Idea and is an American Room. It is used more particularly for the intimate study of Seven Americans: John Marin, Georgia O'Keeffe, Arthur G. Dove, Marsden Hartley, Paul Strand, Alfred Stieglitz and Number Seven (six + X). . . ."[5] A third gallery, supported at first through funds raised by the Strands, Dorothy Norman, and Stieglitz's wife Georgia O'Keeffe, was opened in December 1929 in Room 1710 at 509 Madison Avenue. This was An American Place [3]. At first the same artists were exhibited here as at the Intimate Gallery, except for Hartley, who in the early 1930s dropped Stieglitz as his dealer.[6] Because of his age and declining strength, Stieglitz abandoned photography in 1937; through the 1930s he seemed to some people an anachronism, since his battle waged so valiantly on behalf of modern art in the first two decades had been won on many fronts.

In all three of his galleries Stieglitz avidly pursued a policy of noncommer-

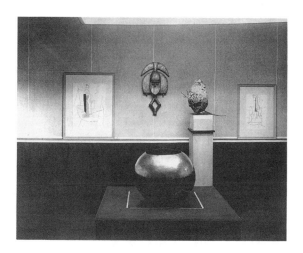

2. Braque–Picasso Exhibition at
 291.

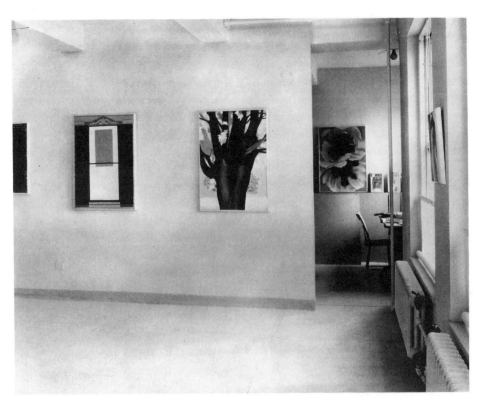

3. O'Keeffe Exhibition at An American Place, 1931.

cialism. Early in his career, although a prize-winning photographer himself, he found the giving of prizes for art infantile.[7] Later, when running his galleries, he disliked sending bills for anything,[8] and would not charge the artists he sponsored a commission for sales.[9] Moreover, he even refused to sell works to those he considered unappreciative or unenlightened. Dorothy Norman recalled that one woman, upon telling Stieglitz—without knowing who he was— that she had been looking for Stieglitz's gallery, was instructed that Stieglitz had no gallery. After she departed amid laughter, Stieglitz explained to those assembled in An American Place: "Something more was at stake than her knowing where she was for the moment. And I am not in business. I am not interested in exhibitions and pictures. I am not a salesman, nor are the pictures here for sale, although under certain circumstances certain pictures may be acquired. But if people really see something, really need a thing, and there is something here that they actually seek and need, then they will find it in time. The rest does not interest me."[10] Herbert Seligmann, who had worked with Stieglitz and the critic Paul Rosenfeld on the experimental magazine *MSS* in 1922 and 1923, reported that while at the Intimate Gallery Stieglitz sold a shabbily dressed girl Marins (normally going for $175 to $350) for $50, with a down payment

of $5, without even asking the buyer her name or address. What impressed him was her enthusiasm toward Marin, an enthusiasm that brought on tears.[11] Stieglitz did not bother—or refused—to list his galleries in the telephone directory.

The atmosphere that Stieglitz created in his galleries was not one of a noisy market, but rather of a cloistered shrine, in which he served as the high priest initiating guests to the mysteries contained therein. Always there was the intimation that the Muse of Modernism held some delicious secret, which she might cautiously and discreetly impart only to the most sincere of her devotees. Stieglitz, of course, fostered this intimation. He used his galleries not simply to hang exhibitions but as places to proselytize others. He possessed a true evangelical passion. Seligmann said of him that he could "talk sixteen hours daily for a week and has often done so."[12] His flair for theatricality and his rare ability to fire the onlooker were often noted. Dorothy Brett observed that there was an invisible half of Stieglitz that "lies in the look behind the look in the eyes. . . ."[13]

Stieglitz captivated his listeners, and mystified them, all at once. According to Waldo Frank, he used words not "as things-in-themselves," but to point "to what, in ever widening concentric circles, lies beyond them. . . ."[14] Remarks of Stieglitz's, if accurately reported, must have sounded at times like the incantations of a Buddhist monk: "I am the moment. I am the moment with all of me and anyone is free to be the moment with me. I want nothing from anyone. I have no theory about what the moment should bring. I am not attempting to be in more than one place at a time. I am merely the moment with all of me."[15] This statement about having no theory as to what the moment should bring was consistent with his refusal to advocate any particular mode or style of painting as great or even desirable art. Stieglitz also said he had no theory as to the current form that art should take; nor did he have a legacy he wished to transmit to the future. He liked to predict that on the day of his death he would take the perfect photograph. As he was dying, his masterpiece would slip from his hands to break on the ground.[16]

Stieglitz was against institutions and isms of all sorts. He decried all systems of classification, scoffing at those who would neatly label works of art: "It is as if there were a great Noah's ark in which every species must be separated from every other species, so that finally . . . they would fall upon one another and kill each other."[17] That he played no role, then, in the Armory Show is not at all surprising. For it was the purpose of that mammoth affair to present a neatly packaged development of the art of the nineteenth century up to the year 1913, while Stieglitz could not abide any pigeonholing. The Armory Show, besides, was the culmination of the concerted work of Arthur B. Davies, Walt Kuhn, and Walter Pach, who had wrested control of the planning and staging of the exhibition from the more traditionally minded Henri group.[18] Stieglitz,

who needed to be the center of attention, was hardly suited temperamentally to bend to the joint wishes of any group. With his esoteric pronouncements, Stieglitz—distrustful of mass education and mass media—sought through the cloistered mystique of his galleries to promote the growth of a small intellectual elite, and to encourage the isolated artist to foster his individualism.

So many of Stieglitz's pronouncements ran to the negative—his dislike of classifications and labels, his refusal to advocate a particular style, and so on—that it would seem difficult to discover any positive aim he sought for his galleries. But the many things Stieglitz did not like held the key to what he was trying to put across. When spelled out, that rings with a deceptive simplicity. He tried, first, to promote only artists whose work revealed a directness and forthrightness toward whatever was pictured. Second, he would have the gallery visitor experience the work on its own terms, and those terms only.

Dorothy Norman recalled that Stieglitz wanted the visitor to experience what the creator had experienced. He insisted that you cannot be told what a work is *about*, just as "you cannot, for example, be told about such phenomena as sunsets or love."[19] Art, to be effective, to be true, had to get to the nature of the thing. Directness precluded comment or interpretation, notions of style and classification, even thinking about the work. One of his pronouncements was that "art begins where thinking ends. Have you ever heard Wagner operas? In *Lohengrin* the woman asks Lohengrin a question. And he replies: 'I cannot tell you that.' . . . That is what the work of art says to us. There is something in every picture, every living thing, the sky, or the blue eyes of a child, that we cannot know. If we knew it, everything would stop, life would lose its mystery for us."[20]

In his own photographs, Stieglitz, following these precepts for himself, seemed to be taking the subject head on without flinching. In those of New York, he communicated the gritty power, the materiality of the city. In *The Hand of Man* [4] (1902, Art Institute of Chicago), a steam engine going full blast chugs toward the onlooker along crisscrossed gleaming tracks in the sooty dusk. In the *Terminal* (1893, Museum of Modern Art), horses drag a passenger car through a wintry, slush-filled street. *City of Ambition* (1910, George Eastman House, Rochester, N.Y.), captures the looming skyline from a point along a wharf. There is a moored smoking tug in the near middleground silhouetted against low dock buildings and warehouses, and then the smoking tall buildings in the background. The spiritual and the material were one for Stieglitz; the spiritual could reside only within the observed fact, a pantheistic philosophy close to Emerson and the New England Transcendentalists and Whitman. In a photograph he called *Spiritual America* (1923, George Eastman House), he showed a bit of harness and the flank of a draught horse around the groin area. It was about as close as one could get to the very gut of labor. His photographs of clouds he called *Equivalents*. They are clouds as such, not adjuncts

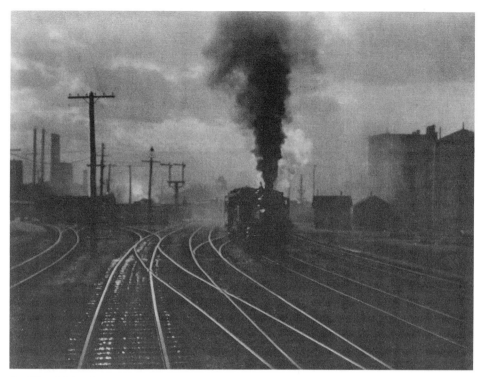

4. Alfred Stieglitz, *The Hand of Man*, 1902.

to a broader scene, not to convey the picture of a cloudy day. Stieglitz explained that "the true meaning of the *Equivalents* . . . (in reality all my photographs are *Equivalents*) comes through directly, without any extraneous or distracting pictorial or representational factors coming between the person and the picture."[21]

When he returned to America in 1890, Stieglitz was appalled by the crassness and craving for money he found in New York. It was a reaction much like Max Weber's, who, upon returning to New York from Paris in 1909, contrasted the Boulevard Saint-Michel with Fifth Avenue: "The Boul' Mich' and Fifth Avenue. What a contrast. Idealism and materialism—light and darkness—culture and ignorance—hope and despair—joy and misery—life and death."[22] Stieglitz (who came back because of the death of his sister) determined to become a force for progress in his native land.[23] Weber, too, decided that in spite of everything he could work in America. Writing in the third person under the pseudonym of Temple Scott, he concluded: "He was thinking that, perhaps, it was not too late to find his youthful joy. He looked up Fifth Avenue with far seeing eyes and forgot the Boulevard Saint-Michel."[24]

His disdain for all classifications notwithstanding, Stieglitz saw it as his special mission to protect, foster, and encourage those early American modernists in whom he believed. He would tell people that Marin was as good an

artist as any European.[25] He put Weber up in a room behind 291 and often invited him for dinner.[26] He advanced Hartley money for his first trip to get him back from Europe;[27] then, resenting the Maine painter's frequent forays abroad, wrote him on February 5, 1929: "He [the critic Henry McBride] felt it [Hartley's work] was reminiscent of too many others—besides which he has the idea that Americans should not flee their country but should work in America even though the conditions for the artist be impossible here. . . . I had hoped that your work would impress him sufficiently to overcome his notions about the American working abroad. But in justice to him I must confess I do feel, and ever have felt, much as he does on that matter."[28]

The American modernists closest to Stieglitz were aware of his conviction that art, to be effective, had to reveal the nature of the subject as well as the artist's emotional reaction to that subject, which must also be conveyed to the observer. It was a view close to that expressed in Kandinsky's *Concerning the Spiritual in Art*, excerpts of which were in fact published in *Camera Work*.[29] Stieglitz, for his part, came to realize fully that painting was distinct from photography, and that the painter who got to the nature of something would do it in ways different from the photographer. The painter could be, ought to be, nonnaturalistic, while the photographer should realize the limitations of the instrument he used: Stieglitz refused to manipulate his negatives by excessive retouching. He argued that "the arts equally have distinct departments, and unless photography has its own possibilities of expression, separate from those of the other arts, it is merely a process, not an art. . . ."[30] He realized that a painting like Marin's *Lower Manhattan (Composing Derived from Top of Woolworth)* [32] (1922, Museum of Modern Art), with its sketchy, schematized buildings radiating outward from the star at the bottom, was an effective visual transcription of the feelings the city of New York engendered, a way of transcribing that could not be duplicated by the camera. Marin himself wrote:

> We have been told somewhere that a work of art is a thing alive. You cannot create a work of art unless the things you behold respond to something within you. Therefore if these buildings move me they too must have life. Thus the whole city is alive; buildings, people, all are alive; and the more they move me the more I feel them to be alive. It is this "moving of me" that I try to express so that I may recall the spell I have been under and behold the expression of the different emotions that have been called into being. . . .[31]

Stieglitz called Marin, Dove, and O'Keeffe his "A-1 men."[32] Dove sought "to feel the power of the ground or sea, and to play or paint it with that in mind."[33] And Frederick Wight wrote that Dove tore a cyclamen to pieces to show his son that the color went through the stem into the root, this to reveal the flower's "condition."[34]

Stieglitz opposed the notion of creating a school, believing that each artist had to work according to his own nature. Individualism was sacred. Harold

Clurman, the critic and essayist, grasped the meaning of 291: " . . . the philosophy, the material, the form of a group were all present, yet the group ideal as such was never established in the minds of the individual artists. Practically speaking, 291 was therefore never quite a group, it was more a protective association."[35] This is not to say that Stieglitz did not, in cases, set himself up as an arbiter of how a painter should paint. He did more than simply accept or reject exhibitions—and, in this way, exhibitors. He felt that he knew when an artist had got to the root of what he was about. So he refused to show Demuth in 1913 because he saw in Demuth's loose, Fauvist-like style of that year a usurping of a province that was rightfully Marin's. Demuth was not being Demuth. As Stieglitz put it succinctly: "the blade of grass does not ask what it is meant to do, but continues upon its way: a blade of grass."[36] And it was not only art that he judged, but individuals as well, although this he usually kept to himself. In a remarkable letter sent to Hartley on October 27, 1923, which he admitted he was reluctant to post and which he started and stopped several times, Stieglitz confided: "You were given your original show in '291' because of my reading Suffering—Spiritual anguish—in your face. And because I felt a supreme worthwhile struggle of a soul. No other reason. . . . I frequently disagree with many of your conclusions and deductions. I only see them as 'Hartleys.' And as such they are of interest and value to me."[37]

Stieglitz had his detractors. They were those—and they appeared, after 291, while he was at the Intimate Gallery and An American Place—who felt themselves put upon by his showmanship and overbearing personality. William Carlos Williams, an associate of painters all his life, admitted in his *Autobiography* that he admired Stieglitz yet confessed to having been talked "deaf, dumb, and blind."[38] In 1921 the critic Henry McBride saw Stieglitz as being ready at the drop of a hat to undertake some fantastic eccentricity, which an unquestioning coterie would inevitably follow: "He's a dear, delightful duck, and I verily believe that if he were to assemble into an exhibition an hundred pairs of old shoes all his followers would find lovely qualities in them. . . ."[39]

But 291 was generally perceived as an oasis of beauty in a desert of insensitivity. *Camera Work* Number 47 for July 1914 featured the views[40] not only of artists and writers but also of "photographers, teachers and engineers, anarchists and journalists, merchants, lecturers, soldiers of fortune, clergymen, chess experts, radicals and conservatives, Frenchmen, Englishmen, South Americans, Germans,"[41] on a given subject: "What 291 is to me." " '291' to me is a 'Salon,' a laboratory, and a refuge," wrote Hutchins Hapgood, "—a place where people may exchange ideas and feelings . . . and where those who are tired of what is called 'practical' life may find a change of spiritual atmosphere."[42] For the Episcopalian minister E. S. Rasay, 291 was "in the great city . . . a little 'agora' where men may listen, and may speak freely. . . ."[43] To the photographer Anna Brigman, it was "like a snowy mountain peak . . . Mecca. . . ."[44] For art dealer

Charles Daniel, 291 was "the original impulse of [my] going into the modern world of art,"[45] and Marsden Hartley found it to be a place where "the artistic searchings of individuals . . . have [been] brought freely before a fairly curious public. . . ."[46] The banker Eugene Meyer, Jr., called it an "oasis of real freedom";[47] the painter Arthur B. Carles "the one place where people gather that has never become a disappointment."[48] More rhapsodically still, Rex Stovel (butler, soldier, actor, and playwright) wrote: "And out of the mists, dimly, but in living fire, before me shone HOPE. And there were quiet forceful voices about me, that were indubitably living voices, and there was deep solace of sympathy and understanding, and I was no more alone."[49]

The picture of 291 that emerges from these evaluations and others is one of a place where individualism was not only tolerated but fostered. There was the ideal of the group, as opposed to what Clurman said. But no movement in the European sense emerged, nor was there the conviction, typical in European movements, that all past art was utterly threadbare and the current art represented an acme. Stieglitz encouraged experimentation; he laid down no laws, but in singlehandedly creating the environment that nurtured those artists he chose and who in turn chose him, he helped to bring forth a modernism in American painting as bold and, on its own terms, as valuable as the contemporary modernism in Europe.

THE PAINTERS OF THE STIEGLITZ CIRCLE

Marsden Hartley (1877–1943), who was to be the most peripatetic of the Stieglitz painters, first came into contact with 291 early in 1909. He had come to New York a decade earlier from his native state of Maine by way of Cleveland, where he had spent a year, and had studied in 1899 under William Merritt Chase and concurrently under Kenyon Cox at the Art Students League, then enrolled for a year at the National Academy of Design. He would spend summers in Maine. His mountainscapes consist typically of the mountain wall covered with colorful foliage going about three quarters the way up the canvas, above which float Ryderesque clouds. Hartley had always retained a great admiration for the visionary painter Albert Pinkham Ryder: according to Elizabeth McCausland, before he left for Europe in 1912, for eight or nine years Hartley had lived on the same street in Lower Manhattan as Ryder without realizing this.[50] The stroke in the mountainscapes is applied in a sort of "stitch" somewhat resembling the stroke in paintings by followers of Seurat, such as Cross and Signac; in fact it was derived from the art of a Swiss Divisionist, Giovanni Segantini (*Carnival of Autumn*, 1908, Museum of Fine Arts, Boston). In some of the Maine series an oppressive note is struck by the tiny buildings huddling piteously at the foot of the mountains, as in *Landscape No. 36* of 1909 (University Gallery, Univer-

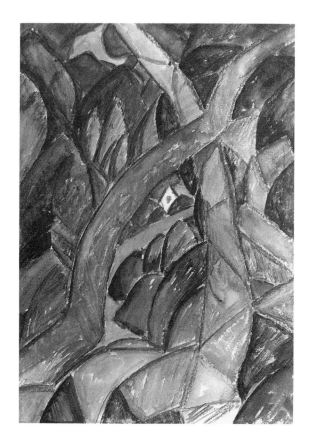

5. Marsden Hartley, *Landscape No. 32*, 1911.

sity of Minnesota). Lewiston, Hartley's birthplace, was a grimy factory town in Maine; he would recall—as though to justify the brooding quality of some of his paintings—"the mills and factories that were once gigantic in the vision of a child, monstrous, terrifying, prison-like. . . ."[51]

Hartley first encountered Picasso's work in that painter's one-man show at 291 in 1911.[52] His *Landscape No. 32* [5] of 1911 (University Gallery, University of Minnesota), with its angular trees and scalloped rocks, was patterned after Picasso's proto-Cubist landscapes of 1908; and, more directly, as Haskell has shown, after some of Weber's landscapes of 1911 (*Forest Scene* [location unknown]).[53] But the small house near the center compressed by rocks and trees derives from Hartley's own vision, as it had been revealed earlier in the *Maine* series. Hartley reached Paris on April 11, 1912. He sought out some of the Americans already there—Maurer, Carles, the photographer Edward Steichen—and visited the Steins' apartment. But he found Paris hard to get used to, alien, and associated with the German colony that met at the Closerie des Lilas. He felt a kinship with Kandinsky's *Concerning the Spiritual in Art*, with the

undercurrent of mysticism that ran through it, as well with the writings of the French philosopher Henri Bergson. Under the influence of the *Improvisations* of Kandinsky and the Analytical Cubism of Braque and Picasso, he began in Paris and continued in Germany paintings consisting of triangles, circles, zigzags, which he saw as recreations of musical experiences (*Musical Theme No. 1 [Bach Preludes]*, 1912–13, location unknown).

Hartley reached Berlin and Munich in January 1913, and met with Kandinsky and Marc. He kept up a steady correspondence with both Stieglitz and Gertrude Stein, in which he contrasted his sense of well-being in Germany with the discomfort he felt in Paris. In a letter of May 9, 1913, to Stieglitz: "I ought to like Munich because the artists were very kind and speak highly of my work and want me to live there. . . ."[54] On a card to Gertrude Stein dated April 29: "Am visiting Franz Marc who is so fine and gentle, a splendid character. I have no sense of *heimweh* here on German soil. Marc assures me that all exhibition conditions are open to me."[55] And in a letter to Stein of June 7, 1913: "I like Deutschland. I think I shall like it for long— I feel as if I were rid of the art monster of Paris . . . there is a wholesome hum everywhere and they don't care much . . . if a man is an artist—they like him if they like him and if he is nice he is not a fool because he is an artist."[56] In Munich, he saw the Tannhauser Show of Franz Marc. He exchanged letters with Marc, who urged him to exhibit with the *Blaue Reiter.* Some of his works were shown in the Touring Herbstsalon in Berlin, Dresden, and Breslau.[57] Hartley returned to America at the end of 1913, returned to Berlin early the next year, and spent that summer in Provincetown.

Kandinsky's influence continued in Hartley's work of 1913. But Kandinsky's forms in the *Improvisations* seem to pulsate with a life of their own, with dark forms hovering ominously almost like the ghostlike remembrances of objects. Hartley's painting has a gayer, more transcendent flavor. His spiky flowers and gyrating petaled circles might lead one to think of fireworks; the whiplashed triangles, of drifting kites. Kandinsky's great spots merge into one another after the fashion of cellular growths, while Hartley's triangles and circles are more clearly demarcated one from the other, as in his *Military* [6] (1913, Wadsworth Atheneum, Hartford). The numbers in this painting point to Hartley's current interest in numerology. In Berlin he was seeing significance in all sorts of numbers. For instance, he wrote to Gertrude Stein on June 7, 1913: "I wish we had some wireless all our own so I could send down a shaft from 4 and you could send up some from 27—4 is my house number—I must learn what 4 means. I was told before I came to Berlin to look for 8-pointed stars. . . ."[58] He did not really think of himself as following in the footsteps of Kandinsky, calling the latter's work "cosmic cubism." (in a letter to Stieglitz on December 20, 1912).[59] In other paintings he took over motifs of Marc, particularly the reclining horse, as seen in *Painting No. 4* [7] (1915, Philadelphia Museum). Here

6. Marsden Hartley, *Military*, 1913.

the flattening of forms and the tapestry-like handling is Hartley's own, far from the spirit of Marc.

There was something in Hartley that responded to tribal rituals, in the broadest sense. This is what he saw in the symbols and paraphernalia of Junker militarism. In his German paintings of 1914–15 (he was back in Germany in early 1915) the triangles and circles of the *Military* of 1913 hardened and took on the definition of epaulets, military crosses, medals, and so on. These objects were set against a bare backdrop, prefiguring the iconic treatment of objects in the Pop Art of the 1960s. As in much Pop Art, the colors are garish, harsh, metallic. But Hartley did not see these objects as the mass-produced ones of Pop Art. He felt in his ceremonial objects the endurance of a way of life. In the *Portrait of a German Officer* [8] (1914–15, Metropolitan) he abstracted those objects of military regalia that served to identify the rank and station of his

7. Marsden Hartley, *Painting No. 4*, 1915.

8. Marsden Hartley, *Portrait of a German Officer*, 1914.

friend and probable lover, Karl von Freyburg, who had been killed on the Western Front in September 1914. Von Freyburg's initials are at the bottom of the painting. In Berlin, Hartley also painted large canvases having to do with Indian themes. His *Indian Composition* of 1915 (Vassar College Art Gallery) shows a triangle encasing a horse like a tent. (The triangle was a favorite form of Hartley's, reappearing years later as mountains in his paintings in 1932–33 of Mexico's Popocatepetl, in 1933 of Germany's Garmisch-Partenkirchen, and in 1939–40 of Maine's Mount Katahdin.)

Hartley was an essayist and poet as well as a painter; in 1916 *Dial* published an essay of his entitled "Tribal Esthetics" in which he wrote admiringly of the American Indian: "In the life of the American Indian all expression symbolizes itself in the form of the dance. . . . We owe the presence of these forms in our midst, centuries old, to the divine idea of the necessity for survival . . . they speak their own tongue among themselves and with extreme rarity admit the alien to the world of their ideas and meanings. . . . It is a life of eminently splendid ritual, and we of this time have lost the gift of ritual."[60] And he lamented to Stieglitz that it was "a shame that the redman is going out of existence as he surely is. . . ."[61]

In Provincetown in the summer of 1916 Hartley painted flattened, tightly fitting, curved and angular shapes derived from sailboats (*Movement No. 9* [9] University Gallery, University of Minnesota). These paintings happen to resemble those of Serge Poliakoff, a School of Paris painter of the 1950s. In 1918, Hartley went to New Mexico, to Taos and Santa Fe. By 1921, he was back in Europe and Berlin, doing recollections of the terrain he had seen in New Mexico. But in the early 1920s his fascination with Cubism and German Expressionism came to an end, and he returned to a style more dependent upon nature, in which forms were given a massively heavy modeling, and some spatial recession was indicated through an imperfect geometric perspective (*Landscape, Vence,* 1924–25, University Gallery, University of Minnesota). The paintings of the early 1940s, up to his death, reveal a renewed fervid devotion to Maine (*Fishermen's Last Supper,* 1940–41, Collection Roy R. Neuberger, New York), his birthplace and the inspiration of the early brooding, Ryderesque, *Dark Mountain* series. Despite his long wanderings in Europe, Hartley had not succeeded in finding his spiritual haven. Toward the end of his life, he wrote movingly: "And so I say to my native continent of Maine, be patient and forgiving. I will soon put my cheek to your cheek, expecting the welcome of the prodigal, and be glad of it, listening all the while to the slow, rich solemn music of the Androscoggin, as it flows along."[62]

Max Weber (1881–1961) arrived in Paris in late September 1905, six and a half years before Hartley. He had been born in Bialystok, Russia, and had reached America with his mother in 1891, settling in Brooklyn. Crucial for his subsequent

9. Marsden Hartley, *Movement No. 9*, 1916.

development were his studies with Arthur Wesley Dow at the Pratt Institute from 1898 to 1900. Dow advocated a system designed to help "the pupil at the very outset to originate a beautiful arrangement, say—a few lines grouped together—and then proceed onward step by step to greater appreciation and fuller power of expression." Dow broke down the composition into its component parts and then analyzed them. Isolating line, he observed directions and thicknesses of lines; isolating color, the arrangement of tonal values and hues.[63]

In Paris, Weber studied first, from 1905 to 1907, at the Académie Julian, where he met Walkowitz; at the Académie Colarossi; and at the Académie de la Grande Chaumière. Then, growing tired of the traditional approaches advocated in those schools, he found a hero in Cézanne, whose work he appreciated at the Salons d'Automne of 1906 and 1907. In 1908 he studied directly under Matisse, along with the Philadelphian H. Lyman Saÿen, the Virginian Patrick Henry Bruce, and various European artists. Weber was surprised to find Matisse urging control and discipline rather than throwing caution to the winds: "He [Matisse] abhorred technical bravura and superficial calligraphic flourish. He

encouraged experimentation, but cautioned us of the subtle inroads and dangers of capricious violent exaggeration and dubious emphasis. He insisted upon good logical construction of the figure. . . ."[64] Matisse, Weber recalled, kept referring to Cézanne, African art, and Greek archaic sculpture. Weber visited the Steins, where he saw many Matisses and Picassos. He went to the studio of the Primitive Henri Rousseau (and in 1910 persuaded Stieglitz to give Rousseau a posthumous exhibition); met with Picasso, Delaunay, Gleizes, Marquet, Segonzac, and Guillaume Apollinaire; and studied African art at the Trocadéro Museum. He went to Spain in the summer of 1906, to Italy in the spring and summer of 1907, and to Belgium and Holland in the fall of 1908.

Back in America in January 1909, Weber applied to his own painting aspects and principles he had observed in modern French art. His *Still Life with Bananas* of 1909 (Forum Gallery, New York), with its tilted tabletop impossibly curved, is based on still lifes of Cézanne of the 1880s and 1890s; his *Composition with Three Figures* of 1910 (William Hayes Ackland Memorial Art Center, University of North Carolina) has its figural types, squat and boldly modeled, closely derived from Picasso's Iberian nudes of 1906–08. The red, unmodified background in the *Fleeing Mother and Child* [Pl. 1, 10] of 1913 (New Jersey State Museum, Trenton) derives from the broad flat planes that Matisse favored (he had used a single red plane throughout the painting in the *Red Studio* of 1911), while the rigidity of the mother carrying the child suggests the example of Rousseau.

Weber met Stieglitz in the spring of 1909. The photographer Edward Steichen was the intermediary, and the relationship began cordially enough. Stieglitz felt that Weber had a special understanding of his own photography, valued his close contacts with European modernists, and took his advice on giving Rousseau a show in November and December of 1910.[65] Stieglitz in turn appreciated Weber's wide range of aesthetic interests, including, for example, Pre-Columbian and American Indian art. In 1910 he published in *Camera Work* Weber's essay "Chinese Dolls and Modern Colorists," in which Weber ventured that he had "seen Chinese dolls and Hopi images and Indian quilts and other savage works finer in color than the works of modern painters."[66] But then friction developed between the two men. One cause was Weber's dislike of Steichen's work. Homer has it that Weber left the Stieglitz Circle in early 1911.[67] The two actually kept in contact thereafter, but things must have been strained. In a letter of January 17, 1914, on some business matter, Stieglitz wrote to Weber: "I exceedingly regret that you had seen fit to have taken my words literally. I have received your new price list, but had found the old one last night. . . . Again I say, it is unfortunate that you should have seen fit to take my words spoken in the excusable white heat yesterday literally."[68]

In another article published in *Camera Work* in 1910, "The Fourth Dimension from a Plastic Point of View," Weber stated that the fourth dimension "exists outside and in the presence of objects, and is the space that envelops

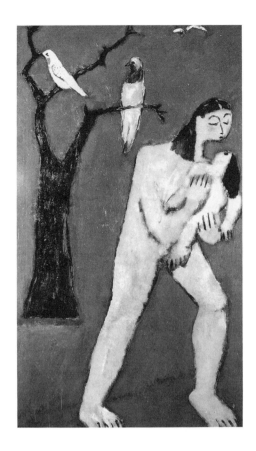

10. Max Weber, *Fleeing Mother and Child*, 1913.

a tree, a tower, a mountain, or any solid; or the intervals between objects or volumes of matter if receptively beheld."[69] The fourth dimension, he added, "arouses imagination and stirs emotion. It is the immensity of all things." Certainly some of Weber's thinking about an aroused imagination and a stirred emotion went into the creation of his *New York* series of 1912–16, a group of paintings resembling Italian Futurist works. (Weber never saw a Futurist exhibition, though Werner speculated that he might have read about Futurism in newspaper reports.)[70] The *Rush Hour, New York* [11] (1915, National Gallery) is a vivid transcription of the excitement generated by the metropolis at its most hectic moment. Stieglitz would have approved of the schematized conveying of the impact the city made on the observer. There are wheels, skyscrapers, and bits of station platforms reduced to arcs, triangles, and rectangles, all combined in a seemingly haphazard, kaleidoscopic array. The heightened contrasts of light and dark, the discordant mingling of curved and pointed forms, the brutal interruption of progresssions of similar shapes, and the combination of occasional acidy greens with earth colors, all make for the confusion of a New York rush hour.

In *New York at Night* [12] (1915, University of Texas Art Museum, Austin), the contrast of lights and darks is just as violent, but the verticals and horizontals describing rectangles prevail, rather than arcs and triangles. Weber wrote of

11. Max Weber, *Rush Hour, New York*, 1915.

this painting: "Electrically illumined contours of buildings, rising height upon height against the blackness of the sky now diffused, now interknotted, now interpierced by occasional shafts of colored light. Altogether—a web of colored geometric shapes, characteristic only of the Grand Canyons of New York at night."[71] The *Chinese Restaurant* (1915, Whitney) is unusual in the *New York* series, with its broad splaying out of planes, as in European Synthetic Cubism: identifiable are the areas of floor tiles at the bottom, hanging pink drapes toward the top, at the right, and so on. There is here, too, the methodical overlapping of images, as seen in the fragmented image of the diner near the top. Conceivably, the idea could have been derived from the illustration of Balla's *Dog on a Leash* in Arthur J. Eddy's *Cubists and Post-Impressionism,* which was published in 1914.[72]

Between 1917 and 1919 Weber painted slender men, clad in colorful, quilted, fantastic garb. Their faces may be derived from the grotesque visages of Picasso's Negroid paintings. The source, though, was probably more direct; for, since his Paris days, he had been a devotee of African art, not only to the extent of admiring its products in the Trocadéro and other museums but even

12. Max Weber, *New York at Night,* 1915.

to approximating in sculpture the exotic forms, as in a polychromed plaster *Figure in Rotation* (1915, bronze, Collection George C. Berman, New Rochelle, N.Y.). Werner noted that Weber may have been the first American artist to have purchased African sculptures (for 10 francs apiece).[73] These men sit or stand rigidly, but there is a comic demureness to them that belies their stances and the grotesqueness of their faces. Unlike the women of 1909–10 derived from Picasso's Iberian nudes, these figures do not exist in spiritual isolation. In the *Two Musicians* of 1917 (Museum of Modern Art), the closed eyes seem to indicate that the performers hear and are moved by the music that they play. In the *Conversation* [13] of 1919 (Marion Koogler McNay Art Institute, San Antonio), the figures nod, communicating and understanding. The primitivism is tempered by a humanism that in a sense undermines it. The highly textured, flat areas of the costumes, rearranged in places, reveal an amalgamation of two influences: American Indian art, especially in the brightly colored blankets; and French Synthetic Cubism. The rearrangements are not as extreme as in Synthetic Cubism, and the articulations of the anatomy are left intact. In the *Abstraction* [14] (1917, Bernard Danenberg Galleries, New York) Weber broke up into Cubist sectionings a head derived from the African prototypes he saw in New York museums.

When working in a Cubist manner in the second decade, Weber could be quite inventive, less derivative, in his more modest gouaches, watercolors, and pastels. His *Sunday Tribune* (1913, Forum Gallery, New York) uses a page from a newspaper—not dismembered, as the French collagists would do, but in its entirety upside down. Over the type he sketched in pastel some vague shapes, as well as cups and a bottle. The shapes for the most part are free of the patterns of the printed page, but not entirely so, for the brown circle in the lower right takes into account the picture of the seated people, and some concession in the upper part is made to the layout of the printed columns. The result is a remarkable patterning, brought forth, it appears, almost like a doodling, yet making for a spatial complexity reminiscent of the more carefully worked-out Cubist collages of Picasso and Braque.

By 1920, Weber's Cubist and Futurist adaptations were over. Jewish themes occupied him a good deal; these may have meant for him a "coming home" in the way that Maine and its rivers and fisherfolk did for Hartley. In the *Talmudists* (1934, Jewish Museum, New York), scholars whose lives are given over to the legal interpretations of the commandments in the Pentateuch—Weber undoubtedly knew Yeshivahs in Brooklyn—ponder and argue points of dispute.

Weber had met Abraham Walkowitz (1878–1965), another Russian-born Jewish artist, in 1906 in Paris, when the two were fellow students at the Académie Julian. Walkowitz had arrived in America from Siberia with his parents in 1889, and settled with them in the Lower East Side. After taking art classes at the

13. Max Weber, *Conversation*, 1919.

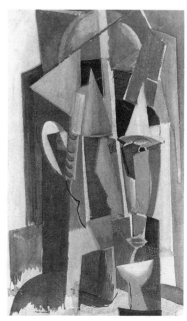

14. Max Weber, *Abstraction*, 1917.

Cooper Union and the Educational Alliance, a community house, he studied at the National Academy of Design from 1898 to 1900 at the time when Marsden Hartley was there. His early work consisted of portraits of Lower East Side types, often the old and forlorn.

In Paris Walkowitz met—through Weber—Picasso, Matisse, Rousseau, and the Steins. Like Weber, he admired the paintings of Cézanne, which he saw at the Salon d'Automne of 1906.[74] At Rodin's studio he met the dancer Isadora Duncan, who was to mesmerize him through the years: "Isadora was my strongest weakness. . . . She was the Walt Whitman of women."[75] Walkowitz executed more than five thousand drawings of her in motion, some pen drawings of geometrical signs, others linear sketches suggesting the fluidity of her movements (*Improvisations of the Dance No. 2*, 1918, Newark Museum). After Paris, he visited Italy in the spring of 1907, where he studied the Italian primitives.

Back in America by the summer of 1907, Walkowitz exhibited his work in January 1908 at the Julius Haas Gallery, then persuaded Haas to give Weber his exhibition in April and May 1909—a difficult selling task, as Haas complained over losing trade on account of the Walkowitz exhibition.[76] Harley introduced Walkowitz to Stieglitz in 1911 or 1912, and thereafter Walkowitz became practically an inhabitant of 291, remaining most days from ten in the morning until ten at night. It was he who persuaded Stieglitz to show the art of children in 1912; and to give O'Keeffe her chance in 1916: "I think, with woman suffrage and all, I think it would be a good idea to have a woman on the walls."[77] He looked upon Stieglitz as "a good fighter, but he didn't know too much about inner things."[78]

From 1908 to 1911, Walkowitz favored the subject of groups at their leisure, strolling and picnicing in the woods, parks, and on the beaches—themes he had observed in the work of Renoir and the contemporary work of the Ashcan painters Maurice Prendergast and William Glackens. The agitated brushwork and purples and bright oranges in some of these paintings (*Central Park*, c. 1908–09, Collection Mrs. David T. Workman, New York) may have been drawn from Matisse. From 1912 to 1917 Walkowitz embarked upon his most avant-garde painting; thereafter it was mostly back to the convivial genre themes. In his *Trees and Flowers* of 1917 (Columbus Gallery of Fine Arts, Columbus, Ohio), the forest scene is presented with the directness of a childlike vision, an evocation of the style of young people, whom he held in esteem.

Like his friend Weber, and John Marin, Walkowitz in the paintings of the second decade and beyond presented a New York in which buildings were off-plumb, leaning and tilting this way and that. The lines and jumbled patterns in Marin's cityscapes conveying fields of force appeared in Walkowitz's cityscapes as something like tidal waves lapping at the bases of the tall buildings (*Cityscape*, c. 1915, Zabriskie Gallery, New York). In *Improvisation of New York* (c. 1915, Zabriskie Gallery), the skyscrapers, reduced to solid triangles, are wedged to-

gether and tipped into a topsy-turvy assortment; at the top of the canvas birds dive at the buildings' roofs like swarms of mosquitos. The birds appear again in the *New York* [15] of 1917 (Whitney), where dimly perceived skyscrapers done in watercolor are obscured by an inextricable tangle of pencil and ink lines. The abstract linear configurations used to catch the rhythmic movements of Isadora Duncan Walkowitz discovered could be used also to express the violent surge of New York. In charcoal and crayon drawings of about 1915 [16, 17] (Zabriskie Gallery), a geometrical network partially conforming to the outlines of tall buildings is superimposed upon those buildings.

The aesthetic was wholly in keeping with the aims of the Stieglitz Group— the conveying through stylization of the emotion that some phenomenon, in this case the city, engendered in the observer-artist. Marin declared that the whole city was alive and that it was the "moving of me" he tried to express, so that he could "recall the spell I have been under and behold the expression of the different emotions that have been called into being. . . ." Walkowitz, in his statement in the catalogue for the 1916 Forum Exhibition in New York, expressed much the same sentiment: "I am seeking to attune my art to what I feel to be the keynote of an experience. . . . When the line and color are sensitized,

15. Abraham Walkowitz, *New York*, 1917.

16. Abraham Walkowitz, *New York Abstraction,* c. 1915.

they seem to me alive with the rhythm which I felt in the thing that stimulated my imagination and my expression. If my art is true to its purpose, then it should convey to me in graphic terms the feelings which I received in imaginative terms."[79]

But whereas Weber and Marin conveyed the excitement of New York in terms of its bustle and movement, Walkowitz alone, it seems, transmitted something of a claustrophobic quality, of buildings hemming one another in. In his lithograph of 1928, *New York of the Future* (Newark Museum), Walkowitz showed crowded clusters of skyscrapers struggling upward like stifled plants to reach the sun and open air. It is the clearest instance of an anti-urban statement produced by any of the early modernists.

In 1913 or 1914 Walkowitz turned out a few nonobjective paintings, which

17. Abraham Walkowitz, *New York*, c. 1915.

18. Abraham Walkowitz, *Symphony in Lines*, c. 1915.

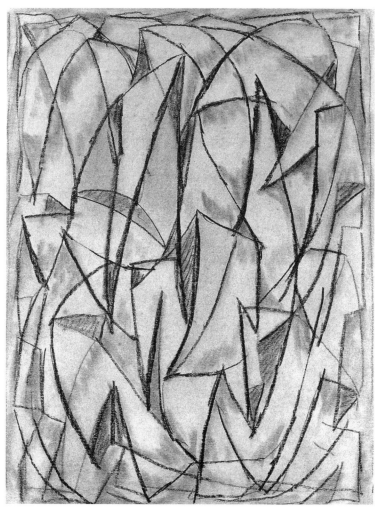

may have been inspired by Dove's ventures in 1910 or, more likely, by Kandinsky's *Improvisation No. 27* (1912, Metropolitan), which he could have seen at the Armory Show. His *Color Symphony* of 1914 (Zabriskie Gallery), like Kandinsky's *Improvisation*, is made up of whiplash lines meandering through spots of color in such a way as to suggest some organic movement or growth. In the charcoal and pastel *Symphony in Lines* [18] (c. 1915, Zabriskie Gallery), the lines have coalesced into discernible arcs and triangles, producing a network still vaguely organic, but one that can be read as the lineaments of some works of the *New York* series.

After the closing of 291 in 1917, Walkowitz's close association with Stieglitz came to an end. Deprived of his most persistent benefactor, cut off from a center, Walkowitz languished for want of support. Gradually he came to realize that his importance to early modernism had belonged to the past, to the days of 291. In 1929 he moved to his niece's home in Brooklyn, and there he remained until his death in 1965. In the 1930s he was part of the WPA Program, and in 1945 he painted a mural for the Porter Library of the Kansas State Teachers College in Pittsburg, Kansas. But he worked in growing isolation. To substantiate his priority, he gave earlier dates to some of his paintings. In his rich Yiddish accent he told Abram Lerner and Bartlett Cowdrey, who interviewed him as an old man on tape for the Archives of American Art, that "in order to be right you must first always be wrong, and then you are right."[80]

Oscar Bluemner (1867–1938) and Alfred H. Maurer (1868–1932) were two artists whose ties to Stieglitz were fragile and intermittent; who were both of German birth or German descent; and who both wound up, after years of neglect, as suicides.

Bluemner was born in Hanover. He came to America in 1892 because of an argument over art, it was said, with Emperor William II. Trained as an architect, he went first to Chicago seeking commissions for buldings at the World's Columbian Exposition. Then it was to New York in 1901, where his partner stole his design for the commission he had won for the Bronx Borough Courthouse. Frustration in architecture led him to try his hand at painting. In the spring of 1912 he returned to Europe, and was given a one-man show at Berlin's Gurlitt Galleries. He traveled next to Paris, and thence through southern France and Italy.

Bluemner may have been exposed to Cubism during his trip in 1912; or if not there, at the Armory Show, where he had five of his landscapes on view, and at 291. In 1915 Stieglitz gave him his first American one-man show. In 1916 he was included in the Forum Exhibition, and from 1917 to 1923 he showed regularly at the Bourgeois Gallery. The influences of Analytical Cubism occur as a form of surface faceting in his almost ubiquitous blocklike houses; these influences are especially discernible in his work of the second decade,

as a painting of 1918 appropriately entitled *Cubistic Village* (Metropolitan) shows. Rightfully, it was as a colorist that Bluemner became known. Because he liked to paint his houses and barns in bright reds and greens, he was called "the vermillionaire." Once having found his way, about the time of the Armory Show, he proceeded with no major variation over the years (*Vermillion House*, [19] before 1930, Private collection, New York), although by about 1920 the tiltings and facetings had disappeared.

There is a dualism in Bluemner's art: his buildings retain their meticulous, draftsman-like touch, but this is offset by the bright colors and the heavy, painterly handling of the outlines on occasion, as in the *Cubistic Village* [20], of 1918. He was a mystic at heart, trying to produce a mood in the observer, as the Stieglitz artists characteristically tried to do. But his way was through his color modifications. He wrote: "Every color has a specific effect on our feelings. I give to such a color-effect a corresponding shape in analogy with nature. A color and shape produces an emotion"[81]—opinions corresponding to those of Kandinsky.[82]

By 1934 Bluemner saw himself as having been a middle-of-the-roader between the extreme modernists and the conservative representational artists. After having seen a show of abstract American art at the Whitney in 1935, he offered up, tongue in cheek, this prayer: "Let us pray for the Abstract: 'O Lord, take off, take all off, pull from, rescind, reduce the superfluous, the all-too-much, the overdone, and make us simple and pure, save us from the opposite, the concrete, that which grew together, by addition and summing up. Save us from the complex, from complications and our complexes, Amen'!"[83]

Despite his activity and exposure, Bluemner was appreciated only by a small, loyal following, even though he was not as radically Cubist as some of the other early modernists—Weber, say, Walkowitz, Maurer, or several others. When he slashed his throat in 1938, he was broken in health and struggling financially.

Alfred Maurer was born in New York, the son of a German immigrant, Louis Maurer. Louis, a lithographer and well-known Currier and Ives artist, was an authoritarian father in the traditional German mold, who kept a strong hold on his son even late in life. As a young man, Alfred was already heading for success as an artist in his own right. His *Arrangement* of 1901 (Whitney Museum)—a painting of a studio model posed among various exotic props done in the Dark Impressionist manner of the fashionable William Merritt Chase—won for him the prestigious Carnegie Medal with its attendant cash prize of $1,500.[84] There followed a number of broadly painted city scenes with groups of people in interiors, in the manner of the Ashcan School (*Evening at the Club*, c. 1904–05, Addison Gallery, New York).

But Maurer was already planting the seeds of his future loneliness and financial difficulties, for having arrived in Paris in 1897—the first of the early

19. Oscar Bluemner, *Vermillion House,* before 1930.

modernists to go to Europe—he did not keep to safe paths. By 1907 he was
doing wildly brushed, brilliantly colored landscapes (*French Landscape,* c. 1907,
Blanden Art Gallery, Fort Dodge, Iowa; *Landscape* [21], c. 1908, University Gal-
léry, University of Minnesota) after the contemporary work of Matisse but with
the transitions in value even more abrupt. He probably met Matisse at the Steins',
whom he visited regularly. Gertrude Stein mentioned in her autobiography that
Maurer once calmed Fernande Olivier, Picasso's principal girlfriend during the
first decade.[85]

Maurer was happiest in Paris. After he returned to New York in 1914 at
the outbreak of the war, he kept his Parisian apartment, hoping to return, until
finally in 1925 its contents were sold because of arrears in the rent.[86] Back in
America at the age of forty-six, Maurer found himself with few prospects. To
economize (or perhaps because of a deathbed promise to his mother) he stayed
with his father at 404 West 43rd Street, sleeping and painting in a small bedroom

20. Oscar Bluemner, *Cubistic Village,* 1918.

21. Alfred H. Maurer, *Landscape*
(also called *Autumn*), c. 1908.

while his father kept the large bedroom on the top floor.[87] There was a tense animosity between the two men, fostered because they produced completely different kinds of art. Louis's work continued to be bought; and when, on his hundredth birthday, he was celebrated as the sole surviving Currier and Ives artist, he told reporters apologetically: "My son paints, too."[88]

Alfred was shown at 291 in 1909 with Marin, and in 1910 as part of the Younger American Painters Exhibition; thereafter he was forgotten by Stieglitz. The one persistent supporter he knew in his lifetime was the bookdealer E. Weyhe, who bought his first painting by Maurer in 1922, and then showed his work regularly from 1924 through 1931.[89] In 1962, Weyhe as a very old man could still recall that he had been visited about 1925 by the psychiatrist Dr. Dana, brother to the director of the Newark Museum who had championed

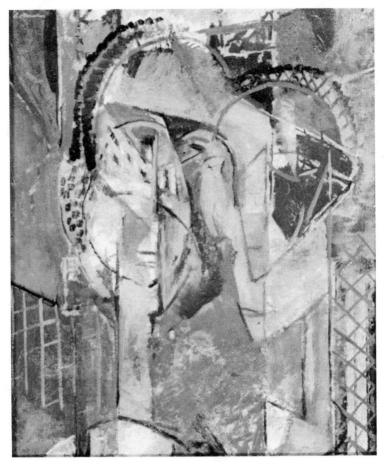

22. Alfred H. Maurer, *Two Heads*, c. 1929–30.

Weber's early work, and was urged to undergo treatment because he saw fit to exhibit Maurer's paintings in the window of his shop.[90]

Maurer wandered sadly about New York after his return from France, but spent summers at Marlboro-on-the-Hudson, where he took an interest in the children and marriages of the young women visitors, for whom he would buy ice-cream cones.[91] About 1925 Maurer began a series of paintings of them, which he showed both singly and in pairs, as in the *Florentines* (c. 1929, Phillips Collection). They appear strangely passive, with long, mannered, Modigliani-like necks and large, sad eyes. Gradually the pairs of women merged Cubist-style, as in the *Two Heads* (c. 1930, Berkshire Museum, Pittsfield, Mass.). Maurer was suddenly becoming aware of the expressive possibilities of the Cubism he had seen in Europe fifteen years ago and more, and the Cubism he had probably seen in America since then. His many *Heads*, with their partial dislocations, are formally closer to the work of the Cubist satellites—and in the first third

of this century of modernist artists anywhere only the Russian *Blaue Reiter* artist Alexej von Jawlensky consistently made the head a conveyor of such intense feelings. Maurer could have seen the paintings of both Gleizes and Metzinger, for example, at the Independent Artists' Exhibition in 1917 and in the Brooklyn Museum in 1926. And examples of Gleizes were in the Montross Gallery in New York in 1918, as well as at the sixth annual Société Anonyme Exhibition in 1921.

The *Heads* of men are the most startling. Often they are shown in pairs, confronting one another (as father and son?), sometimes intermingling. In *Dark Abstract Heads* (c. 1930, Dr. and Mrs. George P. Blumdell, Rockville, Md.) a middle eye is shared. In *Two Heads* [22] (also called *Two Men,* c. 1929–30, Potamkin Collection), there seem to be two protagonists, with parts of the two skulls seemingly disjointed or disembodied from the principal mass. In some heads there is a deliberate coarsening of the technique through scumbling of the paint and application of parts of the surface with a palette knife. This contributes to the overall sense of inward turbulence, of pent-up savagery. The *Head of a Man (Maurer's Father)* (c. 1931, New Bertha Schaeffer Gallery, New York) has a crudely distorted physiognomy—a nose off-center, an overly large right ear and no left ear, the upper part of the head fixed with the lower part sagging and the chin decomposing. One needs to look at the *art brut* of Dubuffet for a savagery as intense. One of the most awesome, probably the most hieratic of the *Heads* is the *George Washington* [23] of 1932 (Portland Art Museum), which was painted to commemorate, in a way, the dual celebration held that year on the occasion of the two-hundredth birthday of George Washington and the hundredth birthday of Louis Maurer (Maurer had been born on February 21; Washington on February 22).[92] The face is as rigid and fearsomely inflexible as a primitive idol, with the whites, grays, dark browns, and cold strip of blue to the right contributing to the starkness. Maurer may well have been identifying Washington, the hieratic Father of Our Country (as portrayed by Gilbert Stuart[93]) with his own father.

Many of Maurer's still lifes reveal Cubism used in such a way as to lay bare his sense of suffering, isolation, of a world crumbling. In the *Abstraction (Still Life with Doily)* [24] (1930, Phillips Collection) the fruit, in Cubist fashion, seems to merge with bits of the doily. Significantly, Maurer has shown the plaster cracking off parts of the wall, as the boards below can be seen. The room containing the table and the objects on it is in the process of decomposition. And in the *Contortionist,* (1927–28, University Gallery, University of Minnesota), the picture of a circus or sideshow performer—a subject that occurs only this one time in Maurer's *oeuvre*—the human body doubled over appears somehow as something obscene, a great hanging piece of meat or overly ripe fruit.

Shortly after the double celebration of the birthdays of Washington and Louis Maurer, Alfred Maurer entered New York's Beth Israel Hospital for an

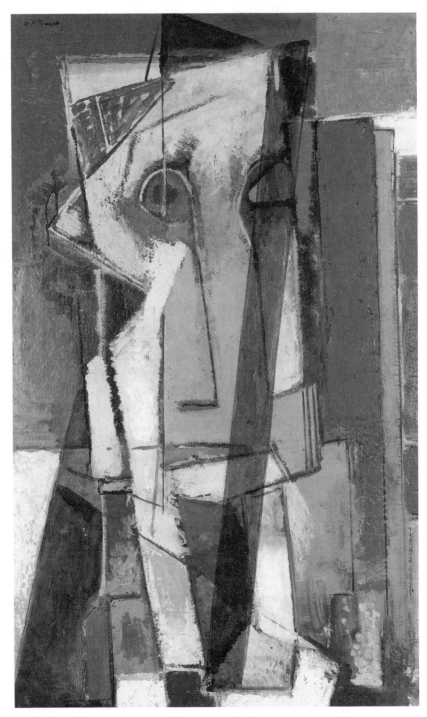

23. Alfred H. Maurer, *George Washington*, 1932.

24. Alfred H. Maurer, *Abstraction (Still Life with Doily)*, 1930.

operation on his prostate gland. The operation proved successful. But as he was recovering at home, his father died, on July 19. For a short while he occupied his father's large bedroom. Then on August 4, Maurer, aged sixty-five, hanged himself on a third-floor door frame. His biographer, Elizabeth McCausland, has said that he probably did so because his father, the object of his hatred and a reason for living, was now gone.[94] One cannot be sure. But the neglect he suffered as an artist must have been a contributing factor.

The three painters Stieglitz championed the most persistently and the longest—beyond the period of 291 and into those of the Intimate Gallery and An American Place—had a more accepting view of the world than Alfred Maurer. They were Arthur Garfield Dove (1880–1946); John Marin (1870–1953); and Georgia O'Keeffe (1887–), whom Stieglitz married in 1924.

In 1908 and 1909, Dove was in Paris for eighteen months, and traveled about Cagnes in the South of France. There he met the Philadelphia painter Arthur B. Carles, and befriended Alfred Maurer, who had been in France since 1897. He exhibited at the Salons d'Automne of 1908 and 1909. He was particularly drawn to the art of Cézanne: his *Lobster* of 1908 (Mr. and Mrs. Hubbard H. Cobb) is a still life in which the compositional complexity of receding planes recalls Cézanne. Before his trip abroad, Dove had graduated from Cornell and then done illustrations for *Harper's, Scribner's, Collier's,* and other magazines. Upon his return to America, the illustration continued as a means of support, but in his painting, which mattered most to him, he now went beyond Cézanne to paint objects and scenes that were simplified and modified from their actual appearance, and sometimes abstracted to the point of unrecognizability. In 1927 Dove explained what he was about: "Why not make things look like nature? Because I do not consider that important and it is my nature to make them this way. To me it is perfectly natural. They exist in themselves, as an object does in nature."[95]

Typically, Dove showed objects and flora and fauna stylized from a country or marine environment, or extreme stylizations in which a biomorphic basis is still recognizable. This was the world he knew. He bought a farm in 1910 in Westport, Connecticut, and won a prize for raising chickens.[96] In 1923 he bought a yawl called *The Mona,* into which he moved with his second wife, the painter Helen Torr, and for years cruised about the harbors of Long Island Sound. From 1929 to 1934 the Doves remained in the second floor of the Ketewomkie Yacht Club in Halesite in exchange for taking care of the boats.[97] In 1934, Dove sold the yawl, and settled on a farm in Geneva, New York, close to Hobart College, which he had attended thirty-five years earlier.

Taken as a whole, American landscape and marine painting from the 1880s into the first decade of this century set a certain *fin-de-siècle* mood: there were the hazy, silvery, Impressionist works of Twachtman, Weir, and Hassam; the golden visionary landscapes of Inness at the end of his career; the fantastic

dark scenes of Ryder; the remarkably modern but still exquisitely delicate *Sympho-nies* and *Nocturnes* of Whistler; and the late forlorn seascape settings of Winslow Homer, which revealed man as no longer a combatant of the elements but a passive onlooker.

The early modernists in America who were landscapists removed the sense of inwardness and symbolism that had veiled the objects of nature. For them, nature was no longer to be enshrouded in a mist. Some of them, especially— Dove, Marin, O'Keeffe, and the New Mexican artist Raymond Jonson—saw nature as vibrant, alive, physically imminent, and they sought to represent processes of growth and expansion in organic terms. Dove showed the rising of a moon (*Moon,* 1935, Mr. and Mrs. Max Zurrier, Los Angeles), the turbulent rush of water (*Waterfall,* 1925, Phillips Gallery, Washington, D.C.), the pushing forth of leaves (*Plant Forms,* 1915, Whitney), the passage of sound over water (*Fog Horns,* 1929, Colorado Springs Fine Arts Center), and a newly furrowed field (*Fields of Grain As Seen From Train* [25], 1931, Albright-Knox Gallery, Buffalo). There are a variety of animals, vaguely recognizable through undulating, wobbly forms, the color of the creature usually accurately caught, with a sense of the characteristic activity—horses hauling (*Team of Horses,* 1911, Dr. Mary C. Holt, Bay Shore, N.Y.), cows grazing, goats skipping. Despite the liberties taken, there is the assurance conveyed of Dove's intimate knowledge of the countryside, the ocean inlets, the deeper water (which he experienced when living in his yawl). No one has ever written better of him than Paul Rosenfeld in his collection of critical essays, *Port of New York:* "The brownish, cream-white pastel made from the herd of cows brings the knowledge of some one who has almost gotten into the kine themselves; and felt from within the rich animality of their beings, felt the thrust of the thin legs and toss of the horned front, the unashamed udderful fecundity; and then given it out again in characteristic abstraction and soft, sensitive, fuzzy spotting."[98]

Dove's views on his painting were expressed as statements within his exhi-bition catalogues, for example, in the catalogue to his exhibition of 1929 at the Intimate Gallery:

> Anybody should be able to feel a certain state and express it in terms of paint or music. I do not mean feeling a certain way about something, that is taking an object or subject and liking certain things about it and setting down those things.
>
> But, for instance, to feel the power of the ground or sea, and to play or paint it with that in mind, letting spirit hold what you do together rather than continuous objective form. . . .[99]

The pastel *Plant Forms* is a picture of nature that is fecund and energized. The curved forms, leaves and grasses that have been simplified, radiate outward, expanding and pulsating toward the periphery. There is no sign of human pres-

25. Arthur G. Dove, *Fields of Grain As Seen From Train*, 1931.

ence, of any container or limitation like a fence. Dove has focused on a small part of a yard or field, has found a part of the natural world that is untamed, unhampered by man, growing wild and unencumbered. In the *Reaching Waves* (1929, Metropolitan), he also abstracted from a larger context one element of nature, exploiting its potential for expansion in space. The surging roll of the wave is his subject. Unlike Homer's late seascapes, there is no onlooker or bounding rocks or distant horizon. The rolling of the wave becomes a process, a distillation of motion. Unlike Balla's *Dog on a Leash*, it is not the several position-ings of an object that Dove shows, not a movement from point to point, but a surging, involving a filling up but without a concomitant emptiness or void.

In the *Fields of Grain As Seen From Train* [25] nothing is seen of the train itself, no trace of tracks or smoke. Dove has caught the lyricism of the rolling fields and sloping horizon as seen from the train window by an unseen passenger. The furrowed row of earth converges very rapidly toward the horizon, on which are the bottoms of triangular forms meant as trees or foliage. A large orb, perhaps representing a spore from the field below, wafts lazily in the breeze and seems to float toward the spectator; it is an element that tempers the precipi-tous leap of the furrowed row, as does the gently curving horizon line at the top of the painting. Speed is implied through the intimated transience of the scene, which exists from the vantage point of the unseen passenger; as the vantage point will change because of the motion of the unrepresented train, the scene of the painting will be replaced by another.

Dove managed to cull the pastoral out of improbable situations. When he painted on metal the image of a telegraph pole (*Telegraph Pole* [26], 1929, Art Institute of Chicago), he chose to place this implement of communication deep within the countryside, where there is no passer-by. Looming starkly in the background is a great hill, and beyond that the sky. Dove has concentrated upon the woody aspect of the pole: at first glance the object seems to be a tree. The network of wires and cables leading into the city, which distinguishes the treelike object as an implement of technological civilization linking man with man and city with city, has been omitted.

In his naturescapes, Dove sought and found visual equivalents for auditory phenomena. The quivering circular forms in the *Fog Horns* suggest not only the rims or funnels of the horns themselves but the emanation of the sound waves spreading over the waters, pulsating outward like ripples in a pool. The compounding of the visual image with the suggestion of sound occurs also in a number of nonobjective "music paintings," in which Dove tried to convey the character of the musical piece involved. In *George Gershwin's "Rhapsody in Blue" Part I* [27] (1927, William Young, Wellesley Hills, Mass.), the brushstrokes are quick and short, the lines discontinuous and greatly varied in width and direction—evocative of the abrupt transitions of Gershwin's radical jazz. The piece had been played in public for the first time in 1924; three years later

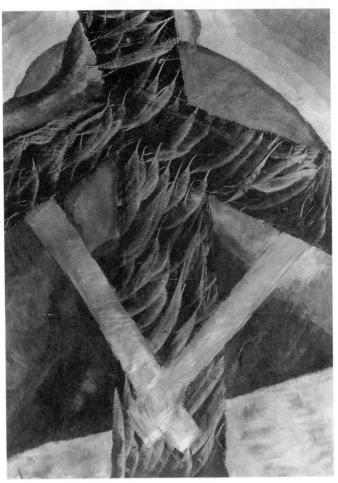

26. Arthur G. Dove, *Telegraph Pole*, 1929.

27. Arthur G. Dove, *George Gershwin's "Rhapsody in Blue" Part I*, 1927.

Dove wrote that "the music things were done to speed the line up to the pace at which we live to-day."[100] Of a different type is the *Chinese Music* [28] (1923, Philadelphia Museum), with its clearly demarcated orbed forms. Although the tune that inspired Dove here is unknown, the rich browns, sonorous blues and grays, and the radiating orbs with the spiked pattern on the topmost form (like the ridge of a dragon's back) convey the opulent splendor of the Far East. In the pastel *Sentimental Music* (1917, Metropolitan), the forms are described by gently curved lines, long and languorous. Here one thinks not of the shrill notes of the *Rhapsody in Blue,* but of a softer, more soothing kind of music, a dance band.

Dove's ventures into nonobjective painting were sporadic. But it is noteworthy that he painted a series of six small nonobjective pastels (*Abstractions Nos.*

28. Arthur G. Dove, *Chinese Music,* 1923.

29. John Marin, *Weehawken Sequence No. 5*, 1903–04 (?).

1, 2, 4, 5, Mr. and Mrs. George Perutz, Dallas) in 1910, the same year in which Kandinsky, regarded as the great pioneer in this area, produced his first nonobjective work, an untitled watercolor. (In America Dove was preceded in this venture by the Chicagoan Manierre Dawson and perhaps by Marin.) Dove's *Abstractions* of 1910 and Kandinsky's *Improvisations* are unrelated stylistically: Kandinsky worked in a loose, linear fashion, with parts of the canvas left bare; Dove handled his pastels heavily, leaving all surfaces densely colored. Dove hit upon his idea without knowledge of what Kandinsky was doing. Kandinsky's works were not shown at the early exhibitions at 291, and excerpts from his treatise *Concerning the Spiritual in Art* were not published in *Camera Work* until July 1912. Even then these excerpts were concerned with Kandinsky's opinions of Cézanne, Matisse, and Picasso, and did not get at the crux of his views on an art of spiritual necessity and the spiritual need for nonobjectivity. Between 1910 and 1912 Dove did a series of ten nonobjective pastels, which he euphemistically called *The Ten Commandments*. After seeing them in Chicago at the W. Scott Thurber Galleries, Bert Leston Taylor was moved to write a poem, "Simultaneousness of the Ambient," which contained this stanza:

> But Mr. Dove is much too keen
> To let a single bird be seen;
> To show the pigeons would not do
> And so he simply paints the coo.[101]

Dove could not reconcile his love of nature with a persistent, systematic working in a nonobjective manner. Years later he wrote: "There is no such thing as abstraction. It is extraction, gravitation toward a certain direction, and minding your own business."[102] The nonobjective "music paintings," fascinating as they are, remain detours within Dove's *oeuvre.*

John Marin, through the early 1890s, worked in four different architectural offices, then as a freelancer designing several houses in Union Hill, New Jersey, in 1893. The dalliance with architecture was important to his later development as a painter, for the concern Marin had then with stresses, weights, valences remained central to his painting, however much his vision broadened. From 1899 to 1901 he studied at the Pennsylvania Academy of the Fine Arts under Thomas P. Anshutz and William Merritt Chase. He made friends there with Arthur B. Carles, who in Europe was to introduce him to the photographer Edward Steichen, in turn the link between Marin and Stieglitz.

According to Mackinley Helm, Marin painted his *Weehawken Sequence* in 1903–4.[103] It is a group of some one hundred pieces that look like colored sketches, quick improvisations of the site; some contain vague hints of land in the foreground, and sky or sea for the background (*Weehawken Sequence No. 22*, Private collection); in others where there can be no connection made with a real object (*Weehawken Sequence No 5* [29], Whitney), orientation is impossible. Although Marin himself ascribed the dating to Helm, Reich has pushed the *Sequence* up to around 1916, arguing that the works, appearing as free as they do, would presuppose knowledge of European modernism, especially Fauvism, and are furthermore totally unlike Marin's known painting of the time, which was rather conventional, bearing the stamp of his training at the Pennsylvania Academy.[104]

Marin went to Europe in 1905, first entering the Parisian atelier of the academic artist Auguste Joseph Delecluse, which he quickly left. Exactly what he saw in Paris that year is unknown, but he could hardly have been unaware of the large retrospectives of Van Gogh and Seurat at the Salon des Indépendants, nor of the first group show of the Fauves at the Salon d'Automne. He took delight, once he had become established, in talking and writing of his past experiences in an offhand way, and described his years in Europe as the time when he "played some billiards, incidentally knocked out some batches of etchings. . . ."[105]

The one unmistakable influence on Marin in Europe was that of Whistler, evident in the silvery-bluish tonality and large, soft, undetailed forms of the watercolors (*Notre Dame*, 1907, New Britain Museum of American Art, Conn.), and in the delicacy and abundant empty space of the etchings (*Notre Dame, Paris*, 1908, Philadelphia Museum). Reich believes there was familiarity also with paintings of the Nabis Bonnard and Vuillard.[106] Marin toured Europe extensively in 1907 and 1908, visiting Rome, Florence, and Venice, where he spent six weeks, in the first year; and in the second, London, Amsterdam, Bruges, Antwerp, and Brussels. He returned to America in late 1909, when his first show was held at 291, went back to Europe the next year, and stayed until early 1911, when he returned to America to stay. In 1910 he visited the Austrian Tyrol: the watercolors he painted there are distinguished by his usual large, soft forms,

30. John Marin, *Austrian Tyrol*, 1910.

with the color generally limited to a number of bluish tonalities and a single majestic mountain peak seeming to float sometimes free of its base (*Austrian Tyrol* [30], 1910, Art Institute of Chicago).

Upon Marin's return to America, he selected the theme of New York, which he interpreted in modern fashion like Weber and Walkowitz. It was not the city as seen by the eye but the impact felt, that Marin wished to impart.

Unlike Weber and Walkowitz, however, the "aliveness" of the city he transmitted was not as generalized, as diffuse. Throughout the second decade he sought a means of transcribing or codifying the hidden dynamic forces he felt were at work within all existence, the land and sea, as well as within the newly formed conglomerations of New York's tall buildings. The forces he perceived were like valences, directions, weights (first thought of, possibly, during his days as architectural draftsman), and he rendered these with arrow-like configurations. Marin often approached painting as a builder measuring weights. This attitude is brought out in his acknowledging the importance of "weight balances" and even the pressure of the air: "Too, the pressure of the air against my body, my body against the air, all this I have to recognize when building the picture."[107]

The first city paintings upon his return were either rather naturalistic or expressionistic, with slight distortions and tiltings. In 1912 he painted several views of the Brooklyn Bridge. One of these (Lisa Marie Marin, New York), a side view captured a mile or so from the bridge, is a sketchily handled but accurate rendition with the buildings of Manhattan seen in the distance. Here the bridge's function as the connecting link between Manhattan and Brooklyn is stressed. In another watercolor, *Brooklyn Bridge* [31] (c. 1912, Metropolitan), where the spectator is made to confront the bridge head on by looking into the arched openings, the stone structure quivers and dips to the left. The tiny figures placed before the arched openings convey the vastness of the edifice,

31. John Marin, *Brooklyn Bridge,*
 c. 1912.

while the implied movement conveys its aliveness, its dangerous unsteadiness, which pedestrians then as well as now might sense, however steady the bridge in fact is.

Buildings of Manhattan—the Municipal Building, St. Paul's Cathedral (*St. Paul's, Lower Manhattan*, 1912, Wilmington Society of the Fine Arts), and especially the Woolworth Building (*Woolworth Building No. 31*, 1913, Museum of Modern Art)—Marin likewise set at instability, quivering and trembling, defying the laws of gravity and the physical limitations of the materials of which they were made, to suggest the dizzying excitement and exaltation New York at the beginning of the second decade inspired. The Woolworth Building, depicted by Marin while it was still going up, was opened on April 24, 1913, as the highest skyscraper of steel construction up to the time (792 feet), and the tallest building in New York, surpassing the Singer Building, tallest since 1908.[108]

Reich suggests that Delaunay's Orphist paintings of St. Sévérin in 1909 and the Eiffel Tower of 1910 may have served as a prototype for Marin's unsteady buildings from 1912.[109] Delaunay at that time in his Eiffel Tower paintings was using Cubist means to suggest the interpenetration of the space contained by the girders and beyond, while Marin did not adopt a Cubist manner until the end of the second decade. More to the point, Marin could have seen Delaunays. In any case they served, at best, as a distant point of departure, as did other Cubist paintings he might have seen—we cannot be certain—when in Europe in 1910 and early 1911. The distortion of the appearance of objects was in the air throughout Europe, and in America among the artists of the Stieglitz and Arensberg groups and the color painters associated with the Synchromists by the beginning or the middle of the second decade. Marin, with a variety of modernist devices at his disposal, was prepared to express rather than merely reproduce the excitement that the coming together of people and buildings in New York generated for him: "I see great forces at work; great movements; the large buildings and the small buildings; the warring of the great and the small; influences of one mass on another greater or smaller mass. Feelings are aroused which give the desire to express the reaction of these 'pull forces,' 'those influences which play with one another; great masses pulling smaller masses, each subject in some degree to the other's power."[110]

By the end of the second decade Marin's watercolor cityscapes of New York showed tall buildings merging in a Cubist manner. In his *Lower Manhattan (Composing Derived from Top of Woolworth)* [32] (1922, Museum of Modern Art) the distinctions between the individual buildings cannot be made out, except in a few instances. The paper star-shaped form sewn onto the bottom of the watercolor coalesces the sense of outward radiation expressed in the buildings, their upward and outward thrust reinforced by the thick black lines acting both as outline and as directional valence. The paper cutout had been inspired by the gold-leaf motif on the Old World Building, which was clearly visible from the top of the Woolworth Tower.

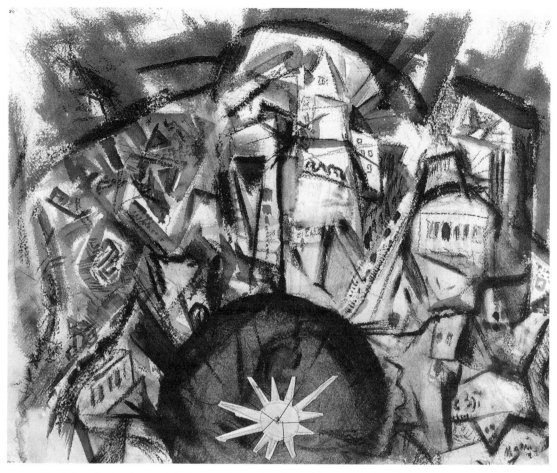

32. John Marin, *Lower Manhattan (Composing Derived from Top of Woolworth)*, 1922.

Then in the *Street Crossing* (1928, Phillips Collection), Marin used a system of Cubist passages for the buldings towering above the street in the upper half of the watercolor. The scene is a comment on the frenzied activity about a New York subway entrance. The solid masses of the buldings have been projected into a series of sharply receding planes, converging upon one another and merging in some places, as though to recapitulate the action below. There, two sketchily painted faceless figures rush by beside a bicycle; traffic lights peer out; in the lower-left corner a figure is moving out of the painting and a subway marquee alludes to the din and speed below the surface of the street. Yet the paroxysm is not all-encompassing, as it is, say, in the Futurist paintings of Boccioni or the *New York* series that Weber painted from 1912 to 1916. Marin did not feel the painter should heighten the excitement generated by a scene to its fullest extent. There ought to be an area or areas of stability, of eye arrest, like the subway marquee in the *Street Crossing*. He put it this way in the catalogue to his 291 exhibition, held in the spring of 1913: "within the frames there must be a balance, a controlling of these warring, pushing, pulling forces."[111]

Marin was long closely associated with Maine. He made his first summer visit in 1914, and kept going back, first to Small Point, then to Stonington and Deer Isle in 1919. In 1915 he bought an island at Small Point, which he named Marin Island. Marin's waterscapes and landscapes, like those of Dove, were born of a direct observation of the workings of nature. This was different from the outlook of the German Expressionist *Blaue Reiter* group, and from such artists as Franz Marc, August Macke, and Paul Klee, all of whom sought a unity with a nature seen as perfect and archetypal. The natural world of Marin is always in a state of flux. There is the sense of becoming, of process. Vitally zestful, rampantly open to experience, Marin was unencumbered by dusky symbolisms. His landscapes, like those of Dove and O'Keeffe, represent a turning outward from the remoteness and self-conscious aestheticism of such late nineteenth-century American painters as Childe Hassam, John Twachtman, and George Inness.

Marin's *Maine Islands* (1922, Phillips Collection), like Dove's *Fields of Grain As Seen From Train* [25] and many other Dove landscapes, gain recourse to a silent, secluded spot of the world—small, remote islands off the Maine coast. But it is the remoteness of location only. The spectator is made to feel contact with the site: the moving clouds and the free circulation of the air, the craggy rocks in the foreground. The enclosure, the device of a frame within a frame adopted probably from Whistler, functions as a large transparent plane, a device occasionally found in European Cubism although neither Marin nor any other of the Stieglitz artists ever referred to themselves as Cubists. The spectator is made to imagine himself passing by or toward these small islands, perhaps viewing them from the window of a plane or boat. In a statement for the catalogue of an exhibition held in 1923, Marin imagined himself as being high in space

33. John Marin, *Sailboat in Harbor*, 1923.

and passing over islands out toward the open sea, a statement noteworthy for its sheer exultation of expression. It is as though Marin, who was intimately familiar with Maine, was able to experience kinesthetically the pull of these small islands as he painted, for he wrote in the catalogue essay for his show at New York's Montross Gallery in 1923: "Speed. We advance upon distance and the oncoming rush of distance meets us and greets us. Aware of the impetuous flight of our senses in space the clouds almost open to let us pass through. Islands of our desire are drawing near but they will not detain us. We will push the horizon back. . . ."

At times, Marin's enclosure device in waterscapes becomes an abstraction, a sign standing for some phenomenon in nature that is felt rather than seen. The light blue hexagonal frame within *Sailboat in Harbor* [Pl. II, 33] (1923, Columbus Gallery of Fine Arts), set before the darker blue of the water and the sky, is an airborne thing of no precise identity; it can connote a breeze, a change of air pressure, because the form is in part transparent and its hexagonal shape seems fluid and capable of change. In the *Sea, Maine* (1921, National Collection) there is nothing of Cubist adaptations through enclosures or other devices. It

is the actual handling of the paint, roughly scumbled and suggestive then of churning water, rather than the kaleidoscopic arrangement of partially diaphanous zones, that is made to serve as the equivalent of nature's dynamism. The approach in this painting forecasts the vigorous handling of the oil medium from the late 1930s until the artist's death in 1953, when the appearance of the waterscapes like *Sea Piece* (1951, Mr. and Mrs. John S. Schulte, New York) was close to the enormous works of the gestural painters of the Abstract Expressionist school.

Much of Georgia O'Keeffe's art has to do with the world of nature: the sun and sky; mountains and plains; trees, plants, and flowers are her frequent subjects. These she shows not as static objects but as alive in the sense that they undergo growth and expansion. In this she is similar to both Dove and Marin, but the things of nature she chooses to show she endows with an extraordinary clarity and vibrancy. Cubist dislocations and fragmentations never appealed to her. In the flower and plant pictures, the environmental context has been eliminated or crowded out (*Black Iris,* 1926, Metropolitan), so that the natural object, pushed up to the foreground plane, confronts the spectator with a stark, even frightening immediacy. These closeup devices were partially influenced by O'Keeffe's long, intimate association with Alfred Stieglitz and her knowledge of the photography of Paul Strand, but they reflect too the lucidity and intensity of her own personality.

Like Dove, Marin, and Raymond Jonson, O'Keeffe needed remoteness and seclusion, time to think, closeness to nature. She was born in a remote part of America, Sun Prairie, Wisconsin, and raised in the neighboring farming country. Years later she told an interviewer that "the thing that is the Middle West, the normal healthy part of America, had a great deal to do with my development as an artist."[112] At fifteen, she moved with her family to Williamsburg, Virginia. After studying from 1905 to 1912 at the Art Institute of Chicago, the Art Students League of New York under William Merritt Chase, and the Teachers College of Columbia University under Arthur Wesley Dow (who had also been Weber's teacher), she settled for two years into teaching jobs around Amarillo in the Texas Panhandle, a vast, dry, seemingly boundless country. She remarked that "that was my country—terrible winds and a wonderful emptiness."[113]

This vastness became the subject of a long series of paintings of horizontals signifying the earth topped by the curved arc of the heavens—that and nothing more. The series began in 1917, while O'Keeffe was still in the Texas Panhandle (*Light Coming on the Plains No. II,* 1917, Amon Carter Museum, Fort Worth), and continued into the 1950s (*From the Plains No. I* [34], 1953, Marian Koogler McNay Art Institute, San Antonio). Fairfield Porter has called these works "the first examples of the 'Californian' school,"[114] linking them to that of the native Westerner Clyfford Still, for example. They may be linked, too, to the nineteenth-century Rocky Mountain paintings of Church and Bierstadt. This is because

34. Georgia O'Keeffe, *From the Plains No. I*, 1953.

O'Keeffe in the series through an economy of means has conveyed something in the American landscape that is grandiose and indeed—to invoke an overused word applicable here—sublime.

O'Keeffe went to New York from Texas in the fall of 1914, and renewed contact with Dow, purchasing his book *Theory and Practice of Teaching Art* and enrolling in his classes at Columbia University. She admired Dove's paintings, which she saw at the Forum Exhibition, and attended exhibitions at 291 in 1915 and 1916, but kept her distance from Stieglitz, who terrified her during those early visits.[115] In the fall of 1916 she taught a semester at Columbia College in Columbia, South Carolina, and during the summer and fall of 1917 she was back teaching in Texas. Her early work reached Stieglitz through Anita Pollitzer, a fellow student in Dow's class, who showed it to him against O'Keeffe's wishes.[116] Most of this work consisted of planes, wavy lines, and egg-shaped forms done in charcoal and watercolor (*Blue No. II* [35], 1916, Brooklyn Museum). In all these pieces the medium is handled with remarkable delicacy. In some, like the *Blue Lines* (1916, Metropolitan) and the *Drawing No. 13* (1915, Metropolitan), Chinese hand-drawn characters are suggested; and perhaps this is not entirely accidental, as Dow was a confirmed Orientalist. The success of the paintings depends to a large extent on O'Keeffe's restraint, on what has been left out. They have no reference to things in nature. O'Keeffe recalled that "I said to myself 'I have things in my head that are not like what anyone has taught me—

35. Georgia O'Keeffe, *Blue No. II,* 1916.

36. Georgia O'Keeffe, *Portrait W, No. II,* 1917.

shapes and ideas so near to me—so natural to my way of being and thinking that it hasn't occurred to me to put them down.' I decided to start anew to strip away what I had been taught. . . ."117

The watercolors of 1917 show O'Keeffe handling the paint broadly, applying it in diffuse washes of grays, sometimes touched with greens and violets (*Portrait W, No. II* [36], 1917, Mr. and Mrs. James W. Alsdorf, Winnetka, Ill.). Still cut off from any identifiable context, these more fully brushed paintings look forward to the color stains of the 1960s, and in places it seems that the paint was allowed to run, a little reminiscent of the veil paintings of Morris Louis.

O'Keeffe has worked nonobjectively throughout her career. After her earliest ventures, her nonobjective paintings allude to, without representing, the world of nature. In the *Blue and Green Music* (1919, Art Institute of Chicago) there are references to processes of the land, the water, or the atmosphere, to the furrowing and turning of the soil, the movement of waves, the billowing and wafting of gas. All of these references operate simultaneously, bringing to mind still another allusion—the rise and fall of music. O'Keeffe's nonobjective works lead to multiple allusions, each reinforcing the other as to meaning and visual coherence. The painting exists primarily as pure form, with the different areas and textures so manipulated as to call to mind vast dimensions belied by the actual measurements of the canvas.

In other nonobjective paintings, body and landscape allusions complement one another so closely as to be virtually inseparable. The *Dark Abstraction* [37] of 1924 (City Art Museum of St. Louis) gives a suggestion of the sloping contours of fields topped by a sliver of sky; or it is as though cross sections of earth had been sliced off, set end on end, and crowned with a part of the sky. At the same time the crevice atop one of these so-called sections of earth can be regarded as a pore in the skin, and the line winding its way to the bottom of the painting not just as a crevice within the earth but also as a hair or nerve ganglion. The interchangeability of landscape and body imagery provides the painting with its particular elusive power. In *Abstraction* [38] (1926, Whitney), the laid-back flaps at the center can be regarded both as the contour of a section of land viewed from a high altitude and as the magnified orifice of a body, or perhaps the fold between arm and torso. In the *Black Abstraction* (1927, Metropolitan), similarly, the projecting line running from the top vertically and then diagonally the length of the canvas may be both the boundary between the shore and a promontory of land and parts of the torso. If the spectator chooses to see this line as a boundary of parts of the torso, then he will probably see the center of the radiating circles as a human orifice—eye, ear, mouth, vagina. Or these radiating orbs can be likened to the circular patterns produced by a pebble dropped in still water, or the diffusing rays of the sun or moon. In these two paintings, the *Dark Abstraction* [37] and the *Black Abstraction,* the color is austere,

37. Georgia O'Keeffe, *Dark Abstraction*, 1924.

the design quite stark and simple. Yet this severity, by eliminating what would be distracting, brings into fuller relief the sensuousness of the imagery. A remarkable blend of chasteness and severity is the quality of these paintings, and of the 1926 *Abstraction* [38], as well as other of O'Keeffe's works.

There is a tenuous line separating the nonobjective paintings from some of O'Keeffe's single flower or plant pictures such as *Black Iris* and *Corn, Dark.* While Dove in his *Plant Forms* showed many leaves and grasses, O'Keeffe, with her characteristic intensity and single-mindedness, liked to focus on a single flower or plant, or at the most two or three. Some of her flower and plant pictures of the 1920s also have a quality not found in any other of the early modernist landscapists: a voluptuousness occasionally intimating sexuality, as in *Black Iris* (1926, Metropolitan), where the opening flower resembles the female

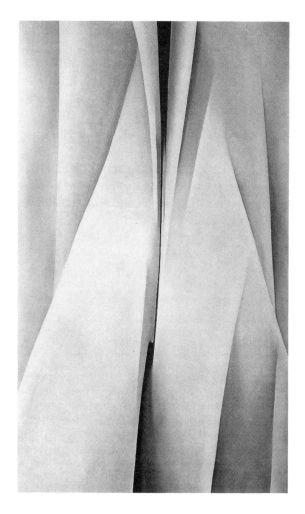

38. Georgia O'Keeffe, *Abstraction*, 1926.

organs. The sexuality is never overly blatant or grossly erotic, however. It is a sexuality-in-nature, integrated with an expansiveness-in-nature, a swelling, a germinating, a bursting forth. The iris seems to have been caught in various stages of its growth, as though it were unfolding before the eyes of the spectator, as though several intervals of growth had been photographed days apart and combined in this single painting. Successive chronological stages are represented at succeeding horizontal levels, with the later, blossoming stage at the top of the canvas. A displacement of the environmental context, which disorients the spectator, coupled with the limited range of other-worldly colors—a muted, vaporous bluish-grey in the *Black Iris,* a coldly burning deep green in the similar *Corn, Dark* (1924, Metropolitan)—tinges O'Keeffe's plants with a dreamlike remoteness.

She made her first trip to the Southwest in 1917, to Colorado and New Mexico. Loving both the desert and the rocky variety of the region, the colors, the invigorating dryness, she spent summers in New Mexico from 1929 onward, and in 1949 made the place her home. O'Keeffe's paintings of bleached desert bones (*Cow's Skull: Red, White, and Blue,* 1931, Metropolitan) are among her most uncanny. A skull is rendered so crisply, presented frontally and looming so starkly that it becomes a thing opposite to its nature, a thing of implacable life. Bones of the desert intruded themselves upon her attention: "I have wanted to paint the desert and haven't known how. . . . So I brought home the bleached bones as my symbols of the desert. . . . To me they are strangely more living than the animals walking around—hair, eyes and all with their tails switching. The bones seem to cut sharply to the center of something that is keenly alive on the desert tho' it is vast and empty and untouchable—and knows no kindness with all its beauty."[118]

But no matter how much O'Keeffe evoked the magical in her paintings of skulls, neither then nor anywhere else in her work would she prove as blatantly cerebral, to the exclusion of other qualities, as the artists of the Arensberg Circle.

NOTES

1. The name was given in 1908. Because in February of 1908 the rent of the Photo-Secession Galleries at 291 Fifth Avenue was doubled and the signing of a four-year lease demanded by the landlord, Stieglitz moved across the hall to 293 Fifth Avenue. The wall was removed, and one elevator was used for the two buildings. Still, "293" would have been the proper designation. Stieglitz used "291" because he found the sound more euphonious. Dorothy Norman, *Alfred Stieglitz: An American Seer,* New York, 1973, pp. 77–79. The floor plan, done from memory by Marie Rapp Boursault, is reproduced in William Innes Homer, *Alfred Stieglitz and the American Avant-Garde,* Boston, 1977, p. 47.

2. The effect produced was that of a

soothing, nongaudy place, where attention was focused on the works. The photographer Edward Steichen was instrumental in determining the interior decoration.

3. It was the painter Abraham Walkowitz who, moved by the work of children he saw in East Side Settlement houses, convinced Stieglitz to have the show. It was followed by three others, including, from November 22 to December 20, 1916, a solo exhibition of ten-year-old Georgia S. Engelhard, Stieglitz's niece. Homer, *op. cit.*, p. 146.

4. Norman, *op. cit.*, p. 32.

5. Preamble on the catalogue statements of the Intimate Gallery. Stieglitz went on: "The Intimate Gallery is a Direct Point of Contact between Public and Artist. It is the Artist's Room. It is a Room with but One Standard. Alfred Stieglitz has volunteered his services and is its directing Spirit. The Intimate Gallery is not a Business nor is it a 'Social' Function. The Intimate Gallery competes with no one nor with anything."

6. Then Hudson Walker became Hartley's dealer. Stieglitz, according to Walker, used to insist upon his own prices for Hartley's works, saying that to lower them would be a deprecation of Hartley's accomplishments, although the painter needed less and was willing to accept less in order to survive. Interview with Hudson Walker, April 1962.

7. Norman, *op. cit.*, p. 45–46.

8. *Ibid.*, p. 77.

9. Homer, *op. cit.*, p. 80. Stieglitz never dropped an artist because he or she did not sell. Making sales was secondary. He simply redoubled his efforts to subsidize that artist, either through his own funds or funds that he solicited.

10. Quoted in Dorothy Norman, "An American Place," in Waldo D. Frank, *et al.*, eds., *America and Alfred Stieglitz; A Collective Portrait*, Garden City, N.Y., 1934, pp. 126–127.

11. Reported in Herbert J. Seligmann, *Alfred Stieglitz Talking*, New Haven, Conn., 1966, p. 11.

12. Herbert Seligmann, "Alfred Stieglitz and His Work at 291," *American Mercury*, 2 (May 1924), p. 84.

13. Dorothy Brett, "The Room," in Frank, *et al.*, *op. cit.*, p. 260.

14. Quoted in Waldo D. Frank, "The New World in Stieglitz," *ibid.*, p. 220.

15. Quoted in Dorothy Norman, "An American Place," *ibid.*, p. 135.

16. *Ibid.*, p. 151.

17. *Ibid.*, p. 137.

18. On the infighting to gain control of the Armory Show, see Milton W. Brown, *The Story of the Armory Show*, Greenwich, Conn., 1963, Chaps. 1–3, pp. 25–76.

19. Quoted in Dorothy Norman, "An American Place," *op cit.*, p. 130.

20. Remark of Stieglitz reputedly made on December 23, 1923. Quoted in Seligmann, *Alfred Stieglitz Talking*, pp. 3–4.

21. Quoted in Norman, *Alfred Stieglitz: An American Seer*, p. 161.

22. Temple Scott, "Fifth Avenue and the Boulevard Saint-Michel," *Forum*, 44 (December 1910), p. 665.

23. He wrote, for example, to Hartley on May 12, 1914: "You speak of New York as an unspeakable place. It is truly that. But it is fascinating. It is like some giant machine, soulless, and without a trace of heart. . . . Still I doubt whether there is anything more truly wonderful than New York in the world just at present." Alfred Stieglitz Archive, Collection of American Literature, Beinecke Rare Book and Manuscript Library, Yale University Library.

24. Temple Scott, *op. cit.*, pp. 684–685.

25. Reported in Seligmann, *Alfred Stieglitz Talking*.

26. Homer, *op. cit.*, p. 134.

27. In a letter he wrote to Hartley on October 11, 1913, Stieglitz reminded him that he took $150 out of his own pocket to get him back to America. Alfred Stieglitz Archive, Collection of American Literature, Beinecke Rare Book and Manuscript Library, Yale University Library.

28. Letter from Stieglitz to Hartley, February 5, 1929, Alfred Stieglitz Archive, *loc. cit.*

29. This is not to suggest that Stieglitz and his artists were under the sway of Kandinsky's thinking. Except for Hartley, they were not well acquainted with his theories. A brief excerpt from Kandinsky's *Concerning the Spiritual in Art* appeared in *Camera Work* 39 (July 1912), p. 34, under the title "Extracts from the Spiritual in Art." Furthermore, in *Camera Work* the excerpt is concerned with Kandinsky's opinions of Cézanne, Matisse, and Picasso. It does not get at the crux of Kandinsky's treatise of an art of internal necessity and the spiritual need for abstraction, nor does it touch upon any of his analyses of the effects of various colors.

30. Quoted in Charles H. Caffin, "Photography as a Fine Art," *Everybody's Magazine*, 4 (April 1901), p. 367.

31. John Marin, "Notes on 291," *Camera Work*, 42 (April–July 1913), p. 18.

32. So called in a letter from Alfred Stieglitz to Charles Demuth, May 12, 1929. Alfred Stieglitz Archive, *loc. cit.*

33. As stated in the Foreword to the catalogue of Dove's exhibition in the Intimate Gallery, April 9–28, 1929. He continued: "letting spirit hold what you do together rather than continuous objective form, gaining in tangibility and actuality as the plane leaves the ground, to fly in a medium more rare and working with the imagination that has been built up from reality rather than building back to it."

34. Frederick S. Wight, *Arthur G. Dove*, Berkeley and Los Angeles, 1958, p. 40.

35. Harold Clurman, "Alfred Stieglitz and the Group Idea," in Frank, *et al., op. cit.*, p. 277.

36. Quoted in Norman, "An American Place," *ibid.*, p. 150.

37. Letter from Alfred Stieglitz to Marsden Hartley, October 27, 1923. Alfred Stieglitz Archive, *loc. cit.*

38. William Carlos Williams, *The Autobiography of William Carlos Williams*, New York, 1955, p. 236. Most of Williams's objections date from Stieglitz's "somewhat crotchety old age": he admits that he began to fall off from Stieglitz only when Hartley was dropped, which occurred only in the early 1930s—*ibid.*

39. Henry McBride, "Modern Art," *Dial*, 70 (April 1921), p. 480.

40. The entire issue, seventy-four pages long, was devoted to the topic: What Does 291 Mean? In the Introduction, Stieglitz himself wrote: ". . . I decided that the Number should contain no pictures; I decided that forthwith I would ask twenty or thirty people, men and women, of different ages, of different temperaments, of different walks of life, from different parts of the country, and some in Europe, to put down in as few words as possible, from ten to no more than fifteen hundred, what '291' means to them; what they see in it; what it makes them feel. Not what it is. And I would ask them to eliminate, if possible, any reference to myself. I felt that in this way I might possibly find out what '291' is, or come near to finding out. For if all would write what they felt in their hearts, a common note in all probability would run through all the worded heartbeats. And thus too the world might learn to know."

41. Herbert J. Seligmann, "291: A Vision Through Photography," in Frank, *et al., op. cit.*, p. 112.

42. Hutchins Hapgood, "What 291 Is to Me," *Camera Work*, 47 (July 1914), p. 11.

43. Charles E. S. Rasay, "291—Its Meaning to Me," *ibid.*, p. 14.

44. Anna Brigman, "What 291 Means to Me," *ibid.*, p. 17.

45. Charles Daniel, "291," *ibid.*, p. 33.

46. Marsden Hartley, "What Is 291?," *ibid.*, p. 36.

47. Eugene Meyer, Jr., "291," *ibid.*, p. 40.

48. Arthur B. Carles, "291," *ibid.*

49. Rex Stovel, "291," *ibid.*, p. 28.

50. Interview with Elizabeth McCausland, April 1962.

51. Quoted in Gorham Munson, "Homage to Marsden Hartley: The Painter from Maine," *Arts*, 35 (February 1961), p. 33.

52. This Picasso exhibition, his first one-

man show in America, consisted of eighty-three works, drawings in charcoal and pen and ink, etchings, and watercolors, from his earliest work through the Blue and Rose periods, into proto-Cubism, and Analytical Cubism, which was represented by the 1910 drawing of a nude. Stieglitz bought that 1910 drawing, the first Cubist picture exhibited in America, for $65.

53. Barbara Haskell, *Marsden Hartley*, New York, 1980, p. 98.

54. Letter from Marsden Hartley to Alfred Stieglitz, May 9, 1913. Alfred Stieglitz Archive, *loc. cit.*

55. Postcard from Marsden Hartley to Gertrude Stein, April 29, 1913, *ibid.*

56. Letter from Marsden Hartley to Gertrude Stein, June 7, 1913, *ibid.*

57. Peter Selz, *German Expressionist Painting*, Berkeley, 1957, p. 266.

58. Letter from Marsden Hartley to Gertrude Stein, June 7, 1913. Alfred Stieglitz Archive, *loc. cit.*

59. Letter from Marsden Hartley to Alfred Stieglitz, December 20, 1912, *ibid.*

60. Marsden Hartley, "Tribal Esthetics," *Dial* (November 1916), pp. 399–401.

61. Letter from Marsden Hartley to Alfred Stieglitz, January 8, 1919. Alfred Stieglitz Archive, *loc. cit.*

62. Munson, *op. cit.*, pp. 39–40.

63. Arthur W. Dow, *Composition*, Boston, 1899, pp. 6, 36–37.

64. From a long handwritten address entitled "The Matisse Class," dated November 19, 1951 (preserved on microfilm, Archives of American Art, The Smithsonian, Washington, D.C.). Weber did not indicate the occasion for the address. He wrote of the formation of the class: "In the course of conversation with Hans Purrmann, who was a very close friend of Matisse, he suggested that we might be able to organize a class of our own under the tutelage of Matisse. He felt quite certain that he could persuade Matisse to give us criticism. Our dream was realized. Matisse graciously agreed to give us and a few other students criticism every Thursday morning. Al-though he lived in modest circumstances he would not accept remuneration for the precious time and energy he gave us, a spirit now almost extinct."

65. This was the first one-man show of Rousseau's paintings anywhere. Most of the four or five oils and two ink drawings came from Weber's own collection of Rousseaus acquired in France. On Weber's recollections of Rousseau, see Max Weber, "Rousseau as I Knew Him," *Art News*, 41 (February 15, 1942), pp. 17, 35.

66. Max Weber, "Chinese Dolls and Modern Colorists," *Camera Work*, 31 (July 1910), p. 51.

67. Homer, *op. cit.*, p. 135.

68. Letter from Alfred Stieglitz to Max Weber, January 17, 1914. Alfred Stieglitz Archive, *loc. cit.*

69. Max Weber, "The Fourth Dimension from a Plastic Point of View," *Camera Work*, 31 (July 1910), 25.

70. Or heard of it from artists recently returned from Europe. Alfred Werner, *Max Weber*, New York, 1974, p. 46.

71. Quoted in *ibid.*, p. 50.

72. Also illustrated as the frontispiece was Gleizes's *Man on a Balcony*, which might have been an inspiration for Weber's fragmented image of the diner. In his book, Eddy reprinted many excerpts from the Futurist manifestos, and even treated proposed Futurist innovations in punctuation and grammar. He wrote that "one of its [i.e., one of Futurism's] fundamental notions in painting is a certain theory regarding the painting of motion. It is that in order rightly, scientifically, to indicate motion on a canvas, it is not sufficient to paint the figure of a man in an attitude of walking, but a series of more or less clearly outlined figures must be shown overlapping, a sort of cinematograph effect . . . if an individual is in motion there must be a blur of many overlapping individuals (see the half-tone of the girl with the dog)"—Arthur J. Eddy, *Cubists and Post-Impressionism*, Chicago, 1914, p. 165.

73. Werner, *op. cit.*, p. 31.

74. Homer, *op. cit.*, p. 140.

75. Quoted in Norma Ketay, "What It Meant to be an Ultra-Modern Jewish Artist in America 60 Years Ago," *The Day—Jewish Journal* (May 11, 1958), p. 7. In an interview with Abram Lerner and Bartlett Cowdrey near the end of his life, Walkowitz said of Isadora Duncan: "She had no laws. She didn't dance according to rules. She created. Her body was music. It was a body electric, like Walt Whitman." Abram Lerner and Bartlett Cowdrey, "A Tape-Recorded Interview with Abraham Walkowitz," *Journal of the Archives of American Art*, IX (January 1969), p. 15.

76. Lerner and Cowdrey, *op. cit.*, p. 14.

77. *Ibid.*, p. 15.

78. *Ibid.*, p. 14.

79. *The Forum Exhibition of Modern American Painting, New York*, 1916, pages unnumbered.

80. Lerner and Cowdrey, *op. cit.*, p. 13.

81. *The Forum Exhibition of Modern American Painting.*

82. Although he was in Germany in 1912, Bluemner as far we know had no contact with Kandinsky or his art theories.

83. Oscar Bluemner, "The Abstract," *Art Digest*, IX (March 15, 1935), p. 9.

84. Included on the jury, which unanimously voted to award Maurer the first prize, were Winslow Homer and Thomas Eakins. Elizabeth McCausland, *Alfred Maurer*, New York, 1951, pp. 65–66.

85. Gertrude Stein, *The Autobiography of Alice, B. Toklas*, New York, 1933, p. 14. Gertrude Stein wrote of Maurer as an "old habitué of the house," and described him as "a little dark dapper man . . . with hair, eyes, face, hands and feet all very much alive"—*ibid.*, p. 13.

86. Bernard Danenberg Galleries, text by Peter Pollack, *Alfred Maurer and the Fauves: The Lost Years Rediscovered*, New York, 1973, pages unnumbered.

87. *Ibid.*

88. Interview with Elizabeth McCausland, April 1962.

89. National Collection of Fine Arts, Washington, D.C., text by Sheldon Reich, *Alfred H. Maurer, 1868–1932*, Washington, D.C., 1973, p. 58. Also interview with E. Weyhe, April 1962. Maurer is reported to have told Holger Cahill during the hanging of the Independents' Show in 1922 that "for fifteen years not a living soul has said a kind word about my pictures"–McCausland, *op. cit.*, p. 149.

90. Interview with E. Weyhe, April 1962.

91. There was never a romantic involvement. Interview with E. Weyhe, April 1962.

92. National Collection, *op. cit.*, p. 113. This was Maurer's last painting.

93. The possible connection with some of Stuart's portraits of Washington made by Maurer when he was painting his own *George Washington* was suggested by Dr. Mark Roskil in 1966, who was then teaching at Harvard.

94. Interview with Elizabeth McCausland, April 1962. Reich, on the other hand, offers that Maurer killed himself partly out of the remorse he suffered over his father's death. He dispels the rumor that Maurer was really suffering from cancer. National Collection, *op. cit.*, p. 113.

95. Statement in the catalogue for Dove's exhibition in the Intimate Gallery, December 12, 1926–January 11, 1927.

96. Frederick S. Wight, *Arthur G. Dove*, Berkeley and Los Angeles, 1958, p. 41.

97. Barbara Haskell, *Arthur Dove*, San Francisco, 1975, p. 38.

98. Paul Rosenfeld, *Port of New York*, New York, 1924, pp. 171–172.

99. "Notes by Arthur G. Dove," Statement in the catalogue for Dove's exhibition in the Intimate Gallery, April 9–28, 1929.

100. Statement in the catalogue for Dove's exhibition in the Intimate Gallery, December 12, 1926–January 11, 1927.

101. Chicago *Tribune*, March 27, 1912. Quoted in Wight, *op. cit.*, p. 30.

102. "Notes by Arthur G. Dove," *op. cit.*

103. According to Helm, "After his [Marin's] spell at the Pennsylvania Academy . . . he . . . made about a hundred small oils [the Weehawken sequence], but

they found no market." Frederick S. Wight and Mackinley Helm, *John Marin: A Retrospective Exhibition,* Boston, 1947, p. 15.

104. Sheldon Reich, *John Marin: A Stylistic Analysis,* Tucson, Ariz., 1970, pp. 87–92. Marin's erroneous dating was confirmed by Reich also through conversation with John Marin, Jr.—*ibid.,* p. 255, n.52.

105. Dorothy Norman, *The Selected Writings of John Marin,* New York, 1949, p. 78.

106. Reich finds in the decorative patterning and the intimate genre subject of two works of 1910, *Girl Sewing* and *Woman in Interior,* evidence of Marin going to Bonnard and Vuillard for prototypes. Reich, *op. cit.,* pp. 27–30.

107. John Marin, "John Marin by Himself," *Creative Art,* 3 (October 1928), p. xxxix.

108. In those two decades, 1910–1930, when Marin, Weber, Walkowitz, and Stella through a variety of modernistic means expressed the excitement generated by New York, a tremendous amount of building was in fact going on which gave the metropolis its present shape. The second decade saw great developments all about Pennsylvania Station (which had been built with its tunnels in the first decade), including the Pennsylvania Hotel, the General Post Office, and Macy's, Gimbel's, and Saks. The Grand Central Terminal was opened on February 3, 1913. The Chanin family came from Brooklyn to build the Strand, Roxy, Little, and Century theatres. Raymond Hood, largely responsible for the Rockefeller Center, built the McGraw-Hill and Daily News buildings. The Thompson-Starrett Construction Company under the leadership of the immigrant Louis J. Horowitz constructed 462 buildings, most of them in Manhattan, including the Equitable, Woolworth, Chrysler, and Equitable Trust buildings, the Paramount Theater, and the Ambassador and Waldorf-Astoria hotels, all of which went up in the 1920s and 1930s. The harbor system, too, proliferated through the second and third decades.

109. Reich admits that the Delaunay connection is speculation. He points out that Marin may have known Delaunay in Paris, where he could have seen at the Salon des Indépendants of 1910 the *St. Séverin* exhibited there, and Eiffel Tower pictures exhibited there the next year. Reich, *op. cit.,* pp. 58–62.

110. John Marin, "Notes on 291," *Camera Work,* 42 (April–July 1913), p. 18.

111. The idea of controlling the visual excitation stayed with Marin. In 1928, the very year he painted his *Street Crossing,* he wrote that "there will be focussing points focussing on—well spots of eye arrest and these spots sort of framed within themselves"—Marin, "John Marin by Himself," *op. cit.* p. xxxviii.

112. Charlotte Willard, "Georgia O'Keeffe," *Art in America,* LI (October 1963), p. 95.

113. Quoted in Lloyd Goodrich and Doris Bry, *Georgia O'Keeffe,* New York, 1970, p. 9.

114. Fairfield Porter, *Art in Its Own Terms: Selected Criticism 1935–1975,* New York, 1979, pp. 179–180.

115. Source given is Homer's interview with Georgia O'Keeffe, September 22, 1972. Homer, *op. cit.,* pp. 236, 294.

116. *Ibid.,* p. 237.

117. Quoted in Katherine Kuh, *The Artist's Voice: Talks with Seventeen Artists,* New York and Evanston, Ill., p. 190.

118. Lloyd Goodrich and Doris Bry, *op. cit.,* p. 23.

2

The Arensberg Circle

THE AMBIENCE OF THE ARENSBERG CIRCLE

In 1917, with attendance decreasing and deficits mounting because of the war, Stieglitz's 291 closed. But from 1914 until 1921, when he moved to California, Walter Conrad Arensberg maintained in his apartment at 33 West 67th Street a kind of salon, which soon came to serve as the focal point of New York Dada, and which provided an ambience and encouraged directions in art different from those at 291.

Arensberg and Stieglitz themselves were different sorts. Stieglitz was a fervent crusader, a polemicist and a propagandist for modern art; Marcel Duchamp called him "a teacher . . . a force . . . [one who] helped American artists more than anyone else."[1] Arensberg, who had no gallery, was the affable host, quietly encouraging, content to remain rather in the background, to bring people together and let things happen on their own. Probably their varied backgrounds in part accounted for this. Stieglitz was a Jew from Hoboken, New Jersey; always in back of his mind there could have been the notion that he was among the dispossessed, and therefore needed to preserve and assert himself. He was educated to open himself to his surroundings—he would feel sympathy for the destitute.[2] In his most famous photograph, *The Steerage* (1907), the one of which he himself was proudest, he caught a group of people leaving New York on the same ship as he (not arriving, as is usually assumed), huddled together beneath the steamship's ladders and gangplanks. Before snapping the shutter of his Graflex, he remembered thinking: "It would be a picture based on related shapes and deepest human feeling."[3] Arensberg, who was thoroughly on the inside socially and intellectually, would never have reacted in that way.

Born in Pittsburgh in 1878, Arensberg received his A.B. degree from Har-

vard in 1900, and was Class Poet. Upon graduation he went to Italy, where began his long obsession with the *Divine Comedy*. In 1903–04 he returned to Harvard to do graduate work in English, and in 1907 married the musician Mary Louise Stevens. The couple lived for a year in Cambridge, Massachusetts, in Shady Hill, the old house of Charles Eliot Norton, and then settled in New York, where they began to collect art.[4] Stieglitz became a photographer of international significance, winning one hundred and fifty medals, but Arensberg had no pretensions of his own in the visual arts; beside his role as collector, patron, and host, he was an intellectual and writer, yet he never wrote about the artists he sponsored or collected nor did he ever organize exhibitions. He did write the only *Manifesto of American Dada,* which was published in Paris in May 1920.[5] Unlike Stieglitz, he was not an electric personality, and did not try to make converts to modernism through impassioned oratory. Stieglitz put up the works of others for sale through his galleries, though at times he was reluctant to sell to those he considered insensitive. Arensberg bought the works of others, and it is in his capacity as a collector that he is best known today through his collections housed in the Philadelphia Museum of Art.[6]

Drawing upon his background at Harvard and his trip to Italy, Arensberg was continually involved in various literary projects—and then increasingly with the writers themselves. When he first settled in New York, before his marriage and the purchase of Shady Hill, he did general and art reporting for the old *Evening Post.* Upon resettling in New York, he grew interested in poetry and poets: he became the friend of Wallace Stevens, the Sanborns, and others, and got involved with the *Rogue* magazine group in Greenwich Village. He studied the latest trends, Symbolism and Imagism, and translated from Baudelaire, Verlaine, Mallarmé, and Laforgue. He wrote his own sonnets and poems, publishing a small volume of poetry in 1914. He was instrumental in the founding, and later the funding, of the avant-garde periodical *Others,* which was started partially to publicize the work of unknown poets.[7] And all the while he was throwing big parties, bringing together writers and artists and possible patrons, whom he plied late into the night with an endless supply of liquor and food.

Beatrice Wood, an aspiring actress and artist from San Francisco, found that because of her visits to the Arensbergs, "life took on a different direction. . . . Drinks were served at midnight and Lou [Mrs. Arensberg] would also bring out trays laden with chocolate eclairs, for those who did not drink, like herself and myself." Walter Arensberg discussed with her her roles in the theater, and listened to her recite from Shakespeare. She recalled that he "loved to discover hidden meanings, and his interest in unraveling nuances made me want to rush from the theater in order to reach his study and work with him."[8]

The Arensberg salon was frequented by artists and writers from America and abroad, with various outlooks and various degrees of ability. Of the Europeans who came, there were the French artists Marcel Duchamp, Albert Gleizes,

and Francis Picabia; Jean Crotti, Duchamp's brother-in-law; the French composer Edgar Varèse, Beatrice Wood's boyfriend of the time; the French critic Henri-Pierre Roché; the French poet Henri-Martin Barzun; and the English poet and caricaturist Mina Loy. The various American literati and other figures included the poets Alfred Kreymborg, Amy Lowell, William Carlos Williams, and Allan Norton; Max Eastman, editor of *The Masses;* and Isadora Duncan. And of the early American modernist painters, there were Charles Demuth from Lancaster, Pennsylvania; John Covert, Arensberg's cousin; Arthur Dove and Marsden Hartley from the Stieglitz Group; Katherine Dreier, Man Ray, Morton Schamberg, Charles Sheeler, Stuart Davis, and the Italian-born Joseph Stella. There were also colorful hangers-on, such as the adventurer Arthur Cravan, who fought the boxing champion Jack Johnson in Barcelona,[9] then succeeded in getting himself arrested by stripping at the Independents' Exhibition of 1917; and Baroness Elsa von Freytag Loringhoven, who shaved her head and painted it purple, wore an inverted coal scuttle for a hat, and had a tempestuous affair with William Carlos Williams.[10]

Both Duchamp and Picabia arrived in New York in 1915, one year before the official founding of international Dadaism at the Café Voltaire in Zurich. As far as art was concerned, Duchamp immediately became the high priest of the Arensberg Circle. Through a pose of indifference, he exercised a cold, sug-

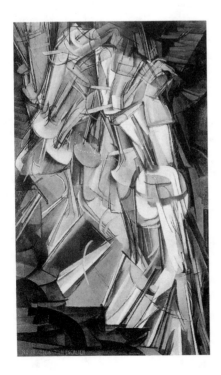

39. Marcel Duchamp, *Nude Descending a Staircase, No. 2,* 1912.

gestive charm. Picabia's wife, Gabrielle Buffet-Picabia, remembered him as "the hero of the artists and intellectuals, and of the young ladies who frequented these circles . . . extravagant as his gestures sometimes seemed, they were perfectly adequate to his experimental study of a personality disengaged from the normal contingencies of human life."[11] The impressionable Beatrice Wood found that Duchamp had "a penetrating gaze that saw all, forgave all."[12] Duchamp had left France largely because his fellow Cubists accorded his *Nude Descending a Staircase, No. 2* [39] an icy reception, but when the painting achieved a *succès de scandale* at the Armory Show, he attained an instant notoriety that helped him solidify his position within the circle. But he and Arensberg, who was content to remain the backstage impresario, were not competitors; they worked harmoniously together. When Duchamp arrived in New York, his gift for Arensberg was a glass ball full of Paris air—an appropriate gift, he conjectured, since Arensberg could afford everything else.[13] Arensberg, true to his generous nature toward those he regarded as kindred spirits, gave Duchamp the complete run of his apartment, then helped him set up his living quarters in the same building two floors above.[14] It was he two years later who furnished the bail money to rescue Cravan from jail.

Before Duchamp's arrival, Stieglitz had made gestures to supporting certain perverse tendencies in American art and aesthetics. In *Camera Work* he published essays of an iconoclastic character, prefigurements of Dada's nihilism, by the critic-poet Benjamin de Casseres and the Mexican caricaturist Marius De Zayas. In his 1911 essay entitled "The Unconscious in Art," de Casseres wrote that "The Intellect is bankrupt. It is only a park pond. The Mississippi and the Amazon flow through the heart. All ends are myths. Life itself explains life. Chance, danger and the irrational constitute the new Trinity."[15] And the following year, in "The Ironical in Art," he maintained: "there is a healthy mockery, a healthy anarchic spirit abroad. Some men are spitting on themselves and their work; and that is healthy too. . . . We should mock existence at each moment, mock ourselves, mock others, mock everything by the perpetual creation of fantastic and grotesque attitudes, gestures, and attributes."[16]

In 1913–15, as a caricaturist, Marius De Zayas made a number of portraits: of Stieglitz [40]; Picabia; Mrs. Eugene Meyer; Theodore Roosevelt; Katharine N. Rhoades [41], a painter of the Stieglitz Group. Each consisted not of the person's recognizable exterior but of groupings of curved lines, geometrical shapes, and mathematical formulae. De Zayas believed that these markings were the person's "geometrical equivalents," and that the inscribed lines represented the invisible forces that bound "the spirit and matter together."[17]

For his Stieglitz caricature, De Zayas went to an object he saw in a catalogue invented by an artist from Pukapuka or Danger Island in the Pacific. This was a wooden stick to which a few circles made of some vegetal material were attached. De Zayas thought the object wonderfully appropriate as a symbol for

40. Marius De Zayas, *Abstract Caricature of Stieglitz*, c. 1913.

41. Marius De Zayas, *Abstract Caricature of Katharine N. Rhoades*, c. 1914.

Stieglitz, as it was a trap for catching souls, and Stieglitz believed this to be his mission in the world.[18]

The caricature of Rhoades, like that of Stieglitz, is based on De Zayas's arcane method, which he set forth, Bohn notes, as follows: (1) The spirit of the individual is to be represented by algebraic formulas, (2) his material self by "geometrical equivalents," and (3) his initial force by "trajectories within the rectangle that encloses the plastic expression and represents life." Presumably the formula for Stieglitz was the most complex because he himself was a complex personality.

As a theoretician, De Zayas in 1912 proclaimed in "The Sun Has Set" that "art is dead": "Its present movements are not at all indications of vitality; they are the mechanical reflex action of a corpse subjected to a galvanic force."[19] Later, De Zayas modified his views to conclude that out of the ashes of traditional western art would arise new forms. The abstract trend of modern art, he insisted in the book he wrote with Paul B. Haviland, *African Negro Art: Its Influence on Modern Art*, would derive from the special way of seeing of the native African, who, "unable to represent the form seen by his eye . . . represents only the form suggested by his mental condition."[20] The abstract qualities of modern art are not unlike the art derived from the African's animistic impulses as, De Zayas would probably have insisted, were his own "Geometrical equivalents."

Even though Stieglitz published these iconoclastic essays, as well as Victor Méric's defense of the creative possibilities of Dada in *Camera Work* for June 1913,[21] the meaning of Dada and the significance of the art of Duchamp and Picabia and their American followers were apparently beyond his grasp. It remained to Arensberg to foster the Duchampian aspect of early American modernism.

Three separate historians—Dickran Tashjian, William Camfield, and William Homer—have tried to show that Picabia (as representative of the artists who turned to the Arensberg Circle) indicated a certain derision for Stieglitz because he was unappreciative of the Dadaist impulse. The key to their argument is one of Picabia's object portraits of 1915, in which various objects, mostly machines and machine parts, were used as symbols of some of the people connected with 291. The piece referred to is a portrait of Stieglitz himself [42], who in his role as a photographer is represented by a camera, beside which is the inscription "291" and the words: "Ici, C'est ici Stieglitz/Foi et Amour." Tashjian points out that the twisted bellows, falling to the side, parodies a limp phallus.[22] For Camfield, the camera is broken and exhausted;[23] and Homer has commented that the two vertical elements attached to the camera are the gearshift and brake lever of an automobile, set in the position for a parked car—a car with no power.[24]

But these scholars, while correct in their interpretation of the Picabia portrait, may be building up a derision for Stieglitz that never really existed. Dorothy Norman, admittedly a Stieglitz enthusiast, should be taken at her word when she reports that Stieglitz was delighted by Picabia's satirical sense of humor, and that Picabia in his turn was impressed with Stieglitz.[25] When the Picabia portrait of Stieglitz appeared, Paul Rosenfeld wrote: "At the side of the drawing stands the legend 'Ici, c'est ici Stieglitz—foi et amour.' A plastic epigram, if you will. But one that might well serve as the motto of a personality unique in America. Faith and love, love for art, faith in its divine power to reveal life, to spur action, to excite the creative impulse, those are the dominant characteristics of Alfred Stieglitz."[26]

There was no war between the Stieglitz and Arensberg circles. Duchamp and Stieglitz got on well. Stieglitz kept his *Richard Mutt*, the Readymade Urinal rejected by the Society of Independent Artists, at 291, where he photographed it. Still, with Duchamp's arrival and his warm acceptance of Arensberg, an entire segment of early American modernism passed under the auspices of Arensberg's patronage, to enjoy his hospitality and draw inspiration from the get-togethers in his apartment. Three of these American artists, to begin with, had had no contact with Stieglitz (Man Ray, Covert, Schamberg). Two others, Dove and Demuth, maintained their contact with Stieglitz; but then there was one side of their art that was rather lyrical (for Dove) and expressionistic (for Demuth), and another that was quite idiosyncratic for the time, a side fostered by Arensberg and inspired by Duchamp and Picabia—that of Demuth's Poster Portraits and

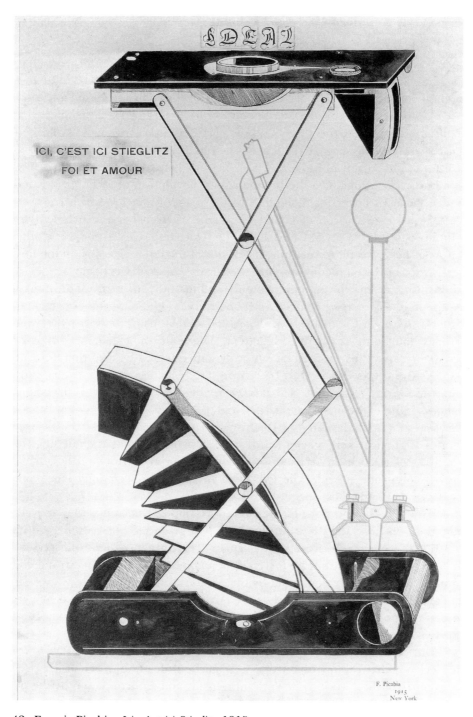

ICI, C'EST ICI STIEGLITZ

FOI ET AMOUR

42. Francis Picabia, *Ici, c'est ici Stieglitz*, 1915.

Dove's assemblages. Arensberg provided an atmosphere different from that of Stieglitz's 291, one that benefited the artists leaning toward the recondite, overly cerebral sort of works that are the ancestors of today's Conceptual art.

Arensberg composed Dada poems, wrote a sort of Dada manifesto, and financially supported the three Dada magazines appearing in New York: *The Blind Man* and *Rongwrong* of 1917, and *New York Dada* of 1921.[27] As the managing director of the Society of Independent Artists, he helped ensure that there would be a Dadaist contingent in the Independents' Exhibition of 1917.[28] No wonder that in Picabia's cover for Volume 8 of the magazine *291*,[29] which consists of a crossword construction of names, the name of Arensberg is included along with those of Picabia's wife Gabrielle Buffet, Duchamp, Crotti, and a few others. But Arensberg was more than the bankroller of the circle. He was on the inside totally, not only completely in concert with the aims of Duchamp and Picabia but inspiring others through his presence and the quixotic turns of his thinking. In his book *The Cryptography of Dante,* he found hidden words and messages through the use of acrostics: words spelled out by using only the first words of lines and lining up their first letters. The code indicated, he discovered, that Dante loved his mother incestuously and came to believe therefore that, like Christ, he was destined to be reborn.[30] The same use of acrostics can be found in Covert's painting *Will Intellect Sensation Emotion* (Yale University Art Gallery)—where the first letters spell out the word "Wise"[31]—as well as on the cover of a book designed by Duchamp.[32] Duchamp collaborated with Arensberg in 1916 in making a semi-Readymade, a ball of twine suspended between two brass plates, which Arensberg provided with a mysterious rattle Duchamp himself could not solve.[33] The two liked to exchange seemingly meaningless messages that had to be deciphered.[34]

The real guiding light of the circle was Marcel Duchamp, who arrived in New York on June 15, 1915. Although he had given up conventional painting in 1913, the objects he made, his calculated performances, and the myths he encouraged about himself, all fostered an ambience in which the arcane could flourish. The notoriety generated by the *Nude Descending a Staircase* [39] of 1912 (Philadephia Museum) exhibited at the Armory Show had preceded him, and he played upon this or at least did not discourage it until he became a central figure in the New York art world.

Duchamp for his part was immediately taken by the vitality of New York. He declared that the art of Europe was finished, dead, and that America was the country of the future. New York, in refusing to be encumbered by the past, in tearing down its old buildings, was to be commended.[35] It struck an interviewer that year of his arrival that Duchamp had "nothing but antipathy for the accepted sense of any of the terms of art."[36] His goal, as he saw it, was to get away from painting as a mark of skill, as pure visual delectation, and "to put painting once again at the service of the mind."

While associated with the Arensberg Circle, Duchamp introduced the notion of the Readymade—a piece of plumbing, a tool, or some other object that had been made by others but which the artist appropriated by choosing it, exhibiting it in a novel way, and affixing to it a clever title. He bought a snow shovel in 1915 and inscribed it: "In advance of the broken arm." Other Readymades were a bicycle wheel mounted in 1913 on the top of a kitchen stool and the bottlerack of 1914. The one that gained him the most notoriety was the porcelain Urinal, which he entitled *Fountain* (1917) and signed *R. Mutt* (Mutt was then the name a well-known New York plumbing firm). It was rejected by the directors of the exhibition of the New York Society of Independent Artists after he had been chosen as one of the artists allowed to submit. The second and final issue of *The Blind Man* was devoted to "the Richard Mutt Case." Duchamp argued that it didn't matter much whether he had made the *Fountain;* it was enough that he had thought of the idea.[37]

Duchamp's last conventional oil paintings date from 1912–13. Each of the three—*The King and Queen Traversed by Swift Nudes* (1912, Philadelphia Museum), *The Bride* (1912, Philadelphia Museum), and *The Passage of the Virgin to the Bride* (1912, Museum of Modern Art)—which predate his arrival in America, give the appearance of the interior of the human organism as some giant machine, with diagramatic renditions of various bodily systems made to appear simultaneously as manufactured tubes, valves, and ducts. Cast into doubt by these paintings was the conventionally held view of man (or woman) as a lofty creature, set apart by his free will from machines, the course and actions of which are predetermined. The issues of free will and determinism raised by these paintings and, by extension, the question of the individual artist's creative freedom and originality, continued to occupy Duchamp after he gave up painting.

Duchamp's *Network of Stoppages* (1914) was an exploration of the effects of chance: lengths of white thread used for invisible mending (*stoppage* in French) were dropped onto a canvas from a height of one meter, then fastened in place where they happened to fall, and preserved by fixing them with varnish. In 1918, for his friend Katherine Dreier, Duchamp took a long canvas and produced upon it in pencil cast shadows of a bicycle wheel, a corkscrew toward the center, and at the right a hatrack, Readymades that actually hung from the ceiling of his studio; an illusionistic tear held by real safety pins; various geometrical shapes, some making up a color chart; and a realistically painted hand executed by a sign painter. Called *Tu m'* (Yale University)—as a contraction, it has been believed, for "Tu m'ennuies" (You bore me)—the piece runs the gamut from shadows of an object to *trompe l'oeil* renditions of an object.

As a comment on the closeness between the masterpiece and the visual cliché, Duchamp in 1919 took a photograph of Leonardo's *Mona Lisa* to which he added in pencil a goatee and mustache and the caption L.H.O.O.Q. (phonetically, "Elle a chaud au cul") (private collection, Paris). Duchamp himself ex-

plained that the woman made to appear as a man went well with Leonardo's homosexuality. In 1920, seizing upon a less obvious aspect of the *Bicycle Wheel*—its ability to move—he set up with the aid of Man Ray a motorized construction of painted glass and metal, the *Rotary Glass Plate* (Yale University), the revolutions of which were now the raison d'être of the piece, a precursor of the kinetic sculpture of the 1960s.

The high point of Duchamp's creations was *The Bride Stripped Bare by Her Bachelors, Even* (the *Large Glass*), the iconography of which was worked out in Europe, but the construction of which was begun in America in 1915 and "incompleted" in 1923 (Philadelphia Museum). It consisted of two panes of glass joined together, to which were applied in wire and paint semblances of machines and machine parts, some done earlier as independent works, like the versions of the *Chocolate Grinder* in the Philadelphia Museum. In *Chocolate Grinder, No. 2* [43],

43. Marcel Duchamp, *Chocolate Grinder, No. 2*, 1914.

the machine is rendered mechanically, with thread sewn onto the canvas at the intersections of the lines of the rollers. The Chocolate Grinder appeared again in the lower pane of glass, along with clothespinlike elements designated by Duchamp as "the malic moulds," a system of tubes, a "water wheel," and so on. That lower half was designated as "The Bachelor Apparatus"; the upper half, containing a somewhat longer cylinder-looking form ("the Bride"), above which was a flattened mold ("the milky way"), and so on, was designated as "The Bride's Domain."

This work, appearing something like a very high transparent room divider, was explained by Duchamp in an elaborate set of notes[38] as being about a frustrated or uncompleted union between the Bride and the Bachelors. Mechanical functions are likened to human ones: for example, in the lower half, gas is cast in "the malic moulds" into the shapes of the nine Bachelors, then escapes through the capillary tubes, where it is frozen and converted into a semisolid fog; the capillary tubes, whose shapes derived from the *Three Standard Stoppages,* lead the spangles to the opening of the first sieve; sucked by the butterfly pump, the spangles pass through the seven sieves to condense into a liquid suspension, and so on. Union does not occur because the "love gasoline" secreted by the Bride is not ignited by the "electric sparks of the undressing," and thus cannot mix with the secretions of the Grinder, leaving the Bachelor to "grind his own chocolate."

After Duchamp's departure for Europe, the *Large Glass* was set up in Katherine Dreier's house in Connecticut. It was lent to the International Exhibition of Modern Art in Brooklyn in 1926. The upper half, or *Bride,* was shattered in transport in 1927. Nine years later Duchamp carefully glued the glass together again rather than reassembling the upper part with a new glass. In this way, with the cracks visible, a chance occurrence became a permanent feature of the work. Earlier, when the huge sheet of glass lay in his New York studio, Duchamp would eliminate the dust everywhere except at the "cones," where it was preserved by fixative.

As a complement to the arcaneness of his works, Duchamp created a female alter ego, Rrose Selavy, a play on the French phrase "Eros, C'est la vie." Appearing in woman's garb, he had himself photographed by Man Ray; and the cover of *New York Dada* (1921) beside its rows of "new york dada" sported a collage of a perfume bottle with a photograph of Duchamp in drag. In 1923, he issued a "Wanted/$2000 Reward" poster, on which were pasted frontal and profile photographs of himself in the style of a mug shot, with the caption: "Known also under the name RROSE SELAVY." Duchamp's prissy and eccentric friend Florine Stettheimer, in her *Portrait of Marcel Duchamp* (1923, Collection Virgil Thomson), showed the sitter twice, first seated in a comfortable chair, and second as a harlequin-like figure perched atop a seat attached to a giant spring.[39] The more conventional-appearing Duchamp in the armchair turns a crank, which

through the spring controls the motions of the harlequin-Duchamp. This might
be a reference to the two personae, but as neither figure is in drag, Stettheimer
probably meant to set forth two aspects of Duchamp's character: the cool, brilliant logician and the capricious, unpredictable Dadaist.

Duchamp's lifelong friend Francis Picabia (1879–1953), a wealthy playboy-artist
born in Paris of Cuban and French parents, also arrived in New York in June
1915. If not as innovative in as many directions as Duchamp, Picabia in his
second New York visit in 1915 developed a machinist style no less fascinating
than his colleague's.

Picabia first came to New York in 1913 to see the Armory Show. While
there he established friendships with Stieglitz and De Zayas at 291, and experienced the great industrial environment. The second trip in 1915 came about
through his conscription in the French Army: he had been sent to the Caribbean
to purchase sugar or molasses for the French forces, and when his ship docked
in New York, he stayed several months. For Picabia as for Duchamp the experience of New York in 1915 was electrifying, and it inspired Picabia's machinist
style, as he himself pointed out in a newspaper interview held in Duchamp's
apartment: "This visit to America . . . has brought about a complete revolution
in my methods of work. . . . Prior to leaving Europe I was engrossed in presenting psychological studies through the mediumship of forms which I created.
Almost immediately upon coming to America it flashed on me that the genius
of the modern world is in machinery and that through machinery art ought to
find a most vivid expression."[40]

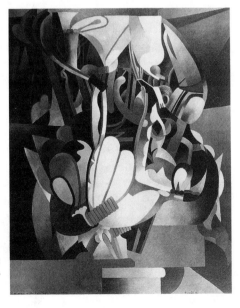

44. Francis Picabia, *Je revois en souvenir ma
 chère Udnie (I See Again in Memory My Dear
 Udnie)*, 1914.

In fact there was already a hint of machine fantasy in some of Picabia's paintings before 1915. In 1913, upon his return to Paris, he painted *Edtaonisl* (Art Institute of Chicago) and *Udnie* (Musée Nationale d'Art Moderne), and the following year, *Je revois en souvenir ma chère Udnie* (*I See Again in Memory My Dear Udnie*) [44] (Museum of Modern Art). The three paintings refer to the exotic dancer Mlle. Napierkowska, whom the Picabias met on the ship to New York in 1913. "Udnie" is a pet name for the dancer; "Edtaonisl" is an alternation of the letters "Étoil[e] and "dans[e]," or "star dancer."[41] In *Edtaonisl*, which shows no hint of machinist imagery, there is an intermeshing of flat angular and curved red, blue, yellow, gray, tan, and white forms. To the right of center seems to be the upper torso of a bending figure. The theme, which (according to Pearlstein) was verified by Gabrielle Buffet-Picabia,[42] had to do with a "clergyman of furtive glance" who kept eyeing the dancer; and the swirling rhythms of the painting were meant as the "rhythm of the dancer, the beating heart of the clergyman, the bridge of the packetboat . . . [and] the immensity of the ocean [as they] strike and entangle each other in metallic forms."[43] The erotic content in *Je revois en souvenir ma chère Udnie* [44] is more explicit, with cream-colored leaflike elements suggesting vulvas, and coilspring and sparkplug protuberances of a rubbery nature (a forecast of the machinist style to come) in purple, black, and rust colors suggesting phalluses.

The machinist style came to full blossoming in 1915, with Picabia's symbolic machine portraits of himself and various colleagues at 291. In each case the particular machine was chosen as a commentary of some sort on the "sitter," who was, of course, not represented in the flesh. Beside Stieglitz [42], symbolized by a camera, the machines were made to represent Paul Haviland, a connoisseur and associate editor of *Camera Work;* De Zayas; Picabia himself; and Agnes Meyer, wife of Eugene Meyer, editor of the *Washington Post* and a member of the Stieglitz Circle. Haviland, De Zayas, and Meyer were responsible for the founding and publishing in 1915 of the magazine *291,* begun as an offshoot of and reaction against *Camera Work;* and the machine portraits were the feature of the July–August issue of *291.*

In *Voilà Haviland* (Collection unknown), the sitter was represented by a portable unplugged upright electric lamp, appropriate for Haviland, according to Camfield, because he was preparing to leave for Europe and become a mobile "portable" light.[44] *Le Saint des saints* (Collection unknown), the picture of a Klaxon horn thrust into the cylinder of a gasoline engine, is a self-portrait, corroborated by the inscription: "C'est de moi qu'il s'agit dans ce portrait." The horn attests to Picabia's self-aggrandizement, his noisy personality; the engine to his enthusiasm for racing cars. A clear-cut interpretation of *De Zayas! De Zayas!* (Collection unknown) has so far not been offered. Most of that ink drawing consisted of the diagram of automobile electrical systems. To the left is a woman's corset; a line leads from the region of what would be the missing woman's heart to a

large sparkplug at the upper right, and another line from the region of the sexual organs to two automobile headlights with a female plug between them at the bottom of the drawing. Homer argues that the inscription at the bottom, which he believes is (but the source is actually Xenophon's *Anabasis*, Willard Bohn has shown) from Ovid's *Tristia*: "Je suis venu sur les rivages/du Pont-Euxin" (I have come to the shores/Of Pont-Euxin), and at the top: "J'ai vu/et c'est de toi qu'il s'agit" (I have seen/And it is you that this concerns), was meant as a greeting to De Zayas and an analogy was thus drawn between Picabia and Ovid. De Zayas had visited Picabia in Paris. Now, in his turn, Picabia was visiting De Zayas in New York. And as Ovid had been banished to Tomi on the Black Sea, Picabia had been set adrift in the New World by his mission for the French Army.[45]

Unlike Duchamp, whose machinist paintings and assemblages had to do with metaphysical states, most of Picabia's machinist works referred to specific people and events. Thus another of the machine portraits of 1915, the *Portrait d'une jeune fille américaine dans l'état de nudité* (*Portrait of a Young American Girl in the State of Nudity*) (Collection unknown) has been postulated by Homer as referring not just to any American female but specifically to Agnes Meyer. The image of the sparkplug and its identification with a young American girl or woman would have been especially appropriate as a symbol for Meyer, who energized the founding of the Modern Gallery with De Zayas, as well as the publication of *291*.[46]

De Zayas, Haviland, and Meyer, the younger associates of Stieglitz, by 1915 were regarding him as an older sage, while he in turn became somewhat passive as the publication of *Camera Work* was suspended and *291* emerged in its stead. Hence Picabia's depiction of Stieglitz as a camera that was worn out or tired [42]. Stieglitz himself remarked: "I was more or less an onlooker, a conscious one, wishing to see what they would do so far as policy was concerned if left to themselves."[47] Stieglitz had put in his time in the fight for modern art in America. But beyond the tiredness there was an obliqueness, even a certain cynicism on the part of these younger associates, most keenly expressed in their views toward the machine, that Stieglitz was not prepared to assimilate. His own views toward America's industrialism were positive and perhaps innocent. His photogravure of 1902, *The Hand of Man*, catches a locomotive steaming powerfully down the tracks: the aggressive machine is imbued with dignity.

Haviland, on the other hand, saw the machine in strange, anthropomorphic terms that would have mystified Stieglitz:

> Man made the machine in his own image. She has limbs which act; lungs which breathe; a heart which beats; a nervous system through which runs electricity. The phonograph is the record of his voice; the camera the image of his eye. The machine is his "daughter born without a mother." That is why he loves her. He has made the machine superior to himself. . . . Having made her superior to

himself, he endows the superior beings which he conceives in his poetry and in his plastique with the qualities of machines. After making the machine in his own image, he has made his human ideal machinomorphic.[48]

Just before making the machine portraits, Picabia produced the drawing *Fille née sans mère (Girl Born without a Mother)* [45] (1915, Philadelphia Museum). It may be considered as an illustration of Haviland's concept of the machine. Picabia's rough drawing is of a vague, indefinite machine that takes on organic properties; the upper part resembles a human foetus. Rods, springs, and dangled wires protrude in gangling disarray, as though the machine-creature, as the title proclaims, were giving birth to its own final life of hardness and clarity.

The novel and perverse art of Duchamp and Picabia, so foreign to the complacent, optimistic outlook of most American artists, fired the imagination of the artists who frequented the Arensberg salon. Their inspiration lived on when they were no longer present in America, throughout the 1920s. Picabia remained in New York in 1915 for only a few months before leaving for Panama. Man Ray recalled that remarkably he could not speak a word of English, and conversed only with Duchamp,[49] who must have acted as his translator. The following year Picabia settled in Barcelona and founded *391*, a magazine based on *291*.[50] He returned to New York in 1917, was in Lausanne in 1918, Zurich at the start of 1919, and Paris with Duchamp that July. Duchamp had come to Paris in July 1919 and returned to New York the following year, where he helped to found the Société Anonyme with Katherine Dreier and Man Ray. This, in effect, was America's first museum of modern art.[51]

45. Francis Picabia, *Fille née sans mère (Girl Born without a Mother)*, 1915.

THE AMERICAN PAINTERS OF THE ARENSBERG CIRCLE

After their Cubist paintings at the beginning of the second decade, Duchamp and Picabia became concerned not with the creation and maintenance of a given style but with the production in art of a number of abrupt sorties, each a tour de force and each shockingly original. This was quickly perceived by their American followers who, for the most part, followed their lead not by taking over features of specific works but by producing works in a broadly similar context, or even works that were quite dissimilar in appearance but were also conceptual in orientation. Duchamp's significance was best expressed by Charles Demuth (1883–1935) from Lancaster, Pennsylvania, in a poem he composed honoring the Urinal *Fountain,* the piece that became the scandal of the Independents' Exhibition. Appearing in *The Blind Man* in 1917, the prose-poem was entitled "For Richard Mutt" (the fictitious maker of the Urinal):

> One must say everything,—
> then no one will know.
> to know nothing is to say
> a great deal
> So many say that they say
> nothing,—but these never really send.
> For some there is no stopping.
> Most stop or never get a style.
> When they stop they make a convention.
> That is their end.
> For the going everything has an idea.
> The going run right along.
> The going just keep going.[52]

Later Demuth became completely taken by the *Large Glass,* and wrote Stieglitz on February 5, 1928, that it "is still the great picture of our time."[53]

By temperament drawn to the recondite and the sinister, Demuth was singularly geared to appreciate Duchamp's position once he encountered it. As a student at the Pennsylvania Academy of Fine Arts from 1905 to 1911, he was one of a group who struck the stance of sophisticated disenchantment. "We were all bored with life: knew everything there was to know," a fellow student recalled, "and only condescended to give our time and talents to painting because it seemed to our jaded spirits the one respectable calling left." As a student Demuth prized the fastidious, the precious, the rare. Marlene Dietrich, Proust, things of leather, and flowers met with his approval; children did not.[54] At the end of the first decade his favorite artist was the overly refined, usually erotic English Art Nouveau painter Aubrey Beardsley, after whom he turned out a number of *femmes fatales.* In 1911, when Demuth was thinking of becoming a writer, he wrote a play entitled *The Azure Adder,* in which characters put forth

all sorts of fin-de-siècle mouthings.[55] In the play there is interest in creating a magazine that will be known, too, as *The Azure Adder* and will be, says Alice, one of the characters, "something like *The Yellow Book*"—the English Art Nouveau and Symbolist magazine, of which Demuth owned copies.

Demuth loved Duchamp's obliqueness. He easily made the leap from Art Nouveau's symbolism to his. Duchamp's play on words, the clever connections between image and title, were taken up by Demuth and applied within the context of his own architectural landscapes. A cluster of factory chimneys Demuth called *End of the Parade, Coatesville* (1920, Collection the late Dr. William Carlos Williams) because that was the spot where the Coatesville parade wound up. Another cluster of factory chimneystacks behind billows of smoke he called *Incense of a New Church* (1921, Columbus Gallery of Fine Arts) to imply that industrialism in America was becoming a new religion. A picture of the Eshelman grain eleva-tors outside Lancaster is dubbed *My Egypt* (1927, Whitney Museum), establishing a double parallel between those structures of his day and the architecture of ancient Egypt: the totemic aspect of the grain elevators and, say, the Pyramids; the fact that ancient Egypt and the rich farmland about Lancaster became grana-ries for surrounding regions. A picture of a smokestack and watertower seemingly huddled together upon a factory roof he called *Aucassin and Nicolette* [46] (1921,

46. Charles Demuth, *Aucassin and Nicolette*, 1921.

Columbus Gallery of Fine Arts) after the medieval star-crossed lovers. Demuth's *Business* (1921, Art Institute of Chicago) could have been distantly inspired by Duchamp's wryness. In it, as a negative comment on American business tinged with a bit of humor, the regularity of factory windowpanes is made to resemble a calendar, suggesting that business is run through the monotonous repetition of time. The double image anticipates by a decade similar devices in the art of Dali.

Demuth's Poster Portraits of 1924 through 1929—so called for their poster-like format)—must owe something of their conception to the machinist portraits of Picabia. Picabia had used machines to allude to the characteristics and interests of his "sitters." Demuth wished to allude to a wider variety of objects, chosen to refer to the vocations, hobbies, or styles of "sitters" who were his friends and associates from the world of art and literature. These sitters included O'Keeffe, Marin, Dove, Charles Duncan, an obscure painter who had been exhibited by Stieglitz in May 1916, the poet William Carlos Williams, Gertrude Stein, and Eugene O'Neill.[56] The objects in the posters are like clues waiting to be deciphered, however much they appear at first glance like blown-up medieval or Renaissance emblems or insignias. Once the clues are deciphered, each painting uncannily suggests the presence of the "sitter." Demuth himself was apologetic about them but knew they had their validity, confiding to Stieglitz, "almost everyone has told me what a mistake I made showing them without explaining that they were made for my own amusement. I'll do three, or more, and show them all next winter. I'll make them look at them until they see that they are, so called, pictures."[57]

The Poster Portraits of O'Keeffe (1924, Yale University) and Williams (1928, Metropolitan), commonly called *I Saw the Figure Five in Gold,* are different not only in respect to their imagery but in the aura each presents. In the Williams poster, shrill reds predominate, and the space is filled to the bursting point as the three Fives seem to rush out at the spectator. In the O'Keeffe poster the fewer elements are grouped more purposefully, it seems, more hieratically. This is fitting. For Williams was a blustery, even over-exuberant man, while O'Keeffe was and is an earnest woman of powerful, quiet convictions. The Williams poster is a pictorial representation of the poet's description of a fire engine in his one-sentence poem "The Great Figure":

> Among the rain
> and lights
> I saw the figure 5 in gold
> on a red
> firetruck
> moving
> tense
> unheeded

to gong clangs
siren howls
and wheels rumbling
through the dark city.

The breaking of the surface into the ray-lines frequently seen in Demuth's archi-
tectural landscapes is effective in making the fire engine appear to be in motion;
while the blue-gray background, with its barest hint of buildings, conveys the
"dark city" of the poem. But the choice of this particular poem as a point of
departure, and the fire engine as the symbol for Williams, was wonderfully
appropriate. Williams was forward in his actions and, for his time, audacious
in his construction of poetry, and a fire engine is a raucous, wailing thing.
Further, Williams was a doctor as well as a poet, and a fire engine is an instrument
of salvation.[58]

In the O'Keeffe Poster Portrait [47], the letters spelling the sitter's name
have been rearranged to form a Latin cross. O'Keeffe's austere character must
have brought the idea of religiosity to Demuth's mind. Then there was her
name, Georgia, perhaps close enough for Demuth to St. George. Moreover, a
few years after the painting of her poster, O'Keeffe was to use (and perhaps
was then planning to use) the motif of the Latin cross in some of her own
paintings. The sliced fruit and the potted plant (a cactus, symbolizing her love
for the desert) call to mind her predilection for botanical subject matter, and
Demuth's undulating, pulsating way of showing these deliberatly simulates her
style.

The poster of Eugene O'Neill was entitled *Longhi on Broadway* (1927, Wil-
liam H. Lane Foundation), and shows a leafy vine bough inserted into a whiskey
bottle standing on pink, orange, and blue pamphlets and magazines, with a
red mask hanging from the neck of the bottle and a blue mask leaning on it.
The masks function as a triple entendre: they refer to the eighteenth-century
Italian painter Pietro Longhi, who painted masked dancers and other masked
figures of the Venetian aristocracy; as a pair they obviously represent the theater;
and, more specifically, they recall that from 1924 O'Neill used masked actors
in some of his plays, the most famous being *The Great God Brown*. The whiskey
bottle refers to O'Neill's addiction to drink, and the vine bough symbolizes
wine, as well, possibly, as Dionysos to whom the first theaters and performances
were consecrated in ancient Greece. Knowing O'Neill's cognizance of Greek
myths, Demuth might have intended this interfolding of meanings, with the
piece of fruit near the bottle upholding the Dionysos connection. The Gertrude
Stein poster (c. 1928) contains a centralized mask, which catches Stein's Buddha-
like look; the word "Love" repeated twice; and the numbers 1, 2, 3, which
have to do with Stein's propensity to say or write a phrase or word three times,
as "a rose is a rose is a rose." She was fascinated by threes, which appear
throughout her work in various ways.[59] Demuth's choice of "Love" may have

47. Charles Demuth, *Poster Portrait: Georgia O'Keeffe*, 1924.

had to do with their past relationship, when Gertrude Stein's Paris apartment at 27 rue de Fleurus served as a warm haven for expatriate and visiting American artists, Demuth among them in 1912. Stein took note of Demuth in her autobiography, recalling that when she knew him he was more interested in writing than in painting.[60] The Dove poster (1924, Yale University) is dominated by a sickle, an allusion to the fact that Dove for years had made most of his living as a farmer. The red ribbon looped about the sickle is the symbol of Dove's second wife, the painter Helen Torr, who was commonly called Reds. The undulating landscape in the background is meant as a simulation of Dove's own style.

The two most enigmatic posters are the Marin (1925, Yale University) and the Duncan (1925, Yale University). The former consists of a field of two stars and three stripes, probably denoting Marin's ultra-conservative political views; and Marin's name, placed upon the word "Play," which in turn overlaps an arrow. Possibly the arrow has meaning in terms of Marin's own painting having to do with valences, directions of forces, weights, and pressures. Force-lines suggestive of arrow shapes can be made out in more than half of Marin's paintings after 1910. Demuth simulated the painting styles of both Dove and O'Keeffe; through the arrow, he would be calling attention to an aspect of Marin's style. The word "Play" came up several times in Marin's writings in reference to those forces of which the arrow can be taken as a sign: in *Camera Work* of April–July 1913 he wrote that "feelings are aroused which give the desire to express the reaction of these 'pull forces,' those influences which play with one another. . . ."[61] For the Duncan poster, where there are plaques with a poster- or billboard-like appearance, no conclusive explanation has been offered. Possibly Demuth has provided a clue to Duncan's profession: to support himself as an artist he worked as a painter of big outdoor advertising signs.

Dove, a stalwart of the Stieglitz group, had a side that showed the impact made on him by the Arensberg milieu. Like Demuth he made composite portraits, but his were collages and assemblages (thus technically outside the province of this book). There are four portraits of particular people. Stieglitz was represented by a photographic plate, camera lens, steel wool, and coiled watch spring (1925, Museum of Modern Art). Dove might have been thinking of Picabia's portrayal of Stieglitz as a camera ten years earlier. Dove's *Grandmother* (1925, Museum of Modern Art), perhaps the most beautifully composed of his collages, consisted of juxtaposed rectangles of weatherbeaten shingles, cross-stitch embroidery, and a page from a Bible concordance upon which are pressed dried fern leaves, materials meant to suggest the grandmother's (his grandmother's?) fragility, love of homespun things, and piety. The *Critic* (1925, Collection unknown), meant as a representation of the extremely conservative art critic Royal Cortissoz, reveals Dove's humor. The body of the critic is made up of the newsprint of an art review; he is perched on roller skates, wears a top hat, and has

a pseudo-monocle hanging about his neck. The critic holds a paper vacuum cleaner to indicate that he blows dirt all about.

The *Portrait of Ralph Dusenberry* [48] (1924, Metropolitan) is made of oil on canvas with attached wood and paper. Dusenberry, a handyman by trade, was portrayed by Dove by some strokes of paint and a painted bit of flag, wooden shingles, a song sheet, and a carpenter's rule used as a frame. Dove spent much of the twenties living on the yawl *Mona* during the warm weather and in old houses near Huntington Harbor and other places about Long Island during the winter. He paid close attention to Dusenberry, whose skills were essential to his own well-being. Dove's verbal description of the handyman contains the "keys" to the assemblage:

> Apropos of the hymn in the "Ralph Dusenberry," the Dusenberrys lived on a boat near us in Lloyd's Harbor. He could dive like a Kingfish and swim like a fish. Was a sort of foreman on the Marshall Field Place. His father was a minister. He and his brother were architects in Port Washington. He drove in to Huntington in a sleigh one winter and stayed so long in a café there they had to bring a wagon to take him home. He came home to his boat one day with two bottles, making his wife so mad that she threw them overboard. He dived in right after them and came up with one in each hand. When tight he always sang "Shall we gather at the river."[62]

The carpenter's rule alludes to Dusenberry's carpentering ability; the shingles, shaped like a kind of fish, to his swimming ability. The music sheet is of the song he would sing when drunk. The flag, looking like a piece of ensign's banner, is supposed to have had to do with Dusenberry's patriotism. The next year Demuth was to use a field of stars and stripes in his Marin poster.

Two close friends from Philadelphia, Morton Schamberg (1881–1918) and Charles Sheeler (1883–1965), occasionally visited the Arensberg apartment. Their impact can be detected in a few pieces.

They were classmates at the Pennsylvania Academy of the Fine Arts, where they studied under William Merritt Chase. After a trip to Paris in 1906, they shared an apartment and studio at 1606 Chestnut Street, Philadelphia In 1908–09 they traveled to London, Paris, and Italy, when they came to admire Cézanne and the Impressionists. From 1910 the two friends shared a Revolutionary farmhouse near Doylestown in Bucks County. Sheeler, especially, admired the clean lines and simple shapes of Bucks County barns, and they became subjects of his paintings. In 1912, to augment their income, they turned to collaborating on commercial photography; by 1917, when they were visiting the Arensbergs, they were finding photography an expressive end in itself.[63]

By 1916 Schamberg was painting diagrammatic machine parts, the first American to do so. He may have been moved to do this, after working in a nonobjective Synchromist style, when he became aware of Picabia's machinist

48. Arthur G. Dove, *Portrait of Ralph Dusenberry,* 1924.

paintings. Both the format and the ordering of parts in Schamberg's machine abstractions were derived from illustrations found in catalogues, just as Picabia's had been. One of 1916 (*Untitled*, Collection Mrs. Jean L. Whitehill, New York) was based on a stocking machine reproduced in a catalogue borrowed from his brother-in-law, a manufacturer of ladies' hosiery, who said upon seeing the painting that "the goddamn thing wouldn't work."[64]

Schamberg's *Still Life with Camera Flashlight* (1916, Philadelphia Museum) is presumably one of his first machine paintings, as the handling is loose and the machine parts not clearly defined. When his vision of the machine coalesced, his handling tightened considerably. Generally he seemed unaware of the mechanical implications of sexuality, the suggestions of animistic states, the passages from one condition to another, that occupied Duchamp and Picabia in their depictions of the machine. For Schamberg, the machine represented something hermetic, icily remote, utterly cut off from human intervention or use. This was so whether he showed the machine as diagrammatic and abstract (*Mechanical Abstraction* [49], 1916, Philadelphia Museum; *Machine*, 1916, Yale University), or as a clearly recognizable implement (*Telephone*, 1916, Columbus Gallery of Fine Arts). One exception was *The Well* [50] (1916), Collection unknown), a depiction of part of a machine something like the human phallus consisting of a large rod or piston descending into, or emerging from, a dark hole or well.

In 1917 or 1918 Schamberg set a plumbing trap upside down in a mitre box and called the assemblage *God* [51] (Philadelphia Museum). He was assisted in the construction by Baroness Elsa von Freytag Loringhoven, who used to shock people by her eccentric behavior and appearance. He might have gotten the idea for the irreverent title from Haviland's set of equations:

> God-creation of man in man's image
> Machine-creation of man in man's image
> God-Machine

The inspiration for the assemblage must have been Duchamp's Urinal *Fountain*. *God* lacks the Urinal's totemistic qualities, as well as its irony. Like Duchamp, Schamberg played on the connection between the piece and the title. We can but speculate whether he would have produced a number of Readymades. Schamberg died in Philadelphia's influenza epidemic of 1918, and was buried on his thirty-seventh birthday.

Charles Sheeler, the Precisionist par excellence, laconic in his manner of speaking, remarkably straightforward, would have seemed the least likely artist to have been touched by the Arensberg spirit. The direction of his work was not determined by his contacts with the New York Dada group. Still, the cleverness of his *Self-Portrait* [52] (1923, Museum of Modern Art), however alien to most of his style, is an authentic part of his *oeuvre*. The oblique connection between image and title played on the ramifications of the telephone, which

49. Morton L. Schamberg, *Mechanical Abstraction,* 1916.

50. Morton L. Schamberg, *The Well,* 1916.

51. Morton L. Schamberg, *God,* c. 1918.

52. Charles Sheeler, *Self-Portrait*, 1923.

in the early 1920s was gaining currency among the American public. Sheeler showed a shadowy reflection of an upper torso, presumably his own, cut off at the chin in the background; in the foreground, sharply delineated, stands a telephone. The telephone becomes the artist because it projects his voice. Sheeler gave the instrument and the torso certain structural connections and similarities. Susan Yeh has observed that the mouthpiece seems like a head, and thus completes the missing part of the man.[65] The telephone stands something as a man would, complementing the vertically oriented shadowy torso. The idea of a machine like a man could have derived from Picabia's machinist portraits. It was not any telephone but Sheeler's own at the time the painting was done, with the number "Audobon 4514," as inscribed on the plate.[66] William C. Agee has found that the tubular-like aspects of Sheeler's *Flower Forms* (1917, Collection Mrs. Earle Horter) refer to passages of Picabia's *Udnie* of 1913,[67] but in this he is grasping for straws. The feeling in the two paintings is wholly different, with an accidental repetition in a couple of shapes.

The influence of the Arensberg spirit on Stuart Davis was also sporadic, but the flavor is discernible. It is there in the top of the *Salt Shaker* (1931, Museum of Modern Art), which is made to look like a face. Following the playful attitude that was part of the Arensberg heritage, Davis in 1921 made a funny

human figure out of bits of paper with some watercolor applications, and entitled it by the seemingly nonsensically word *Itlksez* (Lane Foundation, Leominster, Mass.), actually an acronym for "It looks easy." Jazz was a principal interest of Davis's; the figure is a black musician. Other of Davis's collages must have perished, for he recalled in 1960 that he could "sew buttons and glue excelsior on canvas without any sense of guilt."[68] There is no specific source in Duchamp and Picabia for *Itlksez*, although they both provided Davis with a sense of fun and a willingness to experiment. Tashjian mentions as a direct source Picabia's collage *Midi*,[69] a scene of a tropical beach made of ripolin, feathers, macaroni, and leather on canvas; but that piece actually postdates Davis's.

Davis acknowledged Duchamp's inspiration (not certain pieces as direct influences) on a series of paintings of 1927–28, in which he produced variations combining three thematically unrelated motifs—an eggbeater, an electric fan, and a rubber glove (Phillips Collection, Whitney, Lane Foundation): "Duchamp's suggestion worked slowly. Unesthetic material, absurd material, non-arty material—ten years later I could take a worthless eggbeater, and the change to a new association would inspire me."[70] It was Duchamp's Dadaism but purged of its threatening overtones, of its European nihilism: from these unrelated motifs Davis found geometrical coherence. Davis and Duchamp reversed ends and means, with Duchamp beginning with the logical and coherent and arriving at something completely opposite.

Joseph Stella (1877–1946), who was born in Italy and emigrated to New York when he was nineteen, was the only early American modernist to come directly under the sway of Italian Futurism, of which he saw examples on a return trip to Europe in a large group exhibition of February 1912 at the Bernheim-Jeune Gallery in Paris. Like Weber, Marin, and Walkowitz, he was taken with what he saw as the Futuristic aspects of New York City. Back in America in 1913, he painted the *Battle of Lights, Coney Island* (Yale University), in which through the overlayerings and overcrowding of detail, and the choice of garish greens, reds, and violets, he suggested the raucous hedonism of the seaside resort in high season. The conception may have been based on Stella's recollection of the Italian Futurist Severini's *Dynamic Hieroglyphic of the Bal Tabarin*,[71] which he had seen in Paris. Common to both paintings is the theme of a crowd at a place of pleasure, the discordant crowding of forms, the circular composition, and the incorporation of lettering.

In his use of what Davis would have called "non-arty material," Stella revealed a side that was decidedly anti-art in its coloration, the side that manifested itself after his friendship with Duchamp and contact with the Arensberg Circle. This was a series of collages made from about 1920 to about 1930, and taken up later through the 1930s, consisting of one or two scraps of seemingly discarded paper, small wrappers, or other debris (*Collage, No. 21* [53],

53. Joseph Stella, *Collage, No. 21,*
c. 1920.

Whitney Museum; Andrew Crispo Gallery, New York, formerly Schoelkopf Gallery; Museum of Art, Carnegie Institute). As though to further dispell notions of "fine art," Stella in some of these slashed the collage with brushstrokes of reds, blacks, and blues. Sometimes he kept the commercial label intact ("Chicklets," "Luden's"), bridging the worlds of commercialism and art. Thus Stella, who showed in his *New York Interpreted* polyptich of 1920–22 (Newark Museum), for instance, that he was attracted to the grandiose, mechanized aspects of the city, was drawn also to its anonymous, unnoticed discards. This is what these collages are about—the detritus of human existence, the kinds of materials he must have noticed all about him when he was living on the Bowery from 1900 to 1905.

These pieces are related to, but were probably begun before, Kurt Schwitters's *Merzbilden* were exhibited at the Société Anonyme in 1920, collages far more densely packed and richly textured than those of Stella, and incorporating bits of wood and metal as well as paper. Stella's collages anticipate *l'art brut* of Dubuffet and Oldenburg's early graffiti-based work. Mounted like a kind of emblem on the field of white, these scraps take on an entirely new meaning since they read now as an irregular, nonobjective form silhouetted on that field. Some of the collages seem to refer to an inner realm of experience. Like inkblots

or, in Leonardo's famous example, stains upon a wall, the irregular shape with its eroded, mottled surface leads the mind to conjure all sorts of looming, suggestive images. In some of these collages, so different from Stella's other work, the shapes of the scraps are even made to resemble human profiles.

Katherine Sophie Dreier (1877–1952), a heavy, forceful woman devoted to causes,[72] who studied art first at the Pratt Institute and then in England and on the Continent in 1911–12, when she met Van Gogh's sister and became a champion of and writer on Van Gogh, was introduced to the Arensberg Circle by Marcel Duchamp in 1917. She and Duchamp, ten years her junior, were to maintain a friendship for thirty-five years, until her death in 1952. It was in her library that Duchamp's last painting, *Tu m'* of 1918, was installed, as well as the *Large Glass,* which she purchased from the Arensbergs. She believed that acceptance of modern art could help bring about a better society, that Dadaism was "prepar [ing] the ground for future development," that "at bottom they [the Dadaists] are constructive,"[73] and that the presence of Duchamp was absolutely essential if a more spiritual art was to take root in America.[74]

Dreier is best remembered as a polemicist and an organizer in the growth of early modernism in America. She had a central role in the formation of the Society of Independent Artists, and then ran the Société Anonyme, raising money, staging shows, giving lectures, finding the artists.[75] With the birth of the Museum of Modern Art in 1929, the purpose of that organization had been fulfilled. Dreier retired to her house in West Redding, Connecticut, where she catalogued the Société's collection, preparing it for Yale University (to which she donated the 616 items), and sponsored exhibitions and causes to promote modern art.[76]

But she painted a number of nonobjective paintings from 1918, including some portraits of her friends, such as the *Abstract Portrait of Marcel Duchamp* [54] (1918, Museum of Modern Art), derived from the *Improvisations* of Kandinsky, whom she came to admire above all other artists. She became a follower of the Aso-Neith Cryptogram School of Universal Vibrations, which held that there were hidden meanings in colors and shapes;[77] and so, in writing of Duchamp's portrait in her *Western Art and the New Era,* she claimed that she was revealing his personal characteristics:

> Instead of painting the sitter as seen ordinarily in life, the modern artist tries to express the character as represented through abstract form and color. Thus through the balance of curves, angles and spaces, through broken or straight lines, or harmoniously flowing ones, through color harmony or discord, through vibrant or subdued tones, cold or warm, there arises a representation of the character which suggests clearly the person in question and brings more pleasure to those who understand than would an ordinary portrait representing only the figure and face.[78]

54. Katherine S. Dreier, *Abstract Portrait of Marcel Duchamp,* 1918.

Only two American painters of the Arensberg Circle became thoroughly involved with a conceptual approach to their art throughout all or most of their careers, rather than with a few works or groups of works, as in the case of Dove's assemblages and Demuth's Poster Portraits.

One of these, who studied Duchamp's art quite closely as a basis for his own, was Arensberg's own cousin from Pittsburgh. John Covert (1882–1960) had worked academically, first in Pittsburgh, then in Europe, from 1908 in Munich and in Paris in 1912, where (he later recalled) he didn't see a modern show or even meet the Steins. "It's incredible," he said. "I must have lived in armor."[79] Back in America in 1915, when he was staying with the Arensbergs in Connecticut, he underwent a dramatic conversion at the age of thirty-three, the suddenness of which might suggest something of the abrupt impact his art provokes. Perhaps this event had to do with his rebellion against the academicism he had favored in Europe. As he recalled it, "suddenly with the same trees and hills around I couldn't find a subject. . . . The sun was blazing down from overhead so that each tree floated in its own shadow. Everything was trembling; it was like looking through a molten glass; I was trembling too. I was painting without knowing it: the trees were like gallows and the shadows, the hills, were triangles. I was sopping wet with perspiration when I carted it home. Tried to hide it—God knows I didn't know what I had. . . ."[80]

Probably shortly after this experience, Covert drew more closely within the Arensberg Circle. Now in contact with Duchamp and Picabia, like them he came to see his art not as a working through of a style or approach, however radical, but as a series of detached experiments, each fresh and inviolate in its way, each a kind of sortie. To do this, Covert realized, meant using Duchamp or Picabia as a point of departure, but never patterning himself after Duchamp's own concepts, and, above all, never fashioning a Duchamp style. Meanwhile, Covert took an interest in his cousin's literary projects as well, helping Walter with his cryptography of capital letters in the book he was developing on Dante.[81]

Signaling the change in Covert's art was his *Leda and the Swan* (c. 1915,

Seattle Art Museum), where the form on the right can be read in two ways, as Leda's arm and hand or as the swan into which Zeus changed himself in order to seduce Leda. Some of Covert's paintings work solely on the level of visual puns, such as the *Hydro Cell* of 1918 (Philadelphia Museum), which is simply a picture of apples. The title also reveals Covert's interest in machines, which did not, as they did for Duchamp, provide him with metaphors for erotic functions. At this time Duchamp, as is well known, liked to form quite oblique linkages between the title and the image; Covert's title, *Hydro Cell*, is linked to a more literal image. In Covert's *Water Babies* [55] of 1919 (Seattle Art Museum), the title makes the observer aware of the possible similarity (interchangeability?) between human babies and the dolls represented in the painting. At first glance the dolls seem cuddly and inviting but, on further observation, become frighteningly more than mere dolls. The joinings and articulations of their joints have been emphasized to take on the appearance of hinges, and the feet and arms look like levers. They come to strike us as machine-like things. The play on

55. John R. Covert, *Water Babies,* 1919.

56. John R. Covert, *The Temptation of St. Anthony No. 2*, 1919.

57. John R. Covert, *The Attorney*, before 1923.

their identities goes further, for one doll, half-immersed in water and seen through glass, is distorted into something monstrously gargantuan.

Covert gave the title *The Temptation of St. Anthony No. 2* [56], to a nearly monochromatic, apparently nonobjective painting of 1919 (Seattle Art Museum) that is composed of overlapping slablike elements, which were probably derived from the intersecting planes of Duchamp's *Nude Descending a Staircase*. This title has been taken as an irrelevant or irreverant Dadaist designation,[82] and perhaps it was meant as such. Then again, the sharp contrast of light and dark and the dramatic wedge-shaped thrust moving from lower right to the center may have symbolized for Covert the dramatic confrontation of good and evil in the life of the saint. St. Anthony was sexually tempted; keeping this in mind, Klein has gone so far as to find in the lower portion a woman's legs and a triangle of pubic hair, or the source of the temptation. The idea for the schematization could have been derived from Duchamp's *Bride* of 1912, where female organs and machine parts became inextricably combined.[83] Another oil, *The Attorney*

[57], done shortly before Covert finally gave up art in 1923 (Seattle Art Museum), is a picture of a small man with torso formally dressed but nude from the waist down, set amid flower and leaflike elements suggesting sexual organs. The rubbery forms recall Picabia's *Je revois en souvenir ma chère Udnie.*

Covert was the first early modernist to make works out of "non-arty materials" (in Davis's phrase), anticipating Stella, Dove, and Davis himself in this. Stella used paper. Covert's materials were more varied and unusual, for he made compositions out of cords, wooden dowels, and upholstery tacks attached to composition boards dabbed and marked with oil paint. The groupings are tighter than in Dove's assemblages and lack the high relief Dove sometimes used, as in his *Goin' Fishin'* (1925, Phillips Collection), which is made of bamboo poles, denim shirtsleeves, and bark on painted metal.

58. John R. Covert, *Brass Band,* 1919.

Through these works Covert cleverly translated abstruse concepts, such as the human production of sound, into a visual synthesis. In his *Vocalization* (1919, Yale University), the wooden dowels become shorter and shorter in length toward the top of the composition board, suggesting a voice rising to higher and higher pitch. The regularity of the shapes and the distances between the dowels and the painted tubular forms bring to mind things of the mechanical world—metal steps of steamship ladders, pipes, and so forth. A human process is "diagrammed" through the evocation of the world of machines. This approach is different from Duchamp's. In the *Large Glass,* Duchamp mechanized human emotions and sexuality, whereas Covert has mechanized a more specific process, the production of sound by the human voice, which possesses a quasi-mechanical character to start with.

In Covert's *Brass Band* [58] of 1919 (Yale University), the patterning of light and dark produced by the alternation of the sections of string and paint was derived from Duchamp's *Coffee Grinder,* where string was also applied. Here Covert wanted to convey the idea of the blaring movement of sound—more exactly, the sound of horns. In the rounded forms and pointed ones made of the parallel runs of string, he has caught something of the trombones' thrust. The semicircular forms recall, even more specifically, the shapes of the rounded ends of trumpets and trombones. Francis Naumann, well aware of Covert's liking for visual puns and the most recondite of associations, believes that the *Brass Band* has nothing to do with music-making. Rather, Covert wished to point out that he was using string or cords and paint in such a way as to resemble brass bands.[84] But Naumann's interpretation, however provocative, is threatened by the singular of the title. If Covert's intention was as he claims, he would presumably have called the work *Brass Bands.*

Covert's *Time* [59] (1919, Yale University) is made up of rows of tacks inserted in composition board on which lines, arcs, shadings, and numbers have been inscribed with oil paint. Again, several interpretations are possible. The long, meandering, and apparently directionless rows of tacks bring to mind the tedium, the time expended in bringing a plan to fruition. Michael Klein, on the other hand, paying close attention to the markings and shadings, believes that Covert was alluding to a time that is cosmic in scope. He has pointed out the letters AM and PM, the navigational markings N-E-W, and proposed that the darkening of the composition to the sides could suggest the oncoming of day and night produced by the earth's rotation. The letters x and c/t, underlined with three strokes, point to Einstein's theory of relativity reported in England in November 1919, with the c signifying the velocity of light, the t time, and the x an unknown quantity.[85]

Duchamp wrote in 1963 that he and Covert had been close friends from 1915 to 1918. Earlier he had noted that "among the young American painters who, in 1915, joined forces with the pioneers of the new art movements, John

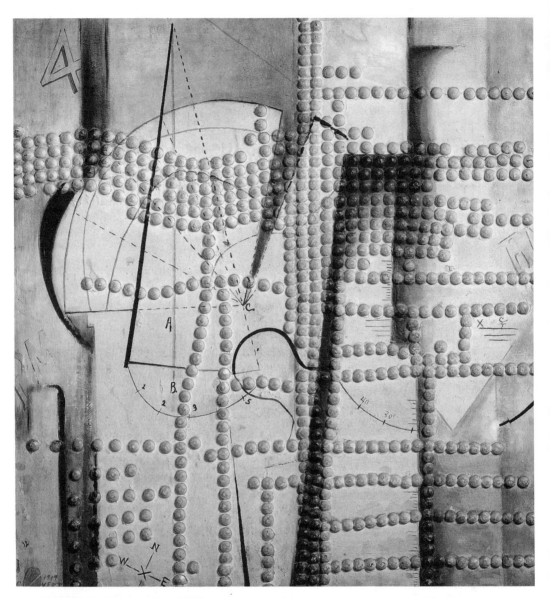

59. John R. Covert, *Time*, 1919.

Covert was an outstanding figure from the beginning.''[86] But Covert was without money and enjoyed little general appreciation. His conceptual sort of art would have been far harder to take in the second decade than, say, Marin's, which could be appreciated as pleasing design. And so, tragically, in 1923 he gave up art to begin his long career in the steel industry by becoming a salesman for the Vesuvius Crucible Company, the Arensberg family business near Pittsburg. He kept up his interest in codes and the recondite by cryptographic notebooks filled with calendars of minute symbolic compartments recording everyday events in his life.

The Philadelphian Emmanuel Radenski (1890–1977), who took the name Man Ray, was very close to Duchamp and became involved in a number of conceptual approaches from 1916 through to the end of his life. He had moved to New York in 1908, taking a job as an architectural draftsman, where he became acquainted with techniques in the world of commercial art he would later adapt to his own ends. He painted in Cubist and Expressionist styles until shortly after he met Arensberg and Duchamp in the summer of 1915 at the small artists' community outside Ridgefield, New Jersey, where he was then living. (In 1914 he had been getting ready to go to France but was stopped by the outbreak of war.)[87] But even before that meeting he was using Cubism in a thoroughly individual fashion, as in the *Village* (1913, Collection Vera and Arturo Schwarz, Milan), with its schematically rectangular buildings bizarrely colored in reds, blues, pinks, and browns. His *MCMXIV* [60] (1914, Philadelphia Museum) con-

60. Man Ray, *MCMXIV*, 1914.

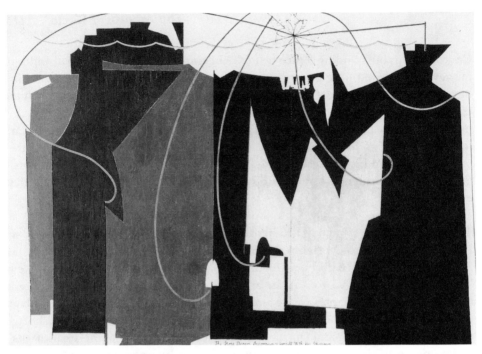

61. Man Ray, *The Rope Dancer Accompanies Herself with Her Shadows*, 1916.

sists of tubular figures and horses, which look as though they had been molded out of dough. The French Cubists used letters and numbers as part of their compositions; Ray in a painting of 1914 entitled *Man Ray 1914* (Private collection) used the letters and numbers of the year as the total image, the raison d'être of the work. Ray's signature became the painting, rather as Jasper Johns's flags would become the painting half a century later—or the painting become a flag. And, as with Johns, the originality of the concept carried the force of the work. While at Ridgefield, Ray handprinted a news sheet of four pages, *The Ridgefield Gazook*, revealing the offbeat humor that would serve him later as a dedicated Dadaist.[88]

Man Ray's flirtation with Cubist painting continued to 1916, with the more than six-foot-long oil *The Rope Dancer Accompanies Herself with Her Shadows* [Pl. III, 61] (Museum of Modern Art). The painting may be considered a pseudo-collage, the large brightly colored flat areas of red, green, yellow, and black describing broad, tentlike flap shapes looking as though they had been fashioned out of crepe paper, over which the dancer gingerly moves. A year earlier in his *Dance* (Collection William Copley, New York) Ray began with pseudo-collage on a far smaller scale. But in his preparations for the *Rope Dancer*, as he relates in his autobiography, he actually had worked first with paper. The subject was inspired by a rope dancer he had seen in a vaudeville show. He made sketches of the dancer's positions on sheets of spectrum-colored paper, cut these out and arranged them in sequences, then focused his attention on the negative

discarded areas of the paper, which became the large color areas of the canvas.[89] The idea for the representation of the dancer's movement, still preserved in the upper part of the painting, was probably derived from Duchamp's *Nude Descending a Staircase*. At this time Ray was working with actual collage in his *Revolving Doors* series, with their layers of overlapping areas (*Revolving Doors* V, 1916, Collection Vera and Arturo Schwarz, Milan). "It looked," Ray said to Arturo Schwarz, speaking of the first of the series, "as if it would make a nice curtain for a theater, for a musical comedy or something."[90]

In 1917, following Duchamp's desire to free himself from the direct manipulation of the paint, Ray developed the technique of painting with an airbrush like a commerical artist. He recounts in his autobiography:

> I was planning something entirely new, had no need of an easel, brushes and the other paraphernalia of the traditional painter. The inspiration came from my office, where I had installed an airbrush outfit with airpump and instruments to speed up some of the work which involved the laying down of large areas of color. . . . It was a process commonly used in commercial work. I became quite adept in the use of the airbrush and wondered if I could use it for my personal painting. . . . Finally, I installed a rented compressed air tank in my attic, bringing home the spray guns to work with. . . . I worked in gouache on tinted and white cardboards—the results were astonishing—they had a photographic quality, although the subjects were anything but figurative. Or rather, I'd start with a definite subject, something I had seen—nudes, an interior, a ballet with Spanish dancers, or even some odd miscellaneous objects lying about which I used as stencils, but the result was always a more abstract pattern. It was thrilling to paint a picture, hardly touching the surface—a purely cerebral act, as it were.[91]

The image in the aerographs was obtained usually by outlining with stencils and templates. A variety of strange effects was produced through the softly graded monochromes. *Hermaphrodite* (1919, Private collection, London) is a picture of a vaguely defined body, bent over backward, cut off at the knees, probably based on a dancer Ray had seen. There is both delicacy and a sense of the primordial—a reminiscence, despite the difference in the medium, of prehistoric Paleolithic figurines. Another, untitled work (1919, Cordier & Ekstrom, Inc., New York), ovular in format, has ridged, curved, angular forms crowded toward the center and interpenetrating, as in the Analytical Cubist paintings of 1910–12. The *Impossibility*, or *Danger-Dancer* (1920, formerly Collection Mme André Breton, Paris), executed with airbrush and oil applied to glass, reveals the influence of the machinist paintings and drawings of Picabia. Seemingly hanging on one of the gears and pinwheels is the word "dancer" printed so that it could alternatively be read as "danger."

Ray was the first American to make a Dadaist assemblage. In 1916, at his second show at the Daniel Gallery, he exhibited as his *Self-Portrait* (Galérie Georges Visat, Paris) two electric bells and a real pushbutton on a black back-

62. Man Ray, *Indestructible Object*, 1964, replica of *Object to be Destroyed* (1923), destroyed in 1957.

ground, with his palm print as signature. Following the lead of Duchamp, he used already assembled and readymade objects. In 1920 he "made" his *Enigma of Isadore Ducasse* (no longer extant) by wrapping a sewing machine in an army blanket and tying it up to produce the premonitions of an anthropomorphic form. The *Enigma* was meant as homage to the proto-Surrealist poet Lautréamont (Isadore Ducasse), who in *Les chants des Maldoror* (published in 1874) used the image "beautiful as the chance meeting of a sewing-machine and an umbrella on a dissecting table."[92] The piece anticipated the recent wrappings (on a far larger scale) of Christo.

In 1918, Ray entitled an eggbeater *Man*, probably a reference to the potential vertical stance of the object (photo: Schwarz Collection, Milan). Some of Ray's objects had an aggressive aspect to them. His *Gift* of 1921 (original lost; replica in Collection Mr. and Mrs. Morton G. Neumann, Chicago) was a hand flatiron with dangerously poised nails attached at the bottom. *Object to be Destroyed* (1923, destroyed in 1957; replica [62], *Indestructible Object*, 1964, Museum of Modern Art) was a metronome with the paper image of an eye attached to the pendulum, which, when swinging, would have a maddening effect on the spectator.

Ray's exploitations of chance and nonsense were further realized through the Rayograph process in photography, which he invented shortly after moving to Paris in 1921, concurrently with but independently of the Hungarian László Moholy-Nagy. The process suggested itself when an unexpected sheet of photography paper accidentally got into the developer, and Ray, regretting the waste of paper, idly placed various objects on that wet sheet, such as a thermometer, then took "whatever objects came to hand; my hotel-room key, a handkerchief, some pencils, a brush, a candle, a piece of twine. . . ."[93] He found that the objects protected the sensitized surface; white silhouettes and soft shadows resulted, or a photograph that had the look of a painting. Wonderful effects were achieved through these cameraless photographs. One made in 1925, which Ray called *Sugar Loaves,* takes on the look of a lunar or underwater landscape. In another of 1924, *Ribbons,* a twisted piece of paper becomes transformed on the photography paper into a mysterious sprialing form. A Rayograph of 1927 (Museum of Modern Art) exploits the contrast between curved, flapping forms and floating, rectangular ones. Ray also discovered the "solarization" process, in which the naked film was grossly over-exposed, giving the negative a bleached look. In some solarized prints, the images look "light-filled" or "bursting with light." Ray went beyond even Stieglitz and Strand in using the camera, not as an instrument to record visual reality but as a means, the initial means, of recasting that reality and thereby rivaling modernist painting on its own terms.

While part of the Arensberg Circle, Ray photographed Duchamp as a transvestite, helped Duchamp publish the only issue of *New York Dada,* and was one of the founders of the Société Anonyme. A man of great versatility, he designed the lighting for the Société's first show, which opened on April 30, 1920, at 19 East 47th Street. In July 1921 he left for Paris, and was to remain there until 1940, when the Nazis occupied the city. Duchamp introduced him to the French Dadaists, and he was welcomed as a friend and kindred spirit by Tristan Tzara, Max Ernst, and others. Ray's friendship with Duchamp lasted thirty-five years, and he continued a wide variety of Dadaist and Dada-related activities in Europe. For instance, in the 1920s he made three films, in which he served as director, cameraman, and editor, and the sound accompaniment was his choice of phonograph records.[94] He lived in Hollywood from 1940 to 1951, and renewed his friendship with the Arensbergs. In 1951 he returned to Paris.

But Ray's activities after 1921 no longer belong to the history of early American modernism. Arensberg, who had been called by Picabia "le vrai dada de New York,"[95] moved to California in 1922, where he lived a much more private sort of life, writing and continuing his collecting. Thus between 1921 and 1923 the underpinnings of an entire segment of early American modernism were removed, as Duchamp, Picabia, Man Ray, and the Arensbergs left New York, and Covert gave up his art. But the lessons and memories of that special

ambience remained fresh throughout the third decade, as can be seen in the conceptual approaches of Demuth's Poster Portraits, Dove's assemblages, Davis's *Eggbeater* series, and Stella's collages.

NOTES

1. Quoted in Dorothy Norman, *Alfred Stieglitz: An American Seer*, New York, 1973, p. 128.

2. As a boy he regularly contributed to an old organ grinder who played out of tune, *ibid.*, pp. 22–24. Stieglitz himself recalled of the period 1893–95, when he would photograph in Lower New York around the Tombs and the old post office: "I loathed the dirty streets, yet I was fascinated. I wanted to photograph everything I saw. Wherever I looked there was a picture that moved me—the derelicts, the second-hand clothing shops, the rag pickers, the tattered and the torn. All found a warm spot in my heart. . . . There was a reality about them lacking in the artificial world in which I found myself. . . ."—*ibid.*, p. 39.

3. *Ibid.*, p. 76.

4. Information from Walter Ivins, long Curator of Prints at the Metropolitan Museum, quoted in Fiske Kimball, "Cubism and the Arensbergs,"*Art News Annual*, 24 (1955), pp. 120, 122.

5. The manifesto, entitled "Dada est Américain," appeared in *Littérature*, 2 No. 13 (May 1920), pp. 15–16.

6. For a history of the Arensbergs' collecting, see Anne d'Harnoncourt, "A. E. Gallatin and the Arensbergs: Pioneer Collectors of Twentieth Century Art," *Apollo*, 149 (July 1974), pp. 52–61.

7. Kimball, *op. cit.*, p. 175.

8. Introduction and notes by Francis Naumann, "I Shock Myself: Excerpts from the Autobiography of Beatrice Wood," *Arts Magazine*, 51 No. 9 (May 1977), p. 135.

9. Cravan, a French poet and self-styled "World Champion at the Whorehouse," struck many poses, one of them being that of a boxer. He was knocked out by Johnson in the first round. He arrived in New York for the second time in early 1917 and his stripping at the Independents' Exhibition while delivering a lecture was calculated as a repetition of a Paris scandal of 1914. Gabrielle Buffet-Picabia, "Arthur Cravan and American Dada," in Robert Motherwell, ed., *Dada Painters and Poets*, New York, 1951, pp. 15–16.

10. Dickran Tashjian, *Skyscraper Primitives: Dada and the American Avant-Garde, 1910–1925*, Middletown, Conn., 1975, pp. 99–101.

11. Gabrielle Buffet-Picabia, "Some Memories of Pre-Dada: Picabia and Duchamp," in Motherwell, *op. cit.*, p. 260.

12. "I Shock Myself," *op. cit.*, p. 134.

13. Hans Richter, *Dada, Art and Anti-Art*, New York, 1966, p. 99.

14. "I Shock Myself," *op. cit.*, p. 135.

15. Benjamin de Casseres, "The Unconscious in Art," *Camera Work*, 36 (October 1911).

16. Benjamin de Casseres, "The Ironical in Art," *Camera Work*, 38 (April 1912), pp. 17–18.

17. With explanatory essays by De Zayas, these are illustrated in *Camera Work*, 47 (April 1914). See also Craig R. Bailey, "The Art of Marius De Zayas," *Arts Magazine*, 53 (September 1978), pp. 136–143.

18. John Willard, "The Abstract Vision of Marius De Zayas," *Art Bulletin*, LXII No. 3 (September 1980), pp. 434–452.

19. Marius De Zayas, "The Sun Has Set," *Camera Work*, 39 (July 1912), pp. 17–18.

20. Marius De Zayas, *African Negro Art: Its Influence on Modern Art*, New York, 1916, p. 32.

21. Méric put forth a manifesto of

"Amorphism," in which he proposed war against form in art, especially in the new tendencies in art. He satirized a "Popaule Picador" who may have been Pablo Picasso or Francis Picabia. The conservative in art was seen as superior. But in its mocking tone and sense of destructiveness, "Amorphism" anticipated Dadaism. The article, originally published in *Les Hommes du Jour*, 276 (May 1913), pp. 8–10, reappeared under the title "Vers l'Amorphisme" in *Camera Work*, Special Number (June 1913), p. 57.

22. Tashjian, *op. cit.*, p. 38.

23. William A. Camfield, "The Machinist Style of Francis Picabia," *Art Bulletin*, 48 (September–December 1966), p. 314.

24. William I. Homer, "Picabia's 'Jeune fille américaine dans l'état de nudité' and Her Friends," *Art Bulletin*, 57 (March 1975), p. 111.

25. Norman, *op. cit.*, p. 120.

26. Rosenfeld wrote under the pseudonymn Peter Minuit. The excerpt on Picabia's machinist portrait of Stieglitz appeared in *Seven Arts* (November 1916), p. 61. Quoted in Norman, *op. cit.*, p. 127.

27. These were published out of the Arensberg Circle. *The Blind Man* (the title alluded to America's shortsightedness toward modern art) lasted only two issues and dealt largely with the Independents' Exhibition. *Rongwrong*, which featured exchanges between Duchamp (called "Marcel Douxami" and Picabia), and *New York Dada*, which contained an explanation of the meaning of Dadaism by Tristan Tzara, a cartoon by Rube Goldberg, contrived newspaper headlines, upside-down photographs by Baroness Elsa von Freytag-Loringhoven (one with wig, one bald), etc., both lasted but one issue.

28. Duchamp and John Covert of the Arensberg Circle were among the founders of the Society of Independent Artists, and the first meetings in the fall of 1916 were held in Arensberg's apartment.

29. *291* ran twelve issues, from March 1915 until February 1916. For a summary of the contents, see Tashjian, *op. cit.*, Chap. 2, "*291* and Francis Picabia."

30. Beatrice, who for Dante symbolized the Virgin Mary, came for Arensberg to be identified with Bella, Dante's mother, thus putting Dante in the place of Christ—Francis Naumann, "Cryptography and the Arensberg Circle," *Arts Magazine*, 51 No. 9 (May 1977), p. 128.

31. *Ibid.*, p. 130.

32. This was the design for the cover of the book *Marcel Duchamp, Ready Mades, etc. (1918–64)* by Walter Hopps, Arturo Schwarz, and Ulf Linde, published in 1964. Selected letters of the first and last lines of the long inscription are printed in red, spelling out the words URINOIR (urinal) and URINE (urine)—*ibid.*, p. 129.

33. The title of the Readymade was "With Hidden Noise"—*ibid.*

34. *Ibid.*

35. He approved of the Futurists' refusal to allow "the dead . . . to be so much stronger than the living"—"A Complete Reversal of Opinions by Marcel Duchamp, Iconoclast," *Arts and Decoration*, V (September 1915), pp. 427–428, 442.

36. *Ibid.*, p. 427. The interviewer wrote of Duchamp that "he is young and strangely unaffected by the vast amount of argument created by his work. He is away from the French front on a furlough. He neither talks, nor looks, nor acts like an artist. It may be that in the accepted sense of the word he is not an artist."

37. Duchamp observed: "Whether Mr. Mutt with his own hands made the fountain or not has no importance. He CHOSE it. He took an ordinary article of life, placed it so that its useful significance disappeared under the new title and point of view—created a new thought for that object"—Marcel Duchamp, "The Richard Mutt Case," *The Blind Man*, 2 (May 1917), 5.

38. This was the "Green Box." For Duchamp's elaborate explanation, see *The Bride Stripped Bare by Her Bachelors, Even: A Typographic Version by Richard Hamilton of Marcel Duchamp's Green Box*, translated by

George Heard Hamilton, New York, 1960. For an interpretation of the *Large Glass* as Duchamp's expression of his incestuous impulses, see Arturo Schwarz, *The Large Glass and Related Works*, Milan, 1967, and *Marcel Duchamp: Notes and Projects for the Large Glass*, ed. Arturo Schwarz, New York, 1969.

39. From about 1915 to the late 1920s, when there was a falling out, Stettheimer and Duchamp were close friends. In some of her portraits, Stettheimer combined with her sitters symbols of their avocations and interests, thus reminding us a little of Demuth's Poster Portraits, where the symbols and clues were used without the corporeal presence of the sitter himself. In the middle ground of her *Portrait of Henry McBride*, the art critic, is a tennis court, alluding to his interest in the sport. In the background are motifs of some of McBride's favorite artists: Lachaise, Demuth, Winslow Homer, Marin. See Parker Tyler, *Florine Stettheimer: A Life in Art*, New York, 1963.

40. The interview was reported in "French Artists Spur On American Art," New York *Tribune*, October 24, 1915, p iv, p. 2.

41. Camfield follows Philip Pearlstein i this matter. William A. Camfield, *Franc Picabia, His Art, Life, and Times*, Princetor N.J., 1979, p. 61.

42. *Ibid.*

43. Philip Pearlstein, "The Paintings (Francis Picabia" (M.A. thesis, New Yor University, Institute of Fine Arts, 1955), | 109.

44. Camfield, *Francis Picabia*, p. 109.

45. Interpretation worked out by H(mer—*op. cit.*, p. 111.

46. *Ibid.*, pp. 114–115.

47. Agnes Ernst Meyer proposed th idea of *291* to Stieglitz in January 191! and Stieglitz took a permissive stance. H remark is quoted in Tashjian, *op. cit.*, p. 2! and its source is "The Magazine *291* an 'The Steerage,' " in the Alfred Stieglitz A chive, *loc. cit.*

48. Statement in *291*, 7–8 (Septembe October 1915).

49. Arturo Schwarz, "An Interview with Man Ray: 'This Is Not for America,' " *Arts Magazine*, 51 No. 9 (May 1977), p. 118.

50. *391* appeared from 1917 through 1924 in nineteen issues. The first four were published in Barcelona, the next three in New York, the eighth in Zurich, and the rest in Paris. Although Picabia wrote Stieglitz that *391* was "a duplicate" of *291*, it was generally not as well produced and in some issues was argumentative in tone on personal levels. A history of *391* may be found in Michel Sanouillet's introduction to the reprint of *391*, Vol. I (Réedition intégrale, Paris, 1960). For summaries of the issues, see Camfield, *Francis Picabia.*

51. There were traveling exhibits and public lectures to give the widest possible exposure of modernism. The Société Anonyme (named by Man Ray after the French term which means simply "incorporated") showed Cubists, Futurists, Dadaists, and Expressionists. The German modernists, Klee, Kandinsky (who served as vice president of the organization from 1923 until his death), Campendonk, and Schwitters were exhibited, as well as such varied early American modernists as Hartley, Stella, Bruce, Walkowitz, Daugherty, Taylor, Matulka, Van Everen, and Man Ray. The collection of the Société Anonyme is now at Yale University.

52. This was published in *The Blind Man*, 2 (May 1917), p. 6.

53. Letter from Demuth to Alfred Stieglitz, February 5, 1928. Alfred Stieglitz Archive, *loc. cit.*

54. Rita Wellman, "Pen Portraits: Charles Demuth," *Creative Art*, 9 (December 1931), pp. 483–484.

55. Charles Demuth, "The Azure Adder," *The Glebe*, I No. 3 (December 1911).

56. There were a few more, including one of Demuth's homosexual friend Bert Savoy and an unfinished one of Marsden Hartley. Abraham A. Davidson, "Demuth's Poster Portraits," *Artforum*, XVII No. 3 (November 1978), pp. 54–57.

57. Letter from Demuth to Alfred Stieg-

litz, April 1925. Alfred Stieglitz Archive, *loc. cit.*

58. An insight of Emily Farnham's in *Charles Demuth, His Life, Psychology and Works* (unpublished Ph.D. dissertation, Ohio State University, 1960), P. 334.

59. Her *Three Lives* was published in 1909. In the *Autobiography of Alice B. Toklas,* she observed meeting geniuses in threes, dancers in threes, and wives of geniuses in threes: "But that is not my fault," she wrote, "it happens to be a fact." Gertrude Stein, *The Autobiography of Alice B. Toklas,* New York, 1933, p. 167.

60. *Ibid.,* p. 163.

61. John Marin, "Notes on 291," *Camera Work,* 42 (April–July 1913), p. 18.

62. Quoted in Frederick S. Wight, *Arthur G. Dove,* Berkeley and Los Angeles, 1958, p. 51.

63. Sheeler went on to enjoy a long career in commercial photography, and distinguished himself as a photographer. Schamberg, had he lived longer, might have also made his contribution. In 1918 Schamberg, Sheeler, and Paul Strand all won prizes in the annual photographic exhibition held in Wanamaker's department store in Philadelphia.

64. Ben Wolf, *Morton Livingston Shamberg,* Philadelphia, 1963, pp. 30, 54.

65. Susan Fillin Yeh, "Charles Sheeler's 1923 'Self-Portrait,' " *Arts Magazine,* 52 No. 5 (January 1978), p. 107.

66. *Ibid.,* p. 108.

67. In his valuable study of the influence of Duchamp and Picabia on the American artists of the Arensberg Circle, Agee in this instance pushes his point too strongly. William Agee, "New York Dada, 1910–1930," *Art News Annual,* XXXIV (1968), p. 111.

68. Quoted in Rudi Blesh, *Stuart Davis,* New York, 1960, p. 16.

69. Tashjian, *op. cit.,* p. 202.

70. Blesh, *op. cit.,* p. 17.

71. Although Severini's *Dynamic Hieroglyphic* was painted after the large Futurist exhibition at the Bernheim-Jeune Gallery of February 1912, Stella was in Europe long enough to have seen it. Baur takes that painting as his "model"—John I. H. Baur, *Joseph Stella,* New York, 1971, pp. 31–32. Jaffe writes: "it is most likely that Stella saw it, or works like it, in Severini's studio"— Irma B. Jaffe, *Joseph Stella,* Cambridge, Mass., 1970, pp. 41–42.

72. For example, she was treasurer of the German Home for Recreation of Women and Children, president of the Little Italy Neighborhood House in South Brooklyn in 1903, and one of the directors of the Manhattan Trade School for Girls from 1903 to 1909—Ruth L. Bohan, "Katherine Sophie Dreier and New York Dada," *Arts Magazine,* 51 No. 9 (May 1977), p. 97.

73. Katherine S. Dreier, *Western Art and the New Era,* New York, 1923, p. 118. Unable to see the nihilistic aspects of Dadaism, she praised Duchamp's shovel, *In Advance of a Broken Arm,* for its good design—*ibid.,* pp. 70–71.

74. This is stated in her letter to Marcel Duchamp of April 13, 1917. The Katherine Dreier–Société Anonyme Collection, Collection of American Literature, the Beinecke Rare Book and Manuscript Library, Yale University.

75. Aline B. Saarinen, *The Proud Possessors,* New York, 1958, pp. 243–249.

76. *Ibid.,* pp. 248–249.

77. Michele De Angelus, "Katherine S. Dreier (1877–1952)," in William I. Homer, ed., Avant-Garde Painting and Sculpture in America, 1910–1925, Wilmington, 1975, p. 70.

78. Dreier, *op. cit.,* p. 112. After her survey from Egyptian art to Post-Impressionism in Chaps. 2 and 3, Dreier plunges into her discussion and boosting of contemporary art, where she illustrates many of the artists she exhibited through the Société Anonyme, including, in order of appearance, Baylinson, Eitshemius, Archipenko, Bruce, Stella, Kandinsky (who, in the frontispiece, is given the only color illustration with a 1921 painting), Campendonk, herself (illustrated is the portrait of *Marcel Duchamp*), Covert, and Schwitters.

79. Quoted in Rudi Blesh, *Modern Art USA*, New York, 1956, p. 92.

80. *Ibid.*

81. Naumann, *op. cit.*, pp. 129–130.

82. George Heard Hamilton, "John Covert: Early American Modern," *College Art Journal*, XII No. 1 (Fall 1952), p. 40.

83. Michael Klein, "John Covert's 'Time': Cubism, Duchamp, Einstein—A Quasi-Scientific Fantasy," *Art Journal*, XXXIII No. 4 (Summer 1974), p. 320, n.17.

84. Naumann, *op. cit.*, p. 130.

85. Klein, *op. cit.*, pp. 315–316.

86. Yale University Art Gallery, *Collection of the Société Anonyme, Museum of Modern Art*, 1920, New Haven, Conn., 1950, p. 192.

87. Schwarz, "Interview with Man Ray," *op. cit.*, p. 117.

88. Even before meeting with Duchamp, Man Ray through his newspaper showed that the attitude of Dada was in him. The *Ridgefield Gazook* had as its opening statement: "Published unnecessarily whenever the spirits move us. Subscription free to whomever we please or displease. Contributions received in liquid form only. This issue limited to local contributors." The *Gazook* had advice on "How to make tender buttens itch," in a section on Graftmanship, by "Mac Kucera of the Au-tomato Mash. & Fool co." Quoted in Arturo Schwarz, *Man Ray*, New York, 1978, pp. 27–28.

89. Man Ray, *Self Portrait*, New York, 1963, pp. 66–67.

90. Schwarz, "Interview with Man Ray," *op. cit.*, p. 118.

91. Ray, *Self Portrait*, pp. 72–73.

92. Man Ray had been introduced to French nineteenth-century Symbolist writings during the Ridgefield days by the young Frenchwoman Adon Lacour, whom he subsequently married.

93. Ray, *Self Portrait*, p. 129.

94. Man Ray made three films: *Emak Bakia* in 1926. *L'Étoile de mer* in 1928, and *Les Mystères du château de dé* in 1929. For a discussion of these films, see Carl I. Belz, "The Film Poetry of Man Ray," Los Angeles County Museum of Art, *Man Ray*, Los Angeles, 1966, pp. 43–53.

95. Letter from Picabia to Walter Arensberg of November 8, 1920. Arensberg Archive, Philadelphia Museum of Art.

3

Color Painters

THE SYNCHROMISTS AND THEIR FOLLOWERS

Rarely in early American modernism was there the millennial consciousness that typified such European movements as Expressionism, Cubism, Futurism, Dadaism, and Surrealism, the conviction that the art of the nineteenth century had been gradually leading to and anticipating *the* major breakthrough. Hartley's reference to his work of 1912 as "cosmic Cubism" is the only instance when any early American modernist refers to his work as Cubist, even though techniques here were similar to those used by Europeans who always called themselves Cubist. By and large the notion of a movement with all its attendant polemicism did not take hold in America from 1910 to 1935. The Stieglitz and Arensberg Groups were loose federations, never proclaiming anything like a manifesto. Weber, for instance, who painted Futurist or Futurist-like cityscapes from 1912 to 1916, said that modern art was as old as the oldest art and that its fundamentals and principles would never change.[1] Hartley, in 1921, wrote that "the progress of the modernist is . . . a slow and painstaking one,"[2] and seven years later ventured that while "the office of modern art [is] . . . to arrive at a species of purism, native to ourselves in our own concentrated period, to produce the newness or the 'nowness' of individual experience . . . modern art must remain in a state of experimental research. . . ."[3] In short, for all the innovations produced in modern painting from 1910 to 1935, there was hardly to be found in America the notion of a revolutionary break with the past.

The exception was Synchromism, a manner of color painting established by Stanton Macdonald-Wright (1890–1973) and Morgan Russell (1886–1953) during the first half of the second decade. Synchromism was greeted with a fervor characteristic of the contemporary European movements—and it is perhaps significant that it was conceived by American artists while they were in Europe.

In his book *Modern Painting: Its Tendency and Meaning* (1915), Willard Huntington Wright, Stanton's brother, wrote of Synchromism as the end point of the progressive evolution of modern painting, which had begun with Delacroix and gone through Impressionism and Cubism. Delacroix, he pointed out, had made color an organic factor in art, but still left it as the adjunct of drawing.[4] The Impressionists overemphasized the objective uses of color, and were still the slaves of nature. Cézanne used color so as to heighten the emotion of volume, to intensify the fundamental organization of the painting; color with him had not yet been carried to its ultimate purity as a free-functioning element. The Synchromists represented the highest stage, for, unlike Cézanne, they rejected all local color. The choice of colors was derived by them, Wright argued, from certain immutable laws. For example, the position of a given volume in space dictated the color; a receding volume was never to be painted yellow, a color that normally advances.

Two painters singled out by Wright for special qualification were Kandinsky and the Orphist-Cubist Robert Delaunay, for they were the ones who might most seriously challenge the preeminence of Macdonald-Wright and Russell. Kandinsky, who was relegated to a chapter entitled "The Lesser Moderns," was supposed to have ignored the fact that color application was to be derived from certain natural laws. Kandinsky who sought refuge in a vague mysticism, and what he designated as "soul" was, Wright insisted, nothing other than associative memory (he did not elaborate on this fascinating explanation).[5] In the end, he found Kandinsky only illustrative and decorative. Delaunay was dismissed just as ruthlessly, but with even more esoteric verbiage. He was accused—and, by extension, his American followers Bruce and Frost may have been included as well—of making decoration that would be profound, instead of profound composition incidentally resulting in decoration. Delaunay reversed the natural order, considering effects before causes; and the result was merely prettiness, the objective mask of beauty. His revolution, like that of the Cubists, was halfway, even though he tried to fool the public under the name of Orphism. His latest work, which was more abstract and luminous, was still at the most "secessionist."[6] (Macdonald-Wright himself looked upon Orphism as simply "Impressionism enlarged and attenuated.")[7]

In asserting that the human body was the constructive basis of the formal arrangements,[8] Huntington Wright got at what was most distinctive about his brother's and Russell's paintings in comparison with those of the other American color painters, as well as those of Delaunay. This analogy with the body involved not the actual depiction of limbs, though sometimes this was hinted at, as in say the *Arm Organization* (1914, Garber Collection, New York). Rather, it was the establishment of a rippling surface movement, which suggested the flexing of limbs held under tension. Macdonald-Wright spoke openly of his debt to Michelangelo, and the subsequent "bump and hollow" look of his art.[9] The

Arm Organization was supposed to have had, near the center, the form of the human arm, which ramified toward the periphery with larger forms as reconstructions of that central motif. And the larger forms broke into parts, each of which was a further restatement of the arm motif.[10]

As a child in Virginia Macdonald-Wright had studied with private tutors. In 1900, at the age of ten, he moved with his family to California. He was adventurous, and at fourteen ran away from home, joined a ship's crew as cabin boy, and wound up in Honolulu. The next year he studied at the Art Students League in Los Angeles with Warren F. Hedges, who had taught with Robert Henri, and his work at this time showed the qualities of the Dark Impressionism then popular.

In 1907 he left for Paris, where he studied briefly at the Académie Colarossi, the Académie Julian, and the École des Beaux Arts. He got far more out of his visits to museums, where he studied the work of Cézanne, the Pointillists Seurat and Signac, and Matisse. Around 1911 he was drawn, together with Russell whom he had just met, to the texts of Chevreul, Von Helmholtz, Ogden N. Rood, and Blanc dealing with the scientific or quasi-scientific analysis of the effects of color. He knew Delaunay—just how well has never been clearly established—and visited his studio,[11] but claims to have evolved Synchromism together with Russell without Delaunay's intervention. The catalyst for the idea for the breakthrough to color painting was the Canadian artist Ernest Percyval Tudor-Hart, whose classes he attended with Russell from 1911 through 1913. Tudor-Hart gave priority to a system of color harmonies in which a set of correspondences was established between tonal sounds and hues.

Macdonald-Wright showed in the Salon d'Automne of 1910 and in the Salon des Indépendants of 1912. The first Synchromist shows took place in 1913, in Munich in June and in Paris at the Bernheim-Jeune Gallery in October. His early Synchromist paintings were still fairly representational Fauvist conceptions, like the *Synchromate en vert* (1912, now lost), which presented in bright color areas Michelangelo's *Dying Slave*. But the foundation for his oncoming work had been laid, and its justification thought out. In the catalogue of the Bernheim-Jeune show he wrote: "Form to me is color. When I conceive of a composition of form, my imagination creates an organization of color that corresponds to it. As the juxtaposition of two or more colors produces a sensation of luminosity, I find it useless to occupy myself with light *per se*. Each color has an inevitable position of its own in what could be called 'emotional space' and has also its precise character. I conceive space itself as of plastic significance that I express in color."[12]

In late 1913 Macdonald-Wright returned to America just after his father's death, and stayed on to see the first American Synchromist exhibition at New York's Carroll Galleries in March 1914. In April he returned to Paris with his brother Willard, with whom he was to collaborate on the books justifying his

approaches to art. Now Macdonald-Wright's painting entered its mature Synchromist phase, with the interweaving planes of color functioning as pure optical sensations. In 1916 he resettled in America, and showed at the prime spots of the early modernists in New York—at 291, the Daniel and Montross galleries, and from March 13 to 25, 1916, at the Forum Exhibition at the Anderson Galleries with fifteen other early modernists, four of whom (Dove, Dasburg, Hartley, and Russell) were represented, like him, by nonobjective pieces. In 1919, badly discouraged by not getting the support, either financial or critical, that he felt he deserved, Macdonald-Wright returned to the place of his boyhood, California. He needed the remoteness of the Far West in which to rethink his own theories.

Before he left the East Coast, however, Macdonald-Wright produced a body of work of distinctive stamp. His paintings from 1915 to 1920, with their multicolored, seemingly swirling hues, appear to the spectator to be almost like eddies of mist, the droplets of which collect to form parts of a straining torso. It is not parts of a body that have been drawn; it is parts of a body made of the same airy substance surrounding them, things made of thickenings of mist. To find anything like this in American painting one has to wait for the color-field canvases of Jules Olitski in the 1960s.

In Macdonald-Wright's *Abstraction on Spectrum (Organization No. 5)* [63] (1914, Des Moines Art Center), the body semblance has not yet been worked out, and the dominant, repeated shape is the circle, stacked in a weaving column up through the center of the painting. One may be reminded of Delaunay's *Discs* (which did not of course serve as a prototype), but the resemblance is superficial. With Delaunay, there is much more containment within an overall geometrical format, while here there is a great deal of dynamism, the vertical and lateral movement being offset by the counter movement into depth. In *Synchromy in Purple* [64] (1917, Los Angeles County Museum of Art), the paint seems to have been applied almost in a light spray, and the droplets have coalesced into a large striding figure, cut off at the knees by the lower edge, moving precipitously toward the spectator. The geometrical shapes of 1914 and 1915, with fairly clean separations between adjacent color areas, as in the *Self-Portrait* (1915, Dr. Moritz Jagendorf), have been replaced by an amorphous, vaporous treatment. There are generally several hues within each painting, still limited within certain overall tonalities. In the *Self-Portrait*, where the figure, cut off at the waist, supports the head at the chin with the right hand, pale reds tinged with violet predominate, but there are green-violets and gray-blue-greens as well. In the *Oriental Synchromy in Blue-Green* [65] (1918, Whitney), dark blue-greens, gray-greens, and gray-blues abound, but to the left there is a startling area of red coloring the upper part of a protruding leg. In this painting, several figures seem to be striding or sitting with legs spread within a space, presumably a room. Gail Levin, citing a reply of Macdonald-Wright to a Whitney Museum request for information sent him in 1953, reports that the arrangement

63. Stanton Macdonald-Wright,
*Abstraction on Spectrum (Orga-
nization No. 5)*, 1914.

64. Stanton Macdonald-Wright,
Synchromy in Purple, 1917.

65. Stanton Macdonald-Wright, *Oriental Synchromy in Blue-Green,* 1918.

of figures was meant to reveal a group of opium smokers. The painter himself was a partaker.[13]

Macdonald-Wright saw himself first and foremost as a colorist. Volumes were the creations of the interrelationships of colors, and must never be isolated by an outline, or through modeling by the manipulation of lights and darks. His color schemas were extraordinarily complex, and virtually impossible to pin down for a given painting through verbal description. In his *Treatise on Color,* which was published in 1924 but really based on thinking developed during the second decade, he revealed that he manipulated colors as though they were the notes of a scale, with set intervals between them (an idea probably first suggested to him in the classes of Tudor-Hart in 1911). The scale of Yellow, for example, consisted of seven steps or levels: Yellow, Green, Blue, Blue-Violet, Red-Orange, Yellow-Orange, and Yellow. The tonic chord consisted of the first, third, and fifth levels of a given scale. The first, fourth, and fifth levels comprised another important chord; and all other chords were subservient to these two. As with the piano, minor chords could be formed. These made for extraordinarily complex color schemas and had about them, he wrote, an air of sadness or incompleteness.[14] If a harsh clash were desired, then Red-Orange or Blue-Green (as in the *Oriental Synchromy in Blue-Green*) should be used; for a less harsh clash, Orange and Blue.

Macdonald-Wright thought in term of chords based on triads of colors. Always he was aware of the emotional values of each color, values that were modified according to the color context within which each individual color was placed. But broadly, Yellow-Green was for him like a spring landscape, extremely cheerful and youthful. Accordingly, the painter, using a dominant key of Yellow-Green, should paint subjects that have to do with freshness, spring, and poetry. Blue-Green has a quality of remembered things, of sadness. Moving toward the cooler colors, he found Blue the color of ethereality, of shadow, of softness, of antimaterialism. It is a color that is highly spiritual and has little obtrusive character; Blue is introspective and inspirational. Although it has the same amount of spirituality as Blue-Green, it has more positive vitality—it is the color of night and of far distances. Violet is the color of deepest depression; it is like a cry *de profundis.*[15]

Before Willard Huntington Wright gave up art criticism for the writing of detective stories under the pseudonym S. S. Van Dine, he wrote a short book in the form of a polemical treatise. The *Future of Painting,* published in 1923, was a fond promulgation of his dream of the establishment of a radically new kind of painting that would no longer involve paints and canvases.[16] Light was to be the new medium rather than pigments. (Huntington Wright did not elaborate on this, but it is noteworthy that Macdonald-Wright produced the first full-length color motion picture.) The reason this new painting had not

progressed further was the fixation on the part of modern painters with traditional media. Here, then, was a vague, esoteric forecast of the spread of a new, nonobjective art at the very time when the influence of Synchromism and Macdonald-Wright was on the wane and that of the more conservative Precisionism on the rise. Not until the 1960s, with color chromatism and light and motion art, would the early promise of Synchromism be fulfilled and the visions of Huntingon Wright come into being.

Macdonald-Wright's co-exhibitor in the shows of 1913, Morgan Russell, had decided to give up his studies in architecture when he came to Paris in 1906. He visited the Louvre, drew in life classes, and became especially interested in Impressionism and Cézanne. By the time he returned to New York in the fall, he was determined to be a painter.[17] For the next two and a half years he shuttled from New York to Paris to New York, where he studied at the Art Students League under the Ashcan painter Robert Henri and the sculptor James Earle Fraser. In 1908, back again in Paris, he became taken with the recent luminous work of Monet, whom he described in a letter to his friend Andrew Dasburg as "the master of light."[18]

Russell was rapidly becoming immersed in the avant-garde world of Paris. He was friendly with Guillaume Apollinaire, the poet Blaise Cendrars, and with Modigliani; he met Rodin; and he attended the open evenings at Gertrude Stein's apartment, where he met, among others, Matisse and Picasso. After a brief trip back to America, he settled in Paris in 1909. He studied sculpture with Matisse, and admired the sculpture of Michelangelo, and of Rodin, who lived near Matisse's studio at the time. For a while at this point the changeable Russell considered becoming a sculptor; his future nonobjective painting, although ultimately derived from the figure, characteristically had a sculptural, planar organization that set it apart from the more painterly productions of Macdonald-Wright.

Turning back to painting again in 1910, Russell recalled his earlier interest in Monet, and became fiercely enthusiastic over Cézanne, whom he praised for "what was rhythm in color."[19] From 1910 to 1913 he kept painting still lifes of a few apples and other objects based on portions of Cézanne's still lifes (*Still Life with Fruit and Glass,* c. 1911–12, Mr. and Mrs. Henry M. Reed, Montclair, New Jersey). Although not yet nonobjective, his painting was becoming freer and more abstract, as was that of Macdonald-Wright at the same time, who also had been assimilating the influences of Impressionism, Cézanne, and Matisse. Strangely enough, these two men who were moving very much in the same direction (the one in Paris continually since 1907, the other on and off since 1906) did not actually meet until 1911 in Tudor-Hart's classes.

Thereafter, under the guidance of Macdonald-Wright, Russell began to plunge into color theory, writing in his notebook for November 5, 1912, that "color and light must be entirely melted into one and felt as such—and light must be expressed as it is felt in us as color."[20] It was Russell who exhibited

the first painting under the designation of Synchromism at the 1913 Salon Des Indépendants, several months earlier than the combined shows. He entered *Synchromie en vert* (1912–13, now lost), a picture of his studio with its piano, strangely curved as though seen through a distorting lens, a sculpture, Puget's *Écorché* seemingly quivering, and a table with still life objects on it impossibly tilted toward the foreground. In a letter to Dasburg of March 12, 1914, he told how he came up with the term "Synchromism":

> The word was born (please don't say Synchronisme which does not apply to painting, the termination is "chrome," "color") by my searching a title for my canvas last year at the Salon—a title that would apply to painting and not to the subject. My first idea was of course, Synphonie but on looking it up to see if it could reasonably be applied to a picture I found that Syn. was "with" and "phone" sound—the word "chrome" (why I don't know) immediately flashed in my mind—(I knew it meant color) and there you are. . . .[21]

Russell's progressive evolvement from naturalism to nonobjectivity can be traced through a dozen pencil sketches of Puget's *Écorché,* the statue of a male nude with upraised arms (it had appeared in the *Synchromie en vert*), which were made through 1913 and 1914. In these sketches, the figure is first rendered accurately, then resolved into a sweeping oval that is roughly sectioned off. The sections then become clearly marked out and separated one from the other, until what began as a figure ends up as studies for *Synchromy in Orange: To Form* (Michel Seuphor, Mr. and Mrs. Henry M. Reed). Sketches after Michelangelo's *Dying Slave* in the Louvre became the organizational basis of Russell's first nonobjective work, the enormous *Synchromie en bleu violacé,* measuring 10 feet 4 inches by 7 feet 6 inches, which must have been the talk of the Bernheim-Jeune show. The original has been lost, but a smaller version, the *Synchromy in Deep Blue-Violet (Synchromy in Light No. 2)* (1913, Lydia and Harry L. Winston, Bloomfield Hills, Mich.), reveals that Russell was locating his color planes according to Chevreul's law of the simultaneous contrast of complementary colors. This held that contrast harmony is increased through the juxtaposition of complementaries, and Russell surrounded his central yellow shape with its complementary shapes of blue-violet, as Gail Levin has pointed out.[22] In the exhibition catalogue of the Bernheim-Jeune show, Russell asserted that the *Synchromie en bleu violacé* had no subject in the ordinary sense of the word. Rather, "its subject is 'dark blue,' evolving in accordance with the particular form of my canvas."[23] Following Ogden Rood's *Modern Chromatics* of 1879, Russell frequently used triads of colors located within an area subscribed by 120 degrees of the color wheel. In the *Synchromy in Orange: To Form* [Pl. IV 66] (1913–14, Albright-Knox Art Gallery) the dominant triad is red-orange-yellow, with yellow-green-blue and blue-violet-red as the secondary triads.

Expressions like archaic and powerfully architectural might be used to

66. Morgan Russell, *Synchromy in Orange: To Form*, 1913–14.

characterize most of Russell's mature Synchromist painting. Although he started with the figure to arrive at his planes of pure color, the result is a sculptural or architectonic ideal rather than the painterly one, with parts of the human form left intact, favored by Macdonald-Wright. The slabs of color in Russell's paintings are usually sharply hewn, standing forth in clear-cut shapes; seldom are there swirls and gestures of the paint, and never is there anything of the airy, misty quality of Macdonald-Wright's work. The planes, flat and unmodulated, can suggest an architectural ensemble, the image of walls of a building, as in the *Synchromy in Orange: To Form* [66]. Russell's early architectural training could have played a part in determining the turn that his painting took. He would then cover his tracks pretty thoroughly, including the origin of his compositions, which lay in the figure in torsion usually taken from Michelangelo. But if one knows his sketches, it is possible to discern in the *Creavit Deus Hominem (Synchromy No 3: Color Counterpoint)* [67] (1914, Museum of Modern Art), for instance, planes—richly scumbled in this case—resolved into trapezoidal prisms and pyramids, the lineament of a figure.

67. Morgan Russell, *Creavit Deus Hominem (Synchromy No. 3: Color Counterpoint)*, 1914.

68. Morgan Russell, *Cosmic Synchromy (Synchromie Cosmique)*, 1913–14.

The *Cosmic Synchromy* [*Synchromie cosmique*] [68] (1913–14, Munson-Williams-Proctor Institute, Utica, N.Y.) is another variety of Russell's color painting, different from his usual archaic style. Containing a number of multihued circles rippling off in an undulating spiral, it is more painterly than most Russells of the second decade and closer in conception to Macdonald-Wright's *Abstraction on Spectrum (Organization No. 5)* of 1914. In his statement in the Forum catalogue, where he professed that he "sought a 'form' which, though necessarily archaic, would be fundamental and permit of steady evolution, in order to build something at once Dionysian and architectural in shape and color," Russell referred specifically to his *Cosmic Synchromy* as demonstrating a next step "concerned with the elimination of the natural object and with the retention of color rhythms. The principal idea in this canvas," he wrote in the *Forum* catalogue, "is a spiralic plunge into space, excited and quickened by appropriate color contrasts."

Russell stayed in Paris while Macdonald-Wright was arranging for the New York Synchromist Exhibition of March 1914 at the Carroll Galleries. They kept in touch by mail, and some hard feelings arose over Russell's sense that Macdonald-Wright was getting the lion's share of the credit.[24] Russell, his changeable nature coming to the fore, decided to give up Synchromism just before he came to New York for a month in 1916 for the Forum Exhibition.[25] This defection took the sails out of the movement, which in effect lasted for only three years.

But Russell, no longer regarding himself as a Synchromist, continued to paint nonobjectively in Aigremont, France, where he settled in 1920, far from the arena of modernism in America. (He was not to return to America until 1931, when he visited Macdonald-Wright in California.) His *Eidos* group used the familiar flattened planes, but instead of the tight, sure interlocking of *Synchromy in Orange: To Form* [66], they were now placed in more random fashion, with no clear-cut rhythm dominating (*Eidos 23*, 1922–23, Mr. and Mrs. Henry M. Reed). In later years, following his conversion to Catholicism, Russell became a traditional artist.

Short-lived as it was, Synchromism had its adherents.

Thomas Hart Benton (1889–1975), the Regionalist Painter, was first a follower and close associate of Macdonald-Wright. Born in a small town in southern Missouri, he studied for a while at the Art Institute of Chicago after doing reporting and illustrating for a newspaper in Joplin, Missouri; in 1908, when he was nineteen and bored with Chicago, he left for Paris. There he roamed through the Louvre and, he recalls in his autobiography *An Artist in America*, felt his eyes moisten before the Hellenistic *Winged Victory*. He studied briefly at the Académie Julian with Jean-Paul Laurens, who left him unimpressed, and did some sketching on his own at the Académie Colarossi.[26] The contemporary artists he met briefly—Marin, Diego Rivera, the English Vorticist Wyndham Lewis, and George Grosz—left him as cold as the academicians. His one friend

in Paris was Macdonald-Wright, and both of them, according to Benton, were then united in the conviction that everyone else in Paris was a fool.[27] In the winter of 1910 Benton was strongly affected by the exhibition of the work of the Neo-Impressionist Paul Signac, and in much of his Paris work (now all lost) he combined the Pointillist method with the flattening of objects, as he remembered them from the Japanese prints he had studied at the Art Institute of Chicago.[28] He liked the work of both Cézanne and Gauguin. The small exhibition he staged of his own painting in Paris was attended by only three people: Macdonald-Wright, and George Carlock and John Thompson, both students of Tudor-Hart.

Benton returned to America in 1912. After looking in vain for a teaching post at the newly founded Art Institute in Kansas City, he settled in New York. When Macdonald-Wright came to New York in 1914, the two immediately resumed their association. Benton came several times to see the Synchromist paintings at the Carroll Galleries. Then followed the throes of his own struggles with Synchromism. He was enchanted that the Synchromists based their compositions on the sculptures of Michelangelo, thus bridging the contemporary with the traditional, and he liked the fact that color was determined by subtending a section of the color wheel. He based one of his own paintings (now lost) on Michelangelo's relief of the *Battle of the Lapiths and Centaurs,* and used a Synchromist palette. But Benton found that it was too difficult for him to render a sculpturesque, partially representational composition with Synchromist color,[29] and so, abandoning all vestiges of the recognizable, he "broke the forms into disconcerting streaks and spots of rainbow light."[30]

Little of Benton's Synchromist work now survives. His *Bubbles* [69] (c. 1916–17, Baltimore Museum of Art), with its grouping of seemingly wafting, multicolored circles, may be an example of the "spots of rainbow light." Macdonald-Wright prevailed upon him to exhibit in the Forum Exhibition, and there he had works of both a representational and a nonrepresentational (or his type of Synchromist) character. His statement in the catalogue reflects his inability to use the figure as the basis of Synchromist compositions, as the movement's founders did: "I believe that the representation of objective forms and the presentation of abstract ideas of form . . . [he made here the clear distinction] to be of equal artistic value."

In 1917 Benton began to sculpt, making a series of abstract constructions which he translated into paintings of blocklike and truncated forms that looked as though they were based on a relief sculpture of bits of wood and cloth. The colors were low-keyed; gray-blues, slate blues, tans, with a few spots of red for the *Constructivist Still Life: Synchromist Color* (1917, Columbus Gallery of Fine Arts). Then came a complete turnabout, brought on by his enlistment in the Navy in the summer of 1918. Benton realized he felt closer to the sailors he encountered than to those he now perceived as the fragile aesthetes of Chi-

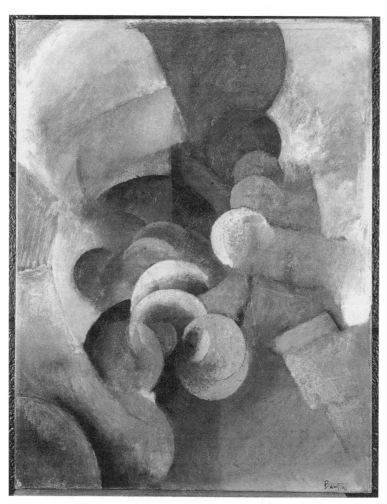

69. Thomas Hart Benton, *Bubbles*, 1916–17.

cago, Paris, and New York.[31] At the Norfolk Naval Base he was assigned the task of making drawings of naval installations. From then on he painted vigorously active "American types,"[32] although for the first few years he sometimes used an approximation of a Synchromist palette (*People of Chilmark* [*Figure Composition*], 1920, Hirshhorn Museum and Sculpture Garden).

Russell's close friend and his companion in Paris, Andrew Dasburg (1887–1979), also passed through a Synchromist period. He first met Russell at the Art Students League in New York, then renewed contact with him in Paris in 1909–10. Like Russell he became enthusiastic over Cézanne, and Russell took him to visit Matisse's studio, as well as the apartment of the Steins. He returned

to America in late 1910 "inflamed like a newly converted evangelist."[33] Back to Paris in 1914, he plunged into color theory, and read the two books that had proved important for the development of both Russell and Macdonald-Wright—Chevreul's *De la Loi du contraste simultané des couleurs* and Rood's *Modern Chromatics*.[34]

Before Dasburg's return to New York at the end of 1914, he was determined to become a nonobjective color painter. In the next two years he painted a series of *Improvisations,* composed of spiraling forms reminiscent of Morgan Russell's *Cosmic Synchromy* [*Synchromie cosmique*] [68], except that he used a dominant blue-green and yellow-ocher palette. Only one of these exists today (*Improvisation,* 1915–16, Mr. and Mrs. Henry M. Reed). Several were exhibited at the Forum Exhibition, and for his statement in the catalogue, Dasburg expressed a purpose that was basically consistent with Synchromist thinking although he never designated himself a Synchromist: "In my use of color I aim to reinforce the sensation of light and dark, that is, to develop the rhythm to and from the eye by placing on the canvas the colors which, by their depressive or stimulating qualities, approach or recede in the rhythmic scheme of the pictures."

In the *Improvisations* the colors vary little in hue, and the space is quite shallow. Portions of some of the areas of blue-green appear diaphanous, intermerging, as in European Analytical Cubism. Relating to the *Improvisations,* but different in format and color tonalities, is the *Sermon on the Mount* [70] (c. 1914,

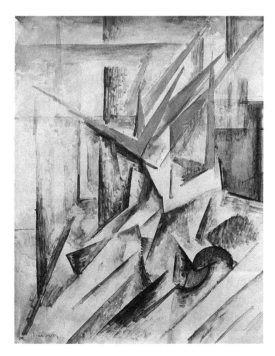

70. Andrew Dasburg, *Sermon on the Mount,* 1914.

Roswell Museum and Art Center, Roswell, N.M.), with its bright red wedges placed on a backdrop of open and closed gray-blue rectangular compartments. Oppositions predominate: the verticals and horizontals oppose the diagonals at the lower right and in the wedges; and the bright reds oppose the more neutral tones. The painting may have been conceived with a specific image, even an incident, in Dasburg's mind, for the diagonals at the bottom can be read as the slope of a mountain. In an interview, he recalled: "I did *Sermon on the Mount* one morning under the inspiration of the idea of Moses and Christ as opposed to the War. My other 'Cubist' pictures were done as problems and give me little satisfaction as expressions of my feelings."[35]

In 1917 Russell went to live at Le Cannet in the South of France. That same year Dasburg, perhaps in part because of Russell's departure, gave up his own brand of Synchromism. His future lay in America—in New York, Woodstock, and later New Mexico. In the third decade he was to turn out canvases that were fashionably modernist but not nearly as adventurous as those of the second.

The final color painter to come under the direct influence of Synchromism was a friend of Benton's (who counted him among the Synchromists).[36] This was William Henry Kemble Yarrow (1891–1941), who imbibed from Macdonald-Wright not the figural component, but the triadic system and the delectable free flow of color seeming to pass effortlessly from one area of a painting to another. One of his few known works, *Flowers* [71] (c. 1920, Mr. and Mrs. Malcolm C. Eisenberg, Philadelphia) fairly resonates with color. Probably done after the departure of Macdonald-Wright and Russell from the East Coast and the abandonment of color painting by Benton and Dasburg, it is a worthy legacy.

THE FOLLOWERS OF THE DELAUNAYS AND OTHER COLOR PAINTERS

Levin shows that the American color painters of the second decade could be grouped on the point of their allegiance or opposition to the Orphist painters Robert and Sonia Delaunay.[37] The Delaunays preferred clearly delineated geometrical forms, especially the circle or disk (Robert Delaunay, *Simultaneous Disk*, 1912, Mr. and Mrs. Burton Tremaine, Meriden, Conn.), which sometimes translated itself into whirling propellors (Robert Delaunay, *Homage to Blériot*, 1914, Mme E. Gazel, Paris). At the same time, they preferred, too, cityscapes of broad vistas (Robert Delaunay, *City of Paris*, 1912, Musée National d'Art Moderne, Paris) and interior scenes, which encompassed varied activities of a group (Sonia Delaunay, *Le Bal Bullier*, 1913, Stadtisches Kunsthalle, Bielefeld, Germany). Like the Synchromists, the Delaunays were color painters who based their work on the researches of Rood and Chevreul. The Synchromists and the Orphists[38]

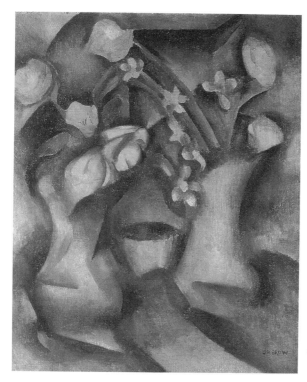

71. William Henry Kemble Yar-
row, *Flowers*, c. 1920.

were "relatives," closer in aim and in the appearance of their respective words than, say, the works of the Stieglitz Group in general were to those of the Arensberg Circle. The main difference between the two groups of color painters lay in this: the Synchromists focused on the human figure, often the single figure, as was the case with Russell and his modifications of Michelangelo's sculpture. The Orphists and their American followers preferred a wider scope for their scene. It is common knowledge that the rifts between relatives are especially sharp. The two chief followers of the Delaunays, Arthur Burdett Frost, Jr. (1887–1917) and Patrick Henry Bruce (1881–1936), were furious over the Synchromists' insistence on the priority of their color schemas.[39] In interviews held in 1975, Sonia Delaunay said that it was she and her husband who had invented Synchromism.[40]

Hartley in Paris in 1912 seems to have been unaware of what the Synchromists were doing, but visited Delaunay's studio to find his paintings "like a demonstration for chemistry on the technical relations of color."[41] The next year in September he attended the First Autumn Salon in Berlin, and saw more Delaunays there, as well as Sonia Delaunay "dressed in her own creation—a dress of simultaneous color effects."[42] Conceivably, Hartley adopted the circular form from the *Disc* series and the *Homage to Blériot*, which he saw in Paris in the spring of 1914 at the Salon des Indépendants, and from Delaunay applied it to a few of his own paintings. He used only from two to four concentric

circles, each painted one solid color (*Abstraction*, c. 1913, Mr. and Mrs. Meredith J. Long; *Composition*, 1914, Columbus Gallery of Fine Arts); Delaunay, in the *Homage to Blériot*, used up to seven concentric circles, many subdivided into four different color zones, to give a more lustrous, lighter feeling.

Delaunay's direct influence on Hartley is speculative. Such is not the case with Frost and his friend Bruce, who enjoyed a close friendship with the Delaunays.

Little of Frost's work remains. He died tragically young, four days shy of his thirtieth birthday, partly as a result of recent unaccustomed dissipation.[43] Henry Reed, who owns most of Frost's paintings, suspects that the father, Arthur Burdett Frost, Sr., the well-known illustrator of the exploits of Uncle Remus and Brer Rabbit and the painter of sporting scenes, became so distraught over the untimely death that he destroyed most of the contents of his son's studio.[44]

Frost, born in Philadelphia, studied for a while at the Pennsylvania Academy of the Fine Arts, and then in 1905, when he was eighteen, at the Chase School in New York, first with William Merritt Chase, later with the ubiquitous Robert Henri. He traveled with his family to London in 1906, then went on to Paris and enrolled at the Académie Julian. He met Bruce in 1907. Through him, he was able to enter the salon of the Steins, where he became aware of Cubism. He wrote to his mother: "The cubists are called so in bulk, but they all don't paint in cubes, nor is there any one thing by which one can class them as a crowd unless it be the obscurity of the subject."[45] Like Bruce, he admired the work of Renoir, and like him he studied with Matisse. He lost interest in illustrative art—a fact that distressed his father no end, who perceived his son's action as one of flagrant rebellion. (Frost, Sr., came from the same sort of artistic milieu as the Currier and Ives artist Louis Maurer, father of Alfred.)

Toward the end of 1912 Frost was becoming aware of Delaunay. His work up to that point had consisted of brightly colored Impressionist subjects, such as *Two Figures in a Garden* (c. 1912, Mr. and Mrs. Henry M. Reed), a scene Reed believes shows Gertrude Stein and Alice B. Toklas.[46] Now he informed his mother: "Leo Stein is not interested except in one man, Delaunay. We are all interested in Delaunay. He seems to be the strong man who has come out of cubisme. . . ."[47] By 1913 Frost was a close personal friend of the Delaunays, spending weekends with them in the country. His paintings exhibited at the Salon des Indépendants in 1914 were inspired by the *Disc* series of Robert Delaunay. These included paintings now lost, but known in general appearance from reproductions in contemporary magazines and from photographs in the collection of Sonia Delaunay:[48] in *Suns*, dark and pale circles of various sizes alternated with light and dark areas and more diffuse areas in the middle tones; and in the *Descent from the Cross*, the light and shaded areas punctuated with circles are crowded so as to form a diagonal running from the upper right to the lower left of the canvas, but here the lineaments of a figure can be made

out as well. The idea of using color painting as the vehicle to present a traditional subject in the *Descent* might have also come from Delaunay, who in 1912 in his *City of Paris* painted the Three Graces fragmented into a patchwork quilt of colors and merged with fragmented sections of Paris.

Frost's only color painting to have survived his European period is the *Harlequin* [72] (1914, Mr. and Mrs. Henry M. Reed), in which the patchwork, diamond-shaped pattern of the costume is exploited for its multihued vivacity. Frost might have had in mind Sonia Delaunay's "Simultaneous" dress with its bigger areas of color, or some of Delaunay's *Windows* series, with their tesserae of shimmering color. James Daugherty saw a harlequin suit projected onto the wall of Frost's studio when he returned to America; the colors could be made to dance by a hand-cranked color machine Frost had designed for himself.[49]

In December 1914 Frost was placed under arrest briefly by French authorities who suspected him, wrongly, of espionage. It was the beginning of the war, and the situation was tense. He was acquitted at his trial, and returned to America in January.[50] Frost set up his studio on East 14th Street in New York. He spent time in the country about Wayne, Pennsylvania, outside Philadelphia, where his parents had moved the previous year. His loosely brushed, high-keyed *Landscape* [73] (c. 1915, Mr. and Mrs. Henry M. Reed) is a view of that area in bloom in the summer. Concurrently with this Impressionism, Frost continued with the color painting related to the work of the Delaunays that he had begun in Paris. His unfinished *Abstraction* [74] (1917, Whitney) is a view of a large group of people within an interior space, where the figures have begun, it would seem, to smooth themselves out into areas of pure color. In the *Colored Forms* (1917, now lost), probably painted several months later, the subject is similar, the view different, and the progression toward nonobjectivity far more advanced: large curving areas not tied to a recognizable source now predominate, with some suggestions of standing figures still in evidence. Frost may have been recalling the swirling rhythms of Sonia Delaunay's dance-hall picture, *Le Bal Bullier,* painted in 1913; or, what was more likely, he may have been looking at Bruce's *Compositions,* which were in their turn somewhat patterned after Sonia's picture. It is known that Frost, while working on his *Colored Forms,* used a photograph of a dance-hall scene to help set the figures and abstracted forms in place. Frost's use of a photograph as an aid to the painting was learned from Bruce, who was using photographs this way before 1914.[51]

The Virginian Patrick Henry Bruce, scion of an old Southern family, came to New York in 1901 when he was twenty. He studied first with William Merritt Chase, and then with Robert Henri, who, as the teacher of Russell, Frost, and Bruce, played an instrumental role in opening all these color painters-to-be to further experimentation. Basing himself on Velásquez and the soft palette of Whistler, Bruce continued to work in Henri's slapdash manner even after he had reached Paris by late 1903 or in January 1904 at the latest. His colors

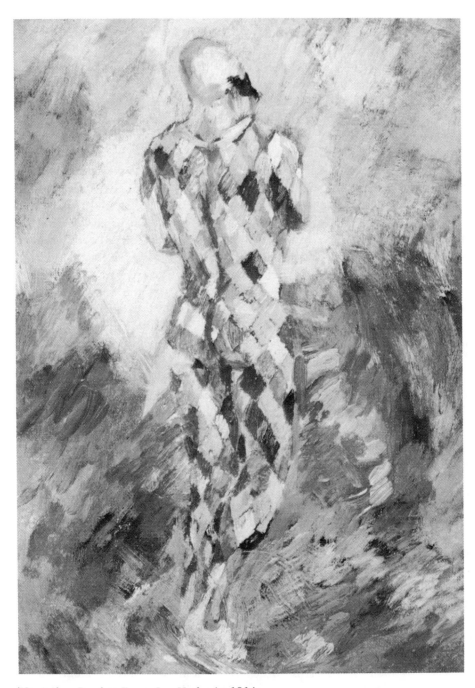

72. Arthur Burdett Frost, Jr., *Harlequin*, 1914.

73. Arthur Burdett Frost, Jr., *Landscape,* c. 1915.

74. Arthur Burdett Frost, Jr., *Abstraction* (unfinished), 1917.

became more luminous upon his exposure to the painting of Renoir and his subsequent enrollment in 1908 in Matisse's school, which he himself organized with Sarah Stein.[52] Like Russell, Bruce had met Matisse at the Stein salon, which was of inestimable importance for many of the Americans in meeting the European modernists. By 1909, however, Bruce was over his enthusiasm for Matisse, which he replaced with an even greater one for Cézanne—or, more properly, Cézanne as seen through the eyes of Matisse. In his "foliage" pictures of the summer of 1912, Bruce concentrated at close range upon flowers in a vase and on a small area of foliage pushed up to the frontal plane. These were inspired by the foliage areas in Cézanne's late watercolors. Bruce demonstrated his powers of organization in his still lifes, such as *Still Life with Tapestry* [75] (1911–12, Mr. and Mrs. Henry M. Reed). The combination of still life objects and textiles and the lack of distortions is Matissian; but Cézannesque is the placement of the table and the nervous, broken stroke.

Bruce met the Delaunays in the spring of 1912, probably several months earlier than Frost. "Delaunay has discovered painting," Frost wrote euphorically to his mother on June 20, 1913.[53] Bruce might have agreed, so closely did he base his paintings of 1912 to 1914 on those of Robert Delaunay. In the swirling,

75. Patrick Henry Bruce, *Still Life with Tapestry*, 1911–12.

interlocking hues of the *Still Life with Comtier* (1912, Mr. and Mrs. Charles M. Daugherty, Weston, Conn.) he aimed at approximating the optical effects of Delaunay's Orphist Cubism. In his *Landscape* of late 1912 or early 1913 (presumed destroyed by Bruce's own hand), the urban view selected is close to that in Delaunay's *Fenêtre* of 1912 (Guggenheim), and the arch at the upper left near the center may be an image of the Eiffel Tower. In late 1913 and early 1914 he took over from Delaunay the interlaced circular shapes of the *Discs* of 1912–13, and absorbed his color theories dealing with simultaneism and other aspects of color. The result, shown at the Salon des Indépendants of 1914, was an enormous canvas, the *Movement, Color, Space: Simultaneous* (1913–14, now lost), where arcs, circles, and flattened overlapping shapes were combined. Together with the Delaunays and other friends, Bruce and Frost liked to attend the weekly gala dances held at the fashionable ballroom, the Bal Bullier.[54] Bruce patterned his *Bal Bullier* (c. 1913–14, presumed destroyed) with its energized rhythms after Sonia Delaunay's painting of the ballroom scene (*Le Bal Bullier*).

After the outbreak of the war, Bruce kept up with the dance-hall pictures but painted them his own way, without overt dependence on the work of the Delaunays. He still followed the color theories of Chevreul and Rood, whose color pairs and triads he maintained through the series of six *Compositions* of 1916 (the theory that the artist should use two colors separated by 90° on the color circle, or three colors subtended by an arc of 120°).[55] But gone from the *Compositions* were the circles and the rather diaphanous treatment of planes typical of the 1912–14 period. Now the paint is applied solidly and for the most part smoothly, with the palette knife as well as with the brush, in blocklike wedges.

The Roman numerals I to VI affixed to the term *Composition* designate not the order in which the *Compositions* were painted but the order in which five of them were purchased by Katherine S. Dreier for the Société Anonyme from Frost, to whom Bruce had shipped the paintings.[56] Agee believes that Bruce painted *Composition III* first, followed by *Composition VI* [76], (Museum of Fine Arts, Houston) then *V, IV, I*, and finally *II*.[57] The painter then moved from traces of naturalism (in *Compositions III, VI*, and *V*, a figure with outstretched arms can be made out toward the upper left of the paintings), rather loose contours, bleeding of areas, broadly brushed surfaces toward smoothly handled surfaces and tightly contained, blocklike areas. In this respect, the proper order of execution may be *Composition V*, followed by *Compositions VI, III, IV, I*, and finally *II*. (The other five *Compositions* are at Yale.) In the first *Compositions*, the swirling, random movements of the dance are imparted; while in the later ones, there is the quality of the architectonic, and one is led to think of stationary buildings rather than moving figures. Agee observes that the diagonal movement from the upper left in *Composition III* is similar to that in the two versions of Duchamp's *Nude Descending a Staircase*, (Philadelphia Museum), that the blocklike

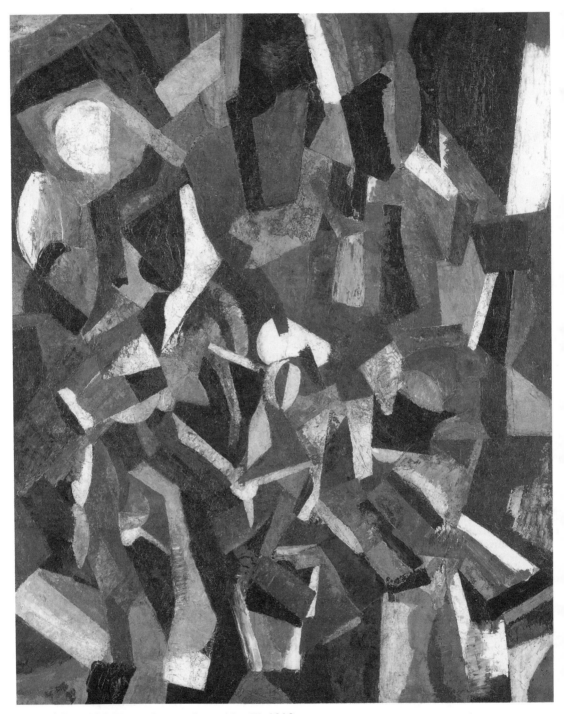

76. Patrick Henry Bruce, *Composition VI*, 1916.

arrangements in *Composition II* are related to Picabia's arrangements in his *Dances à la Source* (1912, Philadelphia Museum) and his *Procession in Seville* (1912, Herbert and Nanette Rothschild, New York), both of which Bruce could have seen at the Salon d'Automne in Paris in 1912.

The blocklike forms in the later *Compositions* clearly anticipate the reductionist constructions in Bruce's still lifes after World War I. Still lifes were all he did from that point, as he cloistered himself more and more within his apartment, removing himself from the Delaunays and members of their circle as well as from color painting. He was to remain in Paris continuously until 1936. Then he returned to America briefly—and committed suicide. Bruce's last twenty years were lonely and difficult ones, but they were also a period of formidable focus, of concentration simply upon objects: upon a tabletop that became arranged in such a way as to reveal an apparent order subtly masking the arranger's disorientation. These later still lifes of Bruce's will be taken up again in Chapter 6.

The legacy of Delaunay in color painting in America did not come to an end with the death of Frost in 1917. In early 1915, when Frost had recently returned from France and taken a studio in New York on East 14th Street, he met a painter from Asheville, North Carolina, James Henry Daugherty (1889–1974), who happened to be occupying the adjoining studio. Frost instructed Daugherty in the principle of simultaneous contrasts and in the methods of building volumes by adjoining various hues without modeling through the manipulation of values.

Daugherty was inclined to be receptive because of his previous training and manner of working. Shortly after his family moved to Washington, D.C., he had studied at the Corcoran Art School in 1906, and then at the Pennsylvania Academy of the Fine Arts under William Merritt Chase and that very bold colorist Hugh H. Breckenridge. The example of Breckenridge may already have been germinating within him when he stayed a while in London, probably in 1913, where he studied with the conservative painter Frank Brangwyn. It was an apprenticeship he described as "paralyzing."[58] In England Daugherty had no association with any avant-garde artist. But upon his return to America, as a commercial artist, he produced some remarkable cartoons and comic strips, in which the small striations of color made for a syncopated rhythm rather similar to that found in Vorticist paintings in England (David Bomberg, *The Mud Bath*, 1912–13, Tate Gallery, London). Vorticism was the English movement comparable to Italian Futurism developing just at the time Daugherty was in London.[59] The boldness of his cartoons (*Broadway Nights* [77], cartoon in the New York *Sunday Herald*, January 31, 1915, color reproduction in Whitney) opened him to Frost's suggestions when they came.

Later in 1915 Daugherty painted high-keyed Impressionist pictures, in which colors were laid down brightly side by side to produce a tapestry-like

77. James Henry Daugherty, *Broadway Nights,*
reproduction from the New York *Sunday
Herald,* January 31, 1915.

78. James Henry Daugherty, *Flight into Egypt,* c. 1920.

effect (*Picnic,* 1915–16, Schoelkopf Gallery, New York). In 1916–17 came the first nonobjective painting, a composition of concentric circles which Daugherty called *My First Essay in Simultaneous Contrast* (Schoelkopf Gallery). It was Delaunay filtered through Frost—Delaunay's *Discs* were perfect circles, with arcs neatly sectioned off into various colors, while Daugherty's painting was more loosely handled, with bleeding edges and scumbling of the paint evident. The forms in his *Untitled* (1918, Mr. and Mrs. Henry M. Reed) were closely fitted triangles, rectangles, and trapezoids, a format fairly close to Russell's *Synchromy in Orange: To Form* [66]. His *Untitled* of 1920 (R. L. B. Tobin) was a gay swirling mélange of arcs, concentric circles, and small trapezoids of green, yellow, red, orange, and blue, with the impact close to that of Bruce's early *Compositions,* by which it might well have been influenced. On the other side of the canvas, Daugherty painted a *Moses* with an orange beard, face sectioned off into blue, yellow, and violet areas, an upper torso composed of arcs of blue, and billowing pants, handled fairly representationally, in bright blue. He liked to present biblical themes in the format of a color painting. The *Flight into Egypt* [78] (c. 1920, Schoelkopf Gallery), with its rather slender Madonna astride a donkey that cannot really be made out, her right hand and right foot, contrary to color painting principles, delineated in outline, has the look of a mosaic with large ''bricks'' of white (as in the curved white elbowless arm), brown, and occasionally red.

From 1920 Daugherty used the idioms of his color painting, none too orthodoxly, in the illustrating of children's books[60] and the painting of murals with scenes, like those of Benton, showing the activities of everyday people. Vibrantly colored planes making for rather bulbous but arresting figures were to be found in his mural *Spirit of Cinema America* (1920) done for Loew's State Theater in Cleveland.

Jay Van Everen (1875–1947), the only one of the early American modernist painters who never set foot in Europe, also took in the simultaneism of Delaunay at second hand, as conveyed through Frost. In 1917, Daugherty, who was then a neighbor of Van Everen's on 78th Street in New York, introduced him to Frost.

Van Everen graduated from Cornell's School of Architecture in 1897 but never practiced in the profession. His paintings have arcs and quadrilaterals, many-sided curved and serrated shapes, all cleanly marked off, that remind one of the patterns made of bright tiles or cut sections of linoleum *(Abstraction* [79, 80], 1920, Yale University; *Untitled* [81], early 1920s, Douglas Hyland). Not surprisingly, he turned his skill at geometric organization to the world of commercial design, fashioning mural decorations for New York's subway stations, and making hand-cut stencils that could be applied to a variety of industrial uses. He was exhibited as a simultaneist with Bruce, Daugherty, and Jan Matulka in exhibitions of the Société Anonyme in 1920 and 1921.

79. Jay Van Everen, *Abstraction*, 1920.

80. Jay Van Everen, *Abstraction*, 1920.

81. Jay Van Everen, *Untitled*, early 1920s.

The term "color painting" denotes a category broader than Synchromism and the simultaneism of Delaunay, encompassing both subdivisions. It refers, rather broadly, to paintings, usually nonobjective or quite abstract, that gain their impact not through some novel twist given to the subject (though that may be involved secondarily), but mainly through the impact of bold and forceful color. It is color that carries the weight of the painting. Color paintings were produced, chiefly in the second decade, by those for whom the manner was a phase, or an occasional departure from other styles. Morton L. Schamberg, best known for his icily careful machine paintings, and Joseph Stella, the painter of industrial landscapes and the maker of collages of discards, both habitués of the Arensberg Circle, knew how to give free rein to their impulse for color.

For Schamberg, the crucial period was 1913–15, before he embarked upon his machine paintings. As with Morgan Russell and Macdonald-Wright, the human figure, sectioned off, was the basis of most of Schamberg's color compositions. But he avoided equally Russell's hard, planar subdivisions and Macdonald-Wright's mistlike clusters of color. In the *Geometrical Patterns* (1914, Dr. and Mrs. Ira Leo Schamberg, Jenkintown, Pa.)—in which a standing nude with raised arms cut off by the upper border at the elbows can be made out—the colored planes of reds and roses mostly, as well as of blue-greens, are made to cohere to the legs and torso like close-fitting lengths of cloth. The arcs and triangles, overlapping and sometimes lightly outlined, interpenetrate, as in the Analytical Cubism of Picasso and Braque, where earth colors dominated. In the *Geometrical Patterns (Standing Nude)* (1913, Dr. and Mrs. Ira Leo Schamberg), there is a more mottled grouping of colors still conforming, by and large, to anatomical divisions. The nude is seen from the back. There is evidence of the vertical division of the backbone, with two backbones being present, as though the upper part of the back and the lower part, while still continuous, shift to become parts of separate figures. Probably the *Canephoros* (1913, Mr. and Mrs. Malcolm C. Eisenberg) was the first of Schamberg's figures of his bold color period. The woman, holding a serving tray balanced upon her head, and cut off at the waist by the lower border, is more solidly constructed than in the *Geometrical Patterns*, with the patches of color being merely patterns of the dress or patches upon the face.

Images of a landscape or relating to a landscape appear toward the close of Schamberg's color period. In his *Untitled (Landscape)* [82] (1914, Mr. and Mrs. Malcolm C. Eisenberg), broad, bold swatches of red, pink, yellow, green, and blue make for the planar composites of a hilly terrain crossed by a low-slung fence. One may guess that the painting represented his own distillations of Fauvism and proto-Cubism, which he could have seen when he was in Paris in 1909, and later at the Armory Show. Still further from the appearance of any visible landscape is the *Abstraction* of 1915 (I. Albert Liverwright, Philadelphia), if indeed the image is related to a landscape. Surely the human figure

82. Morton Schamberg, *Untitled (Landscape)*, 1914.

is not the ideal. The areas of reds, greens, blue-greens, and yellows seem to palpitate. Here is as close an approximation to the tenuous coalescings of Analytical Cubism as any that comes up in contemporary American modernism. The palette of course differs from the earth tones that Picasso and Braque favored, as do the linear, whiplike arcs, inspired—Ben Wolf believes—by Kandinsky's *Improvisation No. 27,* which Schamberg must have seen at the Armory Show.[61]

Stella's period of color painting lasted from 1913 until 1918. His first-hand acquaintance with Italian Futurism, and his probable use of Severini as a source, have been noted by his biographers Baur and Jaffe. Stella conceivably took as a point of departure the intricate pattern of shapes in such an early Severini as the *Boulevard* (1910, Eric Estorick, London) to produce a dense composition of chips of color in his *Spring* (1914, Yale University), where the individual shapes become subsumed in an upward-surging flood of color. He set the scene of most of his color paintings at the Coney Island Amusement Park. Jaffe points out that the multicolored figure standing rigidly in the upper center of the *Battle of Lights, Coney Island* (1913, Yale University) was a familiar decorated pole in the midst of the park.[62] Compared to Severini's *Dynamic Hieroglyphic of the Bal Tabarin* (1912, Museum of Modern Art), which may have been the source, Stella's swirls are denser, gathering into explosive bursts. The tiny chips of red, green, and yellow at the bottom connote the surging crowds; the weaving narrow bands at the top, streamers. The spears of color in the center may be based, as Jaffe suggests, on darting light beams,[63] or may be an adoption of a favorite Futurist device, the "lines of force." In any event, it is not the detail that the spectator focuses upon, but the specks of color, packed together, spinning in clusters and surging upward at the same time. More forcefully than most representational paintings of the site, *Battle of Lights* conveys the excitement the visitor at the crowded amusement park would have experienced.

Stella's variations on the Coney Island spectacular include a nonobjective Pointillist piece with the dots at the bottom darker and smaller; it was at the bottom that the crowds were meant to be situated in the very large Yale painting (it measures 7 by 6 ft. 3¾ in.). Even in this smaller painting, *Battle of Lights, Coney Island* (1913, Hirshhorn), which was probably an initial study for the Yale painting, there is the contrast between the frenetic rhythms at the bottom and the sense of wafting in the upper half, where the streamers are indicated by arcs of the larger dots. In a later version, *Battle of Lights, Coney Island* [Pl. V, 83] (1914–18, University of Nebraska), the colors in the lower part are relegated into spears pushing and jostling one another, suggesting a movement that is brutal and arhythmically sporadic—a movement belonging to a crowd run amok.

As visual metaphors of activity in or about New York, Stella's Coney Island paintings are related to the cityscapes of Marin, Weber, and Walkowitz, also painted in the second decade. But Stella's paintings, unlike theirs, function as reverberations of pure color. Like the Impressionists, Stella was able to experi-

83. Joseph Stella, *Battle of Lights, Coney Island*, 1914–18.

84. Konrad Cramer, *Untitled (Abstraction)*, c. 1911–12.

85. Konrad Cramer, *Abstraction*, c. 1913.

ence the world as a variety of color nuances, sometimes divorced from a corporeal object. A more modest piece than the Coney Island paintings, his small pastel *Sunlight and Water* (1914, Mr. and Mrs. Emanuel M. Terner, New York) is a depiction of the reflections and refractions of light upon water. The pastel is the recreation of an immaterial haze. The closest resemblance in the art of the first third of the century would be to the *Water Lily* paintings of Monet. The pastel also reveals a lyrical side to Stella, a note quite different from that struck in the Coney Island paintings.

What becomes apparent after looking at the many color paintings coming out of America in the second decade is that Stella was especially insightful in wedding the colors he chose to the spirit of the subject. He grasped that colors had their emotional values, as Macdonald-Wright was to set forth systematically in his *Treatise of Color* of 1924. Yellow and green are the dominant colors of Stella's *Spring;* Macdonald-Wright would point out that yellow-green was like a spring landscape, a color that was extremely cheerful and youthful. For the Yale *Battle of Lights,* on the other hand, Stella used rather lurid combinations of reds (dominant areas in the lower central part), pinks streaked with blues and violets, greens and light blues for the darting light beams, and violets, greens, reds, and blue-violets for the weaving streamers at the top.

Konrad Cramer (1888–1963), a German-born artist who settled in New York in 1911, was a less instinctive colorist than Stella, one who needed to base himself on a carefully worked-out color scale. His earliest paintings in America featured an arcane symbolism and motifs made popular by Kandinsky and Franz Marc—he had known the latter in Germany. The horse in the bottom center of his *Untitled (Abstraction)* [84] (1911–12, Weatherspoon Art Gallery, University of North Carolina at Greensboro) was derived from the frequent horses appearing in Marc's paintings. By 1912 he was working nonobjectively, and was calling some of his paintings *Improvisations,* as his friend Dasburg did for his own in 1913. Others were *Abstractions* [85] (c. 1913, Maurice Vanderwoude). Dasburg reported becoming "interested in color charts and chromatic scales, complimentaries [sic], etc., which led to a discussion . . .,"[64] so a good deal of American color painting was based on palettes determined by certain rules. Along with Macdonald-Wright, Russell, Bruce, and Frost, Dasburg and Cramer subscribed to theories of color. Dasburg, in his letter to his wife, went on: "I finally evolved an order of complimentaries [sic] based on the triangle which is satisfying and has possibilities for further experiments. The number 3 seems magical. I believe it always has had a sort of mystical significance. Any order that is based on it and perhaps 7 is satisfying to me."[65] Cramer's *Improvisations* are usually based on four clearly segregated colors, as in the one of 1911 [86] (private collection), where yellow, green, orange-red, and violet are the colors used.[66] The shifting

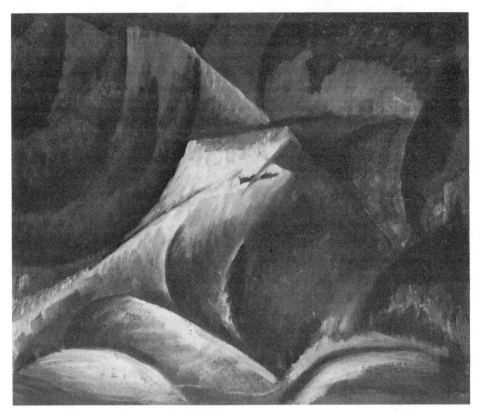

86. Konrad Cramer, *Improvisation*, 1911.

of planes and the method of application of the paint suggest the influence of the current *Improvisations* of Kandinsky.

From the early 1920s Cramer must be considered an independent rather than as one of the color painters. In the third decade he painted still lifes and landscapes quite reductive in manner. From 1930 to 1935 he put forth a series showing the gas stations of the Woodstock area (Cramer, with Dasburg and Henry McFee, was a founder of the Woodstock Art Association in upstate New York); so, with Stuart Davis, Cramer was the first to incorporate this motif regularly.

The 166-piece exhibition originating on January 24, 1978, at the Whitney entitled "Synchromism and American Color Abstraction, 1910–1925" included twenty-nine American painters. Five of these Americans were Synchromists or their followers (Macdonald-Wright, Russell, Benton, Dasburg, and Yarrow); five were followers of or influenced indirectly by the Delaunays (Frost, Bruce, Hartley, Daugherty, Van Everen); and the other nineteen were color painters, who did not belong to those two groupings. Beside Schamberg, Stella, and Cramer, the "unaffiliated" colorists were the Stieglitz painters O'Keeffe, Maurer, Bluem-

ner, Hartley, Dove, Walkowitz, and Weber; Arthur B. Carles, Carl Newman, and H. Lyman Saÿen of the Philadelphia School; and the independents Ben Benn, Stuart Davis, Arnold Friedman, Manierre Dawson, Jan Matulka, and Henry Fitch Taylor. (Rounding out the exhibition were Cézanne and the two Delaunays.) Thus the same painter may belong to more than one grouping. Schamberg, for example, may be classified as an Arensberg artist when his sculpture *God* and his painting *The Well* are considered; as a Precisionist for his other machine paintings; and as a color painter for his *Geometrical Patterns, Untitled (Landscape),* and so on.

Stella's variations of *Battle of Lights* are color paintings; his collages of scraps of paper are in the spirit of Dadaism; and the "polyptich" *New York Interpreted* is Precisionist in style. The organizers of the exhibition deserve credit for broadening one's perceptions of early American modernism by demonstrating the variety of approaches many of the painters took, some of whom would become better known for their styles outside of color painting.

The Whitney show included five pieces by Arnold Friedman (1874–1946). Friedman, a tall, gaunt man, who became embittered by the refusal of the Whitney and the Museum of Modern Art to show his work, labored as a Post Office clerk for some forty years. For half the week he would leave his house in Corona, Long Island, at six in the morning so that he could paint from 3:30 P.M.[67] His interest in painting had been fired by Robert Henri, with whom he studied at New York's Art Students League in 1905. In 1909, taking advantage of a leave of absence from the Post Office, Friedman spent six months in Paris, where he experimented with the Pointillism he observed in Pissaro's paintings. Throughout, his work ranged from nonobjectivity to representationalism, with various degrees of abstraction in between. He explained, not at all apologetically: "Changes in style? You must know then that paint is a coquette and as such must be variously coaxed, coerced, driven, or caressed, and there are as many methods as there are whims and caprices to be met."[68] His late work, from the time of his retirement in 1934, was often derived from Bonnard or the late Monet. One of the most memorable of his paintings is the *Quarry* (c. 1946, David Porter), a view of sprawling hard stone hills with a bird, appearing almost as an inlaid pattern, emerging from the light bursting in the center.

During the second decade, as the Whitney show reveals, Friedman was a nonobjective color painter, favoring quadrilaterals, triangles, and prisms—a little like the hill forms in the *Quarry*—of yellows, yellow-greens, acid greens, red-oranges, grays, and purples *(Untitled* [87], c. 1918, Private collection). "Color in painting is the very heartbeat," he once wrote.[69] There is a surging rhythm to Friedman's color paintings, working as a rippling rise and fall of triangular forms. At least one of these paintings, where the contours of the triangle become curved arcs, Friedman entitled *Hillside* (c. 1917, Arthur G. Altschul). By the 1930s he was rejecting his modernist leanings. On the back of a flower piece

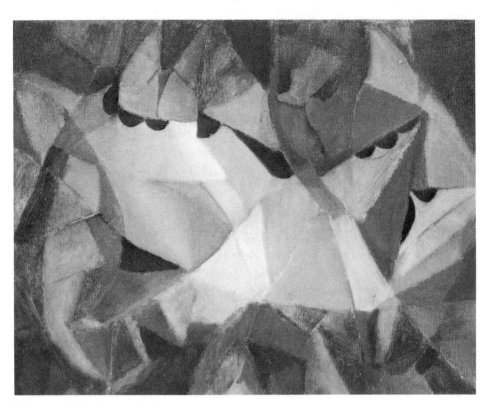

87. Arnold Friedman, *Untitled,*
 c. 1918.

88. Arnold Friedman, *Untitled,*
 c. 1935.

[88] probably dating from the mid-1930s (I. David Orr) he wrote: "Abstraction is retreating according to plan."

Not included in the Whitney show was Leon Kelly (1901–), who was closer to Cubism than to color painting in his predilection for a muted palette around 1920 (*Italian Model,* 1920, Estate of Harriet Janis), but laid his colors on with a heavy impasto, keeping them opaque so that the observer was impressed by the patterning of their incrustation. In the sense that he can be considered a color painter, Kelly had contact neither with the Synchromists nor with the followers of Delaunay and those who followed them. He considered himself closer to the Cubists in Europe than to the Fauves, and subscribed to no color theories.[70]

Kelly was born in Perpignan, France, and brought to Philadelphia soon after his birth.[71] In 1921 he enrolled at the Philadelphia School of Industrial Art (the present Philadelphia College of Art), then studied at the Pennsylvania Academy of the Fine Arts under two of the Philadelphia School of modernists, which had been well established in the second decade about the Academy— Arthur B. Carles and Earle Horter. In 1924 he was awarded a Cresson Fellowship and went to Paris to stay for six years, during which interval he renounced his Cubist manner.[72]

While the Stieglitz–Arensberg opposition expressed an Expressionist–Conceptual polarity, the Color-Painting–Precisionist opposition can be seen as a Romantic–Classical one, rather as Rubens was to Poussin, Delacroix to David. (The Romantic, lyrical aspect of color painting has to do with its appearance and its effect upon the observer, not with the methods involved in producing it.) In late eighteenth- and early nineteenth-century France, color expression (Delacroix) followed linearly defined form (David); but in American modernist painting of 1910–35, color painting preceded Precisionism. This was generally the case, as it was with those artists (e.g., Schamberg, Sheeler, Stella) who were both Precisionists and color painters.

But the polarity is not as simple as all that. A good deal of American color painting, both of the Synchromists and the Delaunayists, was done according to prearranged color schemes worked out on the color wheel, many according to the writings of nineteenth-century theorists. As was pointed out in the Introduction, the systems of geometrical subdivision present in some schools of European Cubism did not have their corollary in America. Early American modernist painting reflects a rather anomalous situation wherein the color painting that was the most lyrical was worked out by methods that were most calculated. Although the chapter on color painting was subdivided as to whether each painter was a Synchromist or one of their followers or a Delaunayist or one of their followers, it would have been equally possible to set up one grouping of methodical colorists and another of instinctive colorists.

The Whitney show was especially enlightening for its inclusion of artists

89. Abraham Walkowitz, *Creation*, 1914.

not normally thought of as color painters. Sheeler, the arch-Precisionist, could paint in 1914 an *Abstraction: Tree Form* (Mr. and Mrs. Henry M. Reed), in which the tree's trunk and the surrounding hills are constructed of tile-like slabs of blue, green, pink, yellow, and violet-brown. In that same year Abraham Walkowitz painted a series of eight small pastels of pinks, blues, reds, and yellows consisting of spirals and wavering concentric circles and spirals, which he designated *Creation* [89] (Metropolitan).

Thus the classifications used for chapter headings—Stieglitz and Arensberg groups, color painters and Precisionism—at times do not correspond to the fluidity of historical reality. Some painters passed in and out of a variety of modernist styles and approaches, belonging as a result under more than one classification.

NOTES

1. Edward C. Bridgman, "Max Weber Modernist," *The Touchstone*, 8 (January 1921), p. 319. In 1954, when something of a painter-patriarch in America, Weber concluded that "the artist who becomes entangled in the intellectual complexities and processes is building a scaffold but not an edifice. Climbing those ladders only, he will inevitably reach doubt and despair"—Max Weber, "Fads and Academies," *Reality*, 2 (Spring 1954), p. 1.

2. The reason for the slow progress, according to Hartley, was that the modernist "has little of actual precedent for his modern premise"—Marsden Hartley, "Dissertation on Modern Painting," *The Nation*, 112 (February 9, 1921), pp. 235–236.

3. Marsden Hartley, "Art and the Personal Life," *Creative Art*, 31 (June 1928), p. xxxiii.

4. Willard Huntington Wright, *Modern Painting: Its Tendency and Meaning*, New York, 1915, p. 278. Huntington Wright condemned Delacroix with these words: "Delacroix's greatest deficiency lay in his inability to recognise the difference between the inventive intelligence and the imaginative instinct. Had he understood this he could have seen that his limitless ambition was incommensurate with his apparently small capabilities" (*ibid.*, p. 42), and praised him

with these: "Let us regard Delacroix as a great pioneer who fought against the zymotic formalism of his day and by doing so opened up a new era of expression" (*ibid.*, p. 46).

5. *Ibid.*, pp. 308–315. Kandinsky, according to Huntington Wright, "attempted to drag it [art] back into the murky medium of metaphysics" (p. 308). He "does not attempt to depict the dynamic forces which produce moods, but strives to interpret his own emotional impressions by means of semi-symbolic and semi-naturalistic visions and by inspirational methods . . . his depiction of the mood is incomprehensible to anyone not temperamentally and mentally at one with him" (p. 313).

6. *Ibid.*, p. 262.

7. Quoted in Gail Levin, *Synchromism and American Color Abstraction 1910–1925*, New York, 1978, p. 28. In an interview shortly before his death, Macdonald-Wright said that Delaunay had simply rigidified human form and put on that the colors of Impressionism—John Alan Walker, "Interview: Stanton Macdonald-Wright," *American Art Review*, 1 (January–February 1974), p. 62.

8. Huntington Wright, *op. cit.*, pp. 301–302. Of Macdonald-Wright, Huntington Wright wrote: "With centuries of tradition urging him to a realistic rendering of the

life about him, he finds it difficult to break entirely with realism and to create without referring to materiality" (p. 302).

9. And Huntington Wright, in 1915, attributed his brother's late development in color and composition to his study of Cézanne and Michelangelo—*ibid.*, p. 284.

10. *Ibid.*, p. 301.

11. According to Agee, both Macdonald-Wright and Russell knew Delaunay, but Macdonald-Wright spent more time with him. M. Knoedler and Co., Inc., *Synchromism and Color Principles in American Painting: 1910–1930*, catalogue and text by William C. Agee, New York, 1965, p. 62.

12. Translated from the statement in the exhibition catalogue, "Les Synchromistes S. Macdonald-Wright et Morgan Russell. Bernheim-Jeune & Cie., Paris, October 27–November 8, 1913."

13. The same information was also given to Russell in an undated letter of 1914. Archives of American Art, Smithsonian Institute, Washington, D.C.—Levin, *op. cit.*, pp. 29, 124.

14. Stanton Macdonald-Wright, *A Treatise on Color*, Los Angeles, 1924, p. 22.

15. *Ibid.*, p. 20.

16. Willard Huntington Wright, *The Future of Painting*, New York, 1923. He believed that the modern world needed more powerful aesthetic stimuli than in the past because of the increased intensity of life, the widespread proliferation of machines, the rapidity in travel, the discoveries in brilliant artificial lights, etc. (p. 24). Music and literature, insisted Huntington Wright, were keeping abreast with the public's changing aesthetic needs, but not painting.

17. Levin, *op. cit.*, p. 10.

18. Russell, commenting on the large Monet show he had seen at the Durand-Ruel Gallery, wrote Dasburg that the painter should think of his palette "as the light in front of him ranging from deep purples and violets thru the blues, green, warm green, y[ellow], o[range], r[ed], purple reds, etc." Morgan Russell to Andrew Dasburg, letter of late August 1908. Andrew Dasburg Collection, George Arents Library

for Special Collections, Syracuse University, Syracuse, N.Y. Quoted in Levin, *op. cit.*, p. 12.

19. Letter to Andrew Dasburg, October 27,1910. Andrew Dasburg Collection, *loc.cit.*

20. Gail Levin, "Morgan Russell's Notebooks: An American Avant-Garde Painter in Paris," *RACAR (Canadian Art Review)*, 3 (1976), pp. 73–87. Also quoted in Levin, *Synchromism*, p. 16.

21. Letter from Morgan Russell to Andrew Dasburg, March 12, 1914. Private collection, New York. Quoted in Levin, *Synchromism*, p. 20.

22. *Ibid.*, p. 26

23. "Les Synchromistes. . . .", *op. cit.*

24. Macdonald-Wright smoothed the crisis by writing Russell that he had Russell's pictures hung in the best spots—Levin, *Synchromism*, p. 28.

25. He was pushed into this decision by eye strain and headaches, and on the advice of a specialist gave up his "vivid color work"—as he described it in a letter to Mrs. Whitney—Levin, *op. cit.*, p. 30. In the summer of 1915 he turned once again to sculpture. However, in France from 1922 to 1930, Russell used the term "Synchromies" on occasion in connection with some excursions into nonobjective painting, especially his *Eidos* series. The *Eidos* were supposed to represent the after images produced in the eye when one has looked at a luminous screen or seen fireworks explode in the air.

26. Thomas Hart Benton, *An Artist in America*, New York, 1937, rev. ed., 1951, pp. 33–34; Thomas Hart Benton, *An American in Art: A Professional and Technical Autobiography*, Lawrence, Kans., 1969, pp. 12–20.

27. Benton, *An Artist in America*, p. 36.

28. Frederick Oswald, Benton's favorite teacher at the Art Institute in Chicago, had introduced him to Japanese woodblock prints. In Paris, Benton continued collecting Japanese prints. Rutgers University Art Gallery, *Thomas Hart Benton, A Retrospective of His Early Years, 1907–1929*, New Brunswick, N.J., 1972, pages unnumbered.

29. Benton could break up objects into different colors when painting in an Im-

pressionist or Pointillist manner, but "when these divisions were enlarged to the size of planes, I found it impossible to retain any drawing. Had I sustained my efforts in this direction, I might have learned to do so; but I might also have slipped into those Cézannesque mannerisms which were to become such widespread and eventually tiresome features of so much modern painting"—*An American in Art,* pp. 22–23.

30. *Ibid.,* pp. 37–38.

31. "My interests became in a flash," Benton wrote, "of an objective nature. . . . I left for good the art-for-art's sake world in which I had hitherto lived. Although my technical habits clung for a while, I abandoned the attitudes which generated them and opened thereby a way to a world which, although always around me, I had not seen"—*An Artist in America,* pp. 44–45.

32. Instrumental in Benton's rejection of modernism during his Navy stay was his rereading of J. A. Spencer's three-volume *History of the United States, from the Earliest Period to the Present Time,* first published in 1858. This helped him toward the idea of producing an art that would be socially relevant and comprehensible to the public at large. Hence his sixty panels, the *American Historical Epic* (only ten were completed), glorified not great men or military events but the common people of America realizing their potential—Mathew Baigell, *Thomas Hart Benton,* New York, 1974, pp. 55, 68, 70.

33. Quoted in Levin, *op. cit.,* pp. 33.

34. Van Deren Coke, *Andrew Dasburg,* Albuquerque, N.M., 1979, p. 41.

35. From an interview with Van Deren Coke, November 1965.

36. Yarrow was born in Glenside, just north of Philadelphia, where he settled. He had no association with the Pennsylvania Academy, only exhibiting in its "Later Tendencies in Art" exhibition in 1921. He must have had contact with Macdonald-Wright in New York. Benton wrote that he was a Philadelphia painter who (like Carles) frequented New York circles—Benton, *An American in Art,* pp. 53–54.

37. In the earlier study, *Synchromism and Color Principles in American Painting: 1910–1930* (New York, 1965), Agee, while acknowledging Frost's and Bruce's debt to Delaunay, still grouped these artists under the broader heading of Synchromism. Levin, in her later study of 1978, places Frost and Bruce off by themselves in her Section 6, where she stresses that they were not Synchromists—see Levin, *op. cit.,* especially pp. 37–42.

38. Confusing the issue further was the Orphists' use of the term "synchrome" to sometimes characterize their paintings. Sonia Delaunay called some of the sketches for her posters "présentation synchrome."

39. Levin, *op. cit.,* p. 37.

40. Levin's interviews with Sonia Delaunay, June 1975 and May–June 1977. *Ibid.,* pp. 39, 123.

41. Postcard from Hartley to Stieglitz, June 20, 1912. Alfred Stieglitz Archive, *loc. cit.*

42. Letter from Hartley to Stieglitz, September 28, 1913, *ibid.*

43. In France, Frost was rather straitlaced, with his father's friend Augustus S. Daggy frequently checking in on him—Henry M. Reed, *The A. B. Frost Book,* Rutland, Vt., 1967, pp. 113–117. After he was back in America, in 1917, he tied in with the English eccentric adventurer Arthur Cravan, and could not really keep up with his antics. Shortly before they were to leave for Mexico to escape serving in the Army, Frost took sick, and soon died—Agee, *op. cit.,* p. 24.

44. Interview with Henry M. Reed, November 14, 1974.

45. Undated letter from Frost to his mother. Henry M. Reed Collection.

46. Interview with Henry M. Reed, November 14, 1974.

47. Letter from Frost to his mother, December 1912. Henry M. Reed Collection.

48. Illustrated in Levin, *op. cit.,* p. 38.

49. Unpublished memoir of Frost by James H. Daugherty. Henry M. Reed Collection.

50. The incident took place when Frost

and Bruce went down to the wharf to see a group of German prisoners who had just arrived. They thought that permission from a sentry permitted their presence at the spot. A French colonel demanded that they leave, and when they stood their ground, Frost was arrested. He was put in jail, tried for espionage, and acquitted—Reed, *op. cit.*, pp. 118–119.

51. When Frost was in France in close contact with Bruce, they would use as models for some of their paintings the photographs in the newspapers they had sent from America. Barbara Rose, "The Price of Originality," in William C. Agee and Barbara Rose, *Patrick Henry Bruce: American Modernist*, New York, 1979, p. 94, n.62.

52. Sarah Stein was studying informally with Matisse when she and Bruce hit upon the idea of persuading him to open a school—*ibid.*, p. 47.

53. Letter from Frost to his mother, June 20, 1913. Henry M. Reed Collection.

54. William C. Agee, "The Recovery of a Forgotten Modern Master," in Agee and Rose, *op. cit.*, p. 21. The source of this information was the interviews conducted with Sonia Delaunay, with Agee in February 1964, and with Rose in February 1978—*ibid.*, p. 41, n.23.

55. *Ibid.*, p. 24.

56. Bruce shipped his *Compositions* to Frost in New York in late 1916. They were shown at New York's Modern Gallery in March 1917, then at the Society of Independent Artists in April–May 1917. Dreier acquired *Compositions I* and *II* and perhaps *VI* in 1918, and *Compositions III*, *IV*, and *V* in 1928—*ibid.*, p. 22.

57. *Ibid.*, pp. 22–25.

58. William C. Agee, *James H. Daugherty* (exhibition catalogue), Robert Schoelkopf Gallery, New York, December 4–31, 1971, pages unnumbered.

59. While there is no evidence of Daugherty's familiarity with Vorticism, he had an Italian friend who, according to his son Charles, may have told him about Futurism—Levin, *op. cit.*, p. 126, n.32.

60. In 1938 Daugherty wrote and illustrated his first children's book, *Andy and the Lion*. Others were *Daniel Boone* (1939), for which he won the Newberry Medal in 1940, and *Abraham Lincoln* (1943). In the 1920s he designed tiles for the New York subway system.

61. Ben Wolf, *Morton Livingston Schamberg*, Philadelphia, 1963, p. 51. Wolf believes of the *Abstraction* of 1915 that the similarity to Delaunay's Orphism is more apparent than real.

62. Irma B. Jaffe, *Joseph Stella*, Cambridge, Mass., 1970. p. 40.

63. *Ibid.*

64. Letter from Andrew Dasburg to his wife, Grace Mott Johnson, October 5, 1913. Collection of their son. Quoted in part in Van Deren Coke, *Andrew Dasburg*, p. 25.

65. *Ibid.*

66. The similarity of the palette in Cramer's *Improvisation* (Figure 86) and in Schmidt-Rottluff's early landscapes is apparent. In his *At the Station* (1908, Kunstkabinett, Stuttgart), that German artist of *die Brücke* used a palette of four colors, too—yellow, green, orange-red, and dark blue. This similarity most likely was not accidental, as Cramer was supposed to have studied with Schmidt-Rottluff before coming to America. *Ibid.*

67. Thomas B. Hess, "Friedman's Tragedy and Triumph," *Art News*, 48 (February 1950), p. 27.

68. Quoted in William Schack, "The Ordeal of Arnold Friedman: Life and Works of an American Jewish Artist," *Commentary*, 9 (January 1950), p. 43.

69. Quoted in Hess, *op. cit.*, p. 59.

70. Telephone conversation with Leon Kelly, May 23, 1980. Kelly was shown in the Hugo Gallery until Mr. Hugo left for Athens, and by Julian Levy when his work took a turn toward Surrealism. He lives now in Loveladies on Long Beach Island off the south shore of New Jersey.

71. Delaware Art Museum, *Avant-Garde Painting and Sculpture in America, 1910–1925* (text by William I. Homer, *et al.*), Wilming-

ton, 1975, p. 86. The section on Kelly was written by H. Nichols B. Clark.

72. Kelly came to find of Cubism that "by its formulated conventionality it seemed to have arrived at an impossibly sterile impasse for the mind." Julian Levy, *Leon Kelly* (exhibition catalogue), International Gallery, Baltimore, February 4–27, 1965. Quoted in Delaware Art Museum, *op. cit.*

4

Some Early Exhibitions, Collectors, and Galleries

The Armory Show of 1913, the Forum Exhibition of Modern American Painters of 1916, and the Exhibition of the Society of Independent Artists of 1917 were critical junctures in the exposure of early American modernist painting to the public.

The Armory Show, in the making from 1911, eventually consisted of some sixteen hundred items—paintings, sculpture, drawings, and prints—of which three quarters were American works.[1]

In 1911, Walt Kuhn, Jerome Myers, and Elmore McRae, three artists who exhibited at the Madison Gallery in New York, met with the director of the Gallery, Henry Fitch Taylor, and came up with the idea of a large exhibition of American art. Out of this modest beginning grew a committee of twenty-five, which called itself the Association of American Painters and Sculptors. The Impressionist painter Alden Weir was elected president, the sculptor Gutzon Borglum vice-president. As a result of internal dissensions, Weir resigned. The Ashcan painter Arthur B. Davies, a man of broad tastes and many financial connections, was elected to take his place, and thereupon the idea of the exhibition was broadened. The committee now stated that the group was "organized for the purpose of holding exhibitions of their work and the best examples procurable of contemporary art, without relation to school, size, medium or nationality."

Walt Kuhn, who had become secretary of the organization, began to negotiate for the use of the Armory of the 69th National Guard Regiment on Lexington Avenue between 25th and 26th Streets in New York. This was in April 1912. In September, Kuhn set out for Cologne to see the Sonderbund Show, an impressive showing of contemporary European modernism, in which Cézanne, Van Gogh, and Munch each had rooms to themselves, and the ascendant Picasso was also included. Kuhn traveled through France, Germany, Holland, and En-

gland, seeing whatever he could of the latest trends. In Paris, with the help of Alfred Maurer, Walter Pach, and Jo Davidson, he contacted dealers and began to arrange for the American installation, then cabled Davies to join him.

Together the pair contacted artists and made the necessary financial arrangements for the transatlantic crossing of hundreds of pieces. Before returning to America, they caught Roger Fry's second modern exhibition at the Grafton Gallery in London. In New York, George Bellows agreed to be in charge of the hanging; William Glackens brought together the American section; and Frederick James Gregg of the New York *Sun* and Guy Pene du Bois saw to the publicity. On February 17, 1913, the show opened in New York's Armory with a playing band and much hoopla. On March 24 it opened in Chicago and on April 23rd in Boston. In these three cities over a quarter of a million people paid to see it.

The Italian Futurists were not represented at all as they had insisted on showing as a group; and the German Expressionists were scantily seen, there being but a single *Improvisation* by Kandinsky, one oil by Kirchner, and a drawing and two sculptures by Lehmbruck. The oldest piece was the *Monk and Witch* by Goya, a miniature on ivory. Arthur B. Davies presented the European section as a continuously spiraling (in terms of radicalism) evolution from Goya, Ingres, and Delacroix through realism, Impressionism, and Post-Impressionism up to and including Fauvism and Cubism. The various artists within this evolution he grouped under three categories: Classicists, Realists (which included Matisse and the Cubists), and Romanticists. In the show there were only two drawings by Ingres, two paintings by Seurat, one painting each by Ingres and Delacroix, and one by Courbet. The European artists represented by the greatest number of items were Van Gogh, Cézanne, Gauguin, the English artist Augustus John, and especially the Symbolist Odilon Redon, who had more than seventy items, including many lithographs. Among the sculptors, Brancusi, Maillol, and Lehmbruck were included. Rodin was represented three-dimensionally only by a single bronze, but there were seven of his pencil and watercolor drawings. The Fauves and Cubists were shown in force. Included of the Fauves were Derain (three oils); Dufy (two oils); Matisse (thirteen oils, including the *Red Studio* and the *Blue Nude;* a plaster sculpture; and several drawings); Marquet (four oils and twelve drawings); and Vlaminck (four oils). Of the Cubists, there were Picasso (five oils, one gouache, a charcoal drawing lent by Stieglitz, and the 1909 bronze, the *Woman's Head*), Braque (three oils, including one of the previous year, 1912), Léger (two oils); as well as Gleizes, Picabia (whose work was greatly admired by the Arensberg Circle), Villon, the Cubist sculptors Archipenko and Duchamp-Villon, the Orphist Delaunay, and Marcel Duchamp, whose *Nude Descending a Staircase* was selected by such conservative critics as Kenyon Cox as deserving special calumny.

The American section was a fascinating mélange of the old and the new,

the tried and the true, and what was then radical in American painting to the art of the early modernists. Included were ten oils by the great visionary painter Albert Pinkham Ryder; four drawings by the neglected nineteenth-century sculptor of tortured, twisting figures, William Rimmer; and oils and watercolors by the American Impressionists then coming into favor, Childe Hassam, Alden Weir, and Theodore Robinson. There were four oils by the pugnacious expatriate James McNeill Whistler, unfortunately none of them from his reductivist *Symphonies* or *Nocturnes*. The Ashcan School and their followers, who depicted street scenes and interiors mostly from Lower Manhattan, were there in force, with paintings by George Bellows, Jerome Myers, Glenn O'Coleman, and all the bona fide members of the group (eight in number), including ten studies of animals made in the Bronx Zoo by George Luks.

The show of the eight painters of the Ashcan School held at the Macbeth Galleries in 1908 had marked the first salvo of rebellion in American painting in this century, although the changes that occurred were made in the subject matter of urban types going about their activities rather than in style. There were works by American painters now forgotten: Jonas Lie, Henry G. Keller, Margaret Hoard, Philip L. Hale, Nathaniel Dolinsky, Edith Dimock, Robert W. Chanler, and others. And there was sculpture by the conservatives Mahonri Young, Jo Davidson, James E. Fraser, and Solon Borglum.

But to return to the Armory Show, on the other side of the ledger the early American modernist painters were also widely represented at the point when native modernism was just beginning to get up steam. John Marin had fourteen paintings in the show, ten of them watercolors, including four versions of the Woolworth Building, and three loosely handled simplified views of the Tyrol done when he had been in Austria in 1910. As yet, there was no evidence of Cubist influence on Marin, or on any other of these American modernists. There were four Fauve paintings by Alfred Maurer, two landscapes and two still lifes, and two early still lifes by Marsden Hartley, predating his involvement with German Expressionism, and six drawings. Morton L. Schamberg, not yet in the period of his machine paintings, showed landscapes and figure studies; and Charles Sheeler, still four years before his Precisionist studies of Bucks County barns, showed mainly flower paintings. Stuart Davis, then under the sway of the political thinking of the Socialist John Reed and the American-scene realism of the Ashcan School, had five watercolors of various New York types and group scenes. There were three oils by Joseph Stella, and five oils and several drawings and watercolors by Abraham Walkowitz, all of still lifes and Ashcan-like genre subjects, predating their Futurist cityscapes later in the decade. Patrick Henry Bruce and Morgan Russell, however, had works shown that were close to their color painting and Synchromist styles—styles they were then in the process of evolving in Europe. Bluemner showed five brightly colored landscapes, and the Zorachs examples of the Fauvism they had recently devel-

90. Armory Show, International Exhibition of Modern Art, 1913.

oped in France. The Philadelphian Arthur B. Carles exhibited two landscapes and the Fauve *Interior with Woman at Piano* (1912–13, Baltimore Museum of Art), which was called simply *Interior*.

Most of the American modernists had no work in the show. These included, among others, the Stieglitz artists Dove and O'Keeffe; the Arensberg artists John Covert (who would be in Paris until February 1915) and Man Ray; the Synchromist Macdonald-Wright and the color painters Frost, Daugherty, Van Everen, Cramer, Friedman; the Precisionists (who were born in the 1890s and too young to show, anyway) George Ault, Spencer, Dickinson, Lozowick, and others; all of the Philadelphia School associated with the Pennsylvania Academy of the Fine Arts except Carles; and such diverse independents as Tom Benrimo, Lorser Feitelson, Raymond Jonson, and Willard Nash (the last three born in the 1890s).

For some of the American modernists, with its panopoly of advanced works the Armory Show was an encouragement to move in directions toward which they were already moving; for others, it was no less than a moment of ecstatic conversion. Counted among the former must be Dove, who in 1910 had painted a series of six nonobjective paintings (without any knowledge of what Kandinsky

had been doing), and the Chicagoan Manierre Dawson, who had been painting nonobjectively even before that and who saw the Armory presentation in his native city. Counted among those directly affected by what they had encountered in the Armory Show was, first, Stuart Davis, who passed from his Ashcan realism to an emulation of the style of Van Gogh (*Landscape*, c. 1916, Mr. and Mrs. Tony Randall), and then to a network of quadrilaterals and partially diaphanous triangles derived mostly from Analytical Cubism (*The President*, 1917, Munson-Williams-Proctor Institute, Utica, N.Y.). Charles Sheeler was another, who fragmented hills and houses (*Landscape*, 1915, Lane Foundation, Leominster, Mass.) after the examples of proto-Cubism (Braque's 1908 *Forest* was in the show) and Analytical Cubism he had seen. Henry Fitch Taylor, who was instrumental in the planning of the Armory Show in its early stages, after seeing the show gave up his Impressionism for a Cubism of flattened, overlapping shapes derived from the art of De la Fresnaye (who had three oils and three drawings in the show), Gleizes (two oils), and the Duchamp brothers. For Tom Benrimo, the show was a revelation, and the facetings of his *Jockeys* (1918, Mr. and Mrs. Arthur A. Collins, Dallas) must be attributed wholly, or at least in large part, to its impact upon him.

Milton Brown wrote that the Armory Show "was without doubt the most important single exhibition ever held in America. It acted on the complacency of American art like a powerful shock. Smug academicians could attempt to ignore it and act as if nothing untoward had happened, but obviously something had happened, something which all the ignoring in the world could not undo."[2] Besides exposing modern art to the public at large as well as to many artists, some of whom became modernists, the Armory Show provided the occasion when the modern works themselves, mainly European, could be purchased by collectors.

The most extravagant buyer at the Armory Show was the Irish lawyer John Quinn,[3] who spent $5,686.75 for works by Derain, Duchamp, Manolo, Pascin, Redon, Signac, Duchamp-Villon, the two oils in the show by his friend Walt Kuhn, and a few works by minor figures. After the Armory Show, he continued to buy. Later in 1913 he acquired from the Stein Collection Matisse's infamous *Blue Nude*. In all, he bought nineteen paintings by Matisse (many from the Montross Gallery), eleven by Seurat, Picasso, more than fifty by Braque, others by Derain, Rousseau, and the Vorticist Wyndham Lewis; and twenty-seven sculptures by Brancusi and by the Vorticist Gaudier-Brzsca. He already owned one Old Master, El Greco's *Christ Driving the Money Changers from the Temple*, which he had purchased for $18,000. European modernism, and above all the French *oeuvre*, was his chief interest. Still, in the end,[4] his collection included works by the American modernists Marin, Maurer, Weber, Hartley, Sheeler, and a good number by his friend Walt Kuhn.

Another lawyer, Arthur Jerome Eddy of Chicago (reputedly the first to own an automobile in Chicago), had his portrait painted by Whistler, about whom he wrote a book, and bought Manet's *Philosopher* when Manet was barely known in the States. When the Armory Show opened in New York, he came to see it, although it had been slated for Chicago too. Spurred on by Quinn, Eddy spent $4,888.50 for eighteen paintings and seven lithographs, which included some of the most radical pieces in the show: Gleizes's *Man on the Balcony*, Picabia's *Dances at the Spring*, and Duchamp's *Portrait of Chess Players* and *King and Queen Surrounded by Swift Nudes*.[5] Like Quinn, Eddy collected beyond the Armory Show. Unlike Quinn's, his collection survived him intact, and most of it passed on to the Chicago Art Institute as the Arthur Jerome Eddy Memorial Collection.

Others who also built their early purchases out of the Armory Show into magnificent collections of modern art were Lillie P. Bliss, Albert C. Barnes, Katherine S. Dreier, and Walter Arensberg, the patron of New York Dada. With them, as for Quinn and Eddy, European modernist works were prized above those of the American modernists—or at least commanded the higher prices.

Lillie P. Bliss purchased lithographs by Cézanne, Gauguin, Redon, Renoir, Denis, and Vuillard—the first of her many purchases in French modernism. Although American modernism did not particularly interest her, she eventually owned works by Arthur B. Davies and Walt Kuhn. In 1929, together with Mrs. Cornelius J. Sullivan and Mrs. John D. Rockefeller, Jr., she founded the Museum of Modern Art, to which she bequeathed her collection.

Preceding the establishment of the Museum of Modern Art was an itenerant collection housed in two rented rooms on New York's East 47th Street. This was the Société Anonyme, founded in 1920 by Marcel Duchamp, Man Ray, and Katherine S. Dreier. (It was called "The Société Anonyme"—meaning incorporated—by Man Ray after the insistence of its guiding spirit, Katherine S. Dreier, that the main idea was to promote "Art, not personalities.") Miss Dreier, though often following the advice of Duchamp, did the financing, made the policies, purchased the works, and was responsible for the programing of the traveling exhibitions, which she took upon herself to promote.[6]

The collection that Miss Dreier assembled differed from those of Quinn, Eddy, and Bliss in that the bulk of it was not French Post-Impressionism, Fauvism, and Cubism. Even Arensberg—who owned many examples of Surrealism, a great many Duchamps and Brancusis, and a smattering of early American modernism— barely touched on the two areas in which she was strongest, namely, Central European Expressionism and Constructivism. Traveling to the Bauhaus, she brought back Kandinskys, Klees, and the *Merzbilder* of Kurt Schwitters. The collection included works by Marc and Campendonk, some of the Italian Futurists, sculpture by the Constructivists Gabo and Pevsner, and a nonobjective painting

by the Dutchman Mondrian. It included, too, early American modernists, who were represented by Man Ray; Schamberg; Joseph Stella, with his enormous *Battle of Lights, Coney Island,* the *Brooklyn Bridge* of 1917–18, and other works; the Stieglitz painters Walkowitz and Hartley; John Covert, with *Time, Vocalization,* and *Brass Band;* the color painters Patrick Henry Bruce, who was represented by five of his *Compositions,* James Daugherty, and Jay Van Everen; and the Synchromist Stanton Macdonald-Wright. There were also works by the more familiar French artists Matisse and Fernand Léger, by Duchamp's brothers Jacques Villon and Duchamp-Villon, and by the Spaniards Juan Gris and Joan Miró.

In 1929, when the Museum of Modern Art was founded, Miss Dreier decided to retire partially to her great house at West Redding, Connecticut. She wrote, studied music, and added a few pieces to the collection. Always the educator, she decided to donate her collection to Yale University in order to inspire those seeing it, and to create in them "an inner moral courage and discipline to be true to the best in themselves."[7] On October 11, 1941, Charles Seymour, president of the university, formally accepted 616 items by 169 artists. Under Miss Dreier's direction, George Heard Hamilton compiled the catalogue, which was finished in 1950, one year before the official dissolution of the Société and two before Miss Dreier's death.[8]

Albert C. Barnes came up with the formula for a silver nitrate, Argyrol, which helped in the treatment of gonorrhea, cystitis, and other ailments, and in 1907, at the age of thirty-five, became a millionaire.[9] In 1910 he looked up his old classmate from Philadelphia's Central High School, the Ashcan painter William Glackens, who introduced him to Prendergast, Demuth, and Maurer, and urged that he spend his money on Impressionist and Post-Impressionist paintings instead of those of the Barbizon School, as he had been doing. Barnes agreed, and in 1912 gave Glackens $20,000 to buy as he saw fit in Paris. Accompanied by Maurer, Glackens acquired a Renoir, a Degas, a Van Gogh, and examples by Cézanne, Monet, Gauguin, Sisley, Pissaro, and Seurat. He then introduced Barnes, who had joined him in Paris, to Gertrude and Leo Stein and the Picassos and Matisses in their collection. When Barnes saw the Armory Show in New York, he bought only a single oil by Vlaminck, as he felt he already owned better works, had seen finer pieces in Paris, and was left unimpressed by the most advanced examples by Duchamp and Picabia.

By the summer of 1913 he was back in Europe acquiring steadily. In 1915 he owned fifty Renoirs, fourteen Cézannes, several Fauve paintings and Picassos. In 1924 the total jumped to one hundred Renoirs; fifty Cézannes, including a large version of the *Bathers;* twenty-two Picassos; twelve Matisses, including the *Joie de Vivre* (in 1930 there were forty); and a large number of works by the leading Post-Impressionists, such as Van Gogh, Gauguin, and Seurat. Among the dealers supplying him in Paris were Vollard, Durand-Ruel, Bernheim-Jeune, and Paul Guillaume.

On a trip to Paris in 1922, Barnes bought several paintings by Pascin, Segonzac, Derain, Gritchenko, Di Chirico, and sculpture by Zadkine. At that time he met the Lithuanian painter Chaim Soutine, from whom he bought, and Jacques Lipchitz, with whom he was to maintain a friendship until Lipchitz asked him to consider buying from an artist friend whose wife needed an operation she could not afford (Barnes insisted that sentiment must never be confounded with quality). In America he acquired as well some works of the early modernists, including Dasburg, whom he visited at Woodstock in 1920; Hartley, whose paintings he purchased in 1921 for only $175 each; Maurer; Sheeler; Carles; and Demuth, from whom he bought the illustrations for Henry James's *Turn of the Screw* and Zola's *Nana,* and some pre-Precisionist Expressionist watercolors like *In Vaudeville* and *At Marshall's* of 1917. Generally speaking, like other collectors, he set the American modernists below the Europeans: he refused to pay the $2,400 that Stieglitz asked in 1930 for a first-rate O'Keeffe, while eight years earlier he had offered Mrs. Havermeyer $10,000 for Renoir's *Mussel Fishers at Berneval*—and was rejected.

By the early 1920s Barnes had assembled in his home in Merion, just outside Philadelphia, the greatest collection of French Impressionist and Post-Impressionist art to be found anywhere in America. In 1925 he officially set his galleries up as a foundation, which he operated as an educational institution open only to those he selected. Today many people in Philadelphia remember Barnes: some as a boorish powermonger who struck out at those who unwittingly offended his overbearing pride, others as a skillful teacher who through his writings and lectures revealed much of what was to be appreciated about his extensive collections.[10]

A collector who amassed a large number of early American modernist works was the lawyer Walter C. Arensberg. He began his buying at the Armory Show by purchasing one lithograph each by Cézanne, Gauguin, and Vuillard, and an oil by Villon. By 1918 he had acquired several Braques and Duchamps, a Schamberg, a Sheeler, Brancusi's *Prodigal Son,* two Rousseaus, a Renoir *Bather* of c. 1917–18, a Cézanne *Group of Bathers,* Picabia's *Physical Culture,* and some Primitive sculpture. He continued to buy steadily. After moving to California in 1922, he added the collection of Arthur Jerome Eddy. Today the Arensberg Collection is especially strong in French classical Cubism (Picasso, Braque, Gris, Delaunay) and certain aspects of European veristic and biomorphic Surrealism (Klee, Miró, Dali). It includes the largest group of Duchamps and Brancusis housed anywhere, as well as many works of the American modernists who visited his apartment at 33 West 67th Street in New York [91]. In this latter group are Covert's *Hydro Cell,* Demuth's watercolor *Bermuda* 1917 and tempera *Lancaster* of 1920, drawings and paintings by Sheeler (the *Barn Abstraction* of 1917 in black conté crayon, etc.), and *Mechanical Abstractions* and other paintings and the sculpture *God* by Schamberg. Among the most famous European works in

the collection are versions of Brancusi's *Bird,* Dali's *Premonition of Civil War,* versions of Duchamp's *Nude Descending a Staircase,* and Duchamp's *Large Glass.* There is also a large group of African and Pre-Columbian sculptures.

In California, the Arensbergs lived for a while in a house built by Frank Lloyd Wright. With his Dadaist activities behind him, Walter Arensberg continued to collect, adding works by Mondrian, Gleizes, Léger, Metzinger, and so on. He put much time into his writing: the *Cryptography of Dante* appeared in 1921, the *Cryptography of Shakespeare* in 1922, and then books dealing with the Francis Bacon controversy—subjects revealing his taste for the esoteric and mysterious. Fiske Kimball, then director of the Philadelphia Museum, first met the Arensbergs in 1947. The collection was willed to the Museum in 1950, three years before Louise Arensberg's death and four before Walter's.[11]

More important than the Armory Show in generating an interest particularly in American modernism was the second great exhibition of the second decade, the Forum Exhibition of Modern American Painters, which was held from March 13 to 26, 1916, in the Anderson Galleries in New York.

The Forum Exhibition was conceived as a challenge to the Armory Show, where it was felt that American modernism was given short shrift. The object, as stated in the catalogue, was "to put before the American public in a large and complete manner the very best examples of the more modern American art," and "to turn public attention for the moment from European art and concentrate it on the excellent work being done in America."[12] The Forum committee consisted of the critic and lecturer Dr. Christian Brinton; the Ashcan artist Robert Henri; W. H. de B. Nelson, editor of *International Studio;* Alfred Stieglitz; Dr. John Weichsel, president of the People's Art Guild; and Willard Huntington Wright, art critic of the *Forum* and author of *Modern Painting: Its Tendency and Meaning.* The sixteen artists who were featured were chosen from among those sponsored by Stieglitz and Charles Daniel. They were: Ben Benn, Thomas H. Benton, Oscar Bluemner, Andrew Dasburg, Arthur G. Dove, Marsden Hartley, Stanton Macdonald-Wright, John Marin, Alfred Maurer, Henry L. McFee, George F. Of, Man Ray, Morgan Russell, Charles Sheeler, Abraham Walkowitz, and William Zorach. The works in the exhibition fell into several styles. There was the Fauvism of Maurer and the broad, flat patternings of Zorach, who had not yet embarked on Cubism; the still Impressionist-based canvases of George F. Of, hardly modernist in a twentieth-century sense; the Kandinsky-inspired *Movements* of Hartley; the Cubist gropings of Charles Sheeler, who had not yet settled upon Precisionism; and, most radical, the organically derived, nonobjective paintings of Dove and the nonobjective Synchromist paintings of Dasburg, Russell, and Macdonald-Wright.

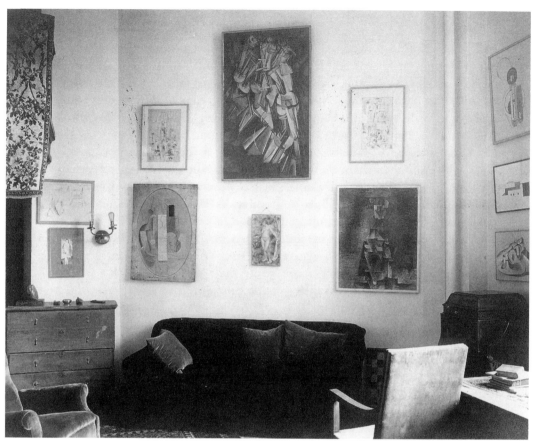

91. Interior of the Arensberg Apartment, New York, c. 1918.

Some of the committee, keenly aware that they were pioneers in bringing to the public an art that was new and unfamiliar, were conciliatory rather than boldly polemical in tone. In his Foreword, Willard Huntington Wright argued that modern art had evolved logically from ancient art through the Renaissance and the nineteenth century. Now no longer was imitation of nature the goal. In modern art it was not the subject that was important but "the inherent aesthetic qualities of order, rhythm, composition, and form." He assured his audience that "Modern Painting is not a fad," and that none of the artists represented was a charlatan or a maniac. Stieglitz was more assertive, for he brought the attack to the public by insisting that the artists must be the leaders. "No public," he wrote, "can help the artist unless it has become conscious that it is only through the artist that it is helped to develop itself. When that is once actually understood, felt, art in this country may have taken root."

In the catalogue of the exhibition, each of the artists had comments on the meaning of his work. A recurrent theme was the divorce of art from a representational intention. Bluemner wrote that "a landscape, as a motive of expression, undergoes a free transformation from objective reality to a subjective realization of a personal vision. Thus the forms, tones, colors we call natural are so changed that the painting harmoniously corresponds to the idea by which it is inspired." Stanton Macdonald-Wright stressed an analogy between his Synchromism and music: "I strive to divest my art of all anecdote and illustration, and to purify it to the point where the emotions of the spectator will be wholly aesthetic, as when listening to good music." And Arthur G. Dove wrote that he would like "to give in form and color the reaction that plastic objects and sensations of light from within and without have reflected from my inner consciousness."

In the years following the Forum Exhibition there appeared collectors who had never bought from the Armory Show and, unlike those who did, took a special interest in early American modernism. The most important of these were Ferdinand Howald, who bought almost exclusively American pieces, and Duncan Phillips.

Howald, born in Switzerland the son of a blacksmith, was moved with his parents to a farm near Columbus, Ohio, when he was one.[13] In 1878 he graduated from the first class of the new Ohio State University, and three years later received his degree in mining engineering. During the next twenty-five years Howald made a fortune in the mining industry of West Virginia, at one time having nine mines under his management. He profited from the stocks he bought during the Panic of 1893. Then in 1906, as the result of the explosion in his Red Ash Mine in which seventy-one lives were lost (he exposed himself by entering the mine and was rebuffed by his employees), he decided to sell out.

Howald had made his first acquisitions in art in 1894, then did not buy again until 1913, when he acquired a portrait by John Opie, the eighteenth-century English artist, and some Renaissance works. In 1915 he visited the Panama-Pacific Exposition in San Francisco, whereupon he sharply increased his schedule of acquisitions. He bought from the National Academy of Design and the New York Watercolor Club, but most of all from the Charles Daniel Gallery, upon which he came to rely, to the tune of twenty-eight paintings in 1916 and twenty-five in 1917. He bought twenty-eight Marins between 1916 and 1924 (including the *Tyrolean Mountains* of 1910, the *Breakers, Maine Coast* of 1917, and the *Sailboat in Harbor* of 1922), and was most responsible during that period for keeping Marin solvent, helping at the same time to force his prices upward, from around $150 per watercolor in 1916 to the $1,200 he had to pay in 1924. (Only Marin of the early modernists, and to an extent Demuth, could command these prices in the mid-twenties.)

Besides Marin and Demuth, Howald's favorite painters were Hartley, Preston Dickinson, and Maurice Prendergast, who does not belong to this study. He amassed thirty-five Demuths, including the stately *Aucassin and Nicolette* and the *Modern Conveniences;* thirty-two Marins; twenty-three Dickinsons (Howald, the ex-mining engineer, who liked Precisionism anyway, was probably especially drawn to factoryscapes, which Dickinson commonly painted); nineteen Hartleys, including multicolored Maine autumnscapes of 1909–11 and the Franz Marc–influenced *Berlin Ante-War* of 1915; eight Sheelers, including a beautifully composed *Bucks County Barn;* seven Man Rays, which he bought between 1918 and 1920, including the nonobjective *Jazz;* and examples of the work of Louis Bouché, Thomas Hart Benton, Elsie Driggs, Macdonald-Wright, Henry L. McFee, Schamberg, Niles Spencer, Weber, Walkowitz, William Zorach, and Dove. He would not buy Georgia O'Keeffe, a fact that prompted a rift with Stieglitz.

Howald collected discreetly, almost anonymously. He did not get to know any of the artists, and to them he remained a mysterious figure. He was not a proselytizer, as were Quinn, Barnes, and especially Dreier, nor did he put his thoughts on art into writing as Eddy, Barnes, Dreier, and Duncan Phillips all did. In 1931, three years before his death, Howald bequeathed his collection partly to his niece, partly to the Columbus, Ohio, Gallery of Fine Arts.

Duncan Phillips settled in Pittsburgh with his parents when he was eight. He attended Yale and majored in English (hence his proclivity for writing). After college he lived with his parents in Washington in the house on 21st Street that was to contain his future collection. In 1907, while he was at college, his parents built the first addition, and in 1916–17 had a skylit gallery designed by McKim, Meade, and White placed over the library. Phillips spent the summer of 1911 in Europe. He visited the Louvre, took an interest in art, and began collecting with his brother in 1916. In 1918, what there was of the collection was incorporated as a memorial to his father and brother, who had both recently

died, tragically close in time. The Phillips Memorial Gallery on 21st Street in Washington has since been renamed the Phillips Collection.

Duncan Phillips's assessment of modern art changed from violent opposition to gradual approbation and, finally, wholehearted acceptance. When he saw the Armory Show, he was aghast, and dubbed Matisse and his followers childish degenerates. In his *Enchantment of Art* of 1914 he praised the Old Masters and would appreciate no one after Corot, whose silvery landscapes he admired. But his *Collection in the Making* of 1926 revealed an aboutface. He had begun to collect the moderns now, American as well as European, and had special praise for John Marin: "He sings of vibrant skies and moving earth forms and luminous, veiled or sharply defined distances. . . . He is not afraid to fail, since he is frankly experimenting on the frontiers of visual consciousness. When he succeeds, he is an impressive master of space and light, and the dynamics of color."[14] In the second edition of the highly revised *Enchantment of Art,* published in 1929, Phillips attributed his changed views to growing maturity in comparison with the shortsightedness of his youth. And in the article "Modern Art, 1930," which appeared in the periodical *Art and Understanding,* he went so far as to argue that Picasso and Di Chirico were the equivalents of Freud and Einstein, since modern art was keeping pace with the brilliant advances in science.[15]

The Phillips Collection consists of great works by mostly great artists, almost all selected personally with a great deal of deliberation by Duncan Phillips himself, works chosen for their intrinsic excellence, with no consideration given to their art-historical importance.[16] The pre-twentieth-century artists represented include, of the Europeans, Goya, Chardin, Constable, Turner, Corot, Renoir (a particular favorite and the most expensive item of the collection is Renoir's *Le Déjeuner des Canotiers,* which Phillips saw for the first time with his wife during their European trip of 1923), Cézanne, Degas, and Van Gogh. Of the nineteenth-century Americans there are Hicks, Homer, Eakins, Inness, and Ryder, in whose *Dead Bird* the paint has been so encrusted as to approximate the texture of rotting flesh. Many of the great European and English twentieth-century artists are included: Picasso, Matisse, Braque, Rouault, Derain, Modigliani, Munch, Kandinsky, Miró, Sutherland, Sickert, Ben Nicholson, Gris, many others, and as fine a group of Klees and Bonnards as can be found anywhere in the country.

The early American modernists whom Phillips collected were Stuart Davis, represented among others by his *Eggbeater No. 1* of 1927; O'Keeffe; Demuth; Hartley; Weber; Sheeler; Alfred Maurer, whose *Abstraction (Still Life with Doily)* is one of the handsomest of all the American Cubist Expressionist paintings; and his two favorites, Dove and Marin. Phillips was the first to collect Dove fervently. Beside several smaller pieces he bought twenty-nine of his major pieces, which ranged from the collages (*Going Fishin', Huntington Harbor I*) to biomorphic stylizations (*Cows in Pasture, Rise of the Full Moon*) to completely nonobjective works (*Primitive Music*). He collected Marin persistently, amassing some

of the finest of his paintings from the 1920s, like the *Maine Islands*, into the 1950s, such as the quasi-Abstract Expressionist *Spring No. 1* of 1953, done in Marin's last year. In 1926, to show the modifications of European Cubism in America, Phillips gave a group show in which he featured Demuth, Sheeler, Dickinson, and Zorach. Thinking of these artists (and probably others of the Precisionists), he asserted in his *Collection in the Making* that the new elements of beauty were to be found in skyscrapers, factories, and machine shops.[17] And through the 1930s, when the more naturalistic approaches of Social Realism and Regionalism were in favor, Phillips kept up his vigorous fight on behalf of modernism, American as well as European.

The Phillipses were intimate friends of Marin, and Duncan Phillips carried on a long correspondence with Dove, in which he encouraged, exhorted, and sympathized with the artist during hard times. So intense and direct an involvement is not to be found on the part of any of the other major collectors. With Dove, this was quite remarkable in that the correspondence had been going on for several years before Phillips and Dove finally met in 1936. Phillips first saw Dove's work in 1922, and made his first purchase in 1926. He alone bought Dove through the 1920s and early 1930s. (William Dove mentioned that his father used to get threatening letters because of his work.)[18] On May 3, 1933, Phillips wrote to Dove: "There is an elemental something in your abstractions, they start from nature and personal experience and they are free from the fashionable mannerisms of the hyperaesthetic and cerebral preciosity of Paris." Marin he venerated. He would often single out that artist, as in the article "Modern Art, 1930," where he poetically observed that Marin "blows through the world of modern art like a bracing wind from the sea or the mountains," and warned that "he requires from the beholder an intuition like his own and an apprehension of the elemental which transcends school and dogma."

Then as now, galleries served as the liaison between the artist and the collector. Outside of Marin and Demuth, who sold easily and at high prices from the mid-twenties, the early modernists typically struggled to sell their modernist paintings (some, like Dove, Daugherty, and Van Everen, could sell their illustrations more easily). The gallery proprietors who showed them helped to further their careers—and at the same time jeopardized their other sales. Most of the galleries showing the early modernists would represent one or two, or a small group. Exceptions, where a broader spectrum was represented, were Stieglitz's three galleries, which functioned also as forums where believers in modernism were proselytized, and the Charles Daniel galleries.

Daniel operated a café and hotel at the northwest corner of Ninth Avenue and 42nd Street. Then, spurred on by exhibitions he saw in 1910 at Stieglitz's 291 (at which he bought Hartleys and two watercolors of Marin for $95), he opened his own gallery in December 1913 on the tenth floor of the building at 2 West 47th Street. In 1924 he moved to 600 Madison Avenue. He represented,

sometimes with other galleries, Bouché, Hartley, Marin, Maurer, Dickinson, Demuth, Blume, Davis, Sheeler, Spencer, Walkowitz, and the Zorachs. He supplied especially Howald, but also Lillie Bliss, Barnes, and Phillips. Daniel kept his gallery open during World War I, when he was especially important, since Stieglitz had closed 291 in 1917 and did not open his Intimate Gallery until 1925. Daniel showed Marin yearly from 1920 to 1925, and Demuth, whose work he did more to champion than anyone else, from 1914 to 1925.

The Modern Gallery, run by Marius De Zayas, opened at 500 Fifth Avenue in October 1915 with an exhibition of works of Braque, Picasso, and Picabia. De Zayas, once part of the Stieglitz Group, did not want to ruffle Stieglitz, and wrote him on August 27, 1915, that he would not replace 291 but would "continue your work with two different methods which complete each other: one purely intellectual at 291 and the other completely commercial at the new gallery.[19] The Modern Gallery during the three years of its existence featured African sculpture and Pre-Columbian art, the work of Van Gogh, Derain, Picasso, Braque, Picabia, Brancusi, Modigliani, and Cézanne of the Europeans; and, of the American modernists, Marin, Dove, Walkowitz, the photographer Paul Strand, Sheeler (who was given his first one-man show in 1918), Schamberg, Bruce, and some lesser lights. Arensberg backed the Modern Gallery, and in turn purchased from it (many Pre-Columbian pieces), as well as from the De Zayas Gallery, which stayed open from 1919 to 1921.

Other commercial galleries that showed early American modernists were more limited in their range. In New York, the Bourgeois Gallery, which opened in February 1914 and was advised by Walter Pach, gave Gaston Lachaise (the sculptor) and Joseph Stella their first one-man shows in 1918. John Storrs, the first American sculptor to work in metal, was given his first one-man show in 1920 at the Folsom Gallery. The Carrol Gallery, supported by John Quinn, championed the Synchromists, and showed Macdonald-Wright and Morgan Russell in 1914. And Morton Schamberg assembled Philadelphia's first exhibition of modern art at the McClees Gallery in 1915. Then, too, certain early modernists were exposed to the public outside commercial galleries. Maurer's special angel was the bookdealer E. Weyhe, who exhibited his work constantly from the early 1920s and served as a faithful friend for that troubled spirit. It was Weyhe who published Phillips's *Collection in the Making* in 1915. John Cotton Dana was one of the most adventurous museum directors in the country. In 1913 he gave Weber a one-man show at his Newark Museum and even had him determine the color schemes for the galleries. It was his policy in 1913, when he had not yet made up his mind about the merits of modernism, to provide the public with the opportunity to see as many painters as possible, however briefly. In the *Newark Museum Bulletin* of that year he ventured that "whatever may be the fate of this development in art, it is today of sufficient importance, if only because of the tempest it has aroused, to warrant . . . careful observation and a little serious thought."[20]

The third great exhibition of the decade—one that would have been beyond the scope of any commercial gallery and even many museums—was sponsored by the Society of Independent Artists. It opened on April 10, 1917, at the Grand Central Palace in New York. While the Forum Exhibition of the preceding year contained only American modernist art, this exhibition, the largest ever held in New York, featured 2,500 works by 1,200 artists from 38 states and several European countries. There was a wide gamut of styles. The makeup of the body of officials reflected the diversity. Two Ashcan artists, William Glackens and Maurice Prendergast, were president and vice-president, respectively; Walter Pach, an artist and critic, was secretary; the Arensberg artist John Covert was treasurer; Arensberg himself was managing director; and on the board of directors were Bellows, Marin, Dreier, Schamberg, Stella, and others, as well as Duchamp (the only European). According to the exhibition's platform, participants were to be anyone who paid the Society the annual dues of $5 and the initiation fee of $1. There were no juries, no awarding of prizes. The works were arranged by alphabetical order of the artists' last names. A few days before the opening, President Wilson had declared war on Germany, and the public saw in this freedom of the arts a counterpart to America's struggle on behalf of democracy. Milton Brown assumed that because the exhibition was held during the war, it was virtually ignored,[21] but Naumann has shown that this was not so. There was much coverage by the press and journals, and a full brass band was in attendance on opening night. Over 20,000 people visited the exhibition during its four-week stay.[22] It is still not certain who originally came up with the idea for the exhibition. Naumann suspects it was Duchamp, who instinctively challenged accepted notions.[23]

Among those shown were the American modernists Bruce, Dove, Demuth, Dreier, Marin, Schamberg, Sheeler, Frost, Maurer, Hartley, Stella, Man Ray, Walkowitz, Weber, and William Zorach. The project proved a financial calamity, for only forty-five works were sold, and the 10 percent commission plus the gate receipts could not cover expenses. John Quinn bought both of the Sheelers.

In spite of the liberal conditions of entry, Duchamp's Urinal, entitled *Fountain* and signed *R. Mutt* after the engineering firm, was rejected as a hoax—and Duchamp in a huff resigned. This rejection was one of the significant aspects to the exhibition, as it underscored a division of interests within the American modernist camp. Even generally sympathetic critics, who could accept nonobjective art as a pleasing kind of decoration, found a Readymade to be beyond their comprehension.

The American modernists who were drawn to the cerebral art of Duchamp and Picabia took different paths from those who were Cubist-oriented or Expressionist at heart. This division found a focus in the two New York salons catering to the American modernist artists, those of Alfred Stieglitz and Walter Arensberg.

NOTES

1. For the planning of the show, a catalogue of the works exhibited, a list of buyers, and so on, see Milton W. Brown, *The Story of the Armory Show,* Greenwich, Conn., 1963.

2. Milton W. Brown, *American Painting from the Armory Show to the Depression,* Princeton, N.J., 1955, p. 47.

3. For a concise treatment of Quinn's habits and tastes as a collector, see Aline B. Saarinen, *The Proud Possessors,* New York, 1958, pp. 206–237.

4. There was one Maurer of 1910: three Hartleys, including the *Musical Theme (Oriental Synchromy)* of 1912–13 (now in the Collection of Brandeis University) and the *Indian Encampment (Indian Composition)* of 1915 (now in the Collection of Vassar College); two Marin watercolors; Weber's *Women on Rocks* of 1911 (Dr. and Mrs. James F. Bing, Baltimore); and nine Sheelers of 1914–17, including *Landscape No. 4* of 1914, *Landscape No. 5* of 1914, and *Landscape No. 1* of 1915 (all in the Fogg Museum), and *Lhasa (Landscape No. 3)* of 1916 (Columbus Gallery of Fine Arts). A detailed record of Quinn's collecting and a catalogue of his collection may be found in Judith Zilczer, *"The Noble Buyer": John Quinn, Patron of the Avant-Garde,* Washington, D.C., 1978.

5. Eddy's purchases are listed in Brown, *Story of the Armory Show,* p. 100.

6. Saarinen, *op. cit.,* pp. 238–249.

7. From Dreier's letter of October 14, 1941, to Charles Seymour, in which she acknowledges Yale's acceptance of her collection. The letter is published in Yale University Gallery of Fine Arts, *Collection of the Société Anonyme: Museum of Modern Art, 1920,* New Haven, Conn., 1950, p. ix.

8. In his Preface, Hamilton pointed out that the collection *is* modern art, for it represents not a historical survey, "but the issues and personalities that made it," and the collection was made by Dreier and Duchamp when there were no institutions dedicated to modern art. The collection "constitutes an heroic struggle for the freedom of expression for the artist"—*Ibid.,* p. xx.

9. The two biographies are William Schack, *Art and Argyrol: The Life and Career of Dr. Albert C. Barnes,* New York, 1960, and Gilbert M. Cantor, *The Barnes Foundation: Reality Vs. Myth,* Philadelphia, 1963. Barnes grew up in a tough section of South Philadelphia; attended Central High School, where his classmates included the Ashcan artists-to-be Glackens and John Sloan; and studied medicine at the University of Pennsylvania. After a year's internship, he traveled to Germany, where he studied philosophy, became interested in chemistry, and met Herman Hille, the son of a Prussian merchant. Teaming with Hille, he came up with the formula for Argyrol. With an initial investment of $1,600, Barnes put his product on the market, and the result was phenomenal: in the first year he made a profit of $40,000, and in the second, $100,000. In 1907, at the age of thirty-five, he was a millionaire.

10. Alternately vying and cooperating with various fine arts departments and institutions, Barnes became increasingly termagant as time went on. A man he met on the street who expressed admiration for the grounds about his house he admitted to the galleries. Abraham Walkowitz, who lambasted his high-handed exclusiveness to his face, was given *carte blanche.* Lillie Bliss, on the other hand, politely asked permission and was told to be at hand promptly at eight in the morning. She was on time, arriving from New York the night before, to find the doors shut tight with no one to greet her. The painter Harold Mesibov, a friend of this writer, tells that when he received a draft notice in 1950, Barnes went personally to the Draft Board and won for him an eight-month deferment. In his theories, Barnes had come under the influence of John Dewey, whose seminar he took at Columbia University in 1917–18. A close personal contact was kept up. Dewey delivered the address at the formal dedication

of the foundation on March 19, 1925, and it was to Dewey that Barnes dedicated his *Art of Painting,* also of 1925, which set forth his theories of aesthetics as an educational system based upon Dewey's teachings. Barnes held that the art produced in any time and place can be qualitatively evaluated through an objective analysis of the artist's use of color, line, and space. Biographical anecdotes, social and economic causes and implications, and the like were completely irrelevant to this evaluation.

11. Walter Arensberg died as the plans for the actual delivery of the collection to Philadelphia were being completed—Philadelphia Museum of Art, *The Louise and Walter Arensberg Collection,* Philadelphia, 1954, Foreword by Fiske Kimball. In the Foreword, dated May 21, 1954, Kimball stated that the collection would open to the public on October 16, 1954; Arensberg had died on January 29, 1954.

12. *The Forum Exhibition of Modern American Painters, March 13 to March 25, 1916,* New York: Mitchell Kennerly, 1916.

13. Edgar P. Richardson gives a biographical account of Howald as the Introduction to the Columbus Gallery of Fine Arts, *American Paintings in the Ferdinand Howald Collection,* Columbus, Ohio, 1969. Marcia Tucker prepared the catalogue.

14. Duncan Phillips, *A Collection in the Making: A Survey of the Problems Involved in Collecting Pictures with Brief Estimates of the Painters in the Phillips Memorial Gallery,* Washington, D.C., 1926, pp. 59–60.

15. Duncan Phillips, "Modern Art, 1930," *Art and Understanding,* I No. 2 (March 1930), p. 138. Phillips felt that there was no need to argue on behalf of modernism, for it had become a "fait accompli" (p. 137). "Art as it was before Matisse and Picasso is interesting only for the museum and its relics. The desire for a stimulating change in the atmosphere of one's home and one's

mind has finally been implemented in us and made to appear as a positive human need" (pp. 136–137).

16. For a history of Phillips's collecting, see Marjorie Phillips, *Duncan Phillips and His Collection,* Boston, 1970.

17. In his estimate of the Precisionist Stefan Hirsch, Phillips wrote: "That fascinating canvas entitled 'New York' employs the third dimension as a factor in design and presents our mechanical age of steel construction and dehumanized industry, symbolized in towering battlements rising in windowless walls above the menace of a black river. It is beautiful in spite of its grimness by reason of the subtle orchestration of marbled tones and skilful organization of the solid boxlike forms. Our civilization is suggested as a fortress manned by invisible armies—and guarded by toy gunboats"—Phillips, *A Collection in the Making,* p. 74.

18. Interview with William Dove, May 1962.

19. Letter from Marius De Zayas to Alfred Stieglitz, August 27, 1915. De Zayas Papers, Collection of Rodrigo De Zayas. Quoted in William I. Homer, *Alfred Stieglitz and the American Avant-Garde,* Boston, 1977, p. 194, and source given in *ibid.,* p. 291, n.47.

20. John C. Dana, "Paintings by Max Weber," *Newark Museum Bulletin,* 3 No. 1 (1913), p. 3. Dana's tastes were remarkably catholic. He urged that products of industrial design be shown in museums—John Cotton Dana, *The New Relations of Museums and Industries,* Newark, N.J., 1919, pp. 8–11.

21. Brown, *American Painting from the Armory Show to the Depression,* p. 67.

22. Francis Naumann, "The Big Show, The First Exhibition of the Society of Independent Artists," Part I, *Artforum,* 17 (February 1979), p. 38.

23. *Ibid.,* p. 35.

5

Precisionism

THE PRECISIONIST AESTHETIC

The decade or so after World War I, when Precisionism took hold, was for America a time of self-absorption, self-congratulation, complacency, and, concomitantly, disentanglement from the affairs of Europe. The war, in which America had been engaged for nineteen months, had proved to be a terrible experience: more than 12 million Americans had been shipped abroad, and of these 53,000 died in battle, and more than 2,500 suffered wounds. In spite of President Wilson's enthusiastic endorsement of it, participation in the League of Nations was voted down by the Senate; and at the beginning of the Harding administration, the government refused even to send observers to the League.

Big business expanded and prospered, while the fledgling labor unions were suspected of radicalism and were stifled. The strike of the steel workers in 1919 was broken after they asked for, among a few other things, one day's rest in seven, the right of collective bargaining, and the abolition of the twenty-four-hour shift. Foreign immigration was cut to a trickle of what it had been during the first two decades. Parochialism had its decided bad effects, such as the revival of the Ku Klux Klan during the Harding administration. Red scares were everywhere. Sacco and Vanzetti, whose guilt was questionable from the start when they were arrested in May 1920 for a payroll murder, were probably prosecuted all the more zealously because they were self-professed anarchists. Nor did the comfortably isolationist America of the 1920s pursue military strength. There was faith in continued peace and prosperity. In 1922, Secretary of State Charles Evans Hughes agreed to a ten-year "naval holiday," which meant America's cessation in building large naval vessels. (Great Britain, Japan, France, and Italy also agreed to limit their navies.) In 1925, the President's appointed Air Board rejected General "Billy" Mitchell's plan for a military air force; he was pilloried by the press and found guilty in a court-martial. Production

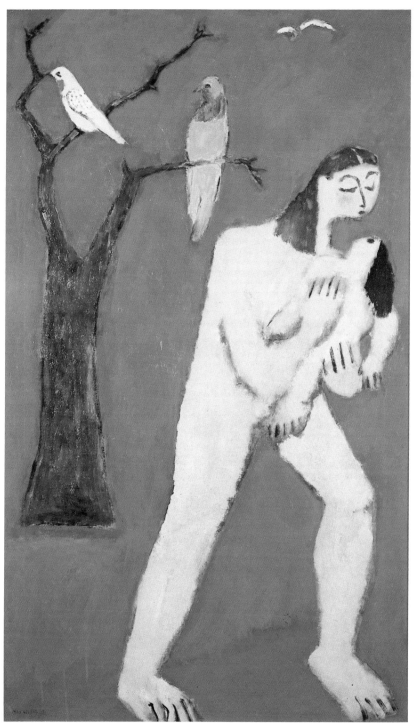

Plate 1. Max Weber, *Fleeing Mother and Child*, 1913.

Plate 2. John Marin, *Sailboat in Harbor*, 1923.

Plate 3. Oscar Bluemner, *Vermillion House*, before 1930.

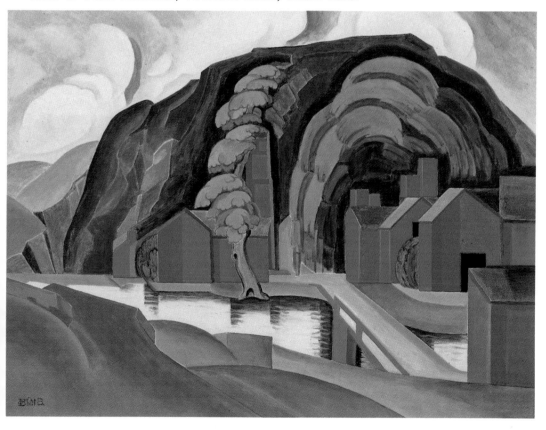

Plate 4. John R. Covert, *The Temptation of St. Anthony No. 2*, 1919.

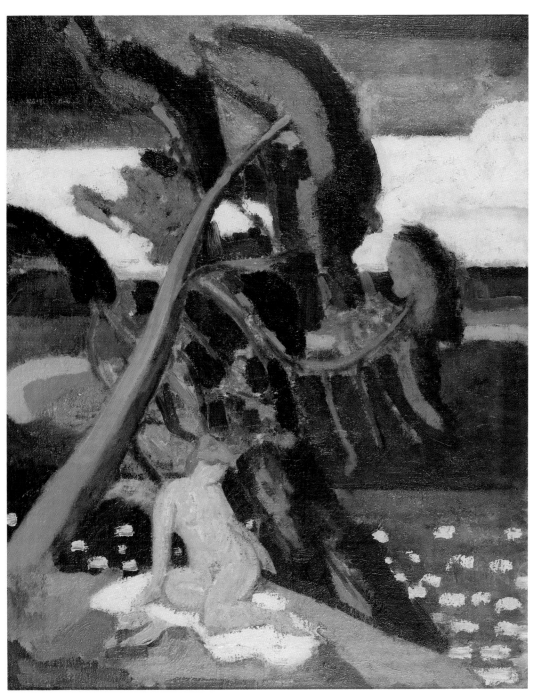

Plate 5. Carl Newman, *Nude Under Tree*, c. 1912.

Plate. 6. William Zorach, *Untitled*, 1912.

Plate 7. Marguerite Zorach, *Landscape*, 1912.

Plate 8. Tom Benrimo, *Chaos*, 1925.

was bent, rather, to the manufacture of mechanical contrivances for a peacetime market—radios, telephones, toasters, electric irons, Hoover cleaners, and Ford cars. Henry Ford developed the assembly-line production of automobiles in his River Rouge plant outside Detroit, where, on May 26, 1927, the 15 millionth Model-T rolled forth. It was this place that Sheeler depicted, all gleaming and silent, in his *Classic Landscape* (1931, Mrs. Edsel B. Ford).

President Warren Harding's genial openness and careless robustness fitted the early 1920s, while "Cal" Coolidge's taciturnness, which really represented a benign satisfaction with the status quo, was applauded in the later twenties. The two greatest popular heroes of the era were homespun, self-reliant types— the self-effacing Charles Lindbergh and the boisterous, salty Babe Ruth. The era had its various levels of creativity and self-awareness. Sinclair Lewis's *Babbitt*, published in 1922, focused on a prevalent American type in the eager but shallow small businessman. In *The Great Gatsby* (1925) F. Scott Fitzgerald revealed that the American dream of success was a deception and nursed elements of self-destruction. But the era's many aspects could not be summarized in one or two types. The 1920s was marked also by the grudging admiration given the bigtime gangster, like Al Capone, who took over the town of Cicero, Illinois; the outburst of an authentic American idiom in music, jazz; the growing independence of women, indicated in its extreme form by the flapper; and the legal institution of "prohibition" in January 1920.

The modernist style expressive of the "Americanism" of the 1920s was Precisionism, or Cubist Realism.[1] This was a thinning out of the complexities of Analytical Cubism through the elimination or virtual elimination of its merging zones and diaphanous passages. Stated positively, Precisionism was a simplification and angularization of form, with the elimination of all or most surface detailing. Precisionism stood as a more naturalistic approach than that found in the more obviously European-based Cubist Expressionist paintings of the second decade or even later. The rearrangement of parts and the breakup of surfaces evident in Weber's cityscapes of the middle teens and (done differently) in Maurer's still lifes and *Heads* of the late 1920s and early 1930s were not part of the Precisionist aesthetic. The forms in the Precisionist painting are hard and brittle. Atmospheric perspective is not provided. Thus the smaller forms meant to be in the distance are as sharply described as those in the foreground. The rendering is linear rather than painterly. The treatment is an impersonal one, and the brushstrokes testifying to the actual application of the paint—the usual evidence of the creative act and the presence of the painter— are not to be seen. Hence the term "Immaculates" which is sometimes given to these painters.[2] Precisionism is a reductive style. The eccentricities and irregularities of the visible world are pared until a certain geometrical core is reached.

Most of Precisionism meant also the choice of a certain kind of subject matter: buildings and industrial structures typical of the American landscape.

These were barns in Bucks County, Pennsylvania (Sheeler, *Bucks County Barn*, 1918, Columbus Gallery of Fine Arts), smokestacks of factories (Dickinson, *Industry II*, n.d., Whitney), buildings within factory complexes, grain elevators (Demuth, *My Egypt*, 1927, Whitney), refineries, bridges (Stella, *The Bridge*, 1922, Newark Museum), skyscrapers, docks, and powerhouses (Spencer, *Power House*, 1936, Lane Foundation, Leominster, Mass.). The Precisionists chose these subjects first for their formal qualities—cleanness of geometrical massing, clarity of line. But there was another qualification as well. The Precisionists were consciously celebrating the America of their time by concentrating on what best typified its power and self-sufficiency: its industrialism.

Things American and things with powerful shapes and crisp detailing—they came to mean the same—drew the attention of the Precisionists. Those same artists who painted factories, steel mills, elevators, and smokestacks painted also Bucks County barns, the medieval Pennsylvania Dutch cloister at Ephrata (Sheeler, *Ephrata*, 1934, Museum of Fine Arts, Springfield), Shaker architecture (Sheeler, *Shaker Buildings*, 1934, Private collection), exteriors of American Victorian houses (O'Keeffe, *Lake George Window*, 1929, Museum of Modern Art), steeples of eighteenth-century Georgian churches (Demuth, *After Sir Christopher Wren*, 1919, Worcester Art Museum; Demuth, *Roofs and Steeples*, 1921, Brooklyn Museum), and nineteenth-century crenellated brick Gothic towers (Ault, *Provincetown No. 1*, 1923, Irwin Bernstein, Philadelphia). In his article on Shaker architecture, Edward Andrews quotes the appreciative response of Sheeler upon entering the Shaker meetinghouse in New Lebanon, New York: "No embellishment meets the eye. Beauty of line and proportion through excellence of craftsmanship make the absence of ornament in no way an omission."[3]

Herein lay a unity of viewpoint and aesthetic choice that bridged the centuries. Vincent Scully has found enduring Precisionist qualities in American architecture, from the Parson Capen House of 1683 in Topsfield, Massachusetts, through the Wentworth-Gardner House of 1760 in Portsmouth, New Hampshire, past the middle of this century in the Munson-Williams-Proctor Institute's Museum of Art by Philip Johnson of 1957–60 in Utica, New York.[4] Precisionist painters readily linked the Precisionist qualities of their work with what they conceived of as the peculiarly American temperamental characteristics of forthrightness, directness, and ruggedness. In her letter to the Philadelphia collector Irwin L. Bernstein, Mrs. George Ault, recalling attitudes of her husband, told how Ault prized American objects and felt a special relevance between his paintings of American buildings and the virtues of his mother, a pioneer woman:

> When Mr. Ault painted "Provincetown No. 1" he and his group were in love with America, seeking it with fresh eyes. In Provincetown, in Woodstock, in the Catskills, and in Maine they were collecting "early American" furniture and objects. With Eugene O'Neil [sic], and Theodore Dreiser and H. L. Mencken (to

mention but a few) they were heady with excitement over the "new art" of the post-war world, and enthusiastically engaged in creating it. . . .

I might add that, in my view, there always was an extra personal element in Mr. Ault's painting of America, deriving from identification with his mother, a pioneer woman, of whom he talked a great deal, and quoted much. I believe this was reflected in his great feeling for Provincetown, and in what the critics referred to as "neo-primitive" painting of the Catskill landscape. . . .[5]

These lines, of course, were not taken from Mrs. Ault's letter to suggest that all or most of the Precisionists had relatives of old American stock, but that behind their taut, static forms and brittle planes there did lurk notions of Americanism.

Beside being a style harboring political preconceptions, Precisionism, in some of its paintings, constitutes a unique way of looking at the world. It was a way that grew out of the style but did not always emanate from it. The Precisionists were sometimes capable of evoking a magical, suspended world, in which activity is absent. People are rarely to be found in Precisionist paintings. When they are, as in Blume's *Home for Christmas* (c. 1926, Columbus Gallery of Fine Arts) and Ault's *Mill Room* (1923, M. H. de Young Museum, San Francisco), they seem as much of a "prop" as the buildings, trees, or machines about them. These people do not act within an environment. They seem as incapable of or uninterested in motions or decisions as the inanimate objects pictured with them. The factories painted by the Precisionists are brand new, and often conjure up the metallic toys made of an erector set. Smoke will never singe their windows, nor will men picket their walls. The objects painted by these artists, whether organic (O'Keeffe, *Cow's Skull: Red, White and Blue*, 1931, Metropolitan) or inorganic, often appear incapable of aging, decay, or change of any kind. And so, too, must America have seemed to its contented inhabitants of the 1920s. The sense of the permanent found in these paintings reflects a vision of America now vanished.

When Sheeler's *Classic Landscape* of 1931 is compared with Léger's *City* of 1919 (Philadelphia Museum), the crystalline character of the Precisionist painting may be observed in its deeper iconographic implication. Sheeler stripped his industrial landscape of its rough edges, of its people, of all signs of activity, to create an airless world of pristine purity. The smoke of chimneys, filtered of its grime and soot—there was no thinking then that the emissions of factories could pollute the air—has become as white as the fleeciest of clouds, and it floats serenely, contrasting with the massive rectangles of the factory blocks below. Perforating Sheeler's factory walls are large windows, but as they are darkened and at a distance from the frontal plane, the observer can gain no access to the activities within. Hence, on the formal level Sheeler did not indicate the shimmering play of light that would have dissolved the clarity of his forms and indicated evanescent atmospheric conditions; and on the iconographical

92. Charles Demuth, *The Govern-ess, Mrs. Grose and the Children,* c. 1918.

level he presented a silent, airless industrialism, whose processes are held frozen and motionless. In Léger's canvas, on the other hand, where the same hard, linear technique prevails, derricks rise and smoke is darkened with soot. Letters of advertisement appear (they do also in some of Demuth's cityscapes), and robot workers move industriously about to a mechanized rhythm.

THE PRECISIONIST PAINTERS

In the second decade, before they had adopted a Precisionist manner, Schamberg (who died in 1918), Sheeler, Demuth, Stella, and Dickinson worked in styles that were more individually expressive, broadly brushed, and/or forcefully colorful. From 1913 to 1915, before his icy paintings of telephones and other mechanical instruments, Schamberg was a color painter. Demuth painted cartoonish-seeming but rather lurid, sexually laden watercolor nightclub scenes (*Negro Girl Dancer,* c. 1916, Dr. Irwin Goldstein); pictures of androgynous acrobats and other circus performers (*In Vaudeville: Bicycle Rider,* 1919, Corcoran Gallery); and illustrations for James's *Turn of the Screw* (*The Governess, Mrs. Grose and the Children* [92]), *The Beast in the Jungle,* Zola's *Nana,* Poe's *Masque of the Red Death,* and other writings of a refined, decadent nature. His work at this time bore a resemblance to George Grosz's paintings of dissolute Germany between the wars. Stella, between 1913 and 1918, was occupied with his *Coney Island* series. Dickinson around 1918 was painting landscapes reminiscent of Franz Marc's *Tyrol* series of 1913–14 (*Composition-Landscape,* Robert H. Fleming Museum, University of Vermont, Burlington) and brightly colored still lifes (*Still Life,* Mr. and Mrs. David I. Orr, Cedarhurst, N.Y.). And Charles Sheeler, who was to become the most deadpan and cool of the Precisionists, in the middle of the decade was painting landscapes in which he attempted to come to terms with Analytical Cubism (*Landscape,* 1915, Lane Foundation). He was trying "to divorce

the object from the dictionary and disintegrate its identity."[6] For all of these artists, Precisionism meant a discipline, a paring of excesses.

Sheeler turned to Precisionism in 1917, the year before the death of his best friend Schamberg, and two years before his move to New York from Philadelphia. His favorite subject at this point was barns in Bucks County, an area of rolling hills some forty miles north of Philadelphia; during weekends beginning in 1910 he had taken a house with Schamberg near Doylestown. In these barn paintings Sheeler omitted all references to the natural setting within which the building stood. He adjusted the proportions of the volumes of the building. His watercolor and gouache *Bucks County Barn* (1918, Columbus) is a dazzling display of economy in its interplay of cuboid masses and various surface textures. In other versions of the subject, he omitted the coloring for some of the planes, thereby flattening the design (*Barn Abstraction,* 1918, Philadelphia Museum). Writing in his "Autobiography" of his barn pictures, Sheeler noted: "In these paintings I sought to reduce natural forms to the borderline of abstraction, retaining only those forms which I believed to be indispensable to the design of the picture."[7]

Doylestown and the surrounding area provided Sheeler with a variety of simple masses and clean-cut silhouettes, firing his imagination and helping bring about his change from Cubist Expressionism to Precisionism. Photographs he took in 1915 of the exterior of a barn and of a stairwell probably in an old house about Doylestown (both Lane Foundation) reveal his predilection for the austere and the architectonic. It was a taste, then, that was made manifest in photography earlier than in painting. After Sheeler moved to New York early in 1919, following the death of Schamberg, he revisited their house in Doylestown, which he maintained until 1923. Thereafter, in spite of his interest in the city, he frequently sought remote areas outside New York; and he found them in South Salem in New York State, in Ridgefield, Connecticut, and later in Irvington-on-Hudson. A *Bucks County Barn* of 1923 [93] (Whitney) is more compact in its massing than the 1917–18 versions, and more abstract in the sense of the isolation of the building from its environmental context. More severe, too, is the elimination of doors and windows.

In the 1920s Sheeler executed a dozen delicately modulated, limpid still lifes containing a few objects on a tabletop, such as a pitcher of flowers and a wineglass (*Dahlias and White Pitcher* [94], 1923, Columbus Gallery of Fine Arts), or a couple of wineglasses and a plate with three pieces of fruit (*Still Life,* 1925, California Palace of the Legion of Honor). Curves are sensitively played off against straight edges; the slowly undulating curve of a pitcher against the steeper curves of the wineglass; the white of the pitcher, in the Columbus still life, against the blue table surface, the tan of the rug, and the nearly identical white of the backdrop of the wall. Most of the objects, as Friedman has shown, are Shaker: the honey-toned table in *Objects on a Table* (1924, Columbus Gallery of

93. Charles Sheeler, *Bucks County Barn*, 1923.

94. Charles Sheeler, *Dahlias and White Pitcher*, 1923.

Fine Arts), for example. Drawing on information from the local collector of Pennsylvania folk art, Dr. Henry Chapman Mercer, Sheeler became quite knowledgeable about the English, Swedish, Shaker, and Pennsylvania Dutch objects revealing tangibly the history of Bucks County.[8]

Sheeler's painting cannot be discussed without reference to his long and fruitful career as a photographer.[9] With Schamberg, he began to work as a commercial photographer in 1912, and thereafter he continued persistently in the medium, producing, with Stieglitz, Paul Strand, Ansel Adams, Edward Weston, Edward Steichen, and a few others, the finest advanced work in America before World War II. Sheeler's photographs may be conveniently grouped into three categories: those commissioned for specific projects, such as his fashion and portrait pictures for *Vogue* and *Vanity Fair* during the 1920s and his work for the Philadelphia advertising firm N. W. Ayer and Son; those done as studies for paintings; and those done for their own end, like the 1915 photograph of a stairwell. The commercial work is extensive, much of it consisting of photographs of paintings and other objects of art. In 1917 Sheeler photographed the African sculpture in Marius De Zayas's collection, and in the subsequent years other pieces. De Zayas, among the most progressive of gallery proprietors, in 1917 exhibited Sheeler's photographs at his Modern Gallery.

In 1921, Sheeler collaborated with Paul Strand in making *Manhatta*, a six-minute film with quotations from Walt Whitman interpreting New York as an architectural entity. In 1927 he spent six weeks photographing the River Rouge plant near Detroit for the Ford Motor Company. Out of the thirty-two prints,

for which he gained an international reputation as a photographer, a number of paintings developed, including the *Classic Landscape* and the *American Landscape* (both 1930, Museum of Modern Art), the *Rouge River Industrial Plant* (1928, Museum of Art, Carnegie Institute), and the *City Interior* (1936, Worcester Art Museum). In 1929 he made a series of fourteen photographs of Chartres Cathedral, most of which showed his usual powerful, elemental forms, but beyond that, a careful rendering of the individual stones, through which the labor expended in building the cathedral is poignantly suggested. In the 1940s Sheeler photographed works of art in the collections of the Metropolitan Museum at the invitation of the director, Francis Henry Taylor. Many of these prints were subsequently incorporated into art books, and used especially to illustrate art studies within the Museum's *Bulletin*.

Photographs in several instances served Sheeler as models for paintings. Often the results were quite happy. Susan Yeh has shown that the conté crayon *Industrial Architecture* (1931, Private collection) is practically a replica of the photograph of the Pulverizer Building (Museum of Modern Art) from the *Rouge River* series, and that the *American Landscape* was derived from the photograph *Storage Bins at the Boat Slip* (Ford Archives, Henry Ford Museum, Dearborn, Mich.).[10] The clever, high-angled view of the buildings, their slanting away from the center of the canvas, and their abrupt cutoff at the tops in *Church Street El* (1921, Cleveland Museum) were taken over from a still from *Manhatta*. The painting as well as the film captures the soaring height of New York—and a little of its oppressing emptiness when the skyscrapers are viewed from above at a distance. Sometimes the paintings were so overloaded with detail as to blur the distinctions between painting and photography, and undermine the abstract cohesion of the forms. Examples are the *City Interior,* derived from a photograph of the River Rouge plant, and a painting of train wheels (*Rolling Power,* 1939, Smith College Museum of Art) derived from a print, *Wheels,* made for *Fortune*. More intense coloration, at times with strident combinations, comes into Sheeler's painting in the 1940s and 1950s, a time when he worked a great deal with color photography. The flat blue, brown, and purple areas in some of these later paintings (*Ore into Iron*, 1953, Lane Foundation) look as though they were based on a color negative.

Some of Sheeler's most successful paintings combine the judicious use of sharp-focus photographic-like detail with tight abstract cohesion. Such a painting is *Upper Deck* [95] (1929, Fogg Museum), one of Sheeler's early ventures into a mechanical subject. (Schamberg preceded his friend in this subject matter by more than ten years.) Part of the shipboard instrumentation was based, distantly, on the photograph of the funnel of the steamer *S.S. Majestic* (Lane Foundation). In the *Upper Deck* Sheeler raised what might have been the banal rendering of instrumentation to an exemplary Precisionist painting through a combination

95. Charles Sheeler, *Upper Deck,* 1929.

96. Charles Sheeler, *View of New York*, 1931.

of emphasis on the geometrical purity of forms and the intricacy of their interplay, clever overlappings and variations of lighting, and the eccentric point of view. He wrote, referring to this painting: "This was the inauguration of a period that followed for a good many years of planning a picture very completely before starting to work on the final canvas, having a blueprint of it and knowing just exactly what it was going to be. . . ."[11]

Of his *View of New York* [96] (1931, Museum of Fine Arts, Boston)—an interior containing parts of chair and a photographer's table, a lamp, and an open window facing out to a sky streaked with fleecy clouds—Sheeler wrote: "It is very uncompromising; some might call it inhuman. It is the most severe picture I ever painted."[12] There is little modeling, the objects appearing as dark shapes rather than as three-dimensional and tangible. The depth of the room is not expressed: the walls, floor, and ceiling, through which the room's perspectival pull would be indicated, are all eliminated, so that the wall at hand and the window in it together function as a screen against which the shapes are set. In photographic terms, there is a virtual elimination of depth of field. But as silhouettes, the objects are made to interrelate. The round lamp corresponds in shape to the wheel; the rectangular back of the chair tilted to the plane of the back wall, to the rectangular frames of the half-opened window, as well as to the section of space framed by the press. Working only with these four objects, Sheeler has effectively filled the canvas without overcrowding it. There is ample

breadth and spaciousness, without a sense of emptiness, a human proportionality arguing against Sheeler's own suspicion of inhumanness.

Demuth first went to Provincetown in the summer of 1914. It was the time there of the Provincetown Players and the theater movement. He became friends with Eugene O'Neill, the Socialist John Reed, Stuart Davis, Hutchins Hapgood, Louis Holliday and his sister Polly, Hippolyte Havel, and others.[13] He returned to Provincetown in the summer of 1916, this time with Hartley (a fellow homosexual), who accompanied him to Bermuda in the fall of 1917. Attracted by the trim crispness of Bermuda's eighteenth-century houses, Demuth painted pale watercolors of architectural landscapes in which the buildings, in a near-Cubist fashion, were made to integrate partially with the surrounding hilly landscape. Blottings were used, making for subtle grained textures, as well as ruled lines, setting off various planes, which were dislocated and allowed to float free in space (*A Red-Roofed House*, [97] 1917, Philadelphia Museum; *Old Houses*, 1917, Los Angeles County Museum of Art). The inspiration for this style came from the late landscapes of Cézanne, which Demuth saw in Albert Barnes's collection. In Bermuda and in Provincetown Demuth painted also the schooners and sailboats he saw moored and sailing about the harbors and coves. At this time his watercolors used raylike diagonals, which morphologically were like the Italian Futurists' "lines of force," but functionally lacked their shattering power. These ray-lines enriched the surface and provided certain structural emphases by repeating the lines describing edges of roofs and other parts of buildings and sails of boats (*Bermuda No. 2 [the Schooner]*, 1917, Metropolitan). In some of the most extreme of these paintings from the end of the second decade, Demuth intermingled boat sails with the roofs and clapboard siding of wooden houses—a treatment found in his conception of *Gloucester* [98] (1919, Museum

97. Charles Demuth, *A Red-Roofed House*, 1917.

98. Charles Demuth, *Gloucester*, 1919.

of Art, Rhode Island School of Design), an old fishing town on the Massachusetts coast north of Boston.

In 1919 Demuth passed out of his Cézannesque phase, and painted cityscapes of Georgian churches and factoryscapes which, in a Precisionist manner, were more tightly constructed. For the former he characteristically used tempera; for the latter, oil. The churches were in and about Demuth's native Lancaster, Pennsylvania (*After Sir Christopher Wren*), a place he loved for its Old World flavor and where he kept his residence with his mother, Augusta, in spite of his voyages and frequent trips to New York, Provincetown, and elsewhere. He needed his mother's nursing because he was seriously ill with diabetes, as he had learned while in France in November 1921.[14]

The industrial sites Demuth chose for his factoryscapes and the residences for his cityscapes were also in and about Lancaster. S. Lane Faison, Jr., has discovered several of them, and has shown, through photographs, the changes Demuth made in his paintings.[15] In *My Egypt* [99] (1927), a picture of the John W. Eshelman and Sons grain elevators, the store at the foot of the structures has been eliminated and the chimney attached to them made more prominent. The *End of the Parade, Coatesville* is a picture of the Lukens Steel Company in Coatesville, a small city on the Philadelphia side of Lancaster. The watertower and smokestack of *Aucassin and Nicolette* are a combination of the superstructures of the Lorillard Factory and an old cotton mill, both in Lancaster. *Modern Conveniences* (1921, Columbus Gallery of Fine Arts) is based on the view of house walls taken from the garden of Demuth's own house on King Street in Lancaster. The planes of those walls have been flattened to reduce the horizontal projections, the iron fire escapes have been emphasized, and a salient chimney has been introduced (or perhaps that chimney no longer existed when Faison made his photograph). And another painting not considered by Faison, the *Paquebot, Paris* (1921, Columbus Gallery of Fine Arts), is a design of the funnels and smokestack of the steamship *Paris* on which Demuth returned to America from France in 1921.

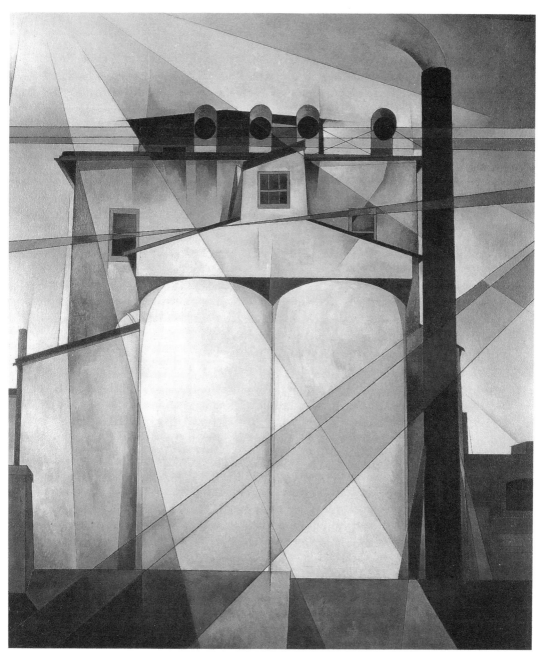

99. Charles Demuth, *My Egypt,* 1927.

Like the other Precisionists, Demuth simplified forms and chose those that were severely geometrical to begin with. But within this format he managed a surface enrichment, a textural complexity that was unique. The ray-lines used with abandon in the 1917–19 period persisted, though they were now more contained by the picture's geometries. In *After Sir Christopher Wren*, the "beams" play gently across the front of a house and the steeple of the Georgian church. In one place where they touch a shutter, they cause the wood to appear as though it had been partially over-painted; in another where they touch a window, they cause the pane to appear frosted. Below each "beam"—so called because Demuth's wedges act as transparent substances—surfaces take on nuances and colorations differing in texture from adjacent surfaces, the surfaces of wood in *After Sir Christopher Wren* and of concrete in *End of the Parade, Coatesville*. Occasionally, the ray-lines have a basis in fact. In *My Egypt* [99], where they play across the grain elevators as beams of searchlights, they have been assimilated near the top of the canvas into the form of telephone wires; and in *Aucassin and Nicolette*, the ray-line has become a blast from the chimney. In some of his cityscapes, Demuth achieved a further surface richness through his introduction of lettering. *Rue du Singe Qui Pêche* (1921, Bernard Heineman, Jr.), loosens commercialism's advertisement signs from their wall moorings; wafted on an invisible wind, they float free before the paneless windows of hotels. In *Buildings, Lancaster* (1930, Whitney) an Eshelman billboard-like sign, three stories high, is attached to the facade of a factory.

Demuth's attitude toward the bourgeoning industrialism of the twenties is not easy to get at. It might best be described as a distant bemusement. He was fascinated by industrialism, as his many paintings of it would indicate. He viewed it neither wholly acceptingly nor with distaste, but with a special obliqueness that can be identified in none of the other Precisionists. His was an overly refined sensibility. Physically slight and hampered by a slight limp caused by a hip injury suffered when he was four, Demuth held Proust as his favorite author when he was young. His home in Lancaster was filled with Victorian bric-à-brac. During the 1920s, in an age that valued extroversion and robustness, Demuth was an alien spirit even for an artist. Rita Wellman, his fellow student at the Pennsylvania Academy, wrote: "He prefers the wooden and plush era to the monel metal and leather one, and cannot be enthusiastic about the creations of any modern decorators, with the exception of Djo Bourgeois. . . ."[16] The titles Demuth gave to some of his factoryscapes (*Incense of a New Church, Nospmas M. Egiap Nospmas M., My Egypt, Aucassin and Nicolette*, etc.) are clever or somewhat ironic asides, which deny industry its hard edge. (The impact made by the Arensberg Circle at the end of the second decade and Demuth's short literary career at its beginning[17] help to account for these titles.) Then there is Demuth's style for the factoryscapes, above all else—the extraordinary delicacy, even preciosity of the surfaces and the softness of the colors. In *My Egypt* [99],

for instance, the grain elevators are a soft gray set against a turquoise sky, rather than a gleaming metallic tone. The refinement with which Demuth endowed his industrialism made it a thing in consonance with his own being but quite unlike itself.

In the unabashed, unconstrained enthusiasm—probably reverence would be the more accurate term—with which he came to regard industrialism, Joseph Stella was the diametrical opposite of the rarefied, aloof Demuth. No other American modernist attained the pitch of his empathy, the exaltedness of his appreciation. Stella would stand on the Brooklyn bridge at night, peering into its surroundings, as he writes in his autobiographical essay, "Brooklyn Bridge; A Page of My Life":

> Many nights I stood on the bridge—and in the middle alone—lost—a defenseless prey to the surrounding swarming darkness—crushed by the mountainous black impenetrability of the skyscrapers—here and there lights resembling suspended falls of astral bodies or fantastic splendors of remote rites—shaken by the underground tumult of trains in perpetual motion, like the blood in the arteries . . . I felt deeply moved, as if on the threshold of a new religion or in the presence of a new DIVINITY.[18]

Stella's *Gas Tank* [100] (1918, Roy R. Neuberger, New York) contains reminders of the *Coney Island* series in the streamers at the bottom and in the prominent light beams. The painting is colored deep blue and black, the color of smoke and soot, pierced here and there by fiery reds; and the gas tank itself is made out with a little difficulty through the polluted atmosphere enveloping it. Stella knew at first hand the steel and coal industries centered in Pittsburgh and West Virginia. Early in the first decade he made drawings of immigrants and factory workers, and the life they endured (*Coal Pile*, c. 1902, Metropolitan). In 1907 he visited West Virginia and in 1908 Pittsburgh to do pictures of the mining environment. The Pittsburgh steel mills seemed to Stella "like the stunning realization of some of the most stirring infernal regions sung by Dante."[19]

But nothing in America moved the Italian immigrant as much as the Brooklyn Bridge. In writing of his painting of that structure (1917–18, Yale University), he rhapsodized: "I appealed for help to the soaring verse of Walt Whitman and the fiery Poe's plasticity. Upon the swarming darkness of the night, I rung all the bells of alarm with the blaze of electricity scattered in lightenings down the oblique cables, the dynamic pillars of my composition, and to render more pungent the mystery of the metallic apparition, through the green and red glare of the signals I excavated here and there caves as subterranean passages to infernal recesses."[20]

In the *Brooklyn Bridge* of 1917–18, the spectator is placed so that he looks directly into the mawlike opening of the spanning cables. The structure is pre-

100. Joseph Stella, *Gas Tank*, 1918.

sented symmetrically, with much care given to the rendering of the raylike cables and the filigree wires, and the cathedral-like tower at the far end beyond which the skyscrapers can be faintly made out. But the dramatic play of light and dark, and the colors—violet blues and blacks alive with quivering areas of yellow, yellow-green, and oranges at the bottom—somewhat obscure the meticulous draftsmanship. Color glows within color, to create Stella's "caves as subterranean passages to infernal recesses." But, more than caves, it is some uncanny mechanical animus, its life palpitating from within, that has been brought forth.

In the *New York Interpreted* group (1920–22, Newark Museum, N.J.) the drawing and the carefully sectioned areas intrude themselves over the glowing color. The space in each of the five paintings has been somewhat flattened, so that each takes on the look of a gigantic, elaborately detailed architectural rendering. Also Stella set up this *New York Interpreted* group as a kind of medieval or early Renaissance polyptich, with a taller central panel, *The Skyscrapers* [101] (1922), based on the triangular Flatiron Building, flanked by two paintings entitled *The White Way*, alluding to Manhattan's theater district, and these, in turn, flanked by *The Port* on the left and *The Bridge*, based on the Brooklyn Bridge, on the right. Probably by using this traditional polyptich form, he sought to endow his theme of the mechanistic panorama of New York with a hieratic dignity.

Stella tells that in preparation for the *New York Interpreted* ensemble he

101. Joseph Stella, *The Skyscrapers*, 1922.

102. Joseph Stella, *The Bridge*, 1922.

wandered about the metropolis, mostly at night, to find "the most salient specta-
cles," and came upon them at the Battery, when there flashed before him "the
skyscrapers, the port, the bridge, with the tubes and the subways."[21] Within
the five panels, without the inclusion of a single figure, Stella caught the character
of the concerted industrial activity, electrically vibrant yet functioning in a perfect
rhythm through the smooth interworkings of its components, like an enormous
well-oiled machine. He described the five panels as the five movements of a
big symphony—"a symphony free in her vast resonances, but firm, mathemati-
cally precise in her development . . . highly spiritual and crudely materialistic
alike." In all five panels the scene takes place at night, since it was at night
that Stella wandered about the metropolis; and besides, he observed that "the
depth of night tempers and renders mysterious the geometrical severity. . . ."[22]

The taller central panel, *The Skyscrapers*, [101] Stella saw as a break in
the rectangular monotony of the ensemble. Blazing below the buildings are
rows of electric lights, protruding like "two wings ready for flight."[23] In *The
White Way, I,* working against the flattening of space established by the complex
patterning of forms, Stella used a strong perspectival pull expressed through
the recession of rows of razor-thin verticals, suggesting the walls of skyscrapers,
or the scaffolding of a theater's backstage area. In *The Port*, there are cables,
girders, ships, "the emerald of the water," factories, and klieg lights, whose
beams coalesce within the design like the ray-lines in the contemporary Precision-
ist cityscapes of Demuth. *The Bridge* [102] in *New York Interpreted* is clearly based
on Stella's special obsession, the Brooklyn Bridge. It is the structure within
the five panels that is most clearly recognizable, and the only one to which an
entire panel (or nearly so) has been devoted. As opposed to the situation created
in the 1917–18 version at Yale, the spectator does not now look into the maw
of the bridge but, situated above it, is made to gaze upon the great span of
the cables gleaming forth out of the darkness. "The bridge arises imperturbable
with the dark inexorable frame among the delirium ranging all around the temer-
arious heights of the skyscrapers and emerges victorious with the majestic sover-
eignty sealed on his arches . . . ," as Stella wrote.[24] In 1939 he painted a version
(Whitney) close to *The Bridge* in the *New York Interpreted*, except that in the predella
there is a vignette of the city instead of a tube of light, and the arrangement
is more schematic and symmetrical. Jaffe believes that Hart Crane based his
poem "The Bridge" on Stella's *Bridge* in the *New York Interpreted* series, a poem
that seizes upon the arching position and dwells on the imagery of cables and
wires:

> Through the round cable strands, the arching path
> Upward, weaving with light, the flight of strings,—
> Taut miles of shuttling moonlight syncopate
> The whispered rush, telepathy of wires.

Up the index of night, granite and steel—
Transparent meshes—fleckless the gleaming staves—
Sibylline noises flicker, wavering stream
As though a god were issue of the stream . . .[25]

Atypically for the Precisionists, Stella envisioned industry as active and forceful. While working on the *New York Interpreted,* he painted factories as sharply contoured silhouettes, looming against a night sky, in which beams of light crossed and crisscrossed (*Factories,* c. 1921, Art Institute of Chicago), or outlined against a sky clouded with the emissions of their smokestacks—emissions seen by Stella as evidence of energy and productivity, not negatively as pollution (*Smokestacks,* c. 1921, Indiana State University, Terre Haute).

Stella was the only one of the Americans who drew directly from the Italian Futurists, whose exaltation toward the machine he naturally assimilated. And Louis Lozowick (1892–1973), who was born in Kiev, where he began his art studies before coming to America in 1906, was the only one to have come into direct contact with the Russian Constructivists, whose admiration for the achievements of science and industry in providing for a rationally efficient urbanism paralleled his own.

In 1912, a dozen years after Walkowitz and Hartley, Lozowick studied at New York's National Academy of Design. From 1915 to 1918 he attended the Ohio State University, from which he graduated Phi Beta Kappa. Among his teachers was the renowned historian Arthur Schlesinger, Sr. In 1918, after graduation, he served with the U.S. Armed Forces, and was stationed in Charleston, South Carolina. He had already seen a good deal of America. But in 1919, before leaving for Paris at the end of that year, he toured the country extensively, visiting the places that would feature in his series of *Cities.* These included, besides New York, Butte, Chicago, Cleveland, Detroit, Minneapolis, Oklahoma, Panama, Pittsburgh, and Seattle. The series came to be done in three stages: the sketches, from about 1922 to 1923; the lithographs, from about 1922 to 1925; and the larger paintings after his return from Europe, from about 1924 to 1927.

Lozowick remained in Europe from late 1919 until 1924. Shortly after reaching Paris, he left for Berlin, where he began his *Cities* series. In 1922, as a member of the *Novembergruppe* organized by Max Pechstein and Cesar Klein, he was given a show of *The Cities* in Berlin's Twardy Gallery. In Berlin he became friendly with the Russian expatriate El Lissitsky; and on a short trip to Russia in 1922, he had contact with the Suprematist Kasimir Malevitch and the Constructivist Vladimir Tatlin. In 1922, both in Berlin and in Moscow, he saw the first Russian exhibition of the Russian Constructivists, whose aim he found to be the creation of "a new esthetic approach to the civilization of today—a new plastic interpretation of the machine age."[26]

Lozowick did not attempt to express the city's vertiginous rush and speed, showing nothing of the activity of lights and billowing smoke found in Stella's work, but instead the marvelously integrated complexity of its well-articulated parts, all held frozen and motionless. As with most Precisionist paintings, no human beings appear within the immensity of Lozowick's urban landscapes. They were exhibited at the Machine Age Exposition held in 1927 at Steinway Hall in New York, for which Lozowick wrote an essay for the catalogue he called "The Americanization of Art." In it, proclaiming proudly: " 'Ah, America,' they say, 'wonderful machinery, wonderful factories, wonderful buildings,' " he ventured that "the dominant trend in America of today . . . beneath all the apparent chaos and confusion is towards order and organization which find their outward sign and symbol in the rigid geometry of the American city: in the verticals of its smoke stacks, in the parallels of its car tracks, the squares of its streets, the cubes of its factories, the arch of its bridges, the cylinders of its gas tanks."[27] Lozowick's statement and the *Cities* themselves confirm his faith during the 1920s in the viability of the American city, a faith he no longer held to as fervently in 1972.[28]

The brittle, gargantuan, simplified structures in each of the *Cities* typified the characteristic feature of each locale, to provide, throughout the series, a panoramic sweep of America. For *Oklahoma* (1926–27, John, Norma, and Lisa Marin), he painted oil wells; for *Butte* [103] (1926–27, Hirshhorn Museum and Sculpture Garden), copper mines and refineries; for *Chicago* (1923, Lee Lozowick, South Orange, N.J.), the tall buildings and the elevated of the Loop; for *New York* (1926–27, Walker Art Center), the buildings one above the other, like the cells of a honeycomb, and a section of the Brooklyn Bridge in the lower left; for *Panama* (1926–27, Hirshhorn Museum and Sculpture Garden), the Canal, with its locks, wharves, barges, and ships; and for *Seattle* [104] (1926–27, Hirshhorn Museum and Sculpture Garden), the tall buildings and aspects of the logging industry, with its crates, logs floating down the river and others being ferried off to the sawmill.

From the 1920s the versatile Lozowick was active as a set designer and writer, as well as a printmaker, illustrator, and painter. His sets, such as the one made for Kaiser's *Gas* staged by Chicago's Goodman Theater in 1926, were based on machine fantasies and were among the most adventurous designed in America during the 1920s. They had been inspired by the Constructivist stage sets he had seen in 1922, including those created by Frederick Kiesler for Karel Capek's *R. U. R.* staged in Berlin.[29] From 1926, when he began an association with the Communist periodical *New Masses*, Lozowick tended to show the city not as an abstract entity of streets, buildings, and bridges, but as people functioning within an environment (*Subway Construction*, lithograph, 1931, Mr. and Mrs. Walter Levine). This marked the beginning of a change. After a trip to Russia in 1932, he frequently made statements of social protest through

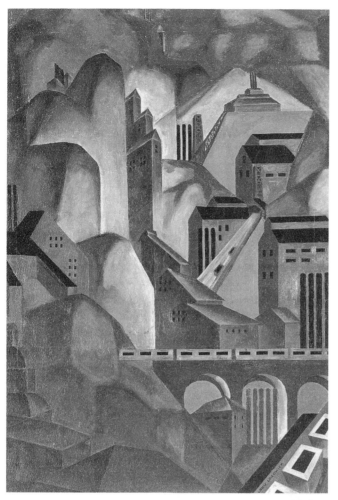

103. Louis Lozowick, *Butte*, 1926–27.

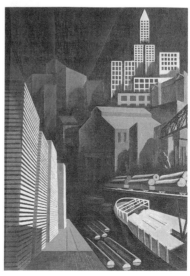

104. Louis Lozowick, *Seattle*, 1926–27.

his art, dealing blatantly with the problem of unemployment and hunger brought on by the Depression. With Ben Shahn, William Gropper, and others, he became part of the Social Realism dominant during the 1930s, the only one of the Precisionists to follow in this direction.

Although Precisionism, with its angular geometrical reductiveness, was a style more amenable to the depiction of buildings, bridges, viaducts, and machinery, it had sufficient scope to admit organic subject matter. Sheeler's plants are always domesticated: set within a room's interior the flowers have been placed in a vase or pitcher, the cactus plant within a planter or pot (*Cactus*, 1931, Philadelphia Museum). Spencer's bits of shrubbery or trees are always dwarfed by buildings or are mostly obscured by them (*Houses, Bermuda*, 1931, Mrs. Catherine Brett Spencer). Ault's trees are little more than leafless stumps, whether shown in the winter (*Brooklyn Ice House*, 1926, Newark Museum) or in the summer (*Woodstock Landscape*, 1938, Brooklyn Museum). Nature, then, could not be allowed by the Precisionist to overrun, or even to stand on a par, with what the engineers and planners had wrought.

The blatant exception to all this are the flower paintings of O'Keeffe, in which the flower, solitary and powerful, has pushed everything out—a fence, grasses, pebbles, a bit of soil—of its environmental context. To classify these paintings as Precisionist is to stretch the definition, but only a little. If the angularization of buildings and machines and the distinct distant objects are not there, the crisp, anonymous handling and the closeup of the object are.

The flowers—hollyhocks, red poppies, calla lilies, jacks-in-the-pulpit, irises—were those O'Keeffe came to know about Lake George in upstate New York, where she and Stieglitz occupied a farmhouse on Stieglitz's family estate. She liked to stay on from April until late in the fall. The unaccustomed largeness and immediacy of the flowers shock the observer, who is used to seeing them small and as a peripheral part of the picture. O'Keeffe wanted them to seem self-contained, to be for the observer as the whole world. Because people, O'Keeffe found, do not take the time to look at a flower, she was determined to "paint it big and they will be surprised into taking time to look at it—I will make even busy New Yorkers take time to see what I see of flowers."[30]

Most of the flower paintings were done as isolated studies (*Red Poppy*, 1927, Daniel Catton Rich; *Two Calla Lilies on Pink*, 1928, Georgia O'Keeffe). *Jack-in-the-Pulpit I–V* (1930, all Georgia O'Keeffe) were conceived as sequential stages, of a sort, of the single flower. These are not the stages of the flower's growth, as O'Keeffe envisaged with her *Black Iris* of 1926, where the crispness of the Precisionist flowers is missing, but the movement of the observer as he comes closer and closer to the flower, and consequently sees less and less of it. There is a gradual diminution of scope and expansion of scale: the *No. II* features a giant plant; in *No. IV* there is a further magnification; until in *No. V*

where, in O'Keeffe's words, "the last one had only the Jack from the flower,"[31] the very identity of the flower is lost.

Because of the deep folds, prominent curves, and fleshlike surfaces of the petals, both in color and texture, the observer regularly finds in O'Keeffe's flower paintings sexual metaphors. O'Keeffe herself, however, is impatient with those who would find layers of meanings in these paintings: "I made you take time to look at what I saw and when you took time to really notice my flower you hung all your own associations with flowers on my flower and you wrote about my flowers as if I think and see what you think and see of the flower—and I don't."[32]

Nothing in Precisionism is quite as startling as O'Keeffe's closeup flowers. Such extreme closeups, coupled with the isolation of the subject, occur also in photographs in the 1920s by Stieglitz, Paul Strand (1890–1976), Edward Steichen (1879–1973), and Edward Weston (1886–1958), so that it is possible O'Keeffe may have benefited from their example. In Maine, Strand liked to photograph details of rocks (*Rock, Georgetown, Maine*, 1927), driftwood, and plants. His photographs in New Mexico of Taos churches starkly isolated against a bare backdrop (*Ranchos de Taos Church, New Mexico*, 1931) endowed the subject with an awesome grandeur never before revealed, and were similar to O'Keeffe's treatment of that subject at about the same time. He was one of the first photographers to concentrate on the geometric beauty of precision machinery, making prints of the subject in the early 1920s (*The Lathe*, 1923), some five years after the machine paintings of Schamberg. Steichen, best known for his photographs of celebrities, could make a print of an isolated flower (*Lotus*, 1922) that is remarkably similar to O'Keeffe's painted flowers.

The Californian Edward Weston worked with large contact prints. He deplored enlargements, fearing loss of detail, and so used a large 8 × 10-inch view camera. Among his subjects were rounded, eroded rocks, lying white against a gravelly earth, so that they appeared somewhat like a human torso; and a pepper (*Pepper, No. 30*, 1930, George Eastman House), overwhelming, filling almost all the space of the print, so that, in Weston's words, "it is classic, completely satisfying. . . ."[33] Echoing Stieglitz's sentiments that a subject must retain its identity and excite through its own uniqueness, through the thingness of what it is, he wrote that "to see the Thing Itself is essential: the Quintessence revealed direct without the fog of impressionism—the casual noting of a superficial phase, or transitory mood."[34] In this statement, Weston has gotten at the key not only of most of his own photography but of much Precisionist painting: the portrayal of a thing as immutable, timeless, incapable of decay. Weston drew most of his subjects from natural objects, which, before being photographed, would not have seemed noteworthy. In 1927 he did a series on shells (*Shell*, 1927, George Eastman House), some of which transcend the subject to appear as part of the human body, to be erotically stimulating, like some of

the flowers of O'Keeffe. In 1930 he photographed a halved artichoke, which appears like the inside of a cave or the lining of a human organ.

O'Keeffe would have had ample opportunity to see the photographs of these men, as they all had associations with Stieglitz. In 1900, Stieglitz bought the first photographs Steichen had ever sold, at $5 each, and in 1907 the two founded the Little Galleries of the Photo-Secession. Strand was shown in a one-man show at 291 in 1916. Weston, who spent much time in California, met Stieglitz and Sheeler in 1922.

Other Precisionist subjects by O'Keeffe, such as New York's tall buildings, painted when she and Stieglitz were living on the thirtieth floor of the Shelton Hotel, were more typical. But even here, in capturing Manhattan's soaring verticality, as did Sheeler in his *Church Street El,* she gives evidence of her individuality. Most of the fifteen city scenes she painted between 1926 and 1929 were shown at night (*Radiator Building—Night, New York,* 1927, Fisk University, Nashville; *New York—Night* [105], 1928–29, Sheldon Memorial Art Gallery, University of Nebraska, Lincoln), when New York can take on a fairy-tale quality. She avoided advertisement signs and harsh, glaring neon lights, but caught the tapestry-like effect of the softer lights of windows seen through heavy air. This is not the electric charge of Stella's *Skyscrapers.* Rather than stressing the volumetric aspect of the buildings, like Sheeler, she pictured the screenlike, flattened apparition of the facade, dematerialized through the filigree spotting of its lights.

The building motifs from the summers at Lake George strike a different note, austere and somewhat forbidding. Still, in O'Keeffe's Precisionist work of this kind there intrudes a moodiness, a sense of mystery, which sets it apart from Sheeler's, with its more strictly academic interest in design and the interplay of volumes and textures. O'Keeffe's *Lake George Window* (1929, Museum of Modern Art) is at first, like many a painting of Sheeler's, a play of stark rectangular forms. Where it differs from his and other Precisionist work is in the aura of mystery, the question of what lies behind the closed window. Bearing comparison with Sheeler's Bucks County barns are O'Keeffe's paintings of the barns about Lake George (*Lake George Barns,* 1926, Walker Art Center) and in Gaspé County in Canada, which she first visited in 1932 (*Barn with Snow,* 1934, Mr. and Mrs. Norton S. Walbridge). For O'Keeffe, the barn is more than simply a rectangular volume; it is a used and lived-in structure, bearing its marks of wear and experience. Sheeler did not think of showing the snow about a barn during winter, the exposed stone foundation, or the weathering of the paint. O'Keeffe had this to say of her Lake George barn, in a note quite foreign to Sheeler:

> With much effort I painted a picture of the front part of the barn. I had never painted anything like that before. After that I painted the side where all the paint was gone with the south wind. It was weathered grey—with one broken pane in the small window. A little of the stone foundation was visible above the grass. I have looked at the barn in summer and have looked at it in winter when the

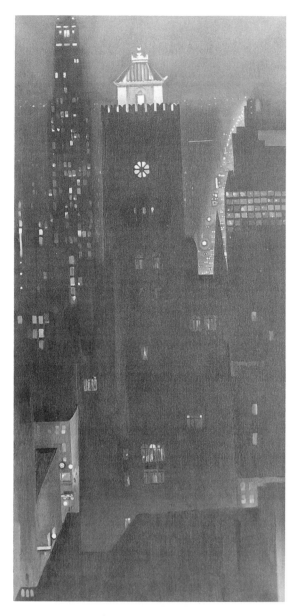

105. Georgia O'Keeffe,
New York —Night, 1928–29.

snow was deep. Lake George had many grey days. When I painted the back of
the barn there was a grey cloud over it toward the lake.[35]

Preston Dickinson (1891–1930) exploited a variety of devices to push
against the limitations of the Precisionist style, while remaining basically commit-
ted to it. His elegance of texture and richness of color at times—as in the *Still
Life with Yellow-Green Chair* [106] (1928, Columbus Gallery of Fine Arts) with
its shadings of green for the tabletop, blade of the knife, bottle, vase, and leaves—
complemented the simplification of form and occasionally worked against it.
Dickinson liked to elaborate detail, seen in the careful rendering of the cubes

106. Preston Dickinson, *Still Life with Yellow-Green Chair*, 1928.

of butter and the profiled teeth of the bread knife. From the beginning of the second decade he had been an enthusiast of Japanese prints. The unusual vantage point and the clever cutting of the bottle to the right and the framed picture to the left are evidence that he had assimilated the lessons of those prints. The vantage points change almost imperceptibly: the table is seen from above; the vase and glass upon it from almost straight on; while the chair and the picture within the painting have been twisted so that they are caught full face. So difficult a compositional synthesis is rare in Precisionist painting.

Born in Greenwich Village, Dickinson studied at the Art Students League from 1906 to 1910 under Chase, the Ashcan artist Earnest Lawson, and George Bellows. His father was an interior decorator who became a sign painter. In late 1910 or early 1911, when he was only nineteen, Dickinson left for Europe, and remained in France until 1914. There, beside the Japanese prints, he grew to like the paintings of Cézanne. In 1912 he exhibited at the Salon des Indépendants and at the Salon des Artistes Français. There is no evidence of his having visited the Steins; it was reported that in Paris he avoided English-speaking people.[36] He did associate with another homosexual painter from America, Charles Demuth. His charcoal and black chalk drawing, *Café Scene with Charles Demuth* (c. 1912, Private collection), reveals an elegantly mustachioed Demuth sitting across from what may be his own sallow-faced portrait. Forms are slightly faceted through the abrupt interchanges of light and dark to remind one of Juan Gris's work of 1912.

A remarkably early Precisionist cityscape by Dickinson, the *Tower of Gold* [107] (1915, Stephan Lion, New York), is unique in the style both for its cartoonish elements and the anticapitalist viewpoint. A capitalist in a black suit sits atop the gold-leafed building in the center, the "tower of gold," which is supported on the backs of workers. To the left he sits on a hill and watches coal carts file by; and in the upper right, holding bars of gold, he accepts the homage of smaller figures. Cloudman maintains that for a while Dickinson espoused radical ideals, which were nurtured by the meetings he attended at Mabel Dodge's salon on Fifth Avenue.[37] She believes, too, that the elaborate detailing and the

107. Preston Dickinson, *Tower of Gold*, 1915.

108. Preston Dickinson, *The Peaceable Village*, n.d.

rich gold leaf are evidence of his study of Persian miniatures.[38] The *Peaceable Village* [108] (Irwin L. Bernstein), the picture of farmsteads clustered about a steepled church, probably dates to the end of the second decade. The crispness of detail and the simplified houses relegate the painting to Precisionism; and the place pictured may be Amish country in the vicinity of Lancaster, or New England farm country, a site in the twentieth century that really harkens back to the nineteenth. Even while Precisionism concentrated on industrial themes, it exhibited a certain yearning for a nineteenth-century pastoral innocence, seen in Sheeler's Bucks County barns and Shaker objects, O'Keeffe's Lake George houses, and now Dickinson's picturesque village.[39]

Many of Dickinson's factoryscapes and still lifes are wonderfully rich in color, as well as being crammed with details and sometimes surface facetings. His *Industry* (c. 1923, Whitney)—a picture of factory sheds and the upper parts of factory buildings—reminds one of Demuth in the delicacy of shadings, but differs in the sheer abundance of superstructure elements, such as watertowers, chimneys, and curved piping. In the *Factory* [109] (c. 1922, Columbus Gallery of Fine Arts)—where blues, blue-greens, yellow-greens, violets, violet-browns, and tans have been orchestrated, and where there is a profusion of ducts, windows, and wires—the stone, steel and wood surfaces in places seem to have been stripped away to reveal the plating of the understructure. The geometrical underpinning is still there, but the activization of the surface pushes the work

close to Analytical Cubism. The *Synphonie Domestique Américaine* (1922, Addison Gallery of American Art), a composition of a tea kettle on a stove, the curving pipe of the stove, wine bottles, a six-gallon container, and other glass containers, is a daring attempt to weld into a coherent unity a mélange of things, some of which merge in Cubist fashion. The *Still Life with Round Plate (Abstraction)* (1924, University of Nebraska, Lincoln) features a fusion of flat still life objects such as a tabletop, tablecloth, and tray, confounding identities, much as in the Synthetic Cubist still lifes of Picasso, Braque, and Gris—a fusion that is rare in the early American modernists.

From the late teens until 1925, Dickinson lived with his sister in Valley Stream, Long Island. When she moved to the Pacific coast, he would spend

109. Preston Dickinson, *Factory,* c. 1922.

much time in Quebec City, and his paintings of that place are unadventurous though competent facsimiles of the site, with no hint of Precisionist reductiveness (*Quebec*, c. 1928, Museum of Fine Arts, Boston). He was unsettled in his last years. There was much drinking and carousing. In June of 1930 Dickinson went to Spain with his artist-friend Oronzo Gasparo, and died there in December of pneumonia, impoverished and friendless.

Although he was born in Cleveland in 1891, George Ault (1891–1948) spent most of his early years in London, where his family moved when he was eight and his father established a printing company. In London he studied at the Slade School of Fine Arts of the University College and in 1908 at St. John's Wood Art School. There were frequent trips to France. Ault returned to America in 1911. There he settled in New York, the scene of many of his paintings, and spent most summers in Provincetown. His first American exhibition was held in 1920 at the Society of Independent Artists in New York, where he was given one-man shows in 1926 and 1928 at the Downtown Gallery. By the early 1920s he was painting machines and machine parts [110], one of the first Americans to do so. He endowed them with a brutal energy, different from Schamberg's delicacy. In 1937 he moved to Woodstock, where he remained until his death.

The term "neo-primitive" used by Mrs. Ault is particularly apt for describing her husband's art. More than any of the other Precisionists Ault endowed his buildings with a rude, monumental power, even while they seem at times to have been constructed, oddly, of building blocks. He painted many of his scenes by night, realizing that night simplifies contours. Light was provided by the moon or by electric lights (*Sullivan Street Abstraction*, 1928, Zabriskie Gallery). One may be led to recall similar acute contrasts of light and dark in the night scenes of the seventeenth-century French painter Georges de La Tour. The walls of Ault's tall buildings could appear like the cavernous walls of some ancient Mesopotamian fortress-palace. Even Sheeler's simplified views of tall buildings do not take on the brutish awesomeness of some of Ault's New York architectural night landscapes. In his *Brooklyn Ice House* [111] (1926, Newark Museum), a wintry day scene, he has focused on the low, squat, gargantuan proportions of the buildings, thereby stressing their prison-like aspect. In *The Mill Room* [112] (1923, M. H. de Young Museum, San Francisco), the lone worker takes on the character of the geometrically severe surroundings. It is a dank and cramped interior, yet the painting stops short of social comment and is really less oppressive than the *Brooklyn Ice House* [111]. There is a crisp cleanliness to the press, the rollers, barrels, and heavy arched openings. The composition is essentially two-dimensional, with the geometricized elements working and interrelating on a surface as a tapestry-like design. The cavernous aspects of this interior have become blunted, almost transmuted into a geometrical fantasy.

Ault's scenes outside the city could have a lightness, even a gaiety. In

110. George Ault, *The Machine*, 1922.

111. George Ault, *Brooklyn Ice House*, 1926.

112. George Ault, *The Mill Room*, 1923.

his *Provincetown, No. 1* [113] (1923, Irwin L. Bernstein) the forms have been flattened even further than in *The Mill Room*, so that the tapestry-like quality is more evident. The forms are not as rigidly geometrical, and the objects—clouds, sailboats, and crenelated tower—have been exploited for their picturesqueness. Some landscapes of the 1930s (*Woodstock Landscape* [114], 1938, Brooklyn Museum) reveal a loosening of the tightness of Precisionism, a combining of the linear quality of buildings and fences with the more broadly brushed areas of skies and trees. These lead to the eerie nocturnes of the countryside about Woodstock of the 1940s (*Old House, New Moon*, 1943, Yale University), in which desolate meadows containing a steeply roofed house or two and a few trees—meadows of empty, looming spaces—are watched over by a moon peeping through serrated clouds possibly inspired by Ryder's work.

Niles Spencer (1893–1952) has been characterized by his colleague Ralston Crawford as a man whose "presence and . . . manner of speech were quiet, restrained . . . [one who did not] los[e] any sleep because he had lost an argument."[40] He was a consistent and committed Precisionist. His work has an evenness of tone, a lack of expressiveness, that distinguishes the best of the style and mars the worst.

In 1913 Spencer had studied at the Rhode Island School of Design. In 1915, having come under the influence of Robert Henri and George Bellows, he was (surprisingly for him) expelled from that then conservative institution for spreading "advanced ideas." From 1917 to 1921 he spent much time at the art colony at Ogunquit, Maine, which had been established by Hamilton Easter Field, the benefactor whose farm at Randolph, New Hampshire, William Zorach had borrowed for the summer of 1915. At Ogunquit, Spencer met Stuart Davis and the modernist sculptor Robert Laurent. His incursion into Precisionism came about as an offshoot of his first European trip in 1921–22, when in Italy he studied the frescoes of Giotto and Piero della Francesca, whose drastic simplifications foreshadowed his own. He also visited the Riviera; then Paris, where he came to appreciate the paintings of Cézanne, Braque, and Gris; and finally the northern coast. The gravely muted colors of the *City Walls* (1921, Museum of Modern Art), the off-whites, oyster and pebble grays, and tan in the center, derive from French classical Cubism.

Back in America in 1923, Spencer settled in New York's Washington Square, and would usually spend part of the year in Provincetown. He was given his first one-man show at the Daniel Gallery in 1925. In 1927 he spent the winter in Bermuda. Wherever he went, he reduced the buildings he found to simple cubes devoid of projections or indentations—deserted shanties and summer cottages of Ogunquit (*The Cove, Ogunquit*, 1922, Newark Art Museum), a corporation shed at Bermuda (*Corporation Shed, Bermuda*, 1928, Columbus Gallery of Fine Arts), buildings in his New York neighborhood (*Near Washington*

113. George Ault, *Provincetown, No. 1,* 1923.

114. George Ault, *Woodstock Landscape,* 1938.

Square, 1928, Mr. and Mrs. Bumpei Usui, New York), old houses in Provincetown (*Gray Building [Provincetown],* [115] 1925, Phillips Collection), and buildings elsewhere (*Buildings* [116], Columbus Gallery of Fine Arts).

At their best, as in the *City Walls,* Spencer's architectural landscapes can be distinguished by an elegaic quietude; but often the prevailing spirit is one approaching blandness. Even within the innocence and limitations of Precisionism, a variety of moods and innuendos emerged. With Spencer, one reaches in vain through the multiplication of cubes and prisms for the stamp of a character, even for that kind of hard and brittle impersonality that is the hallmark of much Precisionist painting. The forms in *Buildings* [116] are uniformly dull, as though projected through a soft-focus photograph. There are no landmarks or emphases in these architectural landscapes, no hint of the emptiness pervading Sheeler's *Classic Landscape,* or of the barren dullness of Ault's *Brooklyn Ice House* [111], which makes itself felt not so much through the manner of rendering as through the careful choice of a clearly identifiable oppressive place. In Spencer's *Buildings,* the viewpoint of the rooftops selected is prosaic, yet not oppressive; and any other section of the city, seen from any other angle, would have done just as well. To push the comparison with photography, or better, with paintings derived from photography, there is a kinship between Spencer and that cultivated mindlessness and blandness sought by such Photo-Realist painters in the late 1960s and the 1970s as Robert Bechtle, whose favorite subjects were station wagons and various nondescript middle-priced cars, and Robert

115. Niles Spencer, *Gray Building (Provincetown),* 1925.

116. Niles Spencer, *Buildings,* 1926.

Cottingham, who painted pictures of sections of signs standing on the facades of undistinguished department stores and supermarkets.

Elsie Driggs (1898–) was born in Connecticut, and studied at the Art Students League in New York in 1919–20. After traveling through Italy in 1922, she returned to America to become impressed with the artistic potential of industrial subject matter. She inspected the Jones and Laughlin Steel Mills at Pittsburgh, and was moved by the strange beauty of the place. The experience remained vivid to her. Years later, in a letter to Martin L. Friedman, she recalled: "The particles of dust in the air seemed to catch and refract the light to make a backdrop of luminous pale gray behind the shapes of simple smoke stack and cone. To me it was Greek. What I went to see was a sight Greco would have enjoyed painting. What I . . . painted when I returned was 'Pittsburgh.' "[41]

In *Pittsburgh* [117] (1927, Whitney) there is no indication of the particles of dust or the refraction of light Driggs mentioned. The smokestacks are there, prominently lined up, their silhouettes isolated against the gray, blank backdrop of the sky crisscrossed by taut wires. The reference in the letter to "Greek" is illuminating. For Driggs, the pure forms of industrialism were as pure and noble

117. Elsie Driggs, *Pittsburgh*, 1927.

as those in Greek art. And in affirming that [El] Greco would have enjoyed painting the mills, she was alluding to what must have been her own sense of wonderment when she first saw the place with its steel furnaces ablaze—even if this aspect of it was not conveyed through her painting. It was a sight that for her was a modern mystic vision, akin to those the Spanish artist had painted in the sixteenth century. She used the Precisionist style to paint other great sights of the day's technocracy, such as *The Queensborough Bridge* [118] (1927, Montclair Art Museum, N.J.), which contains ray-lines like Demuth's.

Other younger painters (born in the 1890s or later) working as Precisionists in the 1920s were Stefan Hirsch (1899–1964) and Peter Blume (1906–). Hirsch's *New York, Lower Manhattan* [119] (1921, Phillips Collection) impresses one as an orthodox Precisionist New York cityscape, with its grouping of solid rectangles for the buildings of the skyline. This painting, however, does not reveal the artist's true sentiments. Hirsch wrote to Friedman that he was concerned by the absence of sun from New York's canyons and had intended to express by the windowlessness of the buildings his "recoil from the monstrosity that industrial life had become in 'megapolitania.' "[42] The optimism and faith in progress, so prevalent during the 1920s, was not subscribed to by all the Precisionists. But Hirsch's situation was special. He had been born in Nuremberg, and studied at the University of Zurich from 1917 to 1919, where he associated with the Dadaist painters and poets. His disappointment with New York's congestion may be attributed to his recent sojourn amid the spaciousness of Switzerland's mountains—he came to New York from Europe in 1919.

Blume was born in Russia, came to America in 1911 when he was five, and began his art studies at the age of twelve with evening classes at the Brooklyn public schools. He then studied at the Educational Alliance in Manhattan, some two decades after Walkowitz. By the 1930s Blume had become a Surrealist, conjuring up a panopoly of phantasms for such paintings as *South of Scranton* (1931, Metropolitan) and *The Eternal City* (1934–37, Museum of Modern Art). From 1926 to 1928 he was a Precisionist—but a Precisionist in cases with a certain undercurrent of fantasy.

Blume was in Northampton, Massachusetts, from February to June 1926, then stayed for the winter of 1926 in Exeter, New Hampshire. Exeter was the site of his *Home for Christmas* [120] (c. 1926, Columbus Gallery of Fine Arts), painted when he was only twenty. The sharply sloped-roofed houses have their models in New England, but there is the aura of the medieval architecture of his native Russia. It is a zestful painting, permeated with youthful exuberance. The stiffness of the figure, the paper-thin flatness of the horse, which looks more like a toy than a live animal, and the absence of a logical perspectival scheme combine to give the painting a naïve, Primitive look. It is the heritage of American folk art, or of such Primitives as Grandma Moses or the Douanier

118. Elsie Driggs, *The Queensbor-ough Bridge*, 1927.

119. Stefan Hirsch, *New York, Lower Manhattan*, 1921.

120. Peter Blume, *Home for Christmas*, c. 1926.

Rousseau, that comes to mind. It is as though Blume was struggling at twenty toward a greater naturalism (he was remarkably gifted for his age) and in the process came up with his own brand of poetry, with its inner coherence. Another snow scene, *Winter, New Hampshire* (1927, Museum of Fine Arts, Boston) is the picture of a farmstead with overlapping sheds, a motif that would have appealed to him as a Precisionist. The fantasy is understated. The wall of one of the sheds is cut through with a triangular opening that could not quite be a window. Through this is seen the head of a horse; and a horse reappears again, as a weathervane, perched upon an iron pole stuck straight onto a rooftop. The intrusion of these animals, the one real, the other counterfeit, lies at the edge of possibility. The *Bridge* (1928, Mr. and Mrs. Martin Janis), however, is a more straightforward painting, without Blume's usual element of fantasy. The various elements—the tug at the foot of the bridge's pylon, the houses bordering the water—seem to be a mélange of views taken at different times.

Sometimes an artist appears as Precisionist when his work in reality was derived from that of a European Cubist satellite. The Frenchman André Lhote favored clearly defined volumes rather than the interfacetings of classical French Cubism. Frank Stamato (1897–1940), a Philadelphian who left sculpture for painting because of ill health, was Lhote's student during some or all of his three trips to France in the 1920s.[43] The pitcher and other objects in Stamato's *Still Life* [121] (c. 1928, John Castagno) are more heavily modeled than one would normally find in Precisionism, and reflect Lhote's influence. Most of Stamato's paint-

ings are Philadelphia street scenes, somewhat reminiscent of Hopper, such as his *Chinese Wall* (c. 1925, Villanova University, Penn.), a picture of the elevated brick wall that used to extend from the Broad Street to the 30th Street Train Station.

Some paintings stand at a point between Precisionism and Analytical Cubism, or between Precisionism and Fauvism. An example of the former, closer to Cubism, is *Still Life* [122] (1916, Columbus Gallery of Fine Arts) by Henry Lee McFee (1886–1953). The surface is fragmented, but not as completely as it would be in classical European Cubism; the bright yellows, reds, and oranges of the fruit are kept in force; and the objects chosen (the books, the squarish table, the decanter) have the volumetric simplicity favored by Precisionists. McFee, from St. Louis, began to study art at the Stevenson School in Pittsburgh in 1907, then came to Woodstock where he made his home. During the middle of the second decade he was close to Dasburg. He favored the work of Cézanne, whose influence can be seen in his *Glass Jar with Glass* (1922–23).

Louis Bouché (1896–1969) by contrast stands somewhere between Precisionism and Fauvism, as in his *Still Life with Flowers* [123] (1919, Columbus Gallery of Fine Arts) shows. Here there is a balance struck between the geometrical solidity of the pitcher, jug, vase, and other containers, and the freer forms of the flowers and scalloped edges of the curtains. Bouché, who painted models in the studio, strollers in Central Park, and a variety of genre scenes, is trying

121. Frank Stamato, *Still Life,* c. 1928.

122. Henry Lee McFee, *Still Life*, 1916.

123. Louis Bouché, *Still Life with Flowers*, 1919.

124. Niles Spencer, *Above the Excavation No. 2*, 1950.

125. Ralston Crawford, *Third Avenue El*, 1949.

to be fashionably avant-garde. The painting betrays both competence and a lack of focus in his training. Born in America to a French father, Bouché was taken to France by his mother when he was twelve and subsequently studied with the Cubist sculptor Henri Laurens, as well as with the more conservative Ménard and Lucien Simon. Returning to America in 1915, he continued his studies with a number of conservative artists whose names are now forgotten— Dumond, Ossip Linde, Luis Mora. In 1922 he was given his first one-man show by that special angel of the Precisionists, Charles Daniel.

Precisionism was widespread and especially characteristic of the period 1920 to 1935. But it continued well into the 1940s and beyond, on a diminished basis. Spencer and Sheeler kept in the main to their own styles, with certain modifications. Spencer, retaining his overall soft coloration, came close to nonobjectivity on occasion (*Above the Excavation No. 2* [124], 1950, White Art Museum, Cornell University, Utica). Sometimes, as in works of Bruce, he ran forms together, producing ambiguities as to their separations, and as to the separation between object and surrounding space (*The Desk [Still Life]*, 1948, San Francisco Museum of Art). Sheeler came to favor tubular forms and off-key colors (*Aerial Gyrations*, 1953, Dr. and Mrs. Melvin Boigon) that were probably stimulated by his interest in color photography.

Of the newer painters, Louis Guglielmi (1906–1956) combined his Precisionist handling of buildings with Surrealist devices, such as making the distance a mirror image of the foreground. His world was at once lonely and menacing. On occasion there could be political overtones. In *One Third of a Nation* (c. 1940, Metropolitan) a fortress-like cluster of buildings, beneath cloud formations that are made to resemble human lips, is crowned by a mourning wreath two stories high. The most tenacious Precisionist after 1935 was probably Ralston Crawford (1906–1978), an Ontario-born artist, who started with a specific site but used that as no more than a jumping-off point for his flat, streamlined shapes set in tension, which suggest the world of highways and smooth synthetic materials (*Grain Elevators*, 1949, Milwaukee Art Center; *Third Avenue El* [125], 1949, Walker Art Center). There is a slickness of surface unknown in earlier Precisionism, linking him to such hard-edge post-painterly Abstractionists of the 1960s as Ellsworth Kelly and Al Held. It is noteworthy that Crawford worked for Walt Disney in 1927. Years later he observed that he was interested "in a kind of pictorial counterpoint—the juxtaposing of one melody or theme in relation to another, or several," and that "interest is created in pictorial structure."[44]

NOTES

1. The term used by Milton Brown in his article "Cubist Realism: An American Style," *Marsyas*, III (1943–45), pp. 139–160, and in his *American Painting from the Armory Show to the Depression*, Princeton, N.J., 1955, pp. 113–129ff.

2. This term was used often in articles and reviews in the 1920s, such as "Immaculate School Seen at Daniel," *Art News,* XXVII No. 5 (November 3, 1928), p. 9. John I. H. Baur took it up again in his *Revolution and Tradition in Modern American Art,* Cambridge, Mass., 1951, pp. 58–62.

3. Edward Deming Andrews, "The Shaker Manner of Building," *Art in America,* 48 No. 3 (1960), p. 44.

4. Vincent J. Scully, Jr., "The Precisionist Strain in American Architecture," *ibid.,* pp. 46–53.

5. Letter from Mrs. George Ault to Irwin L. Bernstein, October 31, 1960. Irwin L. Bernstein Collection.

6. Charles Sheeler, "Autobiography," unpublished manuscript, c. 1937, microfilm in Archives of American Art, Smithsonian Institution, Washington, D.C.

7. *Ibid.*

8. Martin Friedman, *Charles Sheeler,* New York, 1975, p. 20.

9. For a brief but authoritative statement on Sheeler's photographic achievements, see Charles Millard, "The Photography of Charles Sheeler," in Martin Friedman, Bartlett Hayes, Charles Millard, *Charles Sheeler,* Washington, D.C., 1968.

10. Susan Fillin Yeh, "Charles Sheeler: Industry, Fashion, and the Vanguard," *Arts Magazine,* 54 No. 6 (February 1980), pp. 154–158.

11. Charles Sheeler, "Autobiography," *loc. cit.*

12. *Ibid.*

13. Hartley remarked on Demuth's fondness for the parties held in Provincetown— Marsden Hartley, "Farewell, Charles," in *The New Caravan* (edited by Alfred Kreymborg, Lewis Mumford, and Paul Rosenfeld), New York, 1936, pp. 557–558. For an intimate glimpse at some of the relationships formed in Provincetown, and the important part played by Demuth, see Hutchins Hapgood, *A Victorian in the Modern World,* New York, 1939, pp. 371–399.

14. Demuth entered the sanitarium in Morristown, New Jersey, in 1922 and was one of the first to receive injections of the newly discovered insulin. His friend William Carlos Williams wrote that Demuth had "faded to mere bones," and that "insulin came in just the nick of time to save Charley from dissolution"—William Carlos Williams, *The Autobiography of William Carlos Williams,* New York, 1955, p. 152.

15. S. Lane Faison, Jr., "Fact and Art in Charles Demuth," *Magazine of Art,* 43 No. 4 (April 1950), pp. 122–128.

16. Rita Wellman, "Pen Portraits: Charles Demuth," *Creative Art,* 9 (December 1931), pp. 483–484. Marsden Hartley, who first met Demuth in Paris in 1912, observed in him a "quaint, incisive sort of wit with an ultra-sophisticated post-eighteen-ninety touch to it"—Hartley, "Farewell, Charles," *op. cit.,* p. 554.

17. At the beginning of the second decade Demuth was serious about becoming a writer. In 1913 there appeared his most ambitious work, a play, *The Azure Adder,* in the short-lived periodical *The Glebe.* The play was about a group of bohemian artists and writers who proposed to create a magazine known, too, as *The Azure Adder. The Glebe,* 1 No. 3 (December 1913), pp. 1–31.

18. In Joseph Stella's typescript, "Discovery of America: Autobiographical Notes," p. 12. Whitney Museum.

19. *Ibid.,* p. 2.

20. *Ibid.,* p. 12.

21. *Ibid.,* pp. 9–10.

22. From Stella's description. Quoted in John I. H. Baur, *Joseph Stella,* New York, 1971, p. 35.

23. *Ibid.,* p. 12.

24. *Ibid.,* p. 36.

25. Irma Jaffe, "Joseph Stella and Hart Crane: The Brooklyn Bridge," *American Art Journal,* I No. 2 (Fall 1969), pp. 98–107. Crane wrote to Stella in early 1929 requesting his permission to have *The Bridge of New York Interpreted* as the frontispiece to his long poem "The Bridge," on which he had been working the past three years. Crane observed that he and Stella "had the same sentiments regarding the Brooklyn Bridge"—Jaffe, *Stella,* pp. 246–247.

26. Louis Lozowick, "Some Artists of

Last Season," *Menorah Journal,* 12 (August 1926), p. 104.

27. Louis Lozowick, "The Americanization of Art," *Catalogue of Machine Age Exhibition, New York, 1927*, pages unnumbered. Lozowick used pen and ink drawings of machine parts as end decorations of his essay, and one of these, the *Dynamo,* was used for the Lord and Taylor display at the exhibition, which through actual machines, engineering drawings, appropriate sculpture and painting (Sheeler was included) stressed the aesthetic aspects of the machine.

28. Letter from Lozowick to this writer, September or October 1972, now lost. Lozowick spoke of his beliefs of the 1920s, and wrote that they were the beliefs of a certain period of his life.

29. The Constructivist sets in Russia that Lozowick might also have seen in 1922 included Popova's set for the Meyerhold production of *The Magnificent Cuckold.* University of Vermont, *Abstraction and Realism: 1923–1943. Paintings, Drawings, and Lithographs of Louis Lozowick,* Burlington, Vt., 1971, pp. 5–6. Essay by William C. Lipke.

30. Statement in O'Keeffe's 1939 exhibition catalogue.

31. Quoted in Georgia O'Keeffe, *Georgia O'Keeffe,* New York, 1976, pages unnumbered.

32. *Ibid.*

33. Statement in *Daybooks* of August 8, 1930. Weston adds of his *Pepper:* "It has no psychological attributes, no human emotions are aroused: this new pepper takes one beyond the world we know in the conscious mind." Quoted in Nancy Newhall, ed., *Edward Weston, Photographer,* New York, 1968, p. 32.

34. Statement in *Daybooks* of April 24, 1930, quoted in *ibid.,* p. 39.

35. Quoted in O'Keeffe, *op. cit.*

36. Reported in a biographical sketch of Dickinson written in 1934 by his sister, Enid Dickinson Collins. Sheldon Memorial Art Gallery, *Preston Dickinson 1889–1930* (text by Ruth Cloudman), Lincoln, Nebr., 1979, p. 18. In France, Dickinson could speak, read, and write French fluently.

37. *Ibid.,* p. 20. From 1912 to 1917 Mabel Dodge held a salon of a kind at 23 Fifth Avenue, where some of the most lively discussions in New York took place. Among the prominent personalities in regular attendance were Carl Van Vechten, Lincoln Steffens, Max Eastman, and Hutchins Hapgood. Political topics were commonplace—Jerome Myers, *Artist in Manhattan,* New York, 1940, p. 49. Dodge became more radical as time went on, divorced her husband, and lived a while with the Communist sympathizer John Reed. Beside Dickinson, the American modernists who dropped in included Hartley, Marin, and Dasburg. Dickinson's presence was reported to Cloudman by Dr. Moritz Jagendorf, who had attended with him. Sheldon Memorial Art Gallery, *op. cit.,* p. 41, n. 42.

38. Enid Dickinson Collins wrote that Dickinson in "about 1917 . . . spent months doing no painting, but studying the work of the old Persians, measuring and scaling them to arrive at the secret of their wonderful construction." Quoted in *ibid.,* p. 20.

39. This point is well brought out in Hilton Kramer, "The American Precisionists," *Arts Magazine,* 35 (March 1961), pp. 33–37.

40. "A Tribute by Ralston Crawford" in Richard B. Freeman, *Niles Spencer,* Lexington, Ky., 1965, p. 19.

41. Letter of March 23, 1960, quoted in Martin L. Friedman, *The Precisionist View in American Art,* Minneapolis, 1960, p. 37.

42. Letter from Hirsch to Martin L. Friedman of March 29, 1960, quoted in *ibid.,* pp. 34–35.

43. This information was provided to the Philadelphia artist and collector John Castagno by Stamato's family. Stamato exhibited his sculpture regularly in Pennsylvania Academy of Fine Arts annuals, and was awarded two Cresson traveling scholarships by that institution. His first one-man exhibition was held in the spring of 1981 at Villanova University.

44. Statement in exhibition catalogue, Milwaukee Art Center, p. 11.

6

The Independents

THE PHILADELPHIA SCHOOL[1]

By definition, the so-called Philadelphia School painters were associated with the Pennsylvania Academy of the Fine Arts as students or teachers, spent much of their time painting in or about Philadelphia, and cannot easily be consigned to another grouping (hence the omission of Man Ray, who left Philadelphia before he was twenty, and then became intimately involved in the Arensberg Circle; and of Sheeler and Schamberg, discussed already in relation to the Arensberg Circle and the Precisionists, and the Arensberg Circle, the Synchromists, and the Precisionists, respectively.) The Pennsylvania Academy has long been regarded as the bastion of pedagogic conservatism. It was there that the young student Thomas Eakins from 1861 to 1866 was forced to draw endlessly from antique casts, never once being exposed to the live model. The place impressed students with its majestic stillness.[2] Yet from the 1890s, when the Academy was occupying its present location, the great Furness Building at Broad and Cherry streets, there served on the faculty men who were to be the most adventurous of America's painters. The Philadelphia School was characterized generally by a boldness in the use of color. It represented something of a complement to French Fauvism.

Arthur Beecher Carles, Jr. (1882–1952), studied at the Pennsylvania Academy from 1900 to 1907 under Cecelia Beaux and Thomas Anshutz, former pupils of Eakins, and William Merritt Chase, from whom he gained an appreciation of Impressionism and the textural quality of paint. Partly with the help of the Cresson Traveling Scholarship awarded to him by the Academy in eight quarterly installments of $250, Carles lived in Paris from 1907 to 1910 and in 1912. He visited the Steins; associated with Steichen, Marin, and Maurer, with whom in 1908 he formed the New Society of American Artists in Paris; and

met and admired Matisse, with whom he studied informally with Weber and Maurer. Stieglitz gave him a one-man show in 1912, but Carles's interests lay in his native Philadelphia. An Episcopal church in Philadelphia commissioned from him a copy of Raphael's *Transfiguration*. In 1909 Carles made a trip to Rome to study the original, made a small copy there, and the full-sized one in Paris. The fifteen- by nine-foot painting was installed at the church on Broad and Venango streets, then later removed to St. Paul's Reformed Episcopal Church in Oreland, Pennsylvania.[3]

Until 1927, Carles in his still lifes (many flower studies), nudes, and landscapes combined a sense of the academic picture in the poses and compositions with an extraordinary richness of color. Some of his paintings were more tightly controlled, some loose to the point of abstraction; but typically areas of pure color unencumbered by detail carried the emotional weight. In a *Flower Composition* of 1923 (Philadelphia Museum), the broad, fluid brushwork is used uniformly for the flowers, whose stamens and even petals are not delineated except in a couple of instances, and for the cloth background, so that the distinction between background and foreground is kept indistinct, as the touches of orange (near the blues) and greens (near the purples) pulsate throughout the canvas. Local colors for the most part would be maintained in his reclining nudes, but there would be almost garish purple shadows, blue or green accents for the necks and thighs, loose, bright, variegated strokes for the backgrounds of rooms describing nothing identifiable. As with Matisse and some of the other Fauves, the entire area had to be orchestrated with the figures, seen by Carles as meaningful in terms of their coloristic rather than thematic importance (*Interior with Woman at Piano* [126], 1912 or 1913, Baltimore Museum of Art). Modeling was kept at a minimum, so that the bright snatches of color could be at utmost brilliance. In 1913, he declared that "when an artist makes light and shade he spoils color. Paint lies flat. . . . If I have succeeded in making a harmonious color scheme, an acceptable pattern in colors, then I am satisfied."[4] One of Carles's boldest ventures was his largest easel painting. This was *The Marseillaise* of 1918–19 [127] (Philadelphia Museum), inspired by France's victory over the Germans in World War I and based on Delacroix's *Liberty Leading the People* of 1830, which he had seen in the Louvre. His larger than lifesize ivory-colored allegorical nude, leaning back as she seems about to unfurl or perhaps, in a complicated gesture, wrap herself inside the French tricolor, becomes a bolt of light within the stormy, smoky landscape of browns, blues, and violets.

Carles himself was a tempestuous, passionate man. Living mostly in what is today Philadelphia's Center City and about the Museum Fairmount area, he changed addresses frequently, leaving his admirers and the women who doted upon him searching for his whereabouts.[5] His two marriages wound up failures. There were frequent bouts of drinking and missed classes at the Pennsylvania Academy, where he was a controversial teacher from 1917 until his dismissal

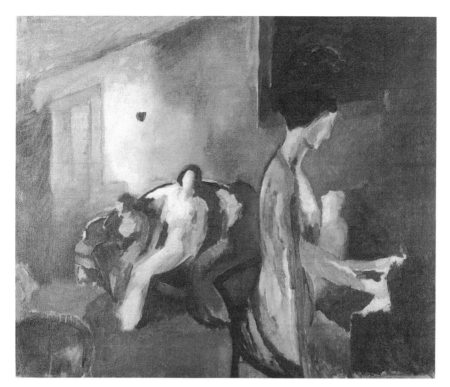

126. Arthur B. Carles, *Interior
with Woman at Piano,*
1912–13.

127. Arthur B. Carles, *The Mar-
seillaise,* 1918–19.

in 1925. Many of his students remember him thankfully for the insistent and creative ways in which he taught that a painting should be organically built up through the use of color. Conscious of the importance of his vision, he joined with McCarter and Breckenridge to bring exhibitions of modern art to the Academy. With them, he organized "Representative Modern Artists" in 1920, "Later Tendencies in Art" in 1921, and "Contemporary European Paintings and Sculpture" from the Barnes Collection in 1923. After his dismissal, faithful students and admirers joined to take private classes with him.

From 1927, his paintings became more abstract still and even, at times, nonobjective. Through his friendship with the Philadelphia Orchestra conductor Leopold Stokowski, he explored connections between music and art. He now gave full vent to the directions pursued earlier. His *Orientale* (1928–29, Hirshhorn Museum and Sculpture Garden) is a spontaneous combination of color planes and free-floating flowers. In his bouquet piece *Arrangement* [128] (c. 1927–28, Art Institute of Chicago), the flowers become color spots hardly tied down to objective fact. Carles could begin with recognizable still life objects upon a table, as in his charcoal study for *Composition No. 5* of 1935 (Philadelphia Museum), and end up with a nearly nonobjective color grid of quadrilaterals, triangles, and circles in which each color has a predetermined place, to make a glowing conclusion of carefully spaced reds, violets, lemon-greens, mauves, and viridians, and of smooth and speckled areas. The pitcher from the drawing can still be made out in the lower left, but its mass has been shattered, with the sections relegated to separate hues. In drawings of his late period, color notes have been inscribed commonly over the surface. Carles studied the properties of color, knowing in advance what the effect would be on the observer, and what colors would be effective next to one another: "Green is the great surface slider. It skids—slips—makes blurred extensions. Green will move into anything except red. Outside of this color—the center of the spectrum—colors generally go in pairs—at least red and black are the most stable stay-put pair. When white comes near the black pairs up with it and seems equally brilliant."[6] One is hardly aware of the calculation, though, only of the glowing color. The Abstract Expressionist painter and theorist Hans Hoffmann, who had worked with Carles in Paris, felt of him that he "understood color as a plastic means, as a monumental building process in which forms do not precede but rather develop out of color."[7]

While Carles bent all his efforts to his painting (and womanizing), H. Lyman Saÿen (1875–1918), a more staid personality, carved out for himself a distinguished career as a scientist and electrical engineer beside his painting. After working for a couple of years as a designer of precision instruments and electrical circuitry, in 1897 he designed and patented a self-regulating X-ray tube. Enlisting in a Philadelphia volunteer unit for service in the Spanish American War, he

128. Arthur B. Carles, *Arrangement*, c. 1927–28.

was sent to Fort McPherson in Georgia to operate the country's first military X-ray laboratory. In 1901 Saÿen was awarded a silver medal at the Pan-American Exposition in Buffalo for an improved design of his self-regulating X-ray tube. Associating with the Steins shortly after he arrived in Paris in 1906, he used his expertise in electrical circuitry in 1912 to devise a means to illuminate Gertrude Stein's atelier. In 1917, with America's entry into the war imminent, he tried to organize a mobile X-ray unit manned by artist volunteers.[8]

Saÿen pursued his career in art without a break from the time he enrolled at the Pennsylvania Academy in 1899. His teachers were Thomas Anshutz and Charles Grafly. His early work is the acme of academic illustrationalism: in 1904–05 four allegorical murals, *Rule of Tyranny*, *Primitive Agriculture*, *Good Government*, and *Rule of Justice* were done and placed in the United States Capitol.[9] In September 1906 the Saÿens were commissioned by the Philadelphia businessman Rodman Wanamaker to produce catalogues and posters for his stores, and were sponsored by him to spend a year or more in Paris. (In 1903, he had married Jeannette Hope, a magazine and newspaper fashion designer and illustrator

who had graduated from the Pennsylvania Academy.) Although he continued with his illustrational work, Saÿen now changed the manner of his easel paintings. Niggling detail disappeared, forms were simplified, color became applied in broad swatches, and a few broad planes formed the organizational basis of the pictures, mostly street scenes in and about Paris. The catalyst must have been, first, the retrospective exhibition of Gauguin, which he caught at the Salon d'Automne in 1906; and second, the classes of Matisse, which he attended in 1907–08. Among his fellow students were Weber, Carles, and Frost, Jr. Carles and Saÿen reacted differently to Matisse's bright Fauve palette: with Carles, the colors were streaked throughout the painting, and interworked with one another, so that the effect was of bits of layers ground together to different degrees; while with Saÿen, the sense of the underlying pattern predominates. One is always aware in Saÿen's landscapes and cityscapes of a certain control, a decorum, of fairly discreet shapes that are blocked in and to which are *then* applied smooth layers of reds, blues, and yellows. In the *Trees* of 1912–14 (National Collection), orbs for the trees are sectioned off—red at the lower left; splotches of orange inscribed within a circle in the middle left; an orange orb spiked with greens, pinks, and eggshell tints to the lower right; and so on. This organizational approach in Philadelphia Fauvism reminds one of the approach within French Fauvism of Braque, who always kept careful control of his arbitrary colors, as opposed to Vlaminck. In Saÿen's *Decor Slav* [129] of 1915 (National Collection), probably painted upon his return to America, there are reds, lemon-yellows, pinks, greens, and blues, used in about equal amounts, carefully juxtaposed next to one another in orbs and triangular slivers of color, and even in mosaic spots in the foreground of the landscape representing the flowerbeds.

Returning to Philadelphia at the outbreak of World War I, Saÿen sought to promote the cause of modern art in his native city, as Stieglitz and Arensberg were doing in New York. He did not attempt to maintain any sort of salon, but he did organize exhibitions. Through Sheeler, Schamberg, and Demuth, he maintained contacts with Stieglitz and New York modernism. Saÿen, with Schamberg, organized and exhibited in "Philadelphia's First Exhibition of Advanced Modern Art," held at the McClees Galleries from May 17 to June 15, 1916. Two years earlier, on the occasion of his first one-man exhibition held at the Philadelphia Sketch Club, he had delivered a lecture entitled "The United States and Modern Art." In that year of the outbreak of World War I he said:

> Modern art . . . is all spontaneity and requires an equally spontaneous apprehension. To feel it requires a quickening of the spirit. It has revealed to us men of great power. Picasso and Matisse will I believe exert a powerful influence for a long time on painting and sculpture. . . .
>
> . . . This is the art that today confronts that atrophied half of the mentality of the United States. . . . It is the modern spirit, the spirit of an emancipated

129. H. Lyman Saÿen, *Decor Slav,* 1915.

democracy and it has not only come at a time when the external man is saturated with the infiltration of the new spirit, but at a period when the mind of the individual presents a scene of moral confusion and the need today is for a new and more liberal brand of order for the old one has grown stale.[10]

In 1916, Saÿen altered the relative looseness of handling typifying the years spent in France for a style in which variously patterned, flat areas, suggested probably by paintings of Matisse, were scrupulously segregated. It was a style that can be seen, too, as a fulfillment of his earlier period, in which there had been an organizational approach to Fauvism. The new work has the look of large mural backdrops, and it is noteworthy that in 1916 Saÿen, in collaboration with his friend Carl Newman, designed four backdrops to be used for the play *Saeculum,* staged at Philadelphia's Academy of Music on February 19, 1917.[11] One of the later works was called *The Thundershower* [Pl. VI, 130], after the wavy patterns in the upper center recalling rivulets of water in a downpour. The 1916 painting was left untitled when first exhibited in that year. Two nearly identical versions were done, one in about 1916 and one in 1917–18 (both National Collection). Two dancing figures, male and female, one stepping to the left, the other bending forward with her legs pointing in different directions in an anatomically impossible way, may be seen in a literal way as trying to

130. H. Lyman Saÿen, *The Thundershower*, c. 1917–18.

131. H. Lyman Saÿen, *Daughter in a Rocker*, 1917–18.

escape the downpour. Striking in these paintings—a feature that occurs nowhere else in early American modernist painting—is the application of a *trompe l'oeil* facsimile of wallpaper to the cardboard (1916 version) and plywood. These are snippets of a landscape of flowers and birds, and the two levels of reality (the one painterly, the other apparently photographic) correspond to similar interplays in contemporary French Synthetic Cubist collages, as well as anticipating the juxtaposition of silkscreened and painted passages in the paintings of the 1960s.

The combination of profile and three-quarter views of the full-length seated figure of the mother in *Daughter in a Rocker* [131] of 1917–18 (National Collection)—the painting took note of the infancy of Saÿen's daughter Ann—anticipates similar devices in Picasso. The vigor of the wavy, checkerboard, and stippled patterns, and the heavy lines segregating patterned, rounded triangular areas, were probably derived from Saÿen's study of American Indian art. His wife recalled that he had a book on American Indian art and was interested in applying its aesthetics to his own paintings.[12]

Saÿen's early death at the age of forty-three in 1918 robbed Philadelphia of one of its most progressive painters and a man who vigorously advanced the understanding of modernism.[13] It can never be definitely known what role his early work with uncontrolled X-rays played in hastening his death.

Saÿen's older friend Carl Newman (1858–1932) was a native European who returned often for visits to the Continent after settling in the United States. He knew Monet and Zorn well, and mingled freely with the Impressionists, but in the first decade of this century painted in a Fauvist manner. He taught at the Pennsylvania Academy from 1892 to 1895, before Saÿen enrolled there. In the summers of 1910 and 1911 he would dine with the Saÿens in Paris (Anshutz was also a visitor), and he spent a few weeks with them at Moret-sur-Loing. When Saÿen returned to America, the Newmans gave him free run of their country home in Bethayres in the hilly Huntingdon Valley north of Philadelphia, where their American landscapes were painted. In 1915–16, Newman had Saÿen decorate the ceiling of his home: this was done as a huge nonobjective Synchromistic painting, with pure pigments on the white ceiling radiating outward from the central core of black, a practical illustration of the color theories of the Orphists and the Synchromists.[14] In their collaboration on the play *Saeculum* for the Annual Artists' Masque, Saÿen directed the scenario and designed the scenery and lighting, while Newman, together with Saÿen, designed the costumes.

Like Saÿen, Newman departed from local colors. His landscapes favored oranges and deep blues, and numerous clumps of curved trees, sometimes reduced to the shape of cones (*View from Window*, [132], c. 1915–16, National Collection). Sometimes, when the foliage would be more amorphous, even energized, the entire vista could be animated: his *Nude Under Tree* [133] of c. 1912

132. Carl Newman, *View from Window*, c. 1915–16.

(Goffman Collection, Blue Bell, Pa.) is struck with an air of foreboding, as a face emerging apparently out of the configurations of the ground and foliage confronts the figure. Since Newman was well off and had no need to sell his paintings or teach or work for a living, he was free to explore his interests in modern art in a number of directions. Some time at the end of the second decade he embarked on an enthusiastic interest in the Cubist movement, having been first stimulated in this by Saÿen. In the National Collection there is an untitled, undated, nonobjective painting [134] of interlocking shapes of yellow, blue, orange, green passing in shading to light green, yellow again, and so on. It is a piece as advanced as any Synchromist painting. Saÿen had lectured on color theory, and the Synchromist ceiling he painted in Newman's house might have moved Newman himself into a number of nonobjective ventures. This is something that will never be clearly established, for, tragically, following Newman's death in 1932, his widow burned his paintings in his studio, as well as many of Saÿen's that were kept there.[15]

Next to Henry Fitch Taylor, Arthur B. Davies, and Carl Newman, Henry Ben-bridge McCarter (1864–1942) was the oldest of all the early modernist painters. He was a student at the Pennsylvania Academy from 1879 to 1885. In the five years he spent in Europe from 1887 to 1892, he came into direct contact with some of France's legendary figures of the Post-Impressionist era, so that to his own students, who included Carles, Crawford, Sheeler, and Demuth, he must have seemed partly attached to a bygone era. As a student at the Academy he had studied with Thomas Eakins. Then, after working as an illustrator for the *Philadelphia Press,* he landed at Paris and studied under Léon Bonnat and Puvis de Chavannes. He saw Van Gogh in life, watched Corot paint. He met with Pissaro, who came to see him, and with Degas. He served an apprenticeship in lithography with Toulouse-Lautrec, of whom he made three drawings from life.[16]

133. Carl Newman, *Nude Under Tree*, c. 1912.

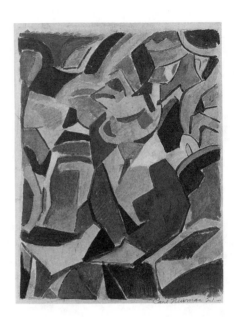

134. Carl Newman, *Untitled,*
1921.

Back in America, McCarter settled in New York, where he supported himself
by illustrating for *Collier's, Scribner's,* and so on. The illustrations, some tight
and detailed, some remarkably free, are all professionally accomplished. In 1902
he began his teaching career at the Pennsylvania Acadamy, which was to last
for forty years. As a teacher he encouraged free expression and individuality,
but ability in draftsmanship came first: he insisted that "all my students first
are as ever academic—I require that. Then we open the window and get it all
off our chests and cut corners after the best new learning in art."[17]

McCarter's work is not as insistently modern as others in the Philadelphia
School. His colors are not as resonant as Carles, as strident and explosive as
Breckenridge. He does not flatten forms as Saÿen did in his late work; there
isn't the smack of German Expressionism in him as sometimes in Carl Newman.
McCarter's colors are more muted, and even his most ı..odern work has some-
thing of the feel of illustration. A lonely man and a supportive friend, to Carles,
for instance, one detects in his unusual color combinations—lemon yellows,
soft blues, pinks—an elegaic quality. He was marvelously alive to the strangely
moving colors one could find in the world if he only looked, if he made himself
aware of the opportunities. Of one of the many times he stayed in Atlantic
City, he observed: "Only to think this place from my studio windows is at night
a superbly handsome modern wonderland. Sashes of colored lights—search
lights swinging—the sea on the beach is mirror color and then turns black—I
wish my students could be fired by the grandeur."[18]

Though tied by training and early experiences to the past generation,
McCarter was open to the poles of the modern art of his middle years. He
professed an intense admiration for Picasso and Matisse. He invited Duchamp
for lunch, and liked his *Nude Descending a Staircase,* which he said influenced

his understanding. His association with Carles, eighteen years his junior, continued years after Carles was his student in the first decade. The two were a nucleus of "The 31," a group showing and promoting advanced tendencies in Philadelphia art during the 1930s. McCarter and Carles were "friendly enemies." The two took long walks and held discussions far into the night. McCarter was keenly aware of the power of Carles's work, his extraordinary color sense, as well as his self-destructive tendencies, which he knew to be the paradoxical source of his creativity. "Arti tore himself to pieces to get those canvases," he recalled. *The Marseillaise* of Carles moved him profoundly: "the inspired nude of God-gifted France in all her force of regeneration." He would fight with the younger man, then ask his advice on color. "I like Carles and his work," he confessed, "but he has a fine element for subtle ruffianly destruction."

From the mid-thirties until 1941, McCarter painted a number of pictures of bells, so done that the metal shells of the bells trail off into rectangles of linear patterns, which are meant as visual metaphors of sound. "I've wanted for years," McCarter wrote, "to paint the fact and the color and vibration of the sound of a 'Chime of Bells.' "[19] One version of about 1937 is in the collection of Mrs. Katherine Garrison Biddle (Bala Cynwyd, Pa); another [135] (*Bells, No. 6*, c. 1941), painted in a great variety of hues—blues, greens, violets, yellows— all kept muted, with the bells' strings merging into the floating rectangles of linear patterns, is in the Philadelphia Museum. McCarter's *Bells* are but one

135. Henry McCarter, *Bells, No. 6*, c. 1941.

instance of many on the part of these American modernists of the search for visual equivalents for auditory phenomena. Musical compositions were the most common subject. Besides Covert's *Brass Band* of 1919 and Dove's paintings of 1917 to 1927 sometimes titled after specific tunes (such as Gershwin's *Rhapsody in Blue*), there are, for example, paintings of Weber in the second decade in which the shapes are amorphous, the handling of the color spotted (*Music,* 1915, National Collection); and the aerograph of Man Ray's entitled *Jazz* in which the forms catch the character of the specific instruments used in a jazz composition, with the vertically oriented darker curved form at the right resembling a bass viol, and the series of superimposed rectangles crossing it at a 45-degree angle a piano keyboard (1919, Columbus Gallery of Fine Arts).

An intimate part of the Philadelphia art scene, and a close friend of McCarter and Carles, was the printmaker, teacher, and commercial illustrator Earl Horter (1883–1940). Horter supported himself as an illustrator for the advertising firm N. W. Ayer. In view of his pictures and prints of picturesque Philadelphia center city streets, excavation sites in New York, and so on, his work cannot be considered mainly modernist. But he was open to a wide variety of influences (as a collector, he had twenty-two Picassos, three Matisses, some Brancusis, as well as pieces by the native Philadelphians Demuth, Sheeler, and Carles), and could

136. Hugh H. Breckenridge, *Abstraction,* c. 1925.

137. Hugh H. Breckenridge, *Kaleidoscope*, c. 1927.

on occasion produce something that bore a Cubist or Futurist stamp. In a pencil drawing of about 1920 of Philadelphia's City Hall (Philadelphia Museum), the tall central tower with the statue of William Penn atop it is made to interpenetrate with a sky seemingly composed of solid fragments. It is a daring interpretation of a well-known building close to (and possibly suggested by) Marin's paintings and prints of the Woolworth Building and Delaunay's paintings of the Eiffel Tower. In a watercolor of a nude, whose flesh is in subtle gradations of pearly grays, oyster whites, and blue-whites, the solidness of the torso is maintained but for the Cubist fragmentations at the perimeter (Sherman Collection, Philadelphia).

More in keeping with the bold colorism of the Philadelphia School are the nonobjective paintings of Virginia-born Hugh H. Breckenridge (1870–1937), who studied at the Pennsylvania Academy from 1887 to 1892, and served on its faculty from 1894 until his death. In 1900 he opened a School of Painting with Thomas Anshutz in Darby, Pennsylvania, which he maintained until 1918;

138. Hugh H. Breckenridge, *Italian Fruit Dish*, 1931.

and in 1920 he opened his summer school, the Breckenridge School of Art, in East Gloucester, Massachusetts. The aim of this school, he proclaimed, was "to encourage in the individual student liberty of sight and freedom. . . . The school is not devoted to any standardized type of art production."[20] It was a sense of freedom arrived at over the years, as his own painting changed from the Impressionism of the first decade. Demuth, who had studied under Breckenridge at the Pennsylvania Academy from 1905 to 1910, was then berated by his teacher for making a painting "the way he felt it." "Feeling and working were not the same thing," Breckenridge said.[21]

Like the illustrator McCarter, Breckenridge had a dual way of painting. His commissioned portraits of doctors, judges, mayors, and other professionals were correctly acceptable to the pillars of society. Meanwhile, from about 1917 to 1935, he painted his *Abstractions*, oil paintings on canvas mounted on heavy cardboard, each length measuring from seven to nine inches. There is less concern here for compositional arrangement than anywhere else in the Philadelphia School. Color carries the weight of the work. Here, for Breckenridge, was the logical outgrowth of his earlier Impressionism: "When I say that I do one thing

today and another tomorrow, I don't mean that those things are unrelated; they play always upon the same instrument—that of color and form as the result of color. . . ."[22] The closest comparison would be with Kandinsky's *Improvisations,* but without the further resonances of the Russian. For Breckenridge, it is color liberated for its own sake. Sometimes the color areas are densely packed, sometimes there are largely unmodified passages (*Abstraction* [Pl. VII, 136] c. 1925, Private collection, Huntingdon Valley, Pa.). There could be suggestions of a landscape configuration, as in his *Landscape No. 1* of 1925 (Goffman Collection, Blue Bell, Pa.), where the colors are at Breckenridge's shrillest.

One of the largest of the *Abstractions* is the *Kaleidoscope* [137] of about 1927 (Private collection, New York), with vivid passages of blue, yellow, orange, and green. Building his free color areas out of a barely recognizable still life motif, Breckenridge colored the fruit bowl a strident violet, in keeping with surrounding passages of blues, violets, and blue-violets (*Italian Fruit Dish* [138], 1931, Goffman Collection). The handling in these color paintings is rapid and spontaneous, with the manner of the brush's application clearly evident. Breckenridge reveled in the material of the paint. It is the balancing of color passages that counts. There is not an underlying geometrical format. Breckenridge was the lustiest of the Philadelphians, playing the part that Vlaminck did among the French Fauves.

NEW YORK INDEPENDENTS

Even in New York not all of the modernist painters had connections with the Stieglitz or Arensberg groups. The independent New Yorkers might have felt more isolated than the Philadelphia painters, for they had no institution like the Pennsylvania Academy of the Fine Arts to provide a center for them. Still, they maintained contacts with some of the other modernists.

Among them were a husband and wife, William and Marguerite Zorach. William gave up his painting for sculpture in 1922, except for a few watercolor sketches.

Born in Lithuania, William Zorach (1889–1966) spent his boyhood in Cleveland, and in 1907 went to New York to study at the National Academy of Design. He probably never even entered 291. In 1909 he traveled to Paris, where he visited the Steins to see there one day "a subdued and unhappy Picasso."[23] Although he was stimulated by Post-Impressionism, Cubism was a mystery to him. In 1911 at the Salon des Indépendants he saw Matisse putting some final touches on his *Red Interior,* and remained unimpressed. The impact of the Matisses, Légers, Delaunays, and Rousseaus he saw was to work upon him later. Marguerite Thompson, whom he was to marry in December 1912, was then more open to the innovations of the French modernists. Back in Cleveland for a while in 1912, Zorach returned to New York in time for the Armory Show,

139. William Zorach, *Untitled*, 1912.

in which he exhibited two paintings (and Marguerite one), and settled in Greenwich Village, where he would remain for almost twenty-five years.

From 1912 to 1917, strong Fauve colors, flat planes, and a naïve idyllic feel, perhaps induced by the Rousseaus or Tahitian landscapes of Gauguin he had seen, permeate William Zorach's work. From 1917 to 1920 there is a breaking open of form in a Cubist manner. An untitled pastorale in the National Collection (untitled [139]) dated 1912 shows luxuriant foliage of many species, with swans gliding serenely on a smooth blue lake and a nude boy riding a white horse.

The moonscape *Mirage—Ships at Night* [140] of 1919 (National Collection), which Zorach painted at Stonington, Maine, where he renewed his friendship with Marin, contains a formal suggestion of Delaunay's use of Cubism. But the spirit is closer to that of German Expressionism, especially to the contemporary work of the *Blaue Reiter*. There is an *Einfühling* into nature, coupled with a Klee-like fantasy, a magical vision done a bit more boldly and less delicately when compared to Klee himself. Three years earlier, in the catalogue to the Forum Exhibition, in which both Zorachs showed, William had written that "it is the inner spirit of things that I seek to express."[24] Such language reflects a similarity to the sentiments of Klee, Marc, and Feininger, although William Zorach remained entirely uninfluenced by all three.

Zorach needed to be in the country. When in the city, he was often drawn for themes to the bits of nature that he could find, as in the *Pelican Cage—Central Park* of 1917 (National Collection). There he plays upon the startling white asymmetries of the birds' bodies; the diaphanous rainbow proscenium marking the top of the cage might have been inspired by Delaunay's *Window* series. In the summer of 1913 he had stayed on a rented farm in Chappaqua, New York. The summer of 1915 was spent on the farm of the elder Quaker art collector Hamilton Easter Field in Randolph, New Hampshire, to whom Zorach had been introduced by Abraham Walkowitz; and the summers of 1917 and 1918 in the hills about Plainfield, New Jersey, on Echo Farm, the property of Mrs. Henry Fitch Taylor, where he rented a cow for milk and grew his own vegetables. Marguerite wrote from Plainfield: "I don't suppose we will ever get any mail unless we get a horse."[25] *One Horse Farm* (National Collection) records this period of their life.

Zorach liked to express what was silent and at rest in nature. In his occasional waterscapes, such as *Mirage—Ships at Night* [140], and in landscapes like *One Horse Farm*, where no work is being done and the people of the farm seem to be listening for a voice in the night (another night scene), he effectively produces a mood of reverie. In the *Pelican Cage*, the pelicans of Central Park, frozen and reduced to a variety of curves as in his own forthcoming sculpture, do not flutter about but stand meditatively poised. In the *One Horse Farm*, the two people of the house (probably himself and Marguerite) are repeated in different sizes, and fragmented by the walls of the ramshackle house to become

140. William Zorach, *Mirage—
Ships at Night,* 1919.

141. Marguerite Zorach, *Landscape,*
1912.

like phantoms inhabiting the lineaments of the old wooden walls. In an interior scene, the *Leo Ornstein—Piano Concert* of 1918 (National Collection), he is interested in catching the mood of the music filling the room: the repetition of the fragmented pianist and the keyboard, the mingling of realistic detail and abstract patterns, convey the reverberations of the music through space during the concert.

In 1920 the Zorachs explored the western slopes of the Sierra Nevada, about the area where Marguerite spent her childhood, and both of them painted views of the Yosemites. William, with great zest, joined the photographer Ansell Adams on mountain-climbing trips. In his watercolors and drawings from that summer there was a break with the earlier more lyrical style, as he abandoned the angularities of Cubism in favor of a looseness and fluidity of handling and a largeness of vision appropriate to the grandeur of the place.

Marguerite Thompson Zorach (1887–1968), who was born in Santa Rosa, California, studied in Paris from 1908 to 1911, where she exhibited in the Salons d'Automne of 1910 and 1911. At the Salons d'Automne and des Indépendants she saw paintings by Matisse, Marquet, Manguin, Friesz, and Derain, by which she steered her course. In Paris, she and William both studied with the Scottish artist John Duncan Fergusson, whose works were similar to those of the Fauves and *Blaue Reiter* artists. After a trip with an aunt in 1911 from Venice to the Near East, then on to the Far East, taking in all nearly seven months, she returned to California, landing at San Francisco.

Like William, solitary immersion in nature moved Marguerite deeply. She spent most of the summer of 1912 in the Sierra Mountains. Among the poems she then composed was one with the line: "Yesterday I leapt with arms wide to hold the storm."[26] She read the nature essays of Emerson. Most of her Sierra paintings, following the Fauvism she had seen in France, catch the grandeur of the setting. She rendered the tree trunks orange and crimson, and the rocky defiles she shot through with patches of orange and dull purple, as in the *Windy Day* (1912, Collection Dr. and Mrs. Fletcher McDowell). The *Landscape* [141] of 1912 in the Goffman Collection is a narrower view of the Sierra terrain, with rocks shown as curved planes of orange, yellow, and blue. Her early work from 1911 until 1915 was invariably in a Fauvist manner, usually with heavy impasto and agitated brushstrokes accompanying the brilliant color and thick lines marking off the different areas (*Judea Hill in Palestine,* 1911, Private collection).

From 1915 to 1919, Marguerite turned to Cubism. It is obvious that she worked closely with William, as they traveled together: there is a common fondness for some themes, and the two echo one another in similar expressions. They spent the summer of 1916 in Provincetown, where they would cross paths with Demuth, and where Hartley, who composed a poem in honor of the Zorachs' one-year-old son Tessim, was their best friend. William's sense of pantheism

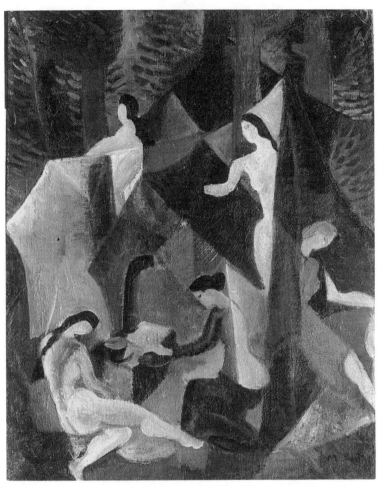

142. Marguerite Zorach, *Camp in the Woods, Yosemite,* 1922.

and unity of nature is slightly lacking in Marguerite's work; her forms are spikier, the space shallower, the cast of the forms sometimes archaic. Paintings derived from her Provincetown experience, the *Provincetown* of 1916 (Collection Mr. and Mrs. Sigmund M. Hyman) and *Ships in the Harbor* of 1917 (National Collection), have lost William's magical quality. This can be seen when these paintings are compared with William's similar treatment of boats in a harbor in his *Mirage—Ships at Night* [140]. But her paintings have another strength, a decorative strength. Some of the oils have the quality of tapestry. In a painting of 1922, *Camp in the Woods, Yosemite* [142] (Collection Irwin L. Bernstein), the figures made out among the trees are expressed in terms of their silhouettes, so that the scene is assessed as an assemblage of flat patterns. From 1920 onward, Marguerite would devote most of her creative energies to the designing and

making of emboideries—which she had first shown at the Daniel Gallery in 1918. She wrote that when she had returned from Paris "full of enthusiasm over the world the Fauves had discovered, paint seemed dull and inadequate to me. The wealth of beautiful and brilliant colors available in woolen yarns so fascinated me that I tried to paint my pictures in wool. That is what my first embroideries were, pictures in wool."[27] After 1930, she returned to her oils, which she continued for the rest of her life.

The Mrs. Taylor who owned Echo Farm, where the Zorachs spent their summers of 1917 and 1918, was married to a key figure in the planning and eventual realization of the Armory Show. Henry Fitch Taylor (1853–1925) was also the oldest of all the modernists, and became converted to modernism as the direct result of his viewing the Armory Show. His was a dramatic turnabout.

Born in Cincinnati, Taylor was a member of Joe Jefferson's Theatrical Troupe in the late 1870s. Jefferson, who also painted landscapes, gave him instruction in art. In 1881 or 1882, Taylor went to Paris, where he enrolled at the Académie Julian. In 1885 he painted in the Barbizon Forest, where he may have met Monet and the American Impressionist Theodore Robinson. He returned to the United States in 1888, and for the next twenty-five years painted in the Impressionist style he had learned in France. He settled near New York, in Cos Cob, Connecticut, where he met with a number of painters, among them Walt Kuhn and Arthur B. Davies. Then, in January 1912, Taylor was elected temporary chairman of the Association of American Painters and Sculptors. The choice was a logical one. Taylor was older than most of the members, had been painting a long time, was generally congenial, and managed the Madison Gallery at 305 Madison Avenue, which he had organized and where the Association first met in December of 1911. After Arthur B. Davies was elected president, Taylor was appointed to the first board of trustees and served on a variety of committees that finally ensured the realization of the Armory Show in 1913.

Through his article in 1966, William Agee rescued Taylor's painting from utter obscurity.[28] Upon seeing the Armory Show, Taylor gave up his Impressionist style, to be influenced first by Cézanne, then, in rapid succession, by Analytical and Synthetic Cubism, Orphism and Synchromism, and by the French painters of the Puteaux Group, Gleizes (who was then in America frequenting the Arensberg salon), Metzinger, and the Duchamp brothers. His paintings, of course, deserve to be known; but generally he does not stand as one of the major talents of the early modernists. His *Figure with the Guitar* (c. 1914, Noah Goldowsky Gallery, N.J.) is a somewhat listless derivation of Braque's and Picasso's seated musicians of 1910–11. The *Cubist Still Life* (1914, Noah Goldowsky Gallery, N.J.) is an unsuccessful mishmash, with the play of profiles at the left looking as though it were derived from Marcel Duchamp's *Sisters* of 1911. Whatever qualities

of design and color might have been realized in the *Peace on Earth* (1914) are diluted by the welter of detail and the epic pretense. The diaphanous areas were probably suggested by the work of Delaunay.

Taylor was at his best when he avoided sentimentalism. *The Parade—Abstracted Figures* [143] (c. 1913, Whitney) is a delicate combination of mauve, purple, blue, and pink areas. His *Untitled Abstraction* of 1915 (Weatherspoon Art Gallery, Greensboro, N.C.), with its curved, metallic-like planes derived from Gleizes in such works as Gleizes's *Man on a Balcony* (1912) that had been in the Armory Show, achieves a strength of design. Taylor grafted his own color system, which he set out in a treatise entitled *The Taylor System of Organized Color*, onto passages derived from others. Continuing his organizational activities, in 1922 he established two groups aimed at giving public exposure to young modernists—the Modern Artists of America, Inc., and the Salons of America.

As with Taylor, the art of Arthur B. Davies (1862–1928) was long rooted in the nineteenth century, in tonalism, in Inness-influenced landscapes (*Along the Erie Canal*, 1890, Phillips Collection), in allegorical figure groupings, in visionary paintings of chaste maidens (*The Jewel-Bearing Tree of Amity*, 1912, Munson-Wil-

143. Henry Fitch Taylor, *The Parade—Abstracted Figures*, c. 1913.

liams-Proctor Institute, Utica) and unicorns, and in some cityscapes encouraged by an association with the Ashcan School. And Davies, even more than Taylor, was active in the organization of the Armory Show. He raised money, and in Paris with Walt Kuhn in 1912 selected the paintings and sculpture to be used for the show as he negotiated with dealers, gallery owners, and the artists themselves.[29] It was Davies who conceived the idea of the show as a demonstration of the evolution of modern art from what he saw as its beginnings in the Romantic period. Davies felt he knew where everything fitted. In the elaborate chart prepared for the Armory Show, he separated "Modern Art" into three groups: the Classicists, headed by Ingres; the Realists, headed by Courbet; and the Romanticists, headed by Delacroix. The Cubists, whose ancestor Davies thought was Ingres, and Picasso belonged to the Classicists; while the Futurists belonged to the Realists. Some painters were considered as belonging to more than one camp: Gauguin was classified with both the Classicists and the Romanticists; Cézanne, with both the Classicists and the Realists.[30]

Davies's superficial classifications and shaky genealogies of modernism and his eclectic veneration of the past led to an adaptation of a Cubist style that was really a patterning of high-keyed colors grafted onto conservatively drawn figures like a harlequin's coat. He could never let go of his preference for groups of elongated figures in a variety of expressive poses. There was a consistency in his tastes, which ranged through history for the mannered, the decorative, and the sentimental, often in combination: Pompeiian frescoes, certain luxury items from the Hellenistic period, Botticelli, and in the nineteenth century the English Pre-Raphaelites, Puvis de Chavannes, and Hans von Marees.

Davies's own willowy women in his *Dancers* [144] of 1913 (Detroit Institute

144. Arthur B. Davies, *Dancers*, 1913.

of Arts) derive from Botticelli and Puvis. There is something contrived and mechanical to the dance steps, where each pose becomes frozen and held. Davies went to the curving planes of Macdonald-Wright, moving in and out of depth, and made of them two-dimensional arcs applied to the surfaces of his figures. In the *Intermezzo* of about 1913 (Graham Gallery, New York) there is another contrived figural composition, with mannequin-like dancers arranged tightly one above the other on the narrow oil panel. The dancers become interwoven with wooden screen partitions, functioning like but not appearing as open frames— a device Davies never attempted before being made aware of Cubism during the Armory Show. He never undertook to rearrange parts of figures, as did the more thoroughgoing American Cubists Weber and Maurer.

Maurer shifted a few details of the face, intermingling several passages in his still lifes. Two of the independent New Yorkers during the 1920s, the Czech-born Jan Matulka (1890–1972) and Stuart Davis (1894–1964), retained the naturalistic appearances of all the parts but restated these in flat patterns whose order they rearranged.

Matulka studied at the National Academy in New York from 1911 to 1916, then spent 1917 traveling in Canada, Mexico, New Mexico, the Bahamas, and Florida. At the end of the second decade he painted Indians he had remembered from the Southwest. He faceted their surfaces into wedges of bright colors (*Indian Dancers*, 1917–18, M. Anschertz Collection, Denver), a method he learned in part from the color painters Jay Van Everen and James Daugherty, whom he met upon his return to New York. In 1920, when Matulka exhibited at the second exhibition of the Société Anonyme with Daugherty, Bruce, and Van Everen, his work was nonobjective (*Composition*, c. 1920, Collection Henry M. Reed). Thereafter, it would incorporate realistic details. His *"42" Manhattan* [145] (Collection Mr. and Mrs. Herbert Sandler), interpreting the city as a complex, well-functioning machine, was probably painted between June 1920 and 1924, when he was influenced by Léger's cityscapes, such as *The City* of 1919. The silhouettes incised on the buildings' walls, the signs, the reassembling of buildings, all have the hallmarks of Léger but, in combination, lack the Frenchman's air of fantasy. Matulka's most powerful works, though, were his Cézannesque landscapes, such as the *White Oak* [146] (c. 1923, Hirshhorn Museum and Sculpture Garden, Smithsonian Institution), with its sleek cow and compact houses, where the branches of the tree reach out like tentacles, taking possession of the surrounding space. Through the exaggerated treatment of light and dark, parts of the tree and houses seem to have been opened up, effectively enhancing the feeling of organic elasticity.

Matulka's *White Oak* [146] reveals a view of nature found frequently in early American modernism, a nature that is energized, expansive, undergoing processes of growth and change. This nature does not consist of clipped hedges

45. Jan Matulka, *"42" Manhattan,* 1920–24.

146. Jan Matulka, *White Oak,* c. 1923.

and tranquil pools. There are writhing trees; rolling, turbulent waters; pulsating flowers—all very different from such other contemporary subjects as the frozen, congealed, immaculate semblances of machines, factoryscapes, and even Hartley's military paraphernalia. Yet, unlike the panoramic landscapes of Church and Moran at the end of the nineteenth century, these landscapes are not calculated to overwhelm the spectator. It is not the grandeur and vastness of nature that the early modernist offers, but usually a corner of a vista, a section of the ocean or a lake district, as with Marin; an area of churning or rolling water, as with Dove, O'Keefe, and Marin; a section of cliff or parched earth, as with the New Mexican Raymond Jonson; or a single plant or flower, as with O'Keefe. There is a direct confrontation with the processes of nature, with the object or area of nature pictured directly, without allusions or symbolic overtones.

Matulka spent the summers in Gloucester, Massachusetts, and maintained a studio in Paris until 1934. He worked in a variety of media not usually explored by the early modernists, as his undated *African Mask* [147] in the Goffman Collection shows, in which he mixed sand with the oil paint. After 1929, when he began teaching at the Art Students League, he largely disappeared from the art world. Interest in him surfaced again during the 1960s.[31]

Stuart Davis, who has already been mentioned in relation to his indebtedness to the Arensberg influence, enjoyed a career that spanned five decades (three of which were beyond the period of our concern) and by the early 1940s was acknowledged a major figure among all twentieth-century American artists. Through most of this time, he played a great number of variations on still life themes and themes of the American scene, modified by his takeoffs on Cubism and abstraction.

147. Jan Matulka, *African Mask*, n.d.

Davis was a Philadelphia émigré to New York, whose father Edward as art editor of the *Philadelphia Press* supervised the Ashcan artists-to-be Glackens, Luks, Shinn, and Sloan. Stuart Davis left high school for New York to study with Robert Henri from 1910 to 1913, a period during which he did pictures in the Ashcan manner of dance halls, pool rooms, and street life. In 1913 he set up his own studio in New York, and had five pieces in the Armory Show, an event that was to determine his future course as a modern artist. He found the work of Van Gogh, Gauguin, and Matisse especially appealing and was at once excited by their "broad generalization of form and non-imitative use of color," as he became aware of "an objective order which . . . was lacking in my own work."[32]

To make a living, Davis did illustrations for *The Masses* under Max Eastman, but resigned in 1916 when Eastman and the Socialist John Reed found that his work was not political enough. From 1916 to 1919, Davis's work abounded in thickly painted landscapes derived in handling and sometimes format from the Van Goghs he had seen in the Armory Show. In this period he also painted a curious nonobjective piece called *The President* (1917, Munson-Williams-Proctor Institute). The broad arrangement of flat quadrilaterals is probably a misreading of Analytical Cubism, with planes laid side by side rather than intersecting, as in Hartley's *Landscape No. 32*. The diaphanous triangles probably derive from Demuth's early use of his ray-lines, which appeared also in 1917 in *Trees and Barns, Bermuda*. Davis first met Demuth in Provincetown in 1913, and kept up contact with him.

From the end of the second decade, Davis successfully reconciled in his painting two seemingly contradictory attitudes: an enthusiasm for French modernism, especially Cubism, and an interest in forms and feelings uniquely American, such as jazz, the sense of which he tried to transcribe. Davis's was a thoroughgoing modernism, in the sense that the formal alterations emanated from the basis of the pictorial construction, rather than being cosmetics grafted onto naturalistically rendered objects, as was often the case with Arthur Bowen Davies. In our period Stuart Davis searched more persistently than any other American modernist except Gerald Murphy for subjects in the paraphernalia of consumerism of American industry. There are paintings of salt shakers, Lucky Strike packages, percolators; and, in his cityscapes, numerous gas pumps, telephone wires, street signs, marquees, and smokestacks. He enumerated the things he liked: "American wood and iron work of the past; Civil War and skyscraper architecture; the brilliant colors on gasoline stations; chain-store fronts, and taxicabs . . . electric signs; the landscape and boats of Gloucester, Mass.; 5 & 10 cent store kitchen utensils; movies and radio; Earl Hines hot piano and Negro jazz music in general."[33] Davis's interpretation of America was at once cool and, like Earl Hines's piano, hot—cool in that the forms seem frozen and

held in place; hot in that the colors are so bright as to have sometimes an electric quality, an intensity of tempo given the various forms.

Although there were always shiftings of the relative positions of objects, Davis's art from 1920 through 1935 ranged between comparatively greater realism and more thorough abstraction. The shiftings were slightest in the *Lucky Strike* of 1921 (Museum of Modern Art), where a flattened cigarette packet seemed to have been converted into an enlarged painting. Schamberg and Sheeler by this date had used machines as subjects, but this was the first time a clean labeled wrapping (Stella used as collages real crumpled wrappers) had been employed as the sole subject, thereby anticipating the Pop Art of Warhol, Wesselman, and others in the 1960s. In Davis's conversion of advertisement into art, Tashjian has observed a correspondence with the contemporary writer Matthew Josephson, who found poetry in American advertisement and, in general, held that the commercial arts should be considered as materials suitable for subjects by the artist.[34] Other paintings as simulated wrappers and labels were a bottle of Odol (*Untitled*, 1924, Collection Mrs. Stuart Davis) and *Sweet Caporol*, a picture of packages and papers (1922, Collection Mrs. Stuart Davis).

Elsewhere the shiftings are greater. In the *Salt Shaker* (1931, Museum of Modern Art), the top of the container has been flattened and separated from the body of the utensil and presented from a top view; it also has been fashioned

148. Stuart Davis, *House and Street*, 1931.

as a face, with the two holes as eyes, a Surrealist touch. The body, presented straight on, is treated diagramatically, somewhat as one may see it in mechanical layouts—a fashion pointedly removed from what was then regarded as the world of "fine arts." In the *House and Street* [148] (1931, Whitney), there are two facades, the one of a closeup of a house, the other of groups of factory blocks, with the composition split down the middle. It is as though one had turned the corner of a street. Similar textures weld the whole into a totality.

Realistic details were largely eliminated in the *Percolator* [149] (1927, Metropolitan) and in the *Eggbeater* series [150] of 1927–28 (variations in Whitney, Lane Collection, Phillips Collection), where Davis made an abstract composition through the unlikely combination of an eggbeater, an electric fan, and a rubber glove. He stripped these objects down, fused them in places with simplified shapes added; color was applied not to each object, but to clarify the spatial positions of the planes. Describing his experience in the studio, Davis recalled: "One day I set up an eggbeater in my studio and got so interested in it that I nailed it on the table and kept it there to paint. . . . I got away from naturalistic forms. . . . I felt that a subject had its emotional reality fundamentally through our awareness of . . . planes and their spatial relationships. . . ."[35]

After 1935 Davis largely abandoned the picturing of objects, however stylized, within a space. Against a uniform bright background he arranged large, flat shapes, so that the painting became an overall color pattern (*Colonial Cubism*, 1954, Walker Art Center). Or letters in a single word, casting a hypnotic effect (and anticipating similar effects in the Optical Art of the 1960s) appeared, like the word "Champion" suggested by a matchbook cover advertising Champion "Little Giant" batteries (*Visa*, 1951, Museum of Modern Art). Keeping abreast of the new developments in Abstract Expressionism, through the late thirties and early forties he met regularly in Greenwich Village bars with John Graham, Willem de Kooning, Arshile Gorky, David Smith, and other avant-gardists of the new generation.

The New York independents also included Konrad Cramer (1888–1963), Mell Daniel (1899–), and Morris Kantor (1896–1974).

Like Oscar Bluemner, Cramer was born in Germany and came here when he was in his mid-twenties, in 1911. He claimed to have been associated with the *Blaue Reiter* group, which was in the process of being formed in Germany at the time he left. Still under the stimulus of the *Blaue Reiter*, he produced some of America's earliest nonobjective paintings (*Improvisation No. 1*, 1912–13, Whitney; *Strife*, 1913, Joseph H. Hirshhorn Private collection), based on Kandinsky's *Improvisations*. He met Stieglitz shortly after arriving in New York, but was never shown at 291. By the time he founded the Woodstock Art Colony with Henry McFee and Andrew Dasburg, he was working in a Synchromist, then in a modified Cubist manner. His *Barns and Corner of Porch* of 1922 (Collection Aileen Cramer, Woodstock), in a combination of oil and collage, is a rather

149. Stuart Davis, *Percolator*, 1927.

150. Stuart Davis, *The Eggbeater, No. 1,* 1927.

vigorous but awkward approach to Cubism, where what succeeds best is an effective contrast of smooth- and rough-appearing surfaces, and spotted and linear textures. In the early thirties Stieglitz got Cramer involved in photography. Daniel, as well as Kantor, was a student about 1913 at New York's Independent School of Art, under the direction of Homer Boss. The motif of extended branches was a recurrent one with Daniel, appearing in his show at De Zayas's Modern Gallery in 1917, and later in the mid-twenties when the branches became simplified, tubular elements. In 1933, when he was only thirty-four, he left art completely to work for the Interchemical Corporation.

Kantor, born in Russia, came to America when he was thirteen and studied for a while at the Independent Art School, "where there was constant talk about the Armory Show" and of values in modern art.[36] His own period of modernism lasted only from 1919 to 1924, after which his street scenes (especially around Union Square where he lived) and waterscapes contained smatterings of simplifications distantly dependent on Cubism. Of his most experimental work, the

Mood of 1921 (New Bertha Schaeffer Gallery) contains delicate, transparent planes probably derived from the Orphism of Delaunay and a softly delineated bounding deer probably taken from the animal motifs of Franz Marc. His knowledge of the Armory Show became a vocabulary of ideas to which he would return: his *Orchestra* of 1922 is built up of blocklike figures with their instruments, which are stylizations from Duchamp's *Nude Descending a Staircase*.

These men, not building in an organic fashion, like Davis, on their modernist direction, round out the picture of the New York Independents.

CHICAGO AND WESTWARD

In Chicago between 1908 or 1909 and 1914 worked an artist who deserves to be at least mentioned in all anthologies of twentieth-century painting. Manierre Dawson (1887–1969), with the possible doubtful exception of some of Marin's *Weehawken* sequence, was the first American to paint nonobjectively, preceding by a year or two Dove's *Abstractions*. His *Prognostic* [Pl. VIII, 151] of 1910 (Milwaukee Art Center), the central panel of a triptych—with its delicate rose, triangular hill forms before a linear network of dull greens and grays—bears a disturbing resemblance to Kandinsky's work of 1909–10, which he was certainly unfamiliar with at the time. In fact the young civil engineer and architec-

151. Manierre Dawson, *Prognostic*, 1910.

tural draftsman, who graduated from Chicago's Armour Institute of Technology in 1908 without the inspiration of the art of others, arrived independently at nonobjective painting from his own isolated efforts based on studies in his courses. *Prognostic,* as Dawson recalled in a letter of April 6, 1969, to Tracy Atkinson, director of the Milwaukee Art Center, was one of a group of seven nonobjective paintings begun probably in 1909: " . . . the others are smaller painted shortly after I graduated from college where I had so many engineering and mathematics courses that the influence of this shows in the backgrounds of coördinates and superposition of differentials. The black lines and circles thrown over these are subconsciously possibly suggested by pencils, pens, and erasers generally strewn over a student's drawing board. This series of seven paintings was interrupted by my European tour."[37]

The European trip, meticulously recorded in Dawson's journal,[38] lasted from June 26 to November 30, 1910. It consisted of whirlwind tours of England, France, Switzerland, Italy, France again, and Germany, in that order. During the trip he filled his journal with descriptions of buildings, cityscapes and country-sides, and accounts of the people he met and the various impressions he received—but there is no mention of Fauvism, German Expressionism, Cubism, or the then-emerging Futurism, nor of any of the artists involved with those movements. He did praise Cézanne (journal entry of November 10, 1910), who "doesn't take the scene at face value but dips into the bones and shows them." He chanced upon John Singer Sargent in Siena on or about September 17, and the venerated American society painter praised one of his wooden panels. He paid two visits to Gertrude Stein's apartment: on the first on November 2, he was told to come back on Saturday evening, and did so. He then sold Miss Stein a panel painting for 200 francs, his first sale; there would not be many others. On November 4, he saw Cézannes at Vollard's gallery. One direct out-come of his visit to the Steins was the *Woman in Brown* [153] of 1912 (University of Texas, Michener Collection), an Analytical Cubist rendition, (as Earl Powell has shown) of Picasso's *Portrait of Gertrude Stein* of 1906, which was hanging in Gertrude Stein's apartment when Dawson was there.[39]

Back in America, Dawson returned to the engineering firm of Holabird and Roche, and continued with his remarkably advanced painting, doing what little he could to attract attention. One of his works, the nearly nonobjective *Wharf Under Mountain,* was hung in the Armory Show when it arrived in Chicago. In 1914 some of his paintings, including *Prognostic* [151], were in a large traveling show that made stops in Pittsburgh, New York (the Montross Gallery), Detroit, and at the Milwaukee Art Center. Dawson, disenchanted with his drafting jobs, followed along to Detroit and Milwaukee to be with his paintings. We know from his journal that on March 1, 1914, he was in Detroit, pretending to be looking at the show but really eavesdropping. Then on April 26 he discovered in the April 17 edition of the Milwaukee *Free Press* a reproduction of *Prognostic,*

152. Manierre Dawson, *Lucrece,*
 1911.

beneath which a nameless wiseacre had placed the caption: "A portrait of Dudley
Crofts Watson" (director of the Milwaukee Art Center). That could have been
the straw that broke the camel's back. Like Covert, Dawson couldn't take the
ridicule or the lack of support, and virtually stopped producing art. In May
1914 he took his family and left Chicago—he was then only twenty-seven—to
settle into the isolation of a farm in Ludington, Michigan.

Dawson's work from his return from Europe in late 1910 through 1913
consisted of Analytical Cubist figures painted on canvas, nearly nonobjective
landscapes painted on wood panels, and low wooden reliefs. The figures, full
length and half length, would seem to be based on the contemporary Cubist
figures of Picasso and Braque, even though Dawson never mentioned these
sources. The *Lucrece* [152] of 1911 (Ringling Museum, Sarasota), the *Cumaea*
[154] the *Woman in Brown* [153], and the *Woman Bathing* of 1912 (Hirshhorn
Collection) are all colored in the earth tones of the Europeans; but the bodies
are at once less abstract and less weighty, and the rhythms flickering and swing-
ing, as though a movie projector were suddenly jammed and the boundaries
of the figures repeated in multiple overlaps. The landscape abstractions and
the wooden reliefs (some in the Schoelkopf Gallery, New York) in their modest
way comprise some of the most delicately nuanced and exquisitely composed
pieces in all early modernism.

One of the finest of these, the *Trees Behind Outbuildings* of 1910 (Dr. and
Mrs. Max Elleberg, New York) reminds us of Mondrian's paintings of trees
done in 1915 when he was using an Analytical Cubist style. More predictably

153. Manierre Dawson, *Woman in Brown,* 1912.

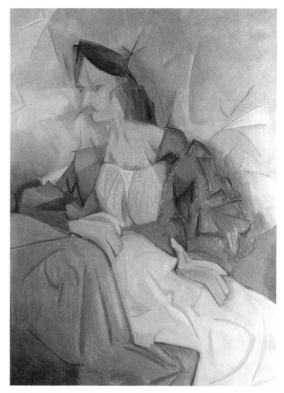

154. Manierre Dawson, *Cumaea,* c. 1912.

composed but equally delicate is the *Two Trees* [155] of 1912 (Dr. and Mrs. Max Elleberg, New York). As early as 1908, Dawson had worked out his aesthetics from his technical studies and purposefully set these down in his journal: "The three most important qualities that art depends on are due to ratio (proportion, if you like): ratio of angle, ratio of intensity, ratio of scale. . . . The subtle direction of a line and its relation to other lines can give great excitement of great movement" (entry of December 26, 1908). Who would have thought such dicta would have emerged from Chicago when they did?

The Santa Fe–Taos area in New Mexico from the mid-teens to the late twenties drew early modernists as well as painters of a more conservative stripe, who were moved alike by the raw grandeur and the desolation of the terrain. The towns were situated in mountain ranges of 7,000 to 8,000 feet, and one could see for miles in the clear, limpid air. The primitivism of these towns in itself proved a boon to nurturing a small art colony, which was visited frequently by writers and rich people eager to buy. In the mid-twenties Santa Fe had no street lights and Taos no sewer or water system.[40]

155. Manierre Dawson, *Two Trees,* 1912.

The area affected people differently. Marsden Hartley came to New Mexico in 1918, went to California in the spring of 1919, and returned to Santa Fe in the early summer. From 1912 to 1915 he had been in France and Germany, working under the influences of Cubism and the Expressionism of the *Blaue Reiter.* His New Mexican landscapes usually had a broken, forlorn tree in the foreground facing a rolling, barren mountainscape, topped by a sky containing low, heavy-hanging clouds (*New Mexico Landscape,* 1919, Philadelphia Museum); the house and chapel interiors might show a prominent scrawny plant in the foreground and behind a picture of an ascetic Christ (*El Santo,* c. 1919, Museum of New Mexico, Santa Fe). McCausland ventured that Hartley's nearly monochromatic *Recollections of New Mexico,* painted in Berlin in 1922–23, in which shapes of a New England landscape were grafted onto scenes of an even more forbidding terrain, were meant as a catharsis of the New Mexico experience. For Hartley "feared the blighted heath of New Mexico."[41] Obviously the emptiness of that vast place dwarfing the human scale got to that lonely man. Belonging to this period is a withered landscape of 1923, *New Mexico Recollections* [156] (Columbus Gallery of Fine Arts, Howald Collection).

Stuart Davis, who spent the summer of 1923 in New Mexico, also abandoned his modern manner to turn to a heavy-handed, crude, but uninteresting

literal style. There was little effort or thought involved in those New Mexican landscapes. Davis, at one with the quickened jazz pace of New York and feeling himself an admirer but completely the outsider here, explained that he "didn't do much work because the place itself was so interesting. . . . It's a place for an ethnologist not an artist. . . . Not sufficient intellectual stimulus. Forms made to order, to imitate."[42]

John Marin spent the summers of 1929 and 1930 there, and was an enthusiastic man by nature open to new experiences—one who did not travel out of compulsion like Hartley. Mabel Dodge Luhan, ex-New York socialite and salon diva, had settled in Taos in 1917, married Tony Luhan, a Pueblo Indian, after divorcing the painter Maurice Sterne, and was Marin's host. The painter from Maine loved to see "six or seven thunderstorms going on at the same time,"[43] storms he showed in watercolor, sometimes schematically as shadings of tone punctuated by crackling lines denoting lightning bolts (*Storm, Taos Mountain, New Mexico*, 1930, Metropolitan). And he observed the dance of the San Domingo Indians, which he captured in watercolor and charcoal with its cast of dozens (Metropolitan).

But Georgia O'Keeffe, coming to Taos in 1929 as the guest of Mrs. Luhan, felt above all a special closeness to the vast, gaunt land and caught, better than anyone else could, the curious vitality within the stillness of sharply etched, simple forms standing clear in a totally barren environment. She focused on both natural forms and the relics and objects of the Indians, which she saw as part of the same order. Her paintings were of desert stones and flowers; Ranchos

156. Marsden Hartley, *New Mexico Recollections,* 1923.

churches [157] (1930, Amon Carter Museum, Fort Worth); skulls bleached white by the heat; and crosses, which interested her "because they represent what the Spanish felt about Catholicism—dark, somber—and I painted them that way." The way she painted them was as dark, looming, powerful shapes, sometimes the spaces beneath the crossbar serving as entrance ways to the multi-colored hills beyond (*Black Cross, New Mexico*, 1929, Art Institute of Chicago). O'Keeffe liked New Mexico so much that in 1945 she bought a house in Abiquiu, where she settled permanently in 1949, three years after Stieglitz's death.

Those were the visitors to New Mexico from the East. Others came to stay, even during our period.

Foremost among them is Raymond Jonson (1891–). Through his painting over a period of more than fifty-five years, Jonson ranks as "dean" of the New Mexican progressive artists. Yet until the 1970s, with the publication of Garman's book on Jonson and its detailed review in a national art journal,[44] his presence went almost unsuspected.

Born in Iowa of Swedish descent, Jonson was the first student to enroll in 1909 at the Museum Art School of Portland, Oregon, studying under a student of Arthur Wesley Dow, the teacher of Weber and O'Keeffe. Next came his studies

157. Georgia O'Keeffe, *Ranchos Church,* 1930.

at the Chicago Academy of Fine Arts from 1910, and his increasing involvement with the Chicago Little Theater as a designer of stage sets and costumes. Jonson's first extended stay in New Mexico took place in 1922, when he visited Santa Fe; he moved there in 1924. He chose to stay away from the arty colony of Taos, and its artists of national reputation, a decision that contributed to his own insularity from the "modernist scene."

Hartley saw the forbidding emptiness of New Mexico's mountainscapes, Marin the interpenetration of various land masses, and of land with sky, and the dramatic events brought on by changes of air pressure over the desert. O'Keeffe for her part responded to the sense of mystical radiance in the dry bones, relics, and desert plants. Jonson in turn was struck by the obdurateness of the rocky terrain, its sheer physical presence. In his *Earth Rhythms* series of 1923 to 1927, in such paintings as *Earth Rhythms No. 3* (1923), *Earth Rhythms* (1927), and the *Cliff Dwellings No. 3* of 1927 (all at University of New Mexico), strata upon strata of rocky ridges are shown. The "modernism" lies in those paintings, as it does in the *Earth Rhythms, No. 10* [158] of 1927 (Collection Mr. and Mrs. Sam Rankin, Albuquerque), in which Jonson sets off sections of brittle earth at impossible angles and opens some of them up, enabling us to see layers of rock and earth and the nuggets of rock within. "It has been said," Jonson observed, "that the New Mexico landscape looks like a cubist painting. During the first fifteen years after my arrival in New Mexico in 1922 I did hundreds of drawings directly from the landscape with the intention of ferreting out the rhythms and forms that could possibly be utilized in the organization of the paintings. 'Earth Rhythms No. 10' was organized from drawings made at Questa, New Mexico. The resulting interrelating forms are based on strong repetitive rhythms somewhat similar to a typical cubist painting."[45]

The implacability of nature in that region (as Breughel might have seen it) was what Jonson was trying to get at, and Cubism—rather than an aesthetic that must be adopted—was merely a means to be used now and then toward that expression. Van Deren Coke has written that in his *Earth Rhythms,* Jonson was influenced by Cézanne and Picabia, whose work he saw at the abbreviated Armory Show in Chicago.[46] It sounds like conjecture, with no basis. The spirit of Cézanne may be there, but there is no stylistic connection; and it is hard to suppose that Jonson in any way would have been drawn to the smooth machine surfaces of Picabia. The similarity is more apparent than real. It was the landscape itself that exerted its spell on Jonson. Just before beginning the series, he proclaimed in his diary an approach to his art that would obviate the direct adoption of other artists' stylistic features. A work of art, he wrote, should be "a rhythmic whole which moves and calls forth the spirit of each object used," and should stand "simply for itself and not a design for something else."[47]

Jonson thought of nature in terms of cyclical processes. In his *Seasons* series of 1922, he set allegorical nudes in a variety of expressive poses set, as

158. Raymond Johnson, *Earth Rhythms, No. 10,* 1927.

in *Winter* (University of New Mexico), within a rocky, barren terrain. The allegorical, somewhat attenuated figures remind one of Hodler's in the 1890s. In 1921 Jonson had been deeply affected by his reading of Kandinsky's *Art of Spiritual Harmony*,[48] and the subsequent nonobjective paintings—like the *Composition Four—Melancholia* (1925, Collection Irwin Bernstein), with its circular forms and Saturn-like rings—could have been done with some knowledge of Kandinsky's Bauhaus period. In 1929 Jonson began his *Digits* series, nonobjective configurations based on various numerical forms; and in 1930 his *Variations on a Rhythm*, based on letters of the alphabet.

Jonson's subsequent career took many turns. In a lifetime of work produced almost entirely in New Mexico, he must be acknowledged as the single figure who did most to bring modern art to the Southwest.

The work of Willard Nash (1898–1943) was rather uneven, and his energies went off in a number of directions: he was once America's highest-paid boy soprano, then became an expert boxer and rifleman. Born in Philadelphia, he settled in Santa Fe in 1920 after studying in Detroit, and lived there until leaving for California in 1936. His father, an engineer, put great pressure on him to drop his career for something that would earn him more money, but Nash persevered, earning money in a number of ways to keep up with his art. In Santa Fe he built his own adobe hut.[49] In 1921 he was instrumental in organizing with Jonson and others (B. J. O. Nordfeldt, Jonson's teacher for a while, was allied in the effort) the group "Los Cincos Pintores" (Five Painters), whose aim was to take art to the people and not surrender to commercialism.

Nash's *Sun Mountain—Abstract* (1924, Roswell Museum, Roswell, N.M.) is a picture of the site in the mountains about Santa Fe of Del Monte Sol, the first promontory to catch the morning light.[50] The sky is tilting, and the planes of the outcroppings of rock, which are vaguely like human muscular forms, interlock in places in a Cubist fashion, not fully, but rather as in the proto-Cubist paintings of Braque in 1908. The *Santa Fe Circus* [159] of 1930 (University of New Mexico) however has little that is recognizable within a landscape (the squiggly lines may be meant as trees). There is a general explosion of form and color, as the parts of the landscape have been reduced to quadrilaterals, variously shaded, with the tiny orb of the sun at the top of the canvas. Late works of Cézanne were probably the source, but the impact is closer to the apocalyptic visions of the German countryside painted by Franz Marc in 1913–14. In his *Students Going to Class* [160] (1934, University of New Mexico) there is a nearly Futurist treatment of figures. Characteristically, Nash treated his subjects representationally, with surface shadings accounting for rather minor dislocations. Such was his rendering of a series of *Penitentes* during the twenties (*Penitentes*, Collection Dr. Edward McLin and James McClary), done after witnessing the "secret" crucifixion ceremonies deep in the New Mexican mountains.[51]

159. Willard Nash, *Santa Fe Circus*, 1930.

160. Willard Nash, *Students Going to Class*, 1934.

Andrew Dasburg (1877–1979) did not settle in Taos permanently until 1930. He made an exploratory visit in 1916, though, visiting his friends Maurice Sterne and his then wife, Mabel Dodge, and kept coming back, spending three or four months out of every year until he moved westward permanently.

When Dasburg settled in New Mexico, he had had more exposure to both European and American modernism than either Jonson or Nash. After studying at the Art Students League and then under Robert Henri, he went to Paris in 1907 and remained there until 1910. He met Matisse, Vollard, Leo Stein, and felt himself under the sway of Cézanne's work. (Dasburg had come home, in a sense. He was born in France, came to America when he was five, and did not become a naturalized U.S. citizen until 1922.) In Paris he saw again Morgan Russell, with whom he had studied at Woodstock. Back in America he exhibited in both the Armory Show and the Forum Exhibition; and throughout that second decade his work was as advanced as that produced by any other American. Like Morgan Russell, he eliminated the recognizable in his paintings, proclaiming in the Forum Exhibition Catalogue:

"I differentiate the aesthetic reality from the illustrative reality. In the latter it is necessary to represent nature as a series of recognizable objects. But in the former, we need only have the sense or emotion of objectivity. That is why I eliminate the recognizable object."[52] Dasburg wrote those words when he was insisting upon a pure art and was allied to the Synchromists. At some point in the beginning of the third decade his aims changed.

The change was signaled by an article he wrote in 1923 for the magazine *Arts*.[53] In it Dasburg insisted that "one cannot write of actual Cubism in America, but only of the effort," because "we lack the intellectual integrity to work logically within the limitations inherent in an idea." Among America's "incomplete" Cubists, Dasburg included himself, as well as Demuth, Hartley, McFee, Weber, Marin, and a number of others. What Dasburg was aware of was that the force of Synchromism had come to an end, and that the Precisionist manner which prevailed in America when he was writing his article was less extreme, or less within the realm of French Cubism, than had been several directions of American modernists during the second decade. There was a hint of deprecation in his statement, the deprecation of a man born in France, whose own approaches to modernism were based on Cézanne and French Cubism. What he did not fully appreciate was that Marin's, Stuart Davis's, and Maurer's responses to French Cubism (the last after the writing of the article) were vital precisely because they were not attempts to provide an intellectual integrity, because they provided a departure coherent in American terms. Unfortunately, while New Mexico inspired Hartley, Marin, and O'Keeffe to interpretations that were deeply felt, it brought forth from Dasburg a modernism that was pat and safe. In his *Landscape* of about 1922 (San Francisco Museum of Art), he dwells on the blocklike aspects of the land with its hedged-in plots. In the *New Mexico*

Village of 1926 (Museum of New Mexico), boxlike adobe houses maintain their boxlike quality, and the distant rounded hills are simply smoothed further into orbs.

Finally, Tom Benrimo (1887–1958) came to live in Taos in 1939, after our period of concern. Benrimo was born in San Francisco, and as a boy he made models of lighthouses, bridges, balloons, and sailboats.[54] In the earthquake and fire of 1906, he and his family lost all their possessions, including the small models. As a young man he went east with his family and settled in New York, but he never forgot the starkness of the desert seen on the train trip in 1908. In 1911, through the connections established by his older brother Harry, a well-known actor, he did work for scenic studios. And in 1913 he saw the Armory Show, and became acquainted with Cubism. All the while his memories of San Francisco remained vivid, as he focused on the violence of what was then still a frontier town. He would recall times "when the wooden sidewalks caught fire," the noise of horse-drawn fire engines, and the way when "runaway horses attached to huge beer wagons pound [ed] down the steep hills," people were "literally flying in all directions to escape the rolling beer barrels."[55] In 1916, during the war, Benrimo entered the Marine Camouflage Service, where he disguised ships from detection—an appropriate sort of Cubist activity. Later, beside his painting, he painted sets for the theater, tended animals in traveling acts, and rode in motorcycle races.

In the Cubist work following the Armory Show, for example Benrimo's *Jockeys* of 1918 (Collection Mr. and Mrs. James H. Clark, Dallas), there is a sense of violence and chaos, of dispersed and unrelated forms being pulled together into an order. One thinks of Benrimo's violent memories centered on his youth. The *Jockeys* has a dramatic strength to it, and a quality of improvisation that suggests later Action Painting and the work of De Kooning, for the forms seem not to have been demarcated beforehand, but to have evolved during the process of painting. The dramatic struggle, the difficult resolution makes for a unique vision among those American modernists who adopted a Cubist manner. In the *Chaos* [161] of 1925 (Collection Mr. and Mrs. James H. Clark), which is an elaboration of the *Jockeys*, the sense of violence and explosion is carried further.

Benrimo's painting in New Mexico became generally more luminous and, reflecting the environment of the Southwest, more spacious and lyrical. At times, the desert's empty spaces prompted paintings in which he put to use his earlier practice as a set designer through dismaying Surrealist constructions. In the *Nostalgic Migration* of 1942 (Collection Mr. and Mrs. Robert D. Bright, Santa Fe), the upper storey of an ornate old building floats over a broad, desert terrain, ostensibly gravitating toward its new moorings. Perhaps Benrimo was referring to his own migration, three years earlier.

161. Tom Benrimo, *Chaos*, 1925.

In California during the third decade a number of artists' group arose, some of whose members produced paintings as advanced as any to be found in the East. Dominant in the memory of Californians then was the great Panama-Pacific Exposition held in San Francisco in 1915, celebrating both the discovery of the Pacific Ocean and the completion of the Panama Canal in August 1914. Most of the 11,403 art works shown predated the twentieth century. Of French art there were Impressionists; Post-Impressionists were scarce (some Signacs), nothing more advanced than Bonnard, Vuillard, Denis, and Marquet, that is, nothing of Cubism. There was, though, a Futurist contingent, and in the Exposition catalogue a nineteen-point Futurist manifesto appeared.[56] The Americans shown were represented by Homer, Sargent, Whistler; the Impressionists such as Hassam, Tarbell, Robinson; and painters of The Eight. Maurer was the only modernist. The first real modern show on the West Coast came in 1922 at Los Angeles's Museum of Science, History, and Art in Exposition Park, when Macdonald-Wright, who had moved to California three years earlier, used his connections with Stieglitz and Daniel to bring over paintings by Benton, Dasburg,

Dickinson, Demuth, Dove, Marin, Maurer, Hartley, Man Ray, McFee, Russell, O'Keeffe, Sheeler, Stella, Walkowitz, and a sculpture by Zorach.

Emerging since 1918 and coalescing in 1923 with the issuing of a manifesto was a group of Oakland painters known as "The Six." Among the precepts of their philosophy were these:

> All great art is founded upon the use of visual abstractions to express beauty.
>
> These abstractions are: Vision, light, color, space (third dimensional form), atmosphere (air), vibration (life, movement), form (length and breadth) and form of accidents such as persons, trees, etc.
>
> Pattern is the means by which the abstractions are arranged and united in such a way as to procure the esthetic end. And by pattern we mean unity, contrast, harmony, variety, symmetry, rhythm, radiation, interchange, line, tone, etc.
>
> Form, i.e., objects, is accidental and transitory, except in its large sense— space. That the object we see happens to be a man instead of a tree or other object is an accident, since if we look a few feet to one side we see an entirely different object. Form is also destroyed and distorted by light, color, vision, and space—in other words, its visual existence is by grace of larger abstractions. . . .[57]

But in spite of the talk about "abstraction," most of the paintings of The Six (William H. Clapp, Louis Siegrist, Maurice Logan, August Gay, Bernard von Eichman, and Selden Gile) were tame by Eastern standards. Beneath the bright colors and bravura brushwork, there was an illustrational core. The character of the work was mainly Impressionist, and in its themes of fishermen, quarries, estuary dwellings, it could be compared to the paintings of The Eight with its reliance on local color.

The most advanced of The Six was Bernard von Eichman (1899–1970), who was born in San Francisco, where he lived until his move to New York in the 1930s. In his *China Street Scene, No. II* [162] (1923, The Oakland Museum, California) there is the barest semblance of figures, and nothing can be made out of buildings or street boundaries, for detail has been sacrificed to the maintenance of a grid of pure color. In this instance there is a coloristic boldness rivaling that of the Synchromists or of the Philadelphian Breckenridge. The year 1923 saw also the formation of "The Group of Independent Artists," which held its first exhibiton in Los Angeles. In the foreword to the catalogue, Macdonald-Wright pointed out that

> The puerile repetition of the surface aspects of the Masters has ceased to interest any intelligent man. The modern artist striving to express his own age cannot be expected to project himself with any degree of sureness five hundred years back and drag forth by the aid of necromantic stupidity the corpse of an art inspired and nourished by a period environment, a greater art, if you will, but a corpse nonetheless. . . . The group maintains that artistic manifestations such as Cubism, Dynamism and Expressionism, are sincere intellectual efforts to obtain a clearer aesthetic vision.[58]

162. Bernard von Eichman, *China Street Scene, No. II,* 1923.

This group included, beside Macdonald-Wright, the Cubist-oriented Max Reno, and Nick Brigante.

Outside The Six was the ranchman Rex Slinkard (1887–1918), who lived on a ranch in Saugus near Los Angeles. He had studied at the Art Students League of Los Angeles with Robert Henri from 1908 to 1910. Marsden Hartley, who met him through the painter Carl Sprinchorn, eulogized him as a "poet-painter" in the catalogue essay written for Slinkard's memorial exhibition, held in 1920 in Los Angeles and at the Knoedler Galleries in New York.[59] Slinkard sometimes painted in a tonalist manner reminiscent of the 1890s: idyllic open range scenes of figures, horses, and deer permeated and partially dissolved by the atmosphere. His drawing, as in the *Young Rivers* [163] of about 1915–16 (Stanford University Museum of Art) was firm and sure, however, probably as sure as could then be found in California. Other paintings, such as *My Song* [164] (c. 1915–16, Stanford University Museum of Art) have broadly handled,

163. Rex Slinkard, *Young Rivers*, c. 1915–16.

164. Rex Slinkard, *My Song*, c. 1915–16.

frontalized figures, starkly presented, rather in the style of the contemporary work of *Die Brücke* but not quite with their overtone of disturbance. Here, the musical title hints at the strong sense of revery, at the mysticism that was part of Slinkard's temperament. "Imagination—that's the one thing I can paint with. I am lost without it," he insisted. (*Contact,* No. 3. Spring, 1921, p. 4.)

The two artists who did most for the cause of modern art in California, Stanton Macdonald-Wright and Lorser Feitelson (1898–), were émigrés. Macdonald-Wright arrived in 1919 after becoming well known for his part in the development of Synchromism; Feitelson in 1927.

Feitelson was born in Savannah but grew up in New York, where he saw the Armory Show repeatedly. He was moved most by the art of Cézanne, Duchamp, and Matisse. Thereafter, he kept abreast of what was progressive, though betraying a certain eclecticism in the number of influences he assimilated. After the Armory Show, while still in his teens, he sought to combine a kinetic effect with a monumentality of conception. In Feitelson's *Absinthe Drinker* of 1917 (Ankrum Gallery, Los Angeles), the subject and general format is derived from a Matisse of 1914, *Mlle Yvonne Landsberg,* but not the combination of profile and frontal views, which comes from French Cubism, nor the repetition of some of the contours, which probably derived from Duchamp or Futurism and makes for a quivering effect. The overall stability of the figure dominates over the motion, which seems to be trying to assert itself. Of this period Feitelson noted that while his early attraction to the "kinetic line" in Cézanne's late work and the work of the Futurists was inevitable, he made his own adjustments. "While the Futurists' lines of form were intended to be dramatically subjective and anti-formal—ending in commotion rather than order—it seemed to me that the same kinetic principles had other and more significant possibilities for creating monumental pictorial structures, in which a dynamic equilibrium could be attained by organization of the disjointed, shifting and rocking lines."[60] A trip to Paris in 1919 prompted the abandonment of this kineticism, and Feitelson turned to Matisse for the expressiveness of his spare, flexible line. At the same time he kept the fluttering poses suggested by Italian Mannerism. In Italy in 1922, he studied closely Renaissance and again Mannerist paintings. Upon his return to New York, he embarked upon a neoclassical period, with solid figures heavily modeled (*Diana at the Bath,* 1922, Brooklyn Museum).

Shortly after settling in Los Angeles in 1927, Feitelson became interested in the metaphysical painting of Di Chirico and Carrà, thus keeping pace, as was his way, with what was *au courant.* Surrealism drew him, but the notion of the European Surrealists that the artist should remain passive and wait for the unconscious to take hold on the creative processes disturbed him. His work of the 1930s—which he termed "Post-Surrealism," and sometimes "subjective classicism"—was characterized by objects placed in strange settings and an arcane, highly personal symbolism, derived, he claimed, from the "normal func-

tionings of the mind." He wrote for his catalogue statement of 1935: "Surrealism, by exposing the plastic possibilities of the subjective, has occasioned the birth of Post-Surrealism, an art that affirms all that Surrealism negates: conscious rather than unconscious manipulation of materials, the exploration of the normal functionings of the mind rather than the individual idiosyncracies of the dream."[61]

Feitelson's *Genesis First Version* [165] (1934, San Francisco Museum of Modern Art) is the picture of part of the naked torso of a woman reflected in a mirror, a table on which lie an egg and a sliced avocado containing a nut, and a glowing planetary body in the night sky beyond the window. All this connotes a linkage in the processes of birth on the cosmic or planetary, human, and natural levels. Always changing, sometimes anticipating trends, by 1950 Feitelson was painting very large nonobjective canvases, some about seven feet in length (*Geomorphic Metaphor,* 1950–51, Los Angeles County Museum), of flat, unmodulated shapes in the manner of such post-painterly abstractionists as Ells-

165. Lorser Feitelson, *Genesis First Version,* 1934.

worth Kelly. Not only as a painter but as teacher, writer, polemicist, and collector, he was instrumental in bringing about some appreciation of modern art in California by the first third of the century.

Macdonald-Wright came to California in 1919 because, as he put it himself, he was not satisfied with his own work or "with the modern development in any sense of the word."[62] An explanation of this reaction was offered by his close friend of his New York years, Thomas Hart Benton, who recalled that Macdonald-Wright had come to New York from Europe with the intention of converting the city instantly through his Synchromism "and when the city failed to capitulate he wandered around from studio to studio full of picturesque blasphemy."[63] In California he shied away from exhibiting until 1930, when at Russell's insistence he consented to be shown with the compatriot of his Synchromist days at the Los Angeles County Museum and elsewhere. But in a number of ways he expanded his interests and activities in art, so that he became viewed as a leader on the West Coast in what was avant-garde.

From 1923 Macdonald-Wright pursued an earlier interest in Eastern art, in Eastern calligraphy, and in Taoism and Zen. In 1919 he had produced the first full-length stop-motion film ever made in full color, making for it some five thousand pictures in pastel. The subject was the eruption of a volcano on a tropical island, which forced the natives to flee.[64] His interest in color and his earlier immersion in Synchromism thus led him into new directions. From 1922 to 1930 he directed the Art Students League in Los Angeles; and in 1924, for his students, he had his *Treatise on Color* privately printed, which set down, for example, the relationships between colors and emotional states he had worked out during his years in Paris. From 1925 to 1927, as a director of the Santa Monica Theater Guild, he had constructed Synchromistic stage settings with abstract colors as backdrops.

As a painter, Macdonald-Wright kept modifying and developing his earlier Synchromist position. His earliest California paintings, like *Canyon Synchromy (Orange)* [166] of about 1920 (University of Minnesota Art Gallery), were landscapes with bits of buildings growing out of the sides of canyons and on the tops of mountains. It is an ethereal vision, as though one had come upon a lost city on the roof of the world—and the return to California may have meant just that to the artist after thirteen years in Europe and New York. Yet the analogy with the human body has not departed entirely, for the surface rhythms still distantly suggest the rippling of muscles and sinews beneath the flesh. In the mid-twenties, Macdonald-Wright concluded that a limitation of Synchromism was its need for spectral color, and he went about adopting a richer though less brilliant gamut of colors. Moreover, he wished for "a pictorialism whose animating subject matter and conception was preponderantly Oriental."[65] A case in point was the *Dragon Forms* (1926, Collection Edythe Polster), with its flattened, juxtaposed shapes, overlapping in places, some curved and serrated,

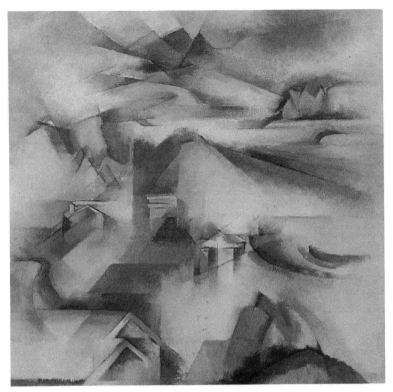

166. Stanton Macdonald-Wright, *Canyon Synchromy (Orange)*, c. 1920.

of violet, green, red, yellow, and yellow-green. The color areas are now unmodulated and less brilliant, and there is no trace of the body analogies evoked through the surface rhythms.

The experimentation never ceased. "In 1925," he pointed out, "I became assured that I had not yet found the right form for myself, a form that satisfied me, and until 1938 I varied all the methods I had previously used, narrowing and widening them, branching into the old fields of abstraction, non-objectivity and semi-objectivity all the while studying the composition of the ancient cultures from Egypt to Italy and from Assyria to China. . . ."[66] What Macdonald-Wright may have meant by "semi-objectivity" was his *Yin Synchromy No. 3* (1930, Santa Barbara Museum of Art), the picture of a naturalistically reclining, vaguely Oriental female before a background of mountains and clouds handled as in the California landscapes of around 1920.

In 1931 Macdonald-Wright returned to New York, and the next year he held a one-man show at Stieglitz's An American Place. The same year he was back in California, where he began doing stonecutting in marble and onyx. By the 1940s modernist painting was being taken seriously far more widely in

California. Macdonald-Wright helped to pave the way. At the same time, the virtual lack of the establishment of any regional modernist tradition in California in 1920 ensured for Macdonald-Wright the openness, the possibility of becoming the forerunner and leader, that apparently was necessary for his development.

INDEPENDENTS IN EUROPE

Except for Van Everen, O'Keeffe, Yarrow, and Benrimo, all the early American modernist painters were in Europe at some point before 1935. But two of them, Gerald Murphy (1888–1964) and Patrick Henry Bruce (1881–1936), produced all their modernist work there, and in spite of some contacts with their countrymen, were therefore quite isolated from the groups of modernists and the painting being done in America.

It would be hard to imagine two greater opposites. Murphy, who lived in France from 1921 to 1934, and in a villa near Antibes from 1924, was a trendsetter in the international jet set of his time. The Gerald Murphys enjoyed skiing just when it was becoming popular with the trendy, and helped introduce the Charleston to Europe.[67] Their intimates were the Dos Passoses, the Hemingways, the Scott Fitzgeralds (Fitzgerald partially based the character of Dick Diver in *Tender Is The Night* on Murphy), the Cole Porters, the Archibald Macleishes, and the Picassos (when Picasso was married to his first wife, Olga Koklova). Bruce, who lived in Paris from 1904 until a few months before he took his own life in New York in 1936, was a Virginian, and, to boot, a direct descendant of Patrick Henry, who tried to govern himself by some chivalric code of the Old South. He was vain and aloof, and from the end of World War I became a virtual recluse among the antiques and bric-à-brac of his apartment. He identified with the bored, overly sensitive aristocrats of whom Proust wrote. He believed that women were inferior, that slavery was a good institution, and that Dreyfuss was guilty.[68] Because of his bad stomach, he subsisted toward the end of his life on a diet of almost raw vegetables. In 1929, when his financial position was growing precarious, he refused to give up wearing shirts cut to order.

Where Bruce came from old Southern aristocracy, Murphy was from a wealthy merchant family. His father Patrick took over Mark W. Cross's Saddlery Shop in Boston in the 1880s and converted it into a profitable New York store. After working for his father for five years, Gerald Murphy joined the Signal Corps during the war, then studied at the Harvard School of Landscape Architecture until, bored with his courses, he left for Europe in 1921 with his wife and three children. In that year, upon seeing an exhibition of the work of Picasso, Braque, and Gris, he enthusiastically declared: "If that's painting, it's what I want to do."[69] The one teacher Murphy had, early in his career, was the Russian émigré Rayonist (a brand of Futurism) Natalia Goncharova; and in his career

he painted but fourteen pictures, most of them curious, remarkable still lifes.

There occur throughout Murphy's *oeuvre* objects that are thought of as usually American and that are the objects, too, commonly sold (a reminder of his family's store?): razors (when working for his father he had been given the assignment of developing an inexpensive safety razor to rival Gillette's), cigar boxes, matchboxes, pens, cocktail shakers, corkscrew openers. It is a pre-Pop imagery, objects with trade names (*Razor* [167], 1924, Dallas Museum), patent numbers (*Watch* [168], 1924–25, Dallas Museum), and labels (*Cocktail*, 1927, Collection Mrs. Philip Barry), objects with names and faces, so to speak, as opposed to the blank, featureless objects filling Bruce's still lifes from 1917 to 1930. Murphy shares with Stuart Davis the distinction of being in the 1920s the first Americans to make pictures consisting entirely of common, commercial objects.

167. Gerald Murphy, *Razor*, 1924.

168. Gerald Murphy, *Watch*, 1924–1925.

But Murphy's work is not only more tightly structured and detailed than Davis's. It also assumes a variety of disjunctions, disruptions in scale, contrived plays between the real and the painted object that anticipate similar devices in, say, the billboard-like paintings of James Rosenquist in the 1960s. The *Razor* [167] looks like not so much a painting of a razor, fountain pen, and matchbox as the painting of or replica of a large-scale advertisement of those objects. The aggrandizement of what amounts to a copy of a copy is best known in the work of Lichtenstein. Murphy's paintings startle through their distortions of scale. A safety razor—an object fitting neatly in one's hand, one whose size is known intimately through touch—becomes blown up out of known proportion. The interior workings of a watch [168] (not an actual watch, but an invented

rearrangement of parts), which conjures up the minuscule, were presented by Murphy in a painting that is an enormous square of nearly billboard proportions, 6.5 feet to the side. In his Notebook, he jotted down: "Always struck by the mystery and depth of the interior of a watch. Its multiplicity, variety and feeling of movement and man's grasp at perpetuity."[70] The interior of the watch becomes a world unto itself, full of tortuous paths and bypaths, gears, pistons, and levers, all intermeshed in apparently perfect coordination. The laborious detail, with the kind of precision given to medieval manuscripts, is staggering. One reason Murphy turned out only fourteen paintings was the slow care with which he worked. He spent four months painting the picture on the inside of the cigar box in *Cocktail*[71]—a *trompe l'oeil* detail worthy of Harnett, but one out of keeping with the diagrammatic rendering of the lemon, the wineglass, and other details.

There are also jarring discrepancies and distortions of scale among the various objects within the single painting. In *Cocktail,* the lemon halves, the wineglass, and tax stamp are larger in scale than the cigars within the box. In the *Wasp and Pear* (1929, Museum of Modern Art), the wasp, normally tiny, is pictured as large as the pear upon which it crawls; while the dotted pattern at the right, representing the cells of the insect's nest, makes for a still further deviation in size. In places in this painting Murphy used a kind of X-ray technique, opening up the insect's nest, stripping away the surface of the leaf at the bottom to expose the structure of the veins. Beyond the play in scales, Murphy offered in this painting the further enrichment of a Cubist-like play between the interiors and exteriors of objects. In the *Doves* (1925, Dallas Museum), a nearly mono-chrome painting except for the few areas of dull blue, different from Murphy's usual vivid, poster-like colors, there are four different scales: the smallest, for the dove in profile to the right of the center of the canvas; the next for the various elements of a Greek temple of the Ionic order, the base and the beginning of the shaft of the column, parts of the architrave, and the scroll of the capital, all rearranged into an ensemble of the artist's fashioning; larger still for the profile of the dove to the left of the center; and the largest scale for the dove's head at the right toward the top of the canvas. Murphy was aware of these discrepancies and planned for them at the outset, as this excerpt from his Note-book concerning an idea for a painting shows: "Scene of a house interior with all chairs and furnishings done in colossal (or heroic) scale. People dwarfed climbing into great chairs to talk to each other; struggling under the weight of huge pencil to write notes on square feet of paper. . . ."[72]

As for Bruce, before 1917 he fits somewhat into the history of color paint-ing. From 1907 to 1912 he had been under the direct tutelage of Matisse. Then from 1913 he had immersed himself in the color theories of Chevreul and Rood, as well as the writings on light and the psychology of vision of Charles Blanc and Von Helmholtz. He befriended the Delaunays, whose Orphist works were inspirations for his own; and was very close to Frost, Jr., although

he did not associate with Macdonald-Wright and Russell. This had been the period of his *Compositions,* based on the movement of people at large public dances, which he himself had like to attend. It had been a fairly happy time for him. By the war's end, despite the departure of Macdonald-Wright to America, the death of Frost, and the breakup of the Orphist Circle that had gathered about Delaunay and Apollinaire (who died in the war), Bruce chose to stay on in Paris.

From 1917 to 1930—he stopped painting, curiously, in the same year as Murphy—Bruce painted still lifes derived entirely from objects in his apartment, in which he kept himself more and more sequestered. The objects in that place became his entire world, and limited to them, he put forth variations placed upon a tabletop, painting them as, it might seem at first glance, something architectonic and hence enduring. In a letter of March 17, 1928, to his friend, the novelist Henri-Pierre Roche, he wrote: "I am doing all my traveling in the apartment on ten canvases. One visits many unknown countries that way."[73] By "unknown countries" Bruce could have meant realms of the mind. Or as he was making his living by selling antique furniture and artifacts, he may have been referring to the many countries actually represented by objects he kept.

William C. Agee, through his uncovering of old photographs, has managed to identify most of the objects pictured in the twenty-five still lifes existing of the 1917–30 period. (Bruce destroyed thirty-three of his paintings in 1933, most of them predating 1917). The basic horizontal plane in each painting was abstracted from one of the four antique tables Bruce kept, two from the seventeenth century, the one Spanish, the other Dutch.[74] There can also be made out a glass with a straw, sometimes with plant life spilling out; and mortars and pestles

169. Patrick Henry Bruce, *Formes* (unfinished), c. 1923–24.

170. Patrick Henry Bruce, *Forms (Peinture/Nature Morte)*, c. 1924.

from his collection of African art, seen in the *Abstract* of about 1928 (Museum of Art, Carnegie Institute) and the *Formes* of about 1928 (Allen Memorial Art Museum, Oberlin College). Common draftsman's tools like a ruler are seen several times, always without markings (*Peinture,* c. 1917–18, Collection Rolf Weinberg, Zurich; *Peinture,* c. 1929–30, Museum of Modern Art; etc.); wooden moldings (in the unfinished *Formes* [169], c. 1923–24, Private collection); and magnets used to secure drawings to a wall or table, which Bruce liked for their half-circle shape (*Forms on Table,* c. 1924, Addison Gallery; *Forms (Peinture/Nature Morte)* [170] (c. 1924, Corcoran Gallery; etc). These tools and objects became for Bruce colored planes, bound and interlocked, and dynamically interacting. There is a sense of both movement and depth, while yet maintaining a two-dimensional pattern as surface—the difficult duality he had learned from Matisse in the first decade. And here, after the sidetrack toward Orphism and the Delaunays from 1912 to 1916, were the lessons of Matisse reasserting themselves.

But as a collection of still life objects, these late paintings of Bruce reveal his conception of his environment. Rose maintains that the order in them is more apparent than real, and that the lack of stability reflects clues of the fragmented world he was experiencing. (When the historian Michel Seuphor visited Bruce in the winter of 1926–27, he found him dejected, staring into the fireplace and threatening to throw in his paintings.[75] Bruce, in these paintings, contravened the laws of physics. Hardly any two of the form-objects within a single painting are depicted from the same point of view. There are crazy tiltings of the table-plane, and usually the form-objects look as though they are about to plunge into our space in an avalanche (*Forms on Table,* c. 1924, Addison Gallery; *Forms No. 5,* c. 1924, B. F. Garber, Marigot, St. Martin; etc.). These pictures, Barbara Rose maintains, are really a powerful metaphor of dislocation and frustration, a longing for coherence, which proved for Bruce unrecoverable.[76] How different in spirit these still lifes are from Murphy's, where, however much sizes may vary illogically, the aim is the consolidation of a new order. Murphy himself thought of his pictures as expressing a native classicism "such as the Greeks must have craved . . . what Emerson meant when he wrote, 'And we [Americans] shall be classic unto ourselves.' "[77]

The golden summer of the Murphys' life was ending by 1933, when they became aware of the beginnings of Nazism and the rise of Hitler, and the Riviera was losing its innocence. In that year they returned to America, settling in New York. Gerald Murphy successfully took over his father's business, gave up his painting, and did not communicate with most of the friends and associates of his European existence. But he had always remained an American: the subjects he chose for his paintings, for example, indicate the wholeness of his life. For Bruce, on the other hand, the contradictions between his political reactionism and the modernism of his painting, between the fastidiousness of his tastes and the onslaught of his grinding poverty, proved too much to overcome.

NOTES

1. The more recent term "Pennsylvania Academy Moderns" was used as the title of the exhibition in 1975 at the National Collection and the Pennsylvania Academy of the Fine Arts. There were a total of forty-three paintings by the following: Brecken-ridge, Carles, Demuth, McCarter, Newman, Saÿen, Schamberg, and Sheeler. Smithsonian Institution Press, *Pennsylvania Academy Moderns, 1910–1940,* Washington, D.C., 1975.

2. Lloyd Goodrich, *Thomas Eakins: His Life and Work,* New York, 1933, pp. 8–9.

3. Philadelphia Museum of Art, *Arthur B. Carles: A Critical and Biographical Study* (text by Henry G. Gardiner), Philadelphia, 1970, p. 146.

4. Arthur B. Carles, "Nature and Life as a Post-Impressionist Sees Them," *Philadelphia Press,* July 21, 1913. Partially quoted in Barbara Boese Wolanin, "Abstraction (Last Painting): A Question of Influence," *Philadelphia Arts Exchange* (November–December 1977), p. 20.

5. Packet of letters addressed to Arthur B. Carles, kindly furnished by the Philadelphia collector Stephen Cassamassima.

6. Quoted by Henry Clifford, "Prophet with Honor," *Art News,* 52 No. 2 (April 1953), p. 48.

7. Quoted in *Art Digest,* 27 (1953), p. 13.

8. Adelyn Breeskin, *H. Lyman Saÿen,* Washington, D.C., 1970, p. 33.

9. Illustrated in *ibid.,* p. 13. *Rule of Tyranny* and *Primitive Agriculture;* but *Good Government* and *Rule of Justice* are not shown.

10. Copy of lecture among Saÿen Papers, National Collection of Fine Arts Library.

11. Saÿen Papers.

12. Autobiography of Jeannette Hope, *Blossoms of Liberty: Notes of Her Ninetieth Year and Some Conversations to Her Daughter from Jeannette Hope, the Wife of H. Lyman Saÿen,* unpublished, pages unnumbered. Saÿen Papers.

13. When a Philadelphia miniature painter, Margaretta Archambault, wrote Saÿen that she was unclear as to what he meant in his talk "The United States and Modern Art," Saÿen responded with a very long letter in which he not only insisted that modern art was valid and important, but traced its history. Copy of letter among the Saÿen Papers.

14. Autobiography of Jeannette Hope, *loc. cit.*

15. Saÿen Papers.

16. Robert Sturgis Ingersoll, *Henry McCarter,* Cambridge, Mass., 1944.

17. *Ibid.,* p. 58. According to his student Anne O'Neill Donohoe, he also admired Celtic art, which he saw as being connected with modern art.

18. *Ibid.,* p. 59.

19. *Ibid.,* p. 77.

20. Valley House Gallery, *The Paintings of Hugh H. Breckenridge (1870–1937),* Dallas, Tex., 1967, p. 17.

21. Quoted in Emily Farnham, *Charles Demuth: Behind a Laughing Mask,* Norman, Okla., 1971, p. 55.

22. Interview with Dorothy Grafly, *The North American,* March 12, 1922. Quoted in Valley House Gallery, *op. cit.,* p. 20.

23. William Zorach, *Art Is My Life,* Cleveland and New York, 1967, p. 24.

24. *The Forum Exhibition of Modern American Painters, March 13 to March 25, 1916,* New York, 1916, pages unnumbered.

25. The Zorach Papers, Archives of American Art.

26. Quoted in Roberta K. Tarbell, "Early Paintings by Marguerite Thompson Zorach," *American Art Review,* I (March–April 1974), p. 46.

27. Marguerite Zorach, "Embroidery as Art," *Art in America,* 44 (Fall 1956), pp. 48–51.

28. William C. Agee, "Rediscovery: Henry Fitch Taylor," *Art in America,* 54 (November 1966), pp. 40–43.

29. Davies's considerable work on behalf of the Armory Show is brought out in Milton W. Brown's, *The Story of the Armory Show,* Greenwich, Conn., 1963.

30. The entire schema with its threefold

division was of course a gross oversimplification; but Davies deserves much credit in attempting what was the most ambitious and definitive historical systematization of the 1908–15 span. See A. B. Davies, "Chronological Chart Made by Arthur B. Davies Showing the Growth of Modern Art," *Arts and Decoration*, 3 (March 1913), p. 150.

31. For information on him, there is Schoelkopf Gallery, *Jan Matulka* (exhibition catalogue), New York, 1970 and *Jan Matulka* (exhibition catalogue), text by Elizabeth Ives Bartholet, New York, n.d. Most extensive of all are Patterson Sims and Merry A. Forest's essays for the exhibition catalogue, *Jan Matulka*, Washington, D.C., 1980.

32. American Artists Group, *Stuart Davis*, New York, 1945.

33. Davis quoted in Katherine Kuh, *The Artist's Voice*, New York, 1962, p. 52.

34. Dickran Tashjian, *Skyscraper Primitives: Dada and the American Avant-Garde, 1910–1925*, Middletown, Conn., 1975, pp. 120–130, 132–146, and elsewhere.

35. James Johnson Sweeney, *Stuart Davis*, New York, 1945, pp. 16–17.

36. Moris Kantor, "Ends and Means," *Magazine of Art*, XXXIII (March 1940), p. 140.

37. Letter from Dawson quoted through the kindness of the Archives of the Milwaukee Art Center and Kathryn Kearney, Assistant Curator of the Center, who provided a photostat on November 25, 1974. Letter quoted in part in Abraham A. Davidson, "Two from the Second Decade: Manierre Dawson and John Covert," *Art in America*, 63 No. 5 (September–October 1975), p. 51.

38. The original of the journal is in Sarasota's Ringling Museum. Dawson wrote in his journal regularly, sometimes daily, from 1908 until 1914, and then less frequently until 1939.

39. Earl A. Powell, III, "Manierre Dawson's 'Woman in Brown,'" *Arts Magazine*, 51 No. 1 (September 1976), p. 77.

40. Sanford Schwartz, "When New York Went to New Mexico," *Art in America*, 64 No. 4 (July–August 1976), p. 93.

41. Elizabeth McCausland, *Marsden Hartley*, Minneapolis, 1952, pp. 34–35.

42. Sweeney, *op. cit.*, p. 15.

43. Quoted in Schwartz, *op. cit.*, p. 96.

44. Ed Garman, *The Art of Raymond Jonson, Painter*, Albuquerque, N.M., 1976. Garman is a California painter who met Jonson in 1938, and remained a devotee. He writes of Jonson in an unflagging, high-minded manner that sometimes obscures the real achievements. A feature of his book is the numerous excerpts from Jonson's diaries. For a scholarly review of Garman's book and an assessment of Jonson's art, see Nicolai Cikovsky, Jr., "The Art of Raymond Jonson," *American Art Review*, III No. 5 (September–October 1976), pp. 129–136.

45. From an interview with Mrs. John Sauters, October 1966. Quoted in University of New Mexico Art Museum, *Cubism: Its Impact in the U.S.A. 1910–1930*, Albuquerque, N.M., 1967, p. 45.

46. Van Deren Coke, *Taos and Santa Fe, the Artist's Environment, 1882–1942*, Albuquerque, N.M., 1963, p. 80.

47. Jonson diaries, excerpts of July 21, 1919, and August 10, 1919. Jonson Gallery Archives, Albuquerque. Quoted in Garman, *op. cit.*, p. 55.

48. Jonson wrote in his diary on August 5, 1921: "I have spent the last two entire days reading and digesting Kandinsky's 'The Art of Spiritual Harmony.' It is the greatest book concerning art I have ever read. It is immense. One cannot, if he be wise, but accept and believe in the truth he puts forth. . . . I believe we must sooner or later know him to be right, at least in theory—and that is the point, theory. And then what about practice? To be able to live and actually work in the spiritual is, of course, a great ideal and one to hope and work for." Quoted in *ibid.*, p. 56.

49. Information kindly supplied by William D. Ebie, Assistant Director of the Roswell Museum and Art Center. Letter of September 20, 1979.

50. *Roswell Museum and Art Center Quarterly Bulletin*, 27 Nos. 2 and 3 (March–August 1979), pages unnumbered.

51. Letter from Ebie, *op. cit.*

52. *The Forum Exhibition of Modern American Painters, March 13 to March 25, 1916.*

53. Andrew Dasburg, "Cubism—Its Rise and Influence," *Arts*, 4 (November 1923), pp. 279–284.

54. *Tom Benrimo (1887–1958)* (exhibition catalogue), Fort Worth, Tex., 1965, p. 2.

55. Quoted in Douglas MacAgy, *American Genius in Review No. I*, Dallas, Tex., 1960, pages unnumbered.

56. On works in the show, see Panama-Pacific International Exposition Co., *The Sculpture and Mural Decorations of the Exposition*, introduction by A. Stirling Calder, San Francisco, 1915. $20,000 was raised by the citizens of San Francisco, the municipality and the state legislature. Contributions from various states of the union and foreign countries swelled the grand total to $50,000. There were 11 main exhibit palaces: Fine Arts, Education, Social Economy, Liberal Arts, Manufacturers and Varied Industries, Machinery, Transportation, Agriculture, Agric. (food products), Horticulture, Mines and Engineering. For an account of the planning and pictures of the site, the exhibit palaces and some of the items on display, see Panama-Pacific International Exposition Company, *Panama-Pacific International Exposition*, San Francisco, 1914.

57. The manifesto is reprinted in San Francisco Museum of Modern Art, *Painting and Sculpture in California: The Modern Era*, San Francisco, 1977, p. 25.

58. *Ibid.*, p. 27.

59. Marsden Hartley, "Rex Slinkard: Ranchman and Poet-Painter," Memorial Exhibition: Rex Slinkard 1887–1918, San Francisco Art Association, 1919. Reprinted in Hartley's *Adventures in the Arts*, New York, 1921, pp. 87–95.

60. Quoted in Henry J. Seldis, "Lorser Feitelson," *Art International*, XIV No. 5 (May 20, 1970), pp. 49–50.

61. Quoted in Jules Langsner, "Permanence and Change in the Art of Lorser Feitelson," *Art International*, VII No. 7 (September 25, 1963), p. 75

62. John Alan Walker, "Interview: Stanton Macdonald-Wright," *American Art Review*, I No. 2 (January–February 1974), p. 63.

63. Benton, *An Artist in America*, pp. 38–39.

64. Walker, *op. cit.*, p. 68. The negative of this film was destroyed in the early twenties in an explosion at the Blum Laboratories in Hollywood.

65. From the statement in the exhibition catalogue of his show in the Stendahl Galleries, Los Angeles, in 1948. Reprinted in David W. Scott, *The Art of Stanton Macdonald-Wright* (exhibition catalogue), Washington, D.C., 1967, p. 13.

66. *Ibid.*

67. Calvin Tomkins, *Living Well Is the Best Revenge*, New York, 1972, pp. 117–118. This popularly written biography still remains the best source on Murphy.

68. Agee and Rose, *Patrick Henry Bruce: American Modernist*, p. 90.

69. Tomkins, *op. cit.*, p. 29.

70. Quoted in *ibid.*, p. 153.

71. *Ibid.*, p. 156.

72. Quoted in *ibid.*, p. 151.

73. Quoted in Agee and Rose, *op. cit.*, p. 81.

74. *Ibid.*, p. 30.

75. Rose's interview with Seuphor, *ibid.*, p. 75.

76. *Ibid.*, p. 82.

77. Tomkins, *op. cit.*, pp. 155–156.

Epilogue

Just as with the beginning of early American modernist painting, no one year can be set as the ending for all artists. No one drew down a great curtain, bringing the phase to a close. But the year 1935 is as good an ending as can be set, for by that year the major events and directions had occurred.

Some of the artists kept going on in their accustomed ways, like Niles Spencer. Some, like Jan Matulka, and Covert, Dawson, and Walkowitz, painted little after 1935. Some—Davies, Demuth, Dickinson, Frost, Jr., Maurer, Saÿen, Schamberg, and Taylor—were dead by 1935. Others changed in accordance with the temper of the times. Lorser Feitelson flattened his space and used large geometric, angular shapes in his nonobjective canvases (*Geomorphic Metaphor*, 1950–51, Los Angeles County Museum of Art). Marin came to prefer oil, which he handled with abandon in his waterscapes in drips and long linear traces (*Sea Piece*, 1951, Mr. and Mrs. John Schulte, New York), reminding one somewhat of the sketches of Pollock. Sheeler, still in a Precisionist format, in the 1950s placed soft areas next to hard, detailed ones, and used off-key purples and tans, color combinations he probably derived from color negatives. Through the 1950s and beyond, O'Keeffe worked on a larger and larger scale, presenting a sense of vastness, as in a picture of sky (*From the Plains II*, 1954, Susan and David Workman), which existed now in fact where it had previously been implied. Davis from the 1950s, too, worked on a larger, mural-like scale, came frequently to incorporate prominent lettering, and placed brightly colored areas next to one another in his nonobjective paintings in such a way as to make the spectator experience aftereffects (*Premiere*, 1957, Los Angeles County Museum of Art), reminding one of some Optical painters.

But early modernist painting during the period before 1935 anticipated many later developments in American art.

Dove's *George Gershwin's "Rhapsody in Blue" Part I* of 1927 and such freely

handled color paintings by Breckenridge as the *Kaleidoscope* of about 1927 are not far from the gestural branch of Abstract Expressionism in Pollock, Kline, Guston, and De Kooning. The practices encouraged by the Arensberg Circle led to the many aspects of Conceptual art current from 1960. In the second and early third decade, the Readymades and assemblages of Duchamp; Schamberg, who made his *God* in about 1918 out of a mitre box and plumbing trap; and Man Ray, who in 1921 presented as the *Gift* a hand-held flatiron to which nails were attached—all anticipated in a general way the assemblages of such varied artists as Edward Kienholz, John Chamberlain, Alexander Lieberman, and Mark di Suvero. Man Ray's use of the airbrush, discovered in 1917 and remarkable for the time, is widely practiced today. The reliance upon free-flowing, free-moving color as the total expression in the paintings of Macdonald-Wright, Breckenridge, Yarrow, and Dawson in his *Prognostic* of 1910 led to the soft-edge branch of post-painterly abstraction in the work of Louis, Frankenthaler, Olitski, and Jenkins. Color as the total expression, contained in defined, sometimes ruled-off sections, as it occurs in the paintings of Russell, Bruce, Saÿen, and Van Everen, led to the hard-edge branch of post-painterly abstraction in the work of Kelly, Held, Frank Stella, Gene Davis, and Noland. Pictures of such common objects as a razor and a cigar-box top in the paintings of Murphy, and gas pumps, a box of Odol, a Lucky Strike wrapper, and a salt shaker in the paintings of Stuart Davis, led to the Pop Art of Warhol, Lichtenstein, Oldenburg, and Rivers (who, like Murphy, specifically used cigar-box covers). And the juxtapositions of objects taken out of context in the Poster Portraits of Demuth and such paintings of Feitelson as *Genesis First Version* of 1934 led to similar devices in Rosenquist, Rauschenberg, and many other artists.

And, so many of the vaunted innovations of American art from 1940 had their precedents in early modernist painting, when the scale of the works was usually smaller, and the sense of important movements being touted alike by the press and by the artists themselves was notably absent.

1910 to 1935 was for American painting a time, nonetheless, of bold adventurousness and willing experimentation, and of sizeable accomplishments.

Bibliography

1. THE STIEGLITZ GROUP

General and Background Material on 291:

Baur, John I. H. *Revolution and Tradition in Modern American Art.* Cambridge, Mass.: Harvard University Press, 1951.

Benson, E. M. "Alfred Stieglitz: The Man and the Book," *American Magazine of Art,* 28 (January 1935): 36–45.

Brown, Milton W. *The Modern Spirit: American Painting 1908–1935.* London: Arts Council of Great Britain, 1977.

Bry, Doris. "The Stieglitz Archive at Yale University," *Yale University Gazette,* 15 (April 1951): 123–130.

Camera Work, 47 (July 1914). Entire issue devoted to the meaning of 291.

Davidson, Abraham A. "Cubism and the Early American Modernist," *Art Journal,* 26 (Winter 1966–67): 122–129, 173.

———. "Some Early American Cubists, Futurists, and Surrealists: Their Paintings, Their Writings, and Their Critics. Ph.D. dissertation, Columbia University, 1965.

Dijkstra, Bram. *The Hieroglyphics of a New Speech: Cubism, Stieglitz, and the Early Poetry of William Carlos Williams.* Princeton, N.J.: Princeton University Press, 1969.

Frank, Waldo, Lewis Mumford, Dorothy Norman, Paul Rosenfeld, and Harold

Rugg, eds. *America and Alfred Stieglitz: A Collective Portrait.* Garden City, N.Y.: Doubleday, Doran & Co., 1934.

Goodrich, Lloyd. *Pioneers of Modern Art in America.* New York: Whitney Museum, 1963.

——— and John I. H. Baur. *American Art of Our Century.* New York: Whitney Museum, Frederick A. Praeger, 1961.

Green, Jonathan, ed. *Camera Work, A Critical Anthology.* Millerville, New York, 1973.

Hamilton, George Heard. "The Alfred Stieglitz Collection." *Metropolitan Museum Journal,* 3 (1970): 371–392.

Homer, William I. *Alfred Stieglitz and the American Avant-Garde.* Boston: New York Graphic Society, 1977.

———, ed. *Avant-Garde Painting and Sculpture in America, 1910–1925.* Wilmington: Delaware Art Museum, 1975.

———. "Stieglitz and 291," *Art in America,* 61 (July–August 1973): 50–57.

Hunter, Sam. *Modern American Painting and Sculpture.* New York: Dell, 1951.

McCabe, Cynthia Jaffee. *The Golden Door: Artist Immigrants of America, 1876–1976.* Washington, D.C.: Smithsonian Institution Press, 1976.

Mellow, James R. *Charmed Circle: Gertrude Stein & Company.* New York: Praeger, 1974.

Mellquist, Jerome. *The Emergence of an Ameri-*

can Art. New York: Scribner's, 1942.

Minuit, Peter (Paul Rosenfeld). "291 Fifth Avenue," *Seven Arts,* I (November 1916): 61–65.

Moak, Peter van der Huyden. "Cubism and the New World: The Influence of Cubism on American Painting 1910–1920." Ph.D. dissertation, University of Pennsylvania, 1970.

Munson, Gorham. "291: A Creative Source of the Twenties," *Forum,* 3 No. 5 (Fall–Winter, 1960): 4–9.

Norman, Dorothy. *Alfred Stieglitz: An American Seer.* Millerton, New York: Aperture, 1973.

———. *Alfred Stieglitz: Introduction to an American Seer.* New York: Duell, Sloan, and Pearce, 1960.

———, ed. *Stieglitz Memorial Portfolio, 1864–1946.* New York: Twice A Year Press, 1947.

O'Keeffe, Georgia. "Stieglitz: His Pictures Collected Him." *New York Times Magazine,* December 11, 1949, 24, 26, 28–30.

Pioneers of American Abstraction. New York: Andrew Crispo Gallery, 1973.

Ritchie, Andrew C. *Abstract Painting and Sculpture in America.* New York: Museum of Modern Art, 1951.

Rosenfeld, Paul. *Port of New York: Essays on Fourteen American Moderns.* New York: Harcourt, Brace and Company, 1924.

———. "Stieglitz," *Dial,* 70 (April 1921): 397–409.

Rugg, Harold. *Culture and Education in America.* New York: Harcourt, Brace and Company, 1931.

Schapiro, Meyer. "Rebellion in Art," Chapter 9 in Daniel Aaron, ed. *America in Crisis.* New York: Knopf, 1952.

Seligmann, Herbert J. *Alfred Stieglitz Talking.* New Haven: Yale University Library, 1966.

Stein, Gertrude. *The Autobiography of Alice B. Toklas.* New York: Harcourt, Brace and Company, 1933.

The Stieglitz Circle. Poughkeepsie, New York: Vassar College Art Gallery, December 2–20, 1972.

vember 1958.

Williams, William Carlos. *The Autobiography of William Carlos Williams.* New York: Random House, 1951.

William Carlos Williams. *Selected Letters.* John C. Thirlwall, ed. New York: McDowell, Obolensky, Inc., 1957.

Young, Mahonri Sharp. *Early American Moderns: Painters of the Stieglitz Group.* New York: Watson-Guptill, 1974.

Zigrosser, Carl. "Alfred Stieglitz," *Twice A Year,* VIII–IX (1942): 137–145.

Zilczer, Judith Katz. "The Aesthetic Struggle in America, 1913–1918: Abstract Art and Theory in the Stieglitz Circle," Ph.D. dissertation, University of Delaware, 1975.

Monographs and Specific Studies:

Ames, Scribner. *Marsden Hartley in Maine.* Orono, Maine: 1972.

Benson, E. M. *John Marin, The Man and His Work.* Washington, D.C.: The American Federation of Arts, 1935.

Oscar Bluemner. New York: New York Cultural Center, December 16, 1969–March 8, 1970.

Oscar Bluemner: American Colorist. Cambridge, Mass.: Fogg Art Museum, October 11–November 15, 1967.

Cahill, Hoger. *Max Weber.* New York: The Downtown Gallery, 1930.

Curry, Larry. *John Marin: 1870–1953.* Los Angeles: Los Angeles County Museum of Art, July 7–August 30, 1970.

Davidson, Abraham A. "John Marin: Dynamism Codified." *Artforum,* IX No. 8 (April 1971): 37–41.

Eldridge, Charles III. "Georgia O'Keeffe—The Development of an American Modern," Ph.D. dissertation, University of Minnesota, 1971.

Gallup, Donald. "The Weaving of a Pattern: Marsden Hartley and Gertrude Stein," *Magazine of Art,* 41 (November 1948): 256–261.

Goodrich, Lloyd and Doris Bry. *Georgia O'Keeffe.* New York: Whitney Museum, 1970.

Goodrich, Lloyd. *Max Weber, Retrospective*

Exhibition. New York: Whitney Museum, 1949.

Hartley, Marsden. *Adventures in the Arts.* New York: Boni and Liveright, 1921.

———. "Art and the Personal Life," *Creative Art,* 31 (June 1928): 31–37.

———. *Collected Poems.* New York: The Viking Press, 1945.

Haskell, Barbara. *Arthur Dove.* San Francisco: San Francisco Museum of Art, November 21, 1974–January 5, 1975.

———. *Marsden Hartley.* New York: Whitney Museum of American Art, 1980.

Helm, MacKinley. *John Marin.* Boston: Pellegrini & Cudahy, 1948.

Johnson, Dorothy Rylander. *Arthur Dove: The Year of Collage.* College Park, Maryland: University of Maryland Art Gallery, March 13–April 19, 1967.

Lerner, Abram and Bartlett, Cowdry. "A Tape Recorded Interview with Abraham Walkowitz," *Journal of the Archives of American Art,* 9 (January 1969): 10–16.

Max Weber, The Years 1906–1916. New York: Bernard Danenberg Galleries, 1970.

McCausland, Elizabeth. *A. H. Maurer.* New York: A. A. Wyn, Inc., 1951.

———. *Marsden Hartley.* Minneapolis: University of Minnesota Press, 1952.

Mellow, James R. "The Maurer Enigma," *Arts,* 34 (January 1960): 30–35.

New York City Museum of Modern Art. *Max Weber, Retrospective Exhibition, 1907–1930.* New York: Plandome Press, 1930.

Norman, Dorothy. *The Selected Writings of John Marin.* New York: Pellegrini & Cudahy, 1949.

O'Keeffe, Georgia. *Georgia O'Keeffe.* New York: Viking, 1976.

Phillips, Duncan. "Arthur Dove, 1880–1946," *Magazine of Art,* 40 (May 1947): 192–197.

Pollack, Peter. *Alfred Maurer and the Fauves: The Lost Years Rediscovered.* New York: Bernard Danenberg Galleries, 1973.

Reich, Sheldon. "Abraham Walkowitz: Pioneer of American Modernism," *American Art Journal,* 3 (Spring 1971): 72–83.

———. *Alfred H. Maurer, 1868–1932.* Washington, D.C.: National Collection of Fine Arts, 1973.

———. *John Marin: A Stylistic Analysis and a Catalogue Raisonné.* Tucson: University of Arizona Press, 1970.

Rich, Daniel C. *Georgia O'Keeffe.* Chicago: Art Institute of Chicago, 1943.

Sawin, Martica R. *Abraham Walkowitz, 1878–1965.* Salt Lake City: Utah Museum of Fine Arts, University of Utah, October 27–December 1, 1974.

Siegel, Priscilla Wishnick. "Abraham Walkowitz: The Early Years of an Immigrant Artist," Master's thesis, University of Delaware, 1976.

Solomon, Alan. *Arthur G. Dove: A Retrospective Exhibition.* Ithaca, New York: Andrew Dickson White Museum of Art, Cornell University, 1954.

Story, Ala. *Max Weber.* Santa Barbara, California: The Art Galleries, University of California at Santa Barbara, February 6–March 3, 1968.

Tomkins, Calvin. "The Rose in the Eye Looked Pretty Fine," *New Yorker* (March 4, 1974): 40–66.

Weber, Max. *Cubist Poems.* London: Elkin Matthews, 1914.

———. *Essays on Art.* New York: W. E. Rudge, 1916.

———. *Primitives.* New York: Spiral Press, 1926.

Werner, Alfred. *Max Weber.* New York: Abrams, 1975.

Wight, Frederick S. *Arthur G. Dove.* Berkeley: University of California Press, 1958.

——— and MacKinley Helm. *John Marin: A Retrospective Exhibition.* Boston: Institute of Modern Art, 1947.

Wilder, Mitchell, ed. *Georgia O'Keeffe.* Fort Worth, Texas: Amon Carter Museum of Western Art, 1966.

The Work of Georgia O'Keeffe: A Portfolio of Twelve Paintings. Introduction by James W. Lane. Appreciation by Leo Katz. New York: Dial Press, 1937.

Zigrosser, Carl. *The Complete Etchings of John Marin.* Philadelphia: Philadelphia Museum of Art, 1969.

2. THE ARENSBERG CIRCLE

General and Background Material:

Agee, William. "New York Dada, 1910–1930," in *The Avant-Garde*, Thomas B. Hess and John Ashberry, eds. *Art News Annual*, xxxiv (1968): 104–113.

Bailey, Craig R. "The Art of Marius De Zayas," *Arts Magazine*, 53 (September 1978): 136–143.

Baur, John I. H. "The Machine and the Subconscious: Dada in America," *Magazine of Art*, 44 (October 1951): 233–237.

Blesh, Rudi. *Modern Art USA: Men, Rebellion, Conquest, 1900–1956*. New York: Knopf, 1956.

The Blindman. Marcel Duchamp, ed. New York, Nos. 1–2, 1917.

Buffet-Picabia, Gabrielle. "Some Memories of Pre-Dada: Picabia and Duchamp," in the *Dada Painters and Poets*, Robert Motherwell, ed. New York: Wittenborn, Schuetz, 1951.

Camfield, William A. *Francis Picabia, His Art, Life, and Times*. Princeton: Princeton University Press, 1979.

———. "The Machinist Style of Francis Picabia," *Art Bulletin*, 48 (September–December 1966): 309–322.

Casseres, Benjamin de. "The Unconscious in Art," *Camera Work*, 36 (October 1911).

"A Complete Reversal of Art Opinions by Marcel Duchamp, Iconoclast," *Arts and Decoration*, 5 (September 1915): 427–428, 442.

De Zayas, Marius. *African Negro Art: Its Influence on Modern Art*. New York: 1916.

———. "Modern Art: Themes and Representations," *Forum*, 54 (August 1915): 221–230.

——— and Paul B. Haviland. *A Study of the Modern Evolution of Plastic Expression*. New York: 291 Gallery, 1913.

———. "The Sun Has Set," *Camera Work*, 39 (July 1912): 17–18.

Demuth, Charles. "For Richard Mutt," *The Blind Man*, 2 (May 1917): 6.

Duchamp, Marcel. *The Bride Stripped Bare by Her Bachelors, Even*. Trans., George Heard Hamilton. New York: George Wittenborn, 1960. A typographic version by Richard Hamilton of Duchamp's "Green Box."

Hapgood, Hutchins. *A Victorian in the Modern World*. New York: Harcourt, Brace, and Company, 1939.

Homer, William I. "Picabia's 'Jeune fille américaine dans l'état de nudité' and Her Friends," *Art Bulletin*, 58 (March 1975): 110–115.

"The Iconoclastic Opinions of M. Marcel Duchamp Concerning Art and America," *Current Opinion*, 59 (November 1915): 346–347.

Kimball, Fiske. "Cubism and the Arensbergs," *Art News Annual*, 24 (1955): 117–122, 174–178.

Kreymborg, Alfred. *Troubador: An Autobiography*. New York: Boni and Liveright, 1925.

Kuh, Katherine. *The Open Eye*. New York: Harper & Row, 1971: 56–64.

May, Henry F. *The End of American Innocence, 1912–1917*. New York: Knopf, 1959.

McBride, Henry. "The Walter Arenbergs [sic]," *Dial* (July 1920): 61–64.

Naumann, Francis. "Cryptography and the Arensberg Circle," *Arts Magazine*, 51 No. 9 (May 1977): 127–133.

———. "The New York Dada Movement: Better Late than Never," *Arts Magazine*, 54 No. 6 (February 1980): 143–149.

———. "Walter Conrad Arensberg: Poet, Patron, and Participant in the New York Avant-Garde, 1915–1920," *Philadelphia Museum of Art Bulletin*, 76 No. 328 (Spring 1980): 1–32.

New York Dada. Marcel Duchamp, ed. New York, No. 1, 1921.

Picabia, Francis. *391*, ed. Michel Sanouillet. Paris: Le Terrain Vague, 1965.

Richter, Hans. *Dada: Art and Anti-Art*. New York: McGraw-Hill, 1968.

Rose, Barbara. *American Art Since 1900*. New York: Frederick A. Praeger, 1975.

Rubin, William S. *Dada, Surrealism, and Their Heritage*. New York: Museum of Modern Art, 1968.

Sanouillet, Michel. *Dada à Paris.* Paris: Jean-Jacques Pauvert, 1965.

Schwarz, Arturo. *The Complete Works of Marcel Duchamp.* New York: Abrams, 1969.

Seldes, Gilbert. *The Seven Lively Arts.* New York: Harper and Bros., 1924.

Tashjian, Dickran. "New York Dada and Primitivism," in *Dada Spectrum: The Dialectics of Revolt,* Stephen Foster and Rudolf Kuenzli, eds. Iowa City: University of Iowa Press, 1979: 115–144.

————. *Skyscraper Primitives: Dada and the American Avant-Garde.* Middletown, Conn.: Wesleyan University Press, 1975.

Verkauf, Willi, ed. *Dada: Monograph of a Movement.* Teufen, Switzerland: A. Niggli, 1957.

Wood, Beatrice. "I Shock Myself: Excerpts from the Autobiography of Beatrice Wood," Intro. and Notes by Francis Naumann. *Arts Magazine,* 51 No. 9 (May 1977): 134–139.

Monographs and Specific Studies:

Baur, John I. H. *Joseph Stella.* New York: Frederick A. Praeger, 1971.

Belz, Carl. "The Role of Man Ray in the Dada and Surrealist Movements," Ph.D. dissertation, Princeton University, 1963.

————. "Man Ray and New York Dada," *The Art Journal,* 23 (Spring 1964): 207–213.

Bohan, Ruth L. "Katherine Sophie Dreier and New York Dada," *Arts Magazine,* 51 No. 9 (May 1977):

Bohn, Willard. "The Abstract Vision of Marius de Zayas," *Art Bulletin,* 62 No. 3 (September, 1980): 434–452.

Davidson, Abraham A. "Demuth's Poster Portraits," *Artforum,* XVII No. 3 (November 1978): 54–57.

————. "Two From the Second Decade: Manierre Dawson and John Covert," *Art in America,* 63 No. 5 (September–October 1975): 50–55.

Hamilton, George Heard. "John Covert: Early American Modern," *College Art Journal,* XII (Fall 1952): 37–42.

Jaffe, Irma B. *Joseph Stella.* Cambridge: Harvard University Press, 1970.

Klein, Michael. "The Art of John Covert," Ph.D. dissertation, Columbia University, 1972.

————. "John Covert's 'Time': Cubism, Duchamp, Einstein—A Quasi-Scientific Fantasy," *Art Journal,* XXXIII No. 4 (Summer 1974): 314–320.

————. *John Covert, 1882–1960.* Washington, D.C.: Hirshhorn Institute Press, 1976.

Langsner, Jules. *Man Ray.* Los Angeles: Los Angeles County Museum of Art, 1966.

Penrose, Sir Roland. *Man Ray.* Boston: New York Graphic Society, 1975.

Ray, Man. *Self Portrait.* Boston: Little, Brown, 1963.

Schwarz, Arturo. "An Interview with Man Ray: 'This Is Not for America,' " *Arts Magazine,* 51 No. 9 (May 1977):

————. *Man Ray: The Rigour of Imagination.* New York: Rizzoli, 1977.

————. *New York Dada: Duchamp, Man Ray, Picabia.* Munich: Prestel-Verlag, 1973.

Wellman, Rita. "Pen Portraits: Charles Demuth," *Creative Art,* 9 (December 1931): 483–484.

Yeh, Susan Fillin. "Charles Sheeler's 1923 'Self-Portrait,' " *Arts Magazine,* 52 No. 5 (January 1978): 106–109.

3. SYNCHROMISM AND OTHER COLOR PAINTING

General and Background Material:

Agee, William C. "Synchromism and Color Principles in American Paining 1910–1930," *Art in America,* 53 (October–November 1965): 75–77.

————. "Synchromism: The First American Movement," *Art News,* 64 (October 1965): 28–31 ff.

Barr, Alfred H., Jr. *Matisse, His Art and His*

Public. New York: Museum of Modern Art, 1951. Reprint, 1966.

Benton, Thomas Hart. *An American in Art: A Professional and Technical Autobiography.* Lawrence, Kansas: The University Press of Kansas, 1969.

———. *An Artist in America.* New York: McBride, 1937.

Birren, Faber. *History of Color in Painting.* New York: Reinhold Pub. Corp., 1965.

Chipp, Herschel B. "Orphism and Color Theory," *Art Bulletin,* 40 (March 1958): 55–63.

Color and Form 1909–1914. Essays by Joshua C. Taylor, Peter Selz, Lilli Longren, Herschel B. Chipp, William C. Agee, and Henry G. Gardiner. San Diego: Fine Arts Gallery of San Diego, November 20, 1971–January 2, 1972.

Damase, Jacques, *et al. Sonia Delaunay: Rhythms and Colors.* Greenwich, Connecticut: New York Graphic Society, 1972.

Homer, William Innes. *Seurat and the Science of Painting.* Cambridge, Mass.: M.I.T. Press, 1964.

Klein, Adrian Bernard. *Color Music: The Art of Light.* London: Lockwood, 1926.

Knoedler and Co., Inc. *Synchromism and Color Principles in American Painting: 1910–1930.* Catalogue and text by William C. Agee. New York: October 12–November 6, 1965.

Levin, Gail. *Synchromism and American Color Abstraction 1910–1925.* New York: Braziller, 1978.

———. "The Tradition of the Heroic Figure in Synchromist Abstraction," *Arts Magazine,* 51 (June 1977): 138–142.

Macdonald-Wright, Stanton. *A Treatise on Color.* Los Angeles: S. M. Wright, 1924.

MacGregor, Alasdair Alpin. *Percyval Tudor-Hart 1873–1954: Portrait of an Artist.* London: Macmillan, 1961.

Rood, Ogden N. *Modern Chromatics, with Applications to Art and Industry.* New York: D. Appleton & Co., 1879.

Synchromism and Related Color Principles in American Painting 1910–1930. New York: Museum of Modern Art, 1967.

Wright, Willard Huntington. *The Future of Painting.* New York: B. W. Huebsch, Inc., 1923.

———. *Modern Painting: Its Tendency and Meaning.* New York: John Lane Company, 1915.

——— and Stanton Macdonald-Wright. *The Creative Will: Studies in the Philosophy and the Syntax of Aesthetics.* New York: John Lane Company, 1916.

Monographs and Specific Studies:

Agee, William C. *James H. Daugherty.* New York: Robert Schoelkopf Gallery, December 4–December 31, 1971.

———. "Patrick Henry Bruce: A Major American Artist of Early Modernism," *Arts in Virginia,* 17 (Spring 1977): 12–32.

——— and Barbara Rose. *Patrick Henry Bruce: American Modernist.* New York: Museum of Modern Art, 1979.

Baigell, Matthew. *Thomas Hart Benton.* New York: Abrams, 1974.

Brigante, Nick and Lorser Feitelson. "Tributes to Stanton Macdonald-Wright," *American Art Review,* 1 (January–February 1974): 54.

Cahill, Hoger. *An Exhibition in Memoriam: Morgan Russell (1886–1953).* New York: Rose Fried Gallery, October 26–November 30, 1953.

Coke, Van Deren. *Andrew Dasburg.* Albuquerque, N.M.: University of New Mexico Press, 1979.

Exhibition of Synchromist Paintings by Morgan Russell and S. Macdonald-Wright. Intro. by M. Russell and S. Macdonald-Wright. New York: Carroll Galleries, March 2–16, 1914.

Hess, Thomas B. "Friedman's Tragedy and Triumph," *Art News,* XLVIII (February 1950): 26–27.

Paintings by Stanton Macdonald-Wright and Morgan Russell. Los Angeles: Stendahl Art Galleries, January 4–23, 1932.

Reed, Henry M. *The A. B. Frost Book.* Rutland, Vt.: Tuttle, 1967.

Retrospective of Konrad Cramer. Rochester, N.Y.: Bevier Gallery, Rochester Institute

of Technology, January 10–24, 1964.
A Retrospective Showing of the Work of Stanton Macdonald-Wright. Intro. by Richard F. Brown. Los Angeles: Los Angeles County Museum, January 19–February 19, 1956.

De Salle, Antonio. "Pictorial Pleasantries by James H. Daugherty." *Print Connoisseur,* X (October 1929): 328–363.

Schack, William. "The Ordeal of Arnold Friedman, Painter," *Commentary,* IX (January 1950): 40–46.

Scott, David W. *The Art of Stanton Macdonald-Wright.* Washington, D.C.: National Collection of Fine Arts, May 4–June 18, 1967.

————. "Stanton Macdonald-Wright: A Retrospective," *American Art Review,* 1 (January–February 1974): 49–53.

Thomas Hart Benton: A Retrospective of His Early Years, 1907–1929. New Brunswick, N.J.: Rutgers University Art Gallery, November 19–December 30, 1972.

Tucker, Marcia. *Jay Van Everen.* New York: Whitney Museum, January 12–February 13, 1972.

Walker, John Alan. "Interview: Stanton Macdonald-Wright," *American Art Review,* 1 (January–February 1974): 59–68.

Wolf, Tom W. "Patrick Henry Bruce." *Marsyas,* XV (1970–71): 73–85.

4. SOME EXHIBITIONS, COLLECTORS, AND GALLERIES

Armory Show, 50th Anniversary Exhibition, 1913–1963. Utica, N.Y.: Munson-Williams-Proctor Institute, February 17–March 31, 1963.

Brown, Milton W. *American Painting from the Armory Show to the Depression.* Princeton: Princeton University Press, 1955.

————. *The Story of the Armory Show.* Greenwich, Conn.: New York Graphic Society, 1963.

Cantor, Gilbert M. *The Barnes Foundation: Reality vs. Myth.* Philadelphia: Chilton Books, 1963.

Constable, William George. *Art Collecting in the United States of America. An Outline of a History.* New York: Thomas Nelson and Sons Ltd., 1964.

Davies, Arthur B. "Chronological Chart Made by Arthur B. Davies Showing the Growth of Modern Art," *Arts and Decoration,* 3 (March 1913): 150.

De Zayas, Marius. "How, When, and Why Modern Art Came to New York," Intro. and Notes by Francis Naumann. *Arts Magazine,* 54 No. 8 (April 1980): 96–126.

D'Harnoncourt, Anne. "A. E. Gallatin and the Arensbergs: Pioneer Collectors of Twentieth Century Art," *Apollo,* 149 (July 1974): 52–61.

Dreier, Katherine S. and Marcel Duchamp; George Heard Hamilton, ed. *Collection of the Société Anonyme, Museum of Modern Art 1920.* New Haven, Conn.: 1950.

Eddy, Arthur J. *Cubists and Post-Impressionism.* Chicago: McClurg, 1914.

The Forum Exhibition of Modern American Painting. New York: Anderson Galleries, March 13–25, 1916.

Kuhn, Walt. *The Story of the Armory Show.* New York: Privately printed 1938.

McCausland, Elizabeth. "The Daniel Gallery and Modern American Art," *Magazine of Art,* 44 (November 1951): 280–285.

Naumann, Francis. "The Big Show: The First Exhibition of the Society of Independent Artists," *Artforum,* Part I, 17, No. 6 (February 1979): 34–39.

————. "Critical Response," *Artforum,* Part II, 17, No. 8 (April 1979): 49–53.

The 1913 Armory Show in Retrospect. Intro. by Frank Anderson Trapp. Amherst, Mass.: Department of Fine Arts and American Studies, February 17–March 17, 1958.

Pach, Walter. *Queer Thing, Painting.* London and New York: Harper & Bros., 1938.

Panama-Pacific International Exposition Company. *Panama-Pacific International Exposition.* San Francisco: R. A. Reid, 1914.

Phillips, Duncan. *A Collection in the Making.* New York: E. Weyhe, 1926.

Phillips, Marjorie. *Duncan Phillips and His Collection.* Boston: Little, Brown, 1970.

Reid, Benjamin Lawrence. *The Man from New York: John Quinn and His Friends.* London and New York: Oxford University Press, 1969.

Saarinen, Aline B. *The Proud Possessors.* New York: Random House, 1958.

Schack, William. *Art and Argyrol: The Life and Career of Dr. Albert C. Barnes.* New York: T. Yoseloff, 1960.

Tucker, Marcia. *American Paintings in the Ferdinand Howald Collection.* Columbus, Ohio: Columbus Gallery of Fine Arts, 1969.

Vaizey, Marina. "Ferdinand Howald: Avant-Garde Collector." *Arts Review,* 25 No. 13 (June 1973).

Weichsel, John. "Another New Art Venture: The Forum Exhibition," *International Studio,* 58 (June 1916): cxvi.

Zilczer, Judith. *"The Noble Buyer": John Quinn, Patron of the Avant-Garde.* Washington, D.C.: Smithsonian Institution Press, 1978.

————. " 'The World's New Art Center' Modern Art Exhibitions in NYC, 1913–1918." *Archives of American Art Journal,* 14 No. 3 (1974): 2–7.

5. PRECISIONISM

General and Background Material:

Andrews, Edward D. "The Shaker Manner of Building," *Art in America,* 48 No. 3 (1960): 38–45.

Brown, Milton W. "Cubist-Realism: An American Style," *Marsyas,* 3 (1943–45) (1946): 139–160.

Buildings: Architecture in American Modernism. New York: Hirschl & Adler Galleries, October 29–November 29, 1980.

Friedman, Martin. "The Precisionist View," *Art in America,* 48 No. 3 (1960): 31–37.

————. *The Precisionist View in American Art.* Minneapolis: Walker Art Center, 1960.

Geometric Tradition in American Painting. New York: Rosa Esman Gallery and Marilyn Pearl Gallery, 1980.

Kootz, Samuel Melvin. *Modern American Painters.* New York: Brewer & Warren, Inc., 1930.

Kramer, Hilton. "The American Precisionists," *Arts,* 35 (March 1961): 32–37.

A New Realism: Crawford, Demuth, Sheeler, Spencer. Cincinnati: Modern Art Society, March 12–April 7, 1941.

The Precisionist Painters 1916–1949: Interpretations of a Mechanical Age. Huntington, N.Y.: Heckscher Museum, 1978.

Tashjian, Dickran. *William Carlos Williams and the American Scene, 1920–1940.* New York: Whitney Museum, 1978.

Taylor, Joshua. *America As Art.* Washington, D.C.: Smithsonian Institution Press, 1976.

Monographs and Specific Studies:

Andrews, Faith and Edward D. Andrews. "Sheeler and the Shakers," *Art in America,* 53 (February 1965): 90–95.

Cloudman, Ruth. *Preston Dickinson, 1889–1930.* Lincoln, Nebr.: Nebraska Art Association, 1979.

Dochterman, Lilian. *The Quest of Charles Sheeler.* Iowa City, Iowa: University of Iowa Press, 1963.

Faison, S. Lane, Jr. "Fact and Art in Charles Demuth," *Magazine of Art,* 43 (April 1950): 123–128.

Farnham, Emily. *Charles Demuth: His Life/ Psychology and Works.* Ph.D. Dissertation, Ohio State University, 1959.

————. *Charles Demuth: Behind a Laughing Mask.* Norman, Okla.: University of Oklahoma Press, 1971.

Freeman, Richard B. *Niles Spencer.* Frankfort, Ky.: University of Kentucky, 1965.

Friedman, Martin L. *Charles Sheeler.* New York: Watson-Guptill, 1975.

————; Hayes, Bartlett; and Millard, Charles W., III. Essays in *Charles Sheeler.* Catalogue for the exhibition at the National Collection of Fine Arts, Washington, D.C.: Smithsonian Institution, October 10–November 24, 1968.

Jaffe, Irma. "Joseph Stella and Hart Crane: The Brooklyn Bridge," *American Art Jour-*

nal, I No. 2 (Fall 1969): 98–107.

Lipke, William C. *Abstraction and Realism: 1923–1943. Paintings, Drawings, and Lithographs of Louis Lozowick.* Burlington, Vt.: University of Vermont, March 14–April 18, 1971.

Millard, Charles W., III. "Charles Sheeler: American Photographer," *Contemporary Photographer,* VI No. 1 (1967):

Murrell, William. *Charles Demuth.* New York: Whitney Museum of American Art, 1931.

Ritchie, Andrew Carnduff. *Charles Demuth.* New York: Museum of Modern Art, 1950.

Rourke, Constance. *Charles Sheeler, Artist in the American Tradition.* New York: Harcourt, Brace, 1968.

Stefan Hirsch, Pioneer Precisionist. Grand Rapids, Michigan: Grand Rapids Art Museum, 1979–80.

Urdang, Beth. *Preston Dickinson.* New York: Zabriskie Gallery, January 15–February 2, 1974.

Wolf, Ben. *Morton Livingston Schamberg.* Philadelphia: University of Pennsylvania Press, 1963.

6. INDEPENDENTS

General and Background Material:

American Genius in Review No. 1. Intro. by Douglas MacAgy. Dallas, Tex.: Dallas Museum for Contemporary Arts, May 11–June 19, 1960.

Breeskin, Adelyn. *Roots of Abstract Art in America, 1910–1930.* Washington, D.C.: National Collection of Fine Arts, 1965.

Cubism: Its Impact in the USA, 1910–1930. Intro. by Clinton Adams. Albuquerque, N.M.: University of New Mexico Art Museum, February 10–March 17, 1967.

Exhibition of Paintings and Drawings Showing the Later Tendencies in Art. Philadelphia: Pennsylvania Academy of the Fine Arts, April 10–May 15, 1921.

Homer, William I., ed. *Avant-Garde Painting and Sculpture in America 1910–1925.* Wilmington, Del.: Delaware Art Museum, 1975.

Pennsylvania Academy Moderns 1910–1940. Essays by Joshua C. Taylor and Richard T. Boyle. Washington, D.C.: National Collection of Fine Arts, 1975.

San Francisco Museum of Modern Art. *Painting and Sculpture in California, the Modern Era.* San Francisco: San Francisco Museum of Modern Art, 1977.

Monographs and Special Studies:

Agee, William C. "Rediscovery: Henry Fitch Taylor," *Art in America,* LIV (November 1966): 40–43.

Arnason, H. H. *Stuart Davis.* Minneapolis: Walker Art Center, 1957.

Baur, John I. H. *William Zorach.* New York: Whitney Museum, 1959.

Blesh, Rudi. *Stuart Davis.* New York: Grove Press, 1960.

Breeskin Adelyn D. *H. Lyman Saÿen.* Washington, D.C.: National Collection of Fine Arts, 1970.

Bywaters, Jerry. *Andrew Dasburg.* Dallas: Dallas Museum of Fine Arts, March 3–April 21, 1957.

Carr, Gerald L. "Hugh Henry Breckenridge, A Philadelphia Modernist." *American Art Review,* IV No. 5 (May 1978): 92–99, 119–122.

Coke, Van Deren. *Taos and Santa Fe: The Artist's Environment, 1882–1942.* Albuquerque, N.M.: University of New Mexico Press, 1963.

Dasburg, Andrew. "Cubism—Its Rise and Influence," *Arts,* 4 (November 1923): 278–283.

Gardiner, Henry G. *Arthur B. Carles.* Philadelphia: Philadelphia Museum of Art, 1970.

Garman, Ed. *The Art of Raymond Jonson, Painter.* Albuquerque, N.M.: University of New Mexico Press, 1976.

Gedo, Mary Mathews. *Manierre Dawson (1887–1969): A Retrospective Exhibition of Painting.* Chicago: Museum of Contemporary Art, Chicago, 1976.

Hey, Kenneth R. "Manierre Dawson: A Fix on the Phantoms of the Imagination," *Archives of American Art Journal*, 14 No. 4 (1974): 7–12.

Kantor, Morris. "Ends and Means," *Magazine of Art*, XXXIII (March 1944): 138–147.

Kelder, Diane. *Stuart Davis*. New York: Praeger, 1971.

Lane, John R. *Stuart Davis: Art and Art Theory*. Brooklyn, New York: The Brooklyn Museum, 1978.

Langsner, Jules. "Permanence and Change in the Art of Lorser Feitelson,"*Art International*, VII (September 25, 1963): 73–76.

Luhan, Mabel D. "Georgia O'Keeffe in Taos," *Creative Art*, 8 (June 1931): 406–410.

MacAgy, Douglas. "Five Rediscovered from the Lost Generation," *Art News*, LIX (Summer 1960): 38–41.

Manierre Dawson: Paintings 1909–1913. Karl Nickel, Intro. Sarasota, Fla.: Ringling Museum of Art, November 6–26, 1967.

Manierre Dawson: Paintings, 1909–1913. New York: Robert Schoelkopf Gallery, April 5–May 1, 1969.

Marin, John. "On My Friend Carles," *Art News*, LII (April 1953): 20, 67.

Retrospective, Paintings by Manierre Dawson. Grand Rapids, Mich.: Grand Rapids Art Museum, April 3–23, 1966.

Rubin, William. *The Paintings of Gerald Murphy*. New York: Museum of Modern Art, 1974.

Schwartz, Sanford. "When New York Went to New Mexico," *Art in America*, 64 No. 4 (July–August 1976): 92–97.

Seldes, Henry J. "Lorser Feitelson," *Art International*, XIV (May 20, 1970): 48–52.

Shepherd, Richard. "M. Kantor 1946," *Art News*, XLV (July 1946): 38–41, 57–58.

Sims, Patterson and Merry A. Foresta. *Jan Matulka, 1890–1972*. New York: Whitney Museum, December 18, 1979–February 24, 1980.

Sweeney, James J. *Stuart Davis*. New York: Museum of Modern Art, 1945.

Tarbell, Roberta K. "Early Paintings by Marguerite Thompson Zorach," *American Review*, I (March–April 1974): 43–57.

———. *Marguerite Zorach: The Early Years, 1908–1920*. Washington, D.C.: National Collection of Fine Arts, December 7, 1973–February 3, 1974.

Tomkins, Calvin. *Living Well Is the Best Revenge*. New York: Viking, 1962.

Valley House Gallery. *The Paintings of Hugh H. Breckenridge 1870–1937*. Dallas, Tex.: 1967.

Ventura, Anita. "The Paintings of Morris Kantor," *Art Digest*, XXX (May 1956): 30–35.

Zorach, William. *Art Is My Life*. Cleveland and New York: World Publishing Co., 1967.

List of Illustrations

* Also illustrated in color

* Also illustrated in color

* Also illustrated in color

* Also illustrated in color

* Also illustrated in color

* Also illustrated in color

Index

Page numbers in italic refer to illustrations.

Other DA CAPO titles of interest